Mona Lisa's Escort

MONA LISA'S ESCORT

André Malraux and the Reinvention of French Culture

HERMAN LEBOVICS

Cornell University Press

ITHACA AND LONDON

First published 1999 by Cornell University Press

Printed in the United States of America

Cornell University Press strives to use environmentally responsible suppliers and materials to the fullest extent possible in the publishing of its books. Such materials include vegetable-based, low-VOC inks and acid-free papers that are recycled, totally chlorine-free, or partly composed of nonwood fibers. Books that bear the logo of the FSC (Forest Stewardship Council) use paper taken from forests that have been inspected and certified as meeting the highest standards for environmental and social responsibility. For further information, visit our website at www.cornellpress.cornell.edu.

Cloth printing 10 9 8 7 6 5 4 3 2 1

Library of Congress Cataloging-in-Publication Data

Lebovics, Herman
 Mona Lisa's escort : André Malraux and the reinvention of French culture / Herman Lebovics.
 p. cm.
 Includes index.
 ISBN 0-8014-3565-X (cloth : alk. paper)
 1. France—Civilization—1945– 2. Malraux, André, 1901–1976—Contributions in French culture. 3. Statesmen—France—Biography. 4. Social change—France. 5. Political culture—France. 6. Symbolism in politics—France. I. Title.
DC33.7.L425 1999
944.083—dc21 98-30461

Contents

Illustrations

Preface

On 23 November 1996, exactly twenty years after the death of André Malraux, the Gaullist government of Jacques Chirac exhumed his body and reinterred him in the Panthéon, the temple of the republic dedicated to the "Great Men" of the nation. The ceremony was part of an elaborate Malraux Autumn of conferences, new editions and translations, exhibitions, plaques, posters, postage stamps, and appreciations. In the course of the fall the historical person became the *sign* André Malraux. The great man in the Panthéon has become one of the most frequently invoked markers of the glory days of the French nation and French culture.

The government's decision to honor Malraux was driven by highly over-determined motives. Cynics point to the colorless nature of President Chirac's government. This Gaullist presidency, the first since 1974, had yet to "cut a scar on the map," to use Malraux's own definition of fame. Perhaps it aimed to do what Premier Michel Debré had done in 1959 at the request of President de Gaulle: bring in Malraux to brighten an image, to give, in the General's words, "distinction" (*relief*) to the new government. With no important contemporary intellectuals to crown this administration, perhaps all the latter-day Gaullists could do was to dig up an old one and recycle him. Fiscal austerity required a cut in the Ministry of Culture's budget. Honoring the founder of the ministry while diminishing his creation—taking back economic capital but offering in its place the symbolic kind—seemed a wise maneuver. Yet however valid these reasons may be, and I think that they played a role, in a more profound sense the Malraux celebration touched an *absence* in the souls of many French intellectuals and artists, and those in France and abroad who have in the past looked to Paris for guidance.

I watched the Panthéon ceremony on television and read all the accounts of the larger observance I could find. It appeared to me that the Malraux Autumn marked for many intellectuals—of all camps—the sad observance,

literally, the burial, of a way of being, of feeling, of thinking. Many French commentators, on both the left and the right, were treating the moment as the consummation of the classical age of French culture, the end of what Michel Foucault had called the classical *épistème*. The speeches at the ceremony, taken together, were "like a funeral oration for engagé intellectuals," in the words of Serge July, the onetime activist and founding editor of the Paris morning newspaper *Libération*.*

I offer this book as a contribution to the assessment of the condition of French culture in modern times. Should we Americans, too, consider Malraux's reburial an act of closure, even of nostalgia, regarding the loss of France's cultural coherence and of the nation's cultural preeminence? Does the Malraux Autumn betoken the exhaustion of the artists and intellectuals who had been France's cultural missionaries? But posed this way the question is too big. People trained in literature and the arts have taught us how aesthetic texts are deeply involved in all the realms of power. We must investigate the specificities of how culture works, or perhaps doesn't work, as historical praxis.

A few years before the Panthéon ceremony for Malraux, as it happened, I had decided to look for a moment, or arguably *the* moment, in contemporary French history when the political leaders' awareness of the dangers the culture faced began to be translated into concrete policies aimed to change old arts institutions or create new ones. By the time I was searching the Internet for the full text of President Chirac's November 1996 speech, I had already concluded that any estimation of the present and the future of French culture in large measure depended on how we understand both the short- and long-term results of André Malraux's efforts to revitalize national cultural life when he served as France's first minister of culture in the years 1959–69. The Malraux Autumn persuaded me that my own thinking had been running on matters that were perplexing some French intellectuals and politicians as well.

My interest in Malraux and his work as minister grows out of my fascination with the workings of the vision of a *True France*. In my book of that title I assessed the harmful social and political effects in the first half of the twentieth century of the French cultural monolith. And at the same time, I tried to point out openings for pluralism in French society and thought. Although I think that my critique of how limited are the ways to be French is right, I want here to explore further the ideology of Frenchness with a more nuanced, and perhaps more sympathetic, understanding of the uses and dilemmas of the idea of cultural solidarity.

How are commonalities worked out—or accepted—among a people, which yield, if not community, at least overlapping universes of discourse, some normal expectations of others, some sense of inclusion, a sense of sol-

*From Serge July's editorial, "La dernière dyable de Malraux," *Libération*, 25 November 1996.

idarity—fundamentally a shared *language* in the broadest sense of the word? This is a question people interested in French culture ignore at the risk of misunderstanding fundamental coherence—or yearnings for coherence—in contemporary French society.

Until recent decades, the shared world of modern France was that of *la civilisation française*. French civilization has meant, and will mean here, two things: the ways of feeling, thinking, and acting expected of someone who was part of France, and the print media, which have systematically colonized the French life-world, affirming an identity of inherited classical print culture with life as it is lived in France. Political inclusion, which included legal inclusion, has meant, finally, cultural assimilation. Accordingly, when public things go wrong in modern France, cultural solutions must be sought along with more proximate ones such as political revolution, elections, or economic measures. Conversely, when in France the culture enters into crisis, the troubles quickly spread into other aspects of life.

Since at least the 1880s, when the republican school consolidated its hegemony over the education of the young, the printed word has dominated *la civilisation française*. Benedict Anderson's influential idea of the creation of an "imagined community" by means of the printed word has been especially, and rightfully, appreciated by people who know France. But what happens to the community when the old culture does not infuse the people it must reach and new media change the ways of connecting?

This work is about the mortal crisis of that classical print culture in the decade of the 1960s, or put another way, about the exhaustion of the classical way of knowing. I mean to describe here a fundamental turning point that French culture came to, and, having not turned, still faces. "Yes, but French culture is always in crisis," my friend Dick Kuisel responded trenchantly when I told him what I was up to. That is true: part of the delight of studying French cultural history is to see the explosive changes from droughts to brilliant new foliage, colorful autumns, and around again. Things have worked in a similar way since, roughly, the Renaissance. We are familiar with the sociological pattern, even if we cannot predict its periodicity: the usual *crise* in France is proclaimed by a declining intellectual or arts clique as it is pushed out of teaching posts or commissions, editorial positions or art venues—its members' names no longer on the tongues of left bank gossips—by a new group of artists or intellectuals. So we should expect a brilliant renewal in the French cultural scene, one of these days.

However, after studying the first decade (1959–69) of France's new Ministry of Cultural Affairs, as it was initially called, I believe that this next flowering will not, cannot, occur in the same way. In 1959 the challenge to France's new cultural ministry was not the normal disorders caused by the unpredictable circulation of symbolic capital in the culture. Rather, André Malraux, the new ministry's head, faced the depletion of these capital reserves with no clear project in place for their renewal or replacement.

The book will follow Malraux's attempts at cultural reformation during

the ten years he served as cultural minister. It will describe his achievements and failures of the 1960s, from his order for the facades of the public buildings of Paris to be cleaned to his preparations for the defense of some of them, the cultural establishments, against the angry Parisian students in May 1968. The political time frame is equally important. The story of Malraux's cultural initiative begins with France's Algerian crisis (1958) and ends with failed plebiscite that caused General de Gaulle and Malraux to resign (1969).

When he assumed his new post at the creation of the Fifth French Republic, Malraux wanted to take what he considered the next step by *marrying*— the language he and General de Gaulle often used—the French people to its historic culture. He wished to implant the culture the way the republican schools of the 1880s and after had institutionalized republican book learning. More immediately, his strategy was to complete the unfinished project of the Popular Front from the days of his leftist youth in the mid-1930s: *giving the state direct responsibility for the culture.*

A word about the way I have ordered this account will be helpful to the reader. After a discussion in the Introduction about the relation of institutions to biography in history, I devote the first two chapters to placing French culture in its political and historical contexts. Chapter 1, about the exhibition of the *Mona Lisa* in the United States in 1963, offers a paradigmatic picture of how French cultural power worked in the years of the Cold War. The second chapter is concerned with the how and the why of France's historic cultural messianism. Here, to prove that Malraux confronted challenges unprecedented in French history, I have traced the history of France's special cultural mission from the time of François I^er. In Chapters 3 and 4, which add the biographical pieces to the picture, I ask how French culture made André Malraux. With the necessary contexts in place, the rest of the book asks how Malraux tried to remake the culture. Malraux, because of who he was, created the ministry, which in turn tried to create more Malrauxs and greater publics for Malrauxs and for the doings of the ministry. "Malraux" became a token for this complex process and a way of evoking its outcome.

Let me conclude this Preface by thanking the many people whose kindness, help, and encouragement allowed me to complete this book. Despite the apparently pessimistic tone of my theme, the way I came to it gives evidence of the vitality, resilience, and deep cultural awareness that pervades contemporary French society. While I was doing research in Paris, I was invited to dinner at the home of a friend, Alain Barbier, an engineer by training and a person of wide culture. When other French dinner guests, also mostly friends, asked me, the American researcher, what aspect of French history I was studying, I could not repress the urge to be provocative. I often learn a lot by doing this, although it does incur certain social risks. (In France, sparking a spirited conversation can be a way of paying for a fine dinner, as long as people are not distracted from the food.)

"Oh, the death of *la civilisation française*," I said offhandedly. Rising eyebrows, side-looks. Maybe I had crossed the line? I defended my claim using some of the ideas that the reader will find in this book, better supported now, I hope, than on that summer evening. Others at the table kindly worried that assertion with me. Finally, Alain said thoughtfully, "No, not the end of *la civilisation française*; that's not what you are studying. Your book is about the end of *a* French civilization. We have to see what follows." And so it is.

Let me also thank my friends and colleagues of the New York Area French History Seminar whom I asked to critique one of my most speculative chapters at one of our monthly sessions. They obliged with enthusiasm; they pushed me hard in the discussion. I want especially to acknowledge those who followed up with written suggestions: Bob Paxton, David Schalk, Isser Woloch, Ann Alter, Jerrold Seigel, Yani Sinanoglou, Joel Blatt, and Tip Ragan.

In France I owe a debt to Bernard and Marcia Scholl, Nicole Gênet, Emmanuelle Loyer, Gérard Noiriel, Marie-Claude Gênet-Delacroix, Philippe Urfalino, and Charles-Louis Foulon, who, in addition, gave me a personal tour of the state Gobelin tapestry manufacture. Geneviève Poujol graciously allowed me to read unpublished transcripts of interviews and drafts of her compilation of documents and comments for her book on the history of the Ministry of Culture. Geneviève Gentil, secretary general of the Comité d'Histoire du Ministère de la Culture, was also very helpful.

In the United States, friends helped me with conversations, reading parts or all of the manuscript, and offering guidance in areas where I was weak, such as art history, colonial studies, computer graphics, bibliographical hunting, proofing, and English grammar: Patricia Mainardi, Janis Tomlinson, Olufemi Vaughan, Hélène Volat, Brigitte Howard, Konrad Bieber, Richard Kuisel, Barbara Weinstein, Victoria Allison, Hedi BenAicha, Alejandra Osorio, Jim Genova, Aaron Hirsch, Ruth Ben-Ghiat, James Morris, Bernard Crick, Donald Lam, Joe Brinley, Bruce Ackerman, and Judit Mészáros. Roger Haydon, my editor, has made the act of writing this book a wonderful conversation with a sympathetic and thoughtful interlocutor.

Finally, I thank the financial benefactors who very well understood the connection between intellectual capital and the economic sort. My Dean, Paul Armstrong, made it possible for me to obtain reproduction rights to many of the photographs in the volume. I also benefited from a fellowship from the American Council of Learned Societies (1994–95) and from my year as a fellow of the Woodrow Wilson Center in Washington, D.C., where I learned something about the relation of culture to the state.

HERMAN LEBOVICS

Port Jefferson, New York

Mona Lisa's Escort

Introduction: The Life Story of a Culture

This book on André Malraux and France's creation of a Ministry of Cultural Affairs proposes a new way—new for me at least—of understanding and telling the story of a life—through those of an organization and the mid-century formulation of a new national cultural project in which they both participated. Looking at the intertwining, and sometimes tangling, of the human story and the historical one will show us, I believe, the complicated but traceable ways in which the personal, the aesthetic, and the political came together to re-create the French nation in the second half of the twentieth century. I hope to make a contribution to the recent history of "the French exception" told, in part, through the life of the individual one French commentator described as a rare and powerful "meta-actor" (*métapraticien*), a person whose life codifies a whole metaphysic.[1]

If a culture is a living thing, then it has a life story. To be sure, "living" and "life" can only be metaphors when used to discuss values, institutions, and practices. Yet examining the attempt to save the "life" of a historic aesthetic culture in danger of extinction, allows us to deploy a strategy of connecting the genealogy of the culture with that of a human actor whose personal history incorporated it. In this book I combine aspects of Malraux's biography with ideas about how culture works, and these with the history of events. The intertwining enriches each line of analysis, I believe, to make a whole greater than the parts.

Now that in both France and the United States the romance with structuralism and its later embroideries has faded, I am persuaded more than ever that we need subjects to do history. But after our assimilation of Michel Foucault's "What Is an Author?" (by one who, ironically, is himself an artisan of master discourses), we need to find new concepts to work with subjects. Determining meaning in historical writing requires us to assess actors' intentions within the frame of options and the conjuncture in which they

operate. This linkage of meaning and the intentions of people in history does not, of course, absolve us from the historian's obligatory doubt about actors' statements of motives. Nor does it allow us naively to attribute outcomes back to the purposive behavior of, say, makers of cultural policy. Above all, it buries the now smelly red-herring dogma that meaning always exceeds intentions. Only historical inquiry will settle which intentions and which meanings were available or operative at a certain conjuncture. The rest is the debates of the Schoolmen.[2]

Such a move does require that we do, in a new way, *both* Malraux's biography *and* historical investigation. But it is not enough simply to turn the world upside-down, as, in the wake of the student rising of 1968, Roland Barthes did with his transvaluation of the life and the work of the author: for him at that point, the author's "life is no longer the origins of his fictions, but a fiction contributing to his work."[3] The observation may give us to think, but it leaves us still going around in a futile chicken-or-egg loop.

Nor can we go by way of "experience." That epistemological blow-out patch some social historians have stuck on their studies to replace Leninist vanguardism won't help us either. Our experience comes to us prefigured, contexted. Experience does not write on us; we give it meaning.[4] How, then, to unite life story, fictions, and the historical world we think important in a theoretically valid and thus useful way? I found Malraux's own intuition about how he became "André Malraux" insightful.

Late in his career he confessed his life-strategy to his friend Roger Stéphane: "Intelligence," he confided, "is knowing how to perform your role in the play."[5] To understand the relationship of André Malraux, writer, adventurer, engagé, cultural theorist, and—above all, in this account—government official, to the project of saving and diffusing French culture in the mid-century, I will focus here on the role he created in the *comédie*, the persona he confected with the materials of history.[6] I am interested in Malraux the minister, not Malraux the novelist. I will leave analysis of his novels to those both more skilled in literary criticism, and more generous about the excesses of his prose, than I am.

Malraux's good friend Gaëtan Picon, a literary critic and ministry official, understood the relation of the man to the persona. "Malraux never stopped writing his *Memoirs*; it seemed that he had no subject other than his own life." One of the curiosities of Malraux's fiction is that, no matter the place or time or personal history, all the protagonists speak with the same voice, that of André Malraux.[7] In October 1968 an interviewer for *Der Spiegel* asked him whether, as the minister of General de Gaulle, he was the same man who had written *Man's Hope* and *Man's Fate*. Malraux did not deny that there was a difference between how he thought when he was young and his present views. "However, I think that external historical factors played an enormous role."[8] Mine will be in part an account of the fabrication with the materials of history of the persona or mask we know as André Malraux,

minister of cultural affairs.

Such a history needs the appropriate style of cultural analysis. I agree with Pierre Bourdieu's argument that discourses, words embedded in expressive patterns, gain their power from their social *situatedness*. So a study of cultural discourse without the institutions and organizations, the finances, the civil society, the state (especially in France), and, above all, the historical moment integrated into the account cannot serve any useful intellectual or worldly purpose.

Cultural Pessimism

In *Strange Defeat*, Marc Bloch's brilliant 1940 assessment of how France succumbed so easily to the German invasion, the historian faulted French university intellectuals of the interwar years, and by extension, the culture. The culture-deciders of the interwar years, Bloch asserted, were "capable neither of preserving the aesthetic and moral values of classic culture nor of creating fresh ones to take their place."[9] At another moment of cultural pessimism two decades later, Minister André Malraux and his coworkers, in effect, tried to respond to the historian's sense of cultural drift. What was special about the decades following World War II? And why did French culture matter so much? Why does it still?

To get a first feel for the difference between the American and the French national stories, the reader might try saying aloud the sentence "American culture is in danger." When I say it, I do not feel alarm, dread, tension, or even curiosity. I feel a little foolish. Like most of us, I live comfortably—or at least equally uncomfortably—in many of America's cultures. I pass from one to another as I change my activities or place. Each goes in and out of creative phase cyclically, and the rhythm is enriching and fascinating. Right-wing policy intellectuals might claim to experience a shudder on pronouncing this sentence. I think more likely they fear for their lucrative contracts for speaking engagements and books where they retail their ideas on the so-called American crisis of values, rather than for the future of jazz or hip-hop, or the attendance at exhibitions of Abstract Expressionist art. We hear from them no lamentations for the talents we waste, or fail to develop, because of a market economy and a state indifferent, even hostile, to nurturing the people who might make the next generation's art.

The statement "The English language is in danger in the United States" does arouse a few more spirits here. But this fear is not culture-driven. It's about ethnic voters—especially Spanish speakers—using government forms, especially ballots, printed in their language to challenge the more assimilated politicians of an older immigration.

Similar sentences referring to French culture or the French language, I be-

lieve, would arouse fearful emotions in most educated French people. What is this "French Exception" that questioning it could evoke symptoms of intellectual and even psychological stress in every French intellectual who would discuss the culture with me? What is the history of this *frisson*?

To locate the specialness of the contemporary crisis of French culture, I will pose these concrete questions: After literally centuries without such an institution, why did the new leaders of the French state in the late 1950s and 1960s feel the need to create a ministry devoted to saving and promoting French culture? How and why was it organized as it was? Why was the administratively inexperienced André Malraux made its first head? What did this new ministry accomplish? Not accomplish? And finally, what does Malraux's work look like today?

What Does Culture Do?

At least three historical strands came together to make Malraux's project a crucial undertaking for the future of France. First, the culture of the classical age and its derivations were the "glue" of modern France and, in the unstable political situation of the postwar years, an important component of national unity and class harmony. The nation was still riven by the fissures that had opened for all to see even before the Vichy years: class, ethnic, regional, and intellectual. Accordingly, at the vulnerable moment of postwar reconstruction, to flood the country with American words, films, and music—the products of what Malraux called "dream factories"—was to threaten the cohesion, perhaps the existence, of the French nation. This much-invoked American Menace expressed the growing sense of cultural incoherence many felt. In this book, you will see the word "America" used a great deal to code French cultural malaise. In France, at least, postmodern multiplicity threatens the inherited vision of national life. There are, and have always been, foreign cultural borrowings to be sure, but always French society has naturalized the foreign into its unique world mission, France's obligation to humanity.[10]

Second, the rapid and sustained economic development of the country from 1945 to about 1974, especially in the regions—aerospace around Toulouse, high-tech around Grenoble and in the south, the massive growth of sophisticated businesses and industries in the greater Paris region, urbanization everywhere with the modernization of agriculture and the plummeting of the farming population—generated higher incomes and amenities for all classes. But these *Trois Glorieux* decades also caused a national crisis of identity. Large segments of the population were detached from their old lives and cast adrift in a potentially anomic modernity.

To have a modern industrial *and* stable society in France two conditions had to obtain: (1) the talented and educated would have to live either in Paris or *as if* in Paris, and (2) people in the regions of France had to share both the

consumer goods and the access to improved life chances that the national culture, in the broadest sense, made possible. De Gaulle and Malraux intensified the process, today largely completed, of what was called decentralization but what was in effect multiplying the culture and sophistication of Paris in all the urban centers of France. Sometimes, as here, decentering strengthens the forces of tradition, rather than defeating them.

Finally, passing after the war from the status of a weak major power to something rather less, and soon stripped of most of its colonies, France deployed its culture—the arts and especially the language—to give it a comparative advantage in the new international competition. In brief, if the elites of the former colonies continued to write in French, they might more readily sign commercial contracts written in that language; and if cultured elites everywhere continued to be open to the charms of French *civilisation*—including, variously, the export to the United States of French cooking (as both taught and mystified by Julia Child and associates), the books of French authors, and the traveling exhibitions of French artworks, then France could expect to bank a good deal of the international variety of what Pierre Bourdieu calls symbolic capital.[11]

Malraux understood his cultural project as a desperate strategy to stave off the Fall. Largely an autodidact himself, he realized that the *civilisation* of the classical age and its emanations was limited to a tiny stratum of the population. When he took office in 1959, it could not unite a divided people, let alone represent the true France abroad. Its institutions didn't work: French music-making was a disaster; the state operas and theaters were in disarray; the reading public for literature was not growing; and French modern art was a prewar memory. Moreover, the heritage of the Vichy years, increased regionalism, new values and new migrations due to modernization, and class conflict had tattered the once-seamless cloak of republican cultural unity: it was questionable whether the culture could continue to fulfill its historical role of ensuring national coherence. Finally, no longer attached to a Great Power, the culture of France risked loss of international prestige and so domestic honor.

A generation of young people then growing up was finding the old classical and authoritarian France not to its liking. An overburdened humanist educational system was creating individuals ill fitted for life in modern industrial culture. Education—not Malraux's portfolio—needed reforms to be sure. But—taking a word that in recent decades French intellectuals had contemptuously associated with German holistic thinking—Malraux and his coworkers concluded that only *the culture* of France could bring together generations, regions, and classes. The danger to France for Malraux was the spread of mechanical rationality—the ideologies of science and technology, of the kind he saw both in the United States and the Soviet Union. His response was art, which would become the new magical bond to replace the lost community and the dissipated aura of religious rites. Outside of France,

Malraux and his allies in the Foreign Ministry took advantage of the moment of decolonization and the relative stalemate of the Cold War to promote France as the *cultural* leader of the First World and the patron of the Third.

If I am right about Malraux and French culture, this book will help us understand why today France continues to be gripped by a crisis of culture which is at the same time a crisis of the nation. For Malraux's culture was deeply stricken on or about May 1968 by, among others, its historic agents— French students, artists, and intellectuals. The university system and the Beaux Arts exploded in the spring of 1968 because they were conceived for a republican epoch, but not a democratic one, and so could not fulfill the expectations of their many students and burdened faculty. Malraux tried to adapt French *civilisation* in its new form of French *culture* to modern democracy. Like the education system, however, that culture went into permanent crisis.[12] And since then patch jobs, defense works, and elaborate celebrations of the heritage have not been able to start a recovery or a self-reinvention.

Themes

To conclude this Introduction, it will be useful to preview some of the strands which run through the chapters. Together they carry my major argument about the relationships of the French state to French culture, about the crisis of this culture, the political response, and, finally, the institutionalization of a politico-cultural nostalgia for a lost golden age. Sometimes one of them is at the center of discussion. Sometimes, because of the tradeoffs I have willingly accepted between reproducing the complexity of the web of connections and the clarity of linear writing, a theme is forced into the background while other issues are under discussion.

First, I have tried to write Malraux's biography in a new way: his life story as cultural history. But also, as I enter into the complexities of culture and the state, his personal story becomes more and more *absorbed* into the politics and institutions of French culture. Second, this is a study of the state's efforts in the 1960s to prop up the faltering culture. As a consequence of its increased commitment to solving the problems of the culture, and its failures to do so, the French government provoked a legitimation crisis of the culture state. Third, the book follows the historic decline of France's print culture in modern times and the increase in the varieties of its visual cultures. I plot the trend away from the word to the image in the post–World War II decades. Malraux's own identity changed from the literary intellectual that he had been in the interwar years to become increasingly the advocate of the visual arts and the new media in the postwar period. But I hope to show, too, Malraux's halting, often misunderstood—and finally, insufficient—efforts as minister to move France into new ways of understanding and of community.

I see a strong design made of colonial and imperial threads woven into the fabric of modern French culture. Let me just sort out the strands here; how they fit into the pattern will become evident. The first chapter treats those of the past: French rulers in the Renaissance and after put forth declarations of cultural leadership, basing their claims on the captured heritages of ancient and Renaissance Italy. Then the Louvre became the preeminent museum of European civilization, filled with its great works by the expansionist conquests of the Revolution and Napoleon. When in the nineteenth century France won no victories in Europe that allowed it materially to increase its cultural holdings or its prestige, the Third Republic's political leaders invoked France's "civilizing mission," to bring its culture to peoples in Africa and Asia. That's the long view.

The nearer scrutiny of the career of Malraux and of his ministry lets us find additional strands of the colonial fabrication of much in modern France. André Malraux had three early and deep involvements with the colonial world: his temple-plundering adventure, his anticolonial journalism in Indochina, and his novels set in China and Indochina. Together they mark a lifelong commitment to connecting himself and French culture to what, when he was minister, was called the Third World. We see the importance of that commitment when he served as President de Gaulle's representative to the French dependencies at the moment when they were deciding their political futures, and then again when he was culture minister. He became a minister of General de Gaulle only because the colonial war in Algeria brought the Gaullists to power in 1958.

When at the moment of French decolonization Malraux needed staff for his new ministry, he recruited as the majority of his senior officers men who had learned their craft as colonial administrators. When he wanted to create a network of Houses of Culture all over metropolitan France, he asked his aide, the former African administrator Emile Biasini, to head the effort: "What you did with the Africans, why not do the same in France?" Malraux and the Foreign Ministry shaped French international cultural policy after decolonization to reclaim French influence by cultural means, venturing France's abundant cultural capital when its political capital had run out. Finally, although it was a field heavily contested by new colonial leaders, *francophonie*—meaning both the language and the culture it expressed— was promoted in French relations with the former colonies.

This list offers tantalizing suggestions of how important features of French culture were made from the intensity and the constancy of France's imperial and colonial involvements. Only more research and thought can turn suggestions into insights and conclusions. This book provides a beginning in such an inquiry.

With what I have written, I hope to help us appreciate better what is at stake today in French fears of African and Muslim immigrants, a unified Eu-

rope, American films and sitcoms, and all the dread of the future jumbled together in the scare-word "Americanization." And I hope that my investigation of the balance of good to harm that results when a government takes on the maintenance of a nation's cultural life may serve to demystify, maybe even bring insights to, the fantasy-rich American conversations about the role of government in the arts.

What better way for an American to begin a discussion of the assertion of France's leading role in the culture of the West than to invite you to visit the special American exhibition of one of the great treasures of the Louvre?

1 *France's* Mona Lisa

Mona Lisa would visit the United States. The Louvre conservators and curators had warned of the grave risks of moving the painting. *Le Figaro* denounced the government for making a lady of this age—more than 450 years old, indeed—take so long a trip. And the political tension between the de Gaulle government and the Kennedy administration made it perhaps an unlikely moment for the noble gesture. Or was it, on the contrary, a well-chosen moment? In any case, André Malraux, newly appointed minister of cultural affairs, had decided.

For many years, Edward T. Folliard, the *Washington Post* White House reporter, had kept alive what could only be described as a passion for the *Mona Lisa*. At an Overseas Writers luncheon held 11 May 1962, on the occasion of Malraux's visit to Washington, he had asked the minister of cultural affairs if the painting might come to the United States for Americans to see this great masterpiece.

An airplane carrying American tourists from Atlanta who had traveled to France to visit the Louvre had recently crashed at Le Bourget, killing all aboard. As Malraux put it in a meeting of the cabinet, "A gesture was necessary."[1] A work from the Louvre was immediately dispatched on loan to Atlanta, where the French act of sympathy was very well received. This, in Malraux's view, predisposed the American government to an interest in more such loans. Moreover, U.S.-French tensions as a result of General de Gaulle's decision to lead France on its own diplomatic military course were at a postwar high. Could the haunting smile of a beautiful Florentine woman, perhaps, calm the angry spirits? At the same time could the export of this piece of French culture, especially in the midst of the Cold War, also write a new page in Clausewitz's treatise on war and state policy, that art is a continuation of international competition conducted by other means?

So Malraux, with the personal decisiveness and lack of bureaucratic

sense—he did not ask anyone at the Louvre first—which marked both his life and his administrative style, immediately answered the reporter that he thought the painting could be shown in America.[2] The Kennedys, especially Jacqueline, who as part of her upbringing had been deeply immersed in *la civilisation française*, put their official weight behind the reporter's yearnings.[3]

On 14 December, eight months later, with the conclusion of the official negotiations, and at the expense of the French government,[4] the small (30 by 21 inches) painting was transported to Le Havre in a well-padded, air-tight, temperature and humidity-controlled aluminum case and placed—alone—in first-class cabin M-79 aboard the *France* for the trip to New York. Adjoining cabins were occupied by Jean Chatelain, Director of French Museums, and Maurice Serullaz, chief curator of the Louvre. Mr. Folliard, *Mona Lisa*'s lover, occupied the discreetly distanced cabin M-120. One night during the voyage some wag put women's shoes to be polished outside the door of cabin M-79. A irreverent joke, perhaps; but at least they were not men's shoes.

On landing, the painting was loaded into a van outfitted with ambulance-like springs. Bracketed front and behind by vehicles carrying armed Secret Service agents, the vehicle with its precious freight took the road to Washington. The convoy passed through the Lincoln and Baltimore Harbor tunnels—cleared of all traffic during its traversal. The masterpiece ended the journey safely at the National Gallery in Washington, where it was locked in a temporary storage site in the basement to await installation upstairs. At a Washington press conference with Chatelain held soon after the painting's delivery, a grateful and perhaps culturally patriotic American reporter asked the head of French state museums whether France might in exchange like to borrow any American paintings. Appalled at even the thought of anyone's suggesting so improbable an aesthetic parity, the embassy official presiding over the session quickly stepped forward to declare the press conference ended.[5]

Malraux had been to the United States the year before. During this visit, to impress the French cultural minister, on 10 May Jacqueline Kennedy took him on a private tour of the National Gallery. Malraux strode through the collection, here pointing out a feature of a Renaissance bust to his rapt retinue (figure 1), there stopping to study a painting of the Nativity by the Sienese Duccio di Buoninsegna, as his companions behind him strained to see what Malraux was seeing (figure 2). Caught by the photographer seemingly alone with his thoughts, he looked long and contemplatively at a work of Filippi Lippi, (figure 3) before the museum's director, John Walker, had him shake hands with visiting schoolchildren near Juan de Valdés Leal's *Assumption of the Virgin* (figure 4).

The First Lady finally brought him before the colonial Boston artist John Singleton Copley's large painting *The Copley Family*, one of the most important early works of American art. Accompanying the special tour, John

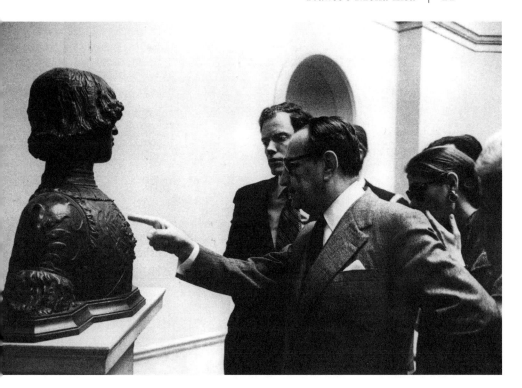

Figure 1. Malraux points out features of Andrea del' Verrocchio's *Guiliano de' Medici* (c. 1475, terra-cotta) to a rapt entourage at the National Gallery, 10 May 1962. Gallery Archives, National Gallery of Art, Washington, D.C.

Walker commented on the importance of the painting in the collection and in the history of American art. The French writer studied the work as Jacqueline Kennedy waited intently for his ruling (figure 5). Finally, he turned to her, "Some pictures are in the gallery because they belong to humanity, and others because they belong to the United States of America. I . . . see that this one is here for the second reason."

The headline of the *New York Times* of the next day read: "Malraux Takes Over National Gallery Tour. Explains Works to Mrs. Kennedy and Museum Officials." It was during this visit, and after this dramatic ritual of political-aesthetic hegemony, that Folliard asked Malraux to send the *Mona Lisa* to show in the same venue.[6]

The *Mona Lisa* Show

At the 9 January 1963 meeting of the Council of Ministers, President de Gaulle explained the absence of the minister of cultural affairs, who nor-

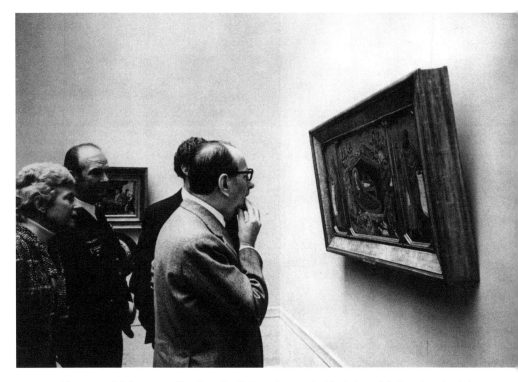

Figure 2. Malraux studies Duccio di Buoninsegna's *Nativity with Prophets Isaiah and Ezekiel* (1308–11, wood). Gallery Archives, National Gallery of Art, Washington, D.C.

mally sat at his immediate right: "M. André Malraux will not be with us today. He has a good excuse; he's keeping company with Mona Lisa."[7] And indeed, in Washington, just a few hours before, on the 8th, coordinated with the convening of the 88th Congress, two thousand people—including President Kennedy, the First Lady, Secretary of State Dean Rusk, members of both houses of Congress, and, of course, André Malraux—inaugurated the three-week display of the French treasure at the National Gallery. The space was inadequate for the crowd of Washington luminaries invited. The sound system broke down. Malraux's talk, in unheard French, was translated into unheard English. Not many of the packed audience could get up front to see the painting about which there was so much fuss (figure 6).

Worrying about the possible damaging effects of the strong TV lights, Madeleine Hours, the conservator sent by the Louvre to protect the painting, stepped over the velvet cord which marked the closest viewers were allowed to come, to check the temperature-humidity recorder under the glass-enclosed painting. One of the Marine guards, thinking to stop an act of

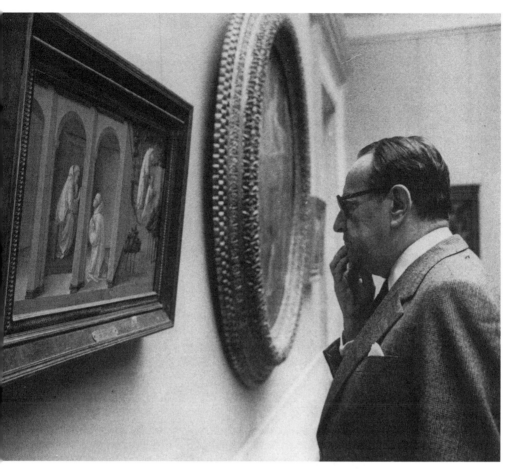

Figure 3. Lost in thought, Malraux views Fra Filippi Lippi's *Saint Benedict Orders Saint Maurus to the Rescue of Saint Placidus* (c. 1445, wood). Gallery Archives, National Gallery of Art, Washington, D.C.

vandalism, lunged at Madame Hours, his bayonet ripping her gown. Fortunately, a Secret Service man leaped forward and rescued her (figure 7).

When it came time for the minister of cultural affairs to speak, Malraux turned to the American president and, using the *Mona Lisa* as the symbol of the identity of Western Civilization with that of France, paid tribute to the American role in the bringing the victory of *civilisation* twice in the preceding half-century (figure 8),

There has been talk of the risks this painting took in leaving the Louvre. They are real, though exaggerated. But the risks taken by the boys who landed one

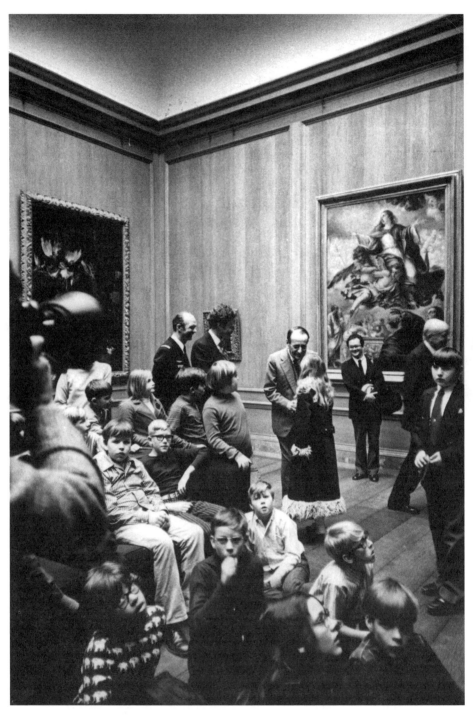

Figure 4. Malraux meets schoolchildren in front of Juan de Valdés Leal's *Assumption of the Virgin* (c. 1670, oil). Gallery Archives, National Gallery of Art, Washington, D.C.

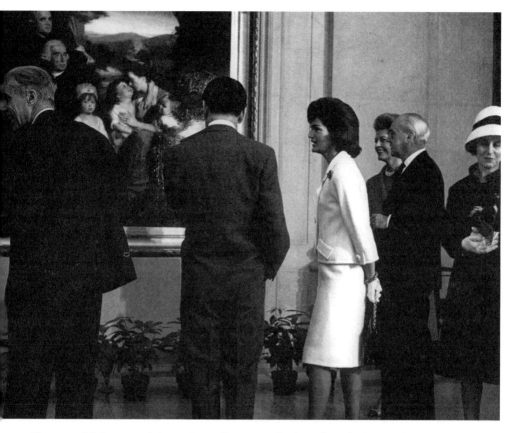

Figure 5. Malraux explains to Jacqueline Kennedy the value of John Singleton Copley's *Copley Family* (1776–77, canvas), acquired just the year before (1961) by the Andrew Mellon Fund for the National Gallery. Gallery Archives, National Gallery of Art, Washington, D.C.

day in Normandy—to say nothing of those who had preceded them twenty-five years before—were much more certain. To the humblest among them . . . I want to say . . . that the masterpiece to which you are paying historic homage this evening, Mr. President, is a painting which he has saved.[8]

In his own remarks, later widely reprinted if not well heard in the hall, President Kennedy put in the United States's own, if more modest, claim to guardianship of Western Civilization: "We citizens of nations unborn at the time of its [the Leonardo painting] creation are *among the inheritors and protectors* of the ideals which gave it birth." Kennedy brought politics once more to art by pointing out that among Leonardo's many gifts was his skill as a military engineer, "an occupation which he pursued, he tells us, in order to preserve the chief gift of nature, which is liberty."[9]

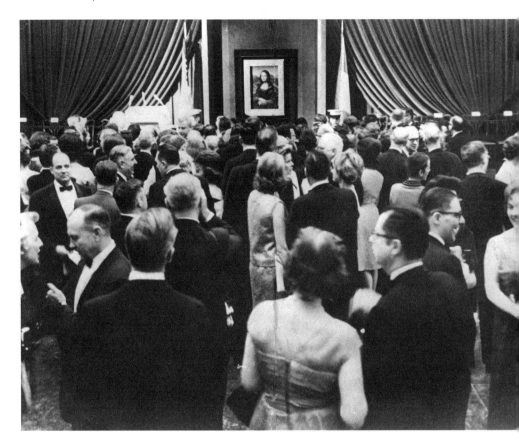

Figure 6. Opening of the *Mona Lisa* exhibition at the National Gallery, 8 January 1963. Gallery Archives, National Gallery of Art, Washington, D.C.

In twenty-seven days in Washington, 674,000 visitors shuffled in line to catch a brief glimpse of the Florentine bride with the famous enigmatic smile. The figure equaled more than half the National Gallery's usual attendance for a whole year. When the three-week exhibition closed, the painting was once again placed in its special transport for the ride back to New York and its exhibition in the Metropolitan Museum of Art. *Mona Lisa* opened in New York on 6 February amid the worst possible conditions for such a cultural blitz: a massive citywide newspaper strike. Nevertheless, in deepest New York winter, the thick lines of museum-goers extended many blocks down Fifth Avenue. Once inside, the visitors were marshaled in dense platoons to be allowed briefly to stand before the painting framed by the gilded Spanish grille in the great hall of the museum (figure 9).

The representatives of the two governments had agreed that, in New York as in Washington, no admission or viewing fee would be charged.[10] But the

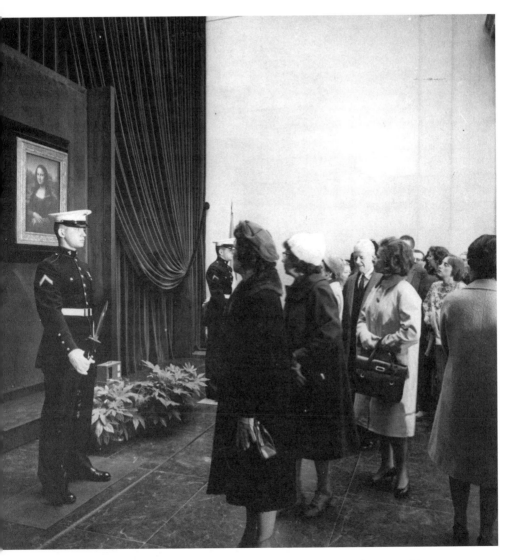

Figure 7. U.S. Marine Corps guards with fixed bayonets protect the *Mona Lisa*. National Archives at College Park, Maryland.

public was not admitted until the 7th, for the opening day was reserved for special guests and a dinner given by Ambassador Hervé Alphand.

The ambassador's banquet further highlights the special meaning of the exhibition. Although the loan was nominally from the French state museum to a state museum in Washington and a private one in New York, the dinner invitation stated prominently that the painting had been "lent by the

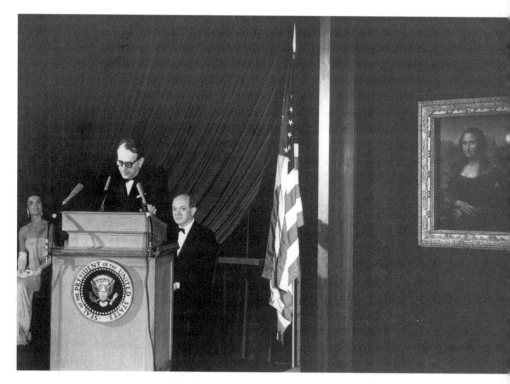

Figure 8. Malraux speaking at the Washington opening. Jacqueline Kennedy sits on one side, Secretary of State Dean Rusk on the other. National Archives at College Park, Maryland.

Government of the French Republic to the President of the United States and the American People."[11] Moreover, when United Nations Secretary General U Thant was not invited to sit at the head table with American and French guests, he and most of the invited UN officials suddenly developed various indispositions and did not attend.[12] So much was the loan of the art object meant as a cultural embrace of the Kennedys and American public opinion.

In his 1930s novel of archaeological prospecting, *The Royal Way*, Malraux had one of the characters, Ramèges, close his part in one of those set-piece philosophical dialogues that filled his fiction with "Let me just summarize by saying, that the work of art tends to become its own myth."[13] That at least American museum officials accepted the political semiology of this painting's display in the United States—and accordingly of France's special role in Western Civilization—may be understood from the remarks of Theodore Rousseau, curator of European paintings at the Metropolitan: "Perhaps the most significant modern tribute to its [*Mona Lisa's*] fame was the attack made upon it in the 1920's by the Dadaists, who ridiculed it as the greatest

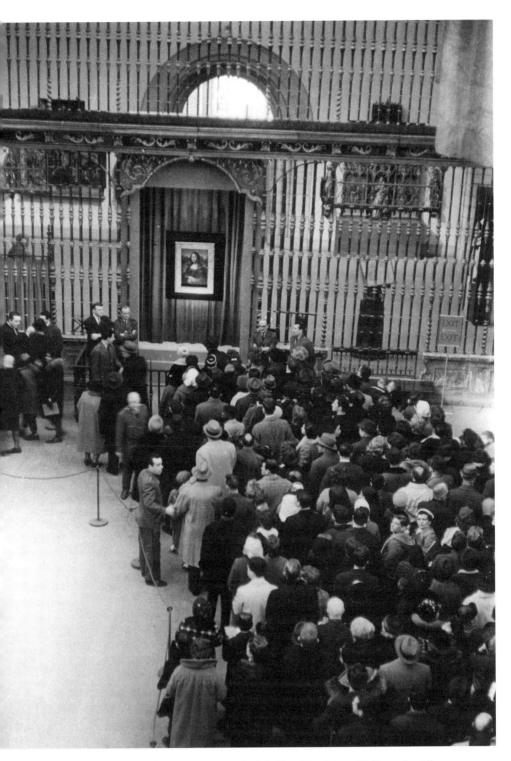

Figure 9. Visitors view the *Mona Lisa* in the Medieval Sculpture Hall, 1963. All rights reserved, The Metropolitan Museum of Art, New York.

symbol of the traditional Western culture they wished to destroy. Their attack was, needless to say, unsuccessful, but their appraisal was just." [14]

Rousseau was referring to—among other liberties taken with the lady—Marcel Duchamp's 1919 version with the added mustache (figure 10). When you pronounce the letters of the title of Duchamp's improved painting, *L.H.O.O.Q.*, it sounds like "Elle a chaud au cul" (She has a hot ass). Along with the hot backside of the painting Duchamp saw with his painterly eye, *she* also expresses a certain maleness. The disorder the ready-made, as Duchamp called found objects that he modified and called artworks, sows in the art canon is nicely complemented by the affront to established gender ideologies. [15]

Between 6 February and 4 March, less than a month, 1,077,521 visitors viewed the work in the Metropolitan. [16] In something under two months a total of 1,751,521 mostly American viewers—many of whom had never before visited a museum or art gallery—came to pay homage to the Renaissance creation brought to them under the aegis of France. More people came to see the painting, commented the National Gallery's John Walker, who traveled with it on its trip back to France in early March, "than had ever attended a football game, a prize fight, or a world series."

And the people who had come to see the *Mona Lisa* roamed the museums and saw other works which may have delighted them too; moreover, the National Gallery continued to receive crowds of visitors for some time after the painting's departure. Even subtracting the extraordinary numbers who came primarily to see this one painting, annual attendance also rose at the Metropolitan. Yet attendance figures were not the most important thing, Walker emphasized in his remarks at the closing of the New York show, "but that she acted as a catalytic agent. Her visit caused an esthetic explosion in the minds of many of those who saw her. . . . This great painting stirred some impulse toward beauty in human beings who had never felt that impulse before" (figure 11). [17] And so the France of de Gaulle and Malraux had penetrated the materialism and barbarism of American life to leave embedded the memory of an undreamt-of beauty in the form of the haunting smile of a young woman made of wood and paint.

But neither the model nor the painter, nor even the materials of the artwork were from France. Visiting Washington while the *Mona Lisa* exhibition was still there, Amintore Fanfani, the Italian prime minister, a man of learning and wide culture, felt obliged to convene a press conference at the National Gallery to correct an important misconception. So that they might pass the information on to their readers, he wished to point out to the reporters that Leonardo da Vinci was Italian, not French. [18] Not only was this not true (although Leonardo may have been culturally Italian, or rather, Florentine, there was, to Machiavelli's regret at the time, no Italy. Italy was created only in 1860). Of more significance, the news interested no one (there is little press about the statement). By the time Italy came into being,

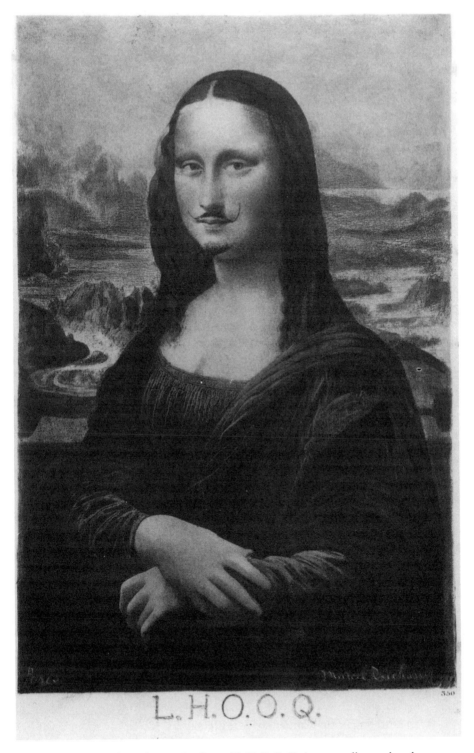

L.H.O.O.Q.

Figure 10. Marcel Duchamp, *Replica of L.H.O.O.Q.* (1919, collotype hand-colored with watercolor). Philadelphia Museum of Art, Louise and Walter Annenberg Collection.

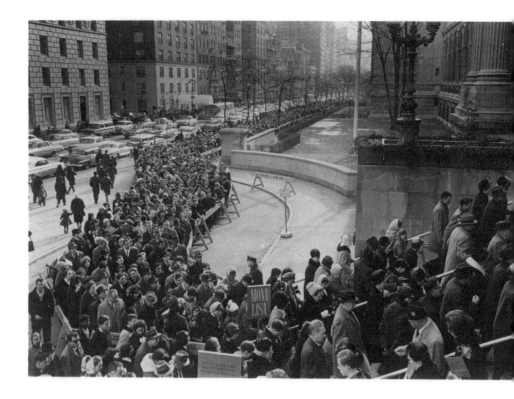

Figure 11. Visitors to the Metropolitan Museum, some surely stirred by an impulse toward beauty which they had never felt before, wait on a line extending far down Fifth Avenue to catch a brief glimpse of the *Mona Lisa*.

Leonardo's masterpiece had already been in the possession of the French state for three and a half centuries. According to the same French paradigm, Pablo Picasso, for example, who by the mid-60s had lived in France for nearly half a century, was counted in France among French artists, a charter member of the School of Paris. Leonardo's creation had come under the protection of the powerful French king and state. The ruler had protected the artist and honored his work in France. So did his successors. Fanfani was just voicing a (defeated) retroactive nationalism. Historically, aesthetic identity leans toward the most powerful.

France's Aesthetic *Force de Frappe*

At the meeting of the Council of Ministers of 16 January—about a week after the Washington exhibition had opened—Malraux, once more seated

at the side of the president, appraised the impact of the display, as Alain Peyrefitte remembers:

> The President of the United States wanted absolutely to show *La Joconde* [as the painting is known in France] to all the politically and economically powerful people of the country. The whole of Congress, the Supreme Court, State Governors, plus an indeterminate number of millionaires, who formed a kind of extraordinary royal court, were brought together for the ceremony. In Washington, we witnessed the strangest display of snobbism we had ever seen.[19]

He left unnoted that, in fact, the goodwill flashing around the ceremonies of the show did not reflect current political relations between the two nations. The moment was one of unprecedented tension between American and French foreign policies. At a December meeting between British Prime Minister Harold Macmillan and President Kennedy in Nassau, the U.S. leader had offered the British American Polaris missiles capable of delivering British nuclear warheads. The missiles were to be integrated into the NATO arsenal, and the American president was to have the final say in their use. Kennedy offered France the same missiles, with the same constraints. De Gaulle received the American proposal with rage; not only did the conditions set by the Americans insult his idea of national sovereignty, but the French had developed neither the delivery systems nor the nuclear warheads to use the weapon. Angered more at what he considered British anti-European duplicity—Britain's special deal with the United States—than at the American attempt to retain its nuclear dominance, on 13 January 1963 de Gaulle vetoed the British application for admission into the Common Market.[20]

He also rejected the useless gift. He refused to allow the stationing of American-controlled Polaris missiles on French soil and, by extension, French adhesion to the U.S.-projected Multilateral Force. De Gaulle wished to continue to develop an autonomous defense force outside the U.S.-dominated NATO. This was the famous French *force de frappe*. He announced these decisions at a major press conference held on that same 13 January. Moreover, disappointed that the United States would not treat France as an equal partner, de Gaulle less than two weeks later (on the 22nd) signed an agreement for bilateral cooperation with West Germany, aiming, in effect, to upstage the United States and more firmly join the two dominant powers in Europe.[21]

But clearly in the opening reception and subsequent ceremonies around the *Mona Lisa*'s visit to the United States, which coincided—were made to coincide?—with this serious disagreement between the two nations, the American government showed only good will toward General de Gaulle, his representative, and France. It is true that in his remarks at the opening President Kennedy had playfully compared the power of the Louvre's painting to the United States's military power:

Mr. Minister, we in the United States are grateful for this loan from the leading artistic power in the world, France. In view of the recent meeting at Nassau, I must note further that this painting has been kept under careful French control, and that France has even sent along its own Commander-in-Chief, M. Malraux. And I want to make it clear that, grateful as we are for this painting, we will continue to press ahead with the effort to develop an independent artistic force and power of our own.[22]

Both Malraux and de Gaulle understood this allusion to France's drive for an independent *force de frappe* as a good-humored play on words, and not mockery of French plans for military grandeur.[23] The French press, however, waxed indignant at this supposed ridicule of France's Great Power ambitions. This journalists' storm annoyed de Gaulle greatly, for, despite the disagreements of the moment, he still held strongly to the position that the two-century-old ties of the United States and France were, and should remain, as strong as ever. De Gaulle told his cabinet members, "No French newspaper has remarked that the prestige of France had risen to such a degree that the President of the United States strengthened his own position in America by showing the intimacy of his ties to de Gaulle!" And the means de Gaulle used to express these long-term ties, despite current short-term disagreements, was an artifact of Western culture valued in both nations, the star painting from the treasure-house of European art, the Louvre (figure 12).[24]

The Value of Loaned Cultural Capital

Of course, in sending the art of the Louvre on tour, France was using art and culture in the service of politics. Representatives of what in the Middle Ages was loosely called "France" had been doing this arguably since the Norman Invasion, the founding of the University of Paris, and the Crusades, and certainly since the reign of François Ier in the Renaissance. In France's great seventeenth century—Michel Foucault's Classical Age—Louis XIV put the diffusion of French cultural influence at the center of state policy. The strategy was more successful and rewarding to France than the king's military campaigns. Thus in one sense, de Gaulle and Malraux were only workers in a long-established French tradition.

Can we imagine an American cabinet member briskly and confidently walking through a foreign museum, stopping in front of artworks, giving praise here, demerits there, as Malraux had done with Jacqueline Kennedy? In the 1950s the State Department sent American jazz musicians abroad to show our cultural achievements. The United States Information Agency had sent paintings by Jackson Pollock and other American abstract expressionist artists on tour.[25] But with the *Mona Lisa* show in Washington and New York in 1963, the exhibition of the *Venus de Milo* in Japan the next year,

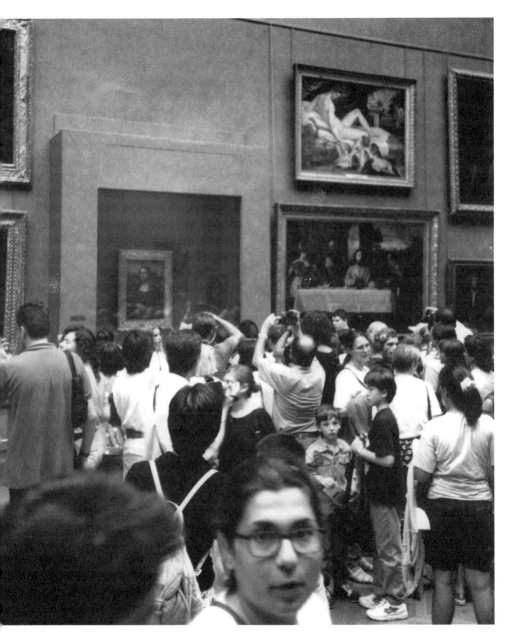

Figure 12. The iconic painting safely back in the Louvre. Photograph by author, August 1997.

another *Mona Lisa* show in Australia in 1970, as well as many, many other less sensational exhibitions throughout 1960s, France was displaying artworks of the *Western* heritage.[26] Speaking for that Western heritage—as we saw Malraux do in Washington—has been France's role in the world for some time. But how did the idea of French *trusteeship* of the cultural patrimony of the West become a self-evident truth—a *doxa* in Pierre Bourdieu's sociological language, an *Idol* in Francis Bacon's more critical vocabulary—for generations of French leaders, for many intellectuals in other nations, and perhaps for Americans waiting in long—and in New York—cold lines for a glimpse of this small painting with so powerful an aura?

2 Once and Future Trustees of Western Civilization

King François Ier, the great military campaigner in Italy and the Renaissance patron of the arts, formulated the French equation of art and political power. In his allegorical *Le triumphe des Vertuz*, Jean Thenaud glorified his ruler by referring to him repeatedly as the "Dictator of Kings," "Caesar," and "Emperor." In 1515 the French ruler celebrated his Italian victories by having his entry into Lyon marked with two (stage set) triumphal arches.[1]

Of course, the idea of rulers gilding their power with art and of artists, for the usual motives of need, sycophancy, and occasionally even conviction, glorifying rulers is not new.[2] A stroll through any of the great museums of the world will show, for example, that chiefs of expansive kingdoms everywhere and throughout the ages have aggrandized their reigns with magnificent art works.

Nor are the universalist claims of French aesthetic imperialism novel. Historically, especially when the state of communications technology made for smaller worlds, rulers—of villages, tribes, regions, empires—have often claimed all of humankind, the world, for their dominion. If they could assemble artists to work for them the way Marie de Medici did, they could own indigenous art. If not, they imported. And accordingly, they claimed the best of the world's art treasures as theirs, graciously accepting objects of art as gifts and tributes, or, if and when they could, appropriating them in warfare. However, most such rulers, or their descendants, were sooner or later dissuaded from such beliefs after military defeats or political humiliations, especially when, powerless, they had to watch their treasures carted off to lend distinction to foreign courts or museums.

From the perspective of art, we can think of the history of the rise and fall of great kingdoms and empires as a kind of totalizing Hegelian dialectic with aesthetic capital ever accumulating, ever going to the new winners. But for some centuries the humiliation of defeat was not a part of the story of creation and rule in France. There great art and great political power grew in

tandem for long enough to become second nature, a self-evident relationship to rulers and to artists both.

In what follows, we will move through the four successive phases that successively instituted the special mission of French *civilisation* in the world: (1) French rulers *copying* great works of art made in classical antiquity (1500s–1790s); (2) the French state's *appropriating* classical works made elsewhere and asserting that France *best continued* the classical tradition of art (1790s–1815); (3) *proclamation of the superiority* of French art over that of all other states in the modern world (1815–1860s). (4) The final move, made in the second half of the nineteenth century, was to win the educated in the West to a consensus that French art, regardless of its relation to, or break from, classical antiquity, was *both the norm and the model* for all other contemporary cultural production. Only the defeat and collapse of France in World War II brought French aesthetic preeminence into question.

The French Exception

Unlike the Chinese emperors, for example, French rulers always had a somewhat *Faustian* relation to art. Well into the nineteenth century, certainly, the emperors took for granted that the perfect civilization already existed in China. There was no need to seek value beyond the borders. They had the Great Wall built, in part, out of the conviction that China was complete, finished. When during the Renaissance Western delegations began to arrive at the court, the emperor received them in the usual manner: as new tributaries, like the Japanese, Koreans or Vietnamese who had arrived before them. The foreign emissaries had obviously come to acknowledge and honor his rule. Westerners may have admired and bought Chinese silk, porcelain, jade, precious carved stones, and other art, but the Chinese wanted little of what the West had for sale. Recall that the British waged two Opium Wars in the nineteenth century to force this Indian-produced commodity on the Chinese to redress an otherwise intractable balance-of-payments problem.

But "France" has never been completed, or finished. From at least the time when François I^er managed the realm's culture, to the reign of Jack Lang— and most important for us, the decade of André Malraux's ministry—the special responsibility of France for the cultural heritage of Europe, and later the world, became an ever more self-evident part of the French *doxa*, the common sense of the land.[3] And this cultural heritage, to adapt André Malraux's famous personal existential phrase in this more political context, had always to be "conquered."

Special missions in the world are not uncommon. The obligation Jesus placed on his followers to spread his teachings, Islam's duty to expand in its early years, U.S. Manifest Destiny in the nineteenth century, and the burden of the New World Order in the late twentieth are cases of special obligations

groups or nations have had thrust upon them by a higher force. What makes the French case exceptional was the unique role of culture in the making of modern France.

We do not have to endorse the old-book fetishism of the white knights of the culture wars, like E. D. Hirsch, Allan Bloom, or the French supporters of the ideas of Leo Strauss such as Tzvetan Todorov and Marc Fumaroli, to see the centrality of culture in the making, expanding, and preservation of France.[4] France was not made out of an alliance of peoples with self-conscious identities who worked out a political union, as was the case of the Dutch Republic, the Swiss Confederation, the United States, and, since 1989, the newly made Germany. Rather, a small royal power created a state in the course of the Middle Ages and, for the sake of its domination and glory, set out to create a people. Because this state's power was at all times as centralized as the means of communication and coercion permitted, struggles about what was France and who spoke for the French people tended initially to be claims for hegemonic domination rather than proposals for inclusion. Thus during the Revolution, and indeed building on the heritage of monarchical Absolutism, the Jacobins set out to make a land of many regions and diverse populations a unitary republic. The ancien régime saw as part of its responsibilities—however sporadically or faint-heartedly it carried them out in the years immediately before 1789—regulation of the kingdom's religious belief and practice, rules of language, aesthetic standards of theater, art, and architecture, and what might be published. The Jacobins followed the same path in their attempt to create a different, but equally total, definition of France to negate the weakened old order, and later to contradict the definition espoused by the counterrevolution.

Sovereignty, the embodiment of France, was transferred during the Revolution from the king to the male members of the nation and, in the Restoration, back again to the king. This unresolved combat about who embodied the nation continued to cause division and conflict in subsequent centuries. Using Disraeli's image for what was wrong with Britain, Pierre Nora has characterized this struggle over French identity as that of the two nations of France. Politically, France reconciled its two selves, its dual personality, according to Nora, when, beginning with the new Fifth Republic in 1959, de Gaulle united the authoritarian monarchical tradition with that of the republican nation to create a polity he dominated, but also reconciled with itself. His new presidential republic was accepted and left intact by the Socialists when they came to power in 1981.[5]

Culturally, national unity took the form of a population assimilated to a common civilization, which was from the late nineteenth century classical in content and republican in its prescriptions.[6] French republicanism interpreted the logic of the nation-state as requiring that political boundaries approximate cultural ones, or more exactly, that to share in the life of the nation one had to be a part of *the* national culture. This imperative of unity,

then, required the French state to concern itself deeply with the cultural life of its citizens in the areas of language and aesthetics. It was the democratized version of a policy inherited from the ancien régime. But also for the last hundred years, in view of the strong pulls of regionalism, the many immigrants, the ever-evoked menace of clericalism, and most important, the need to conduct government under the constraints of universal male, and then female, suffrage, the national society had to be guided to think of itself as One.

Yet, by the time of the Renaissance, both international cultural leadership and cultural merit domestically were linked to classical antiquity, the source of Europe's oldest aesthetic values. Not France, but rather the region that today is Italy, which had inherited the cultural mantle of both ancient Greece and Rome, was the cultural lodestar of Europe. Like Leonardo carrying with him his prized painting of the Florentine young woman Lisa Gioconda, née Gherardini, we can best begin this story of French culture by ourselves taking the road from the Italian peninsula to France.

Leonardo and His Lady, Safe in France

While in Italy in 1515 during one of his military adventures in that much marched-over region, François Ier met Leonardo and started supporting him with a royal pension. During an earlier French occupation of Milan, the count de Chaumont had become Leonardo's patron, but in September 1513, soon after the death of Chaumont, Leonardo left that city for Rome, seeking peace and protection. Apparently, however, Pope Leo X treated the artist so badly that Leonardo decided to take himself and his retinue, along with some favorite paintings, to France, where he arrived by 1516.

We know that the *Mona Lisa* was one of the paintings he took with him. On his death in 1519—the story goes—he left the painting, or perhaps sold it, to François Ier in gratitude for the ruler's having sheltered him in his last years, after he became incapacitated by a stroke, at the Château de Cloux.[7] Or perhaps he died and the king just kept the picture. There is no bill of sale or will making François the painting's new owner. The work has remained a possession first of French rulers and then the French state from the early sixteenth century to the present.

François Ier placed Leonardo's painting in the new Appartement des Bains, the royal bathroom in his residence at Fontainebleau. This was a suite of six rooms decorated with murals on mythological themes and stucco nymphs by the Italian painter Francesco Primaticcio. Three rooms in the suite were reserved respectively for bathing, steaming, and sweating. In the other three the king and his guests dressed, talked, gambled, and dallied, their pleasures enhanced by some thirty easel paintings on the walls. Along with Leonardo's smiling lady, courtiers could appreciate works by Perugino, Raphael, Andrea

del Sarto, Fra Bartolommeo, Guilio Romano, and Sebastiano del Piombo. The historian Roy McMullen repeats a quip to the effect that the Louvre Museum began in François's bathroom.[8]

But, as the rest of us who have tried to display art in our bathrooms have found, the paintings in the Appartement des Bains soon began to deteriorate from the effects of humidity. By the end of the sixteenth century, they had been transferred upstairs to a Cabinet des Tableaux, later called the Pavillon des Peintures. Until the 1650s Leonardo's painting remained there, but sometime in that decade, along with most of the rest of the king's collection, it was moved to the Louvre Palace in Paris. Louis XIV had the *Mona Lisa* moved to the Petite Galerie in Versailles. In the eighteenth century it hung variously in the Tuileries Palace and again in Versailles, where it was put in the dimly illuminated small exhibition rooms in the Direction des Bâtiments. The Revolution did not improve our lady's accessibility much; we know that in 1800 she was in Bonaparte's bedroom in the Tuileries, where she remained until 1804 when the Louvre had been sufficiently renovated to again house her, along with much of the rest of François Ier's collection of works of art and copies, and the large number of works from the princely and state collections of the lands penetrated first by armies of the Revolution and then conquered by Napoleon.[9]

This odyssey of the *Mona Lisa* may serve us as a paradigm for the greater migration of the seat of European civilization from Greece and Rome to Paris. Leonardo died in France after two years in the Château de Cloux. But that was not the end of François's Italian connection; for some years later, after much rehabilitation and expansion of Fontainebleau, François's court artist, the Italian Primaticcio, persuaded the king to send him to Italy to collect antique art for the court. He went to Florence and had molds made of what the art historians Francis Haskell and Nicholas Penny judged to have been "the most famous antique statues to be seen in the city." Primaticcio *also* came back with marble copies of 125 classical statues. On a second trip the king's agent had many bronze reproductions of additional works made from the molds he commissioned.

This copying and bringing to France of great works of classical antiquity — along with the ongoing collection of Renaissance masters — was the key factor in making iconic artworks of the European tradition available for appreciation and further copying outside of Italy. Moreover, it was the decisive move in launching the discourse in which France was, and still is, celebrated as the trustee of this heritage. As Haskell and Penny write,

> The installation of the . . . copies does in fact mark a crucial milestone in the evolution of European taste and culture. Vasari was to write that Fontainebleau thereby became "almost a new Rome" and . . . two later rulers of France, Louis XIV and Napoleon, were to try to emulate François's example and *transfer the prestige of Rome to France by transferring thither her ancient monuments.*[10]

Furthermore—and of equal importance—by reproducing and displaying copies of great works of antiquity and the Renaissance, not only were its rulers beginning to claim France's special relation to the classical heritage of Europe; they were establishing an international aesthetic standard of taste and excellence, based on works in French possession, selected by French hands.[11]

François's successors continued his project. In 1640 M. de Noyes, Louis XIII's Surintendant des Bâtiments, ordered the French artist Nicolas Poussin, then living in Italy, to have copied or to collect antique art objects, pieces of architecture and sculpture, medals from the Arch of Triumph of Constantine, seventy bas-reliefs molded from Trajan's Column, and other works. When he returned to Paris, Poussin had many of the reliefs fitted to the ceiling of the Grand Gallery of the Louvre.[12]

On coming to power in 1661, Louis XIV decided to make his father's hunting lodge at Versailles into a grand palace. Colbert, his minister, commanding that "we must get for France examples of everything of beauty in Italy," sent collectors to Rome, as had Richelieu, Mazarin, and Foucquet. And the French replication of antiquity was further institutionalized in 1666 when Louis established a French art academy in Rome, to train French artists in the classical style, to be sure, but also to set up a kind of copy-center there for students to make marble copies or plaster casts to be brought back to France to decorate the grounds of his new palace. The king encouraged books about the royal collection of classical antiquities, and, with the accumulation of copies, molds, and royal hype, in 1682 the *Mercure Galant* could write, echoing Colbert, "You could say that Italy is in France and that Paris is a new Rome."[13]

So by the age of the Sun King, France had become the fountainhead of classical taste. Louis not only had marble copies made of the finest classical statues in Italy; he had a complete set of plaster casts of his collection molded for the French Academy in Rome. He possessed the greatest assembly of classical statuary in Europe. In the minds of many contemporary people of taste, Louis's holdings were more important than any in Italy, because there the art was scattered or not available for viewing, and certainly not associated with a brilliant court.

Many came to the Academy and to Versailles to see the replicated treasures. In 1682 the Hague Academy installed a set of casts of the French casts. In 1698 Nicodemus Tessin used the French molds to make copies for display in Sweden, and nearly a hundred years later statues made from the same forms were used to decorate a revived Swedish Academy of Arts. In the 1690s John Sobieski III made copies of antique statues for his own reproduction of Versailles outside of Warsaw, Wilanów, or as he preferred, Villanuova. He also laid plans for establishing, like France's, a Polish Academy of Art, which was finally set up by Stanislas Poniatowski. Haskell and Penny describe a print they date between 1696 and 1701, portraying the Berlin Akademie der Künste, which shows many copies of the casts of classical statues already to

be seen in Versailles.[14] By the early nineteenth century the French preeminence in copying and displaying the great artistic heritage of Europe was so taken for granted—at least in France—that Stendhal could substantiate his judgment of the philistinism of the new United States, by rhetorically asking in a letter, "Can one find anywhere in that so prosperous and rich America a single *copy*, in marble, of the Apollo Belvedere?"[15]

Louis XVI's ambitious director general of royal buildings, the comte d'Angiviller Duplessis, laid plans for making the king's art collection unrivaled in the world. This post, especially as d'Angiviller, its last occupant, used it, was an early approximation of a royal minister of culture. As Andrew McClellan notes, "The [Louvre] museum was the crux of the director general's grand scheme to revitalize French art and to demonstrate to Europe, and to posterity, the superiority of the French school and the magnificence of Louis XVI."[16] With of the unraveling of monarchical authority, d'Angiviller wished also to touch the people of France with the persuasive rhetoric of art.[17] The plans of the Directeur des Bâtiments du Roi came to nothing, but from the very fact of their formulation we can understand that even before 1789 the idea of aesthetic culture as the king's interest—art housed in a royal cabinet, for example—was beginning to cede the way to a deliberate vision of art to uplift (decoded: seduce) the people.

The Louvre, People's Museum

Although by the late eighteenth century copies of classical works had assumed canonical status, in the 1790s and especially under Napoleon, the French state could finally, and unexpectedly, indulge its growing taste for the originals. Tocqueville saw the Revolution as completing the work of administrative absolutism of the monarchy. But he neglected the equally important continuity of the project of cultural hegemony. The chief institutional instrument of this enterprise was the Louvre Museum.

Open only to select visitors before 1789, the Louvre was invented in its present form by the Revolution. Its dedication as a public museum in 1793 marked it as a manifestation of the democratic impulse. In a remarkable transvaluation of signs, a king's palace and its aesthetic treasures became a major depot of the cultural hopes of the Revolution. Late in 1789 when the state took over church property as *biens nationaux*, the national patrimony, it suddenly became the owner of the cultural heritage of centuries. But what does one do with a desacralized painting of a saint or an altarpiece? Keep it safe from revolutionary vandals and thieves, to be sure. And make it more accessible to viewers in a new, nonreligious setting.[18] Paradoxically then, anticlerical fervor became the midwife to the modern public museum's practice of mounting noncontexted displays.

By all measures, the most glorious place of exhibition for the *biens na-*

Figure 13. Hubert Robert, *Projet d'aménagement de la Grande Galerie du Louvre* (1796, oil on canvas). Louvre. Courtesy of the Réunion des Musées Nationaux.

tionaux was the Louvre. All citizens were now welcomed into its halls, and many took advantage of the newly opened door to high culture. The change in visitors was significant enough to itself become a theme of art. In the present-day museum hangs a painting by Hubert Robert (1733–1808) (figure 13) depicting a range of French society visiting the Louvre in 1796. In the Grand Gallery we see artists, both male and female, copying masterworks, bourgeois mothers with tugging children, women visitors of various social stations, and men of bourgeois standing and higher. Throughout his life, Robert did many paintings of this hall, some even with the same title. If we compare this representation with a work from the 1780s (figure 14), also displayed in today's Louvre, of the same gallery with grander visitors, we can observe the democratization—certainly of the ideal, maybe even the reality—of French public art.

Moreover, with the transfer of sovereignty from the crown to the nation, the people were encouraged to see the Louvre as *their* museum.[19] The new

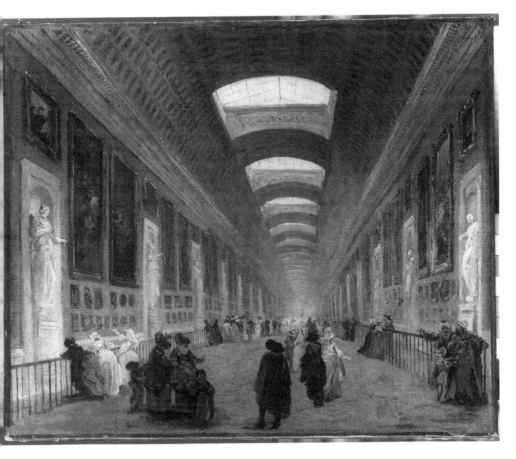

Figure 14. Hubert Robert, *Projet d'aménagement de la Grande Galerie du Louvre* (c. 1780s, oil on canvas). Louvre. Courtesy of the Réunion des Musées Nationaux.

Louvre also signaled the triumph of the revolutionary people against its crowned enemies abroad. On the eve of its designation as the museum of the revolutionary state in 1792, Jacques-Louis David encouraged the minister responsible for the museum, Jean-Marie Roland, to make it an instrument to "extend [France's] glory through the ages and to all peoples to make it the admiration of the universe . . . , the most powerful illustration of the French Republic." [20]

In 1799 a journalist for *La Décade Philosophique* described his visit to the Grand Gallery in language that summarized all the new codes of the Louvre's semiology. He observed artists copying great works and elegantly dressed women, but he saw, too,

a young soldier escorting his father, his mother, and his sister, good village people who had never before left their community, and who apparently had

never seen paintings other than the sign of the local inn or the smoke-covered daub above the altar. These good people could never tell the difference between a Poussin and a Watteau, but they were proud to be there; and the son, all the more proud to be leading them, seemed to be saying, "it is I that conquered many of these paintings.[21]

Conquered Paintings

Napoleon would complete the kings' and the Revolution's projects of making France the keeper and protector of Europe's cultural heritage. Already in the wake of its early foreign victories—the Belgian campaign of 1792, for example—the revolutionary republic began to have artworks seized from enemies of the Revolution sent back to France. In the course of his military campaigns, especially in Italy, Napoleon extended the practice, adding the refinement of insisting that conquered governments sign treaties giving over the war booty.[22] Although manuscripts, furniture, tapestries, scientific instruments and specimens, and art from all periods were sent back to France, in the tradition of his royal precursors Napoleon was especially eager to claim the heritage of classical Europe by acquiring classical art. For example, the Treaty of Tolentino, forced on Pope Pius VI in 1797, contained provisions for the French to select choice works of art from the papal collection along with other cultural objects, including five hundred manuscripts. Of the hundred artworks to be surrendered according to the treaty, Napoleon chose eighty-four Greek and Roman statues and had them sent back to France. As a result of conquests, these ancient works had passed through many kingdoms and empires before arriving in Italian principalities and thence finally in France. As Patricia Mainardi has pointed out, their history was used not only to justify their appropriation by France, but also to deepen the claim that France—not Italy, nor any of the other major powers—was the cultural capital of Europe.[23] By taking possession of the historically multilayered—culturally wrapped—art of the past, France validated its aesthetic-political universalism.

The cultural offensive was not waged just inside the walls of the royal building that still housed powerful state offices in some of its wings.[24] The French state also reaffirmed its claim to the cultural leadership of Europe in the streets. Captured cultural treasures from the Italian peninsula were displayed in a triumphal procession at the Fête de la Liberté held on 27 July 1798. Mainardi's description of the parade—in fact the *third* convoy from Italy—is a marvelous evocation of its conscious reference to those of the Roman *imperium* (figure 15). For our purposes, the parade's elaborateness can be signaled simply by noting that it took ten wagons just to transport natural history specimens and scientific tools; six for books, manuscripts, medallions, music texts, and special printing fonts; and twenty-five for classical sculptures. Carried before the statuary was a banner reading, "Monuments

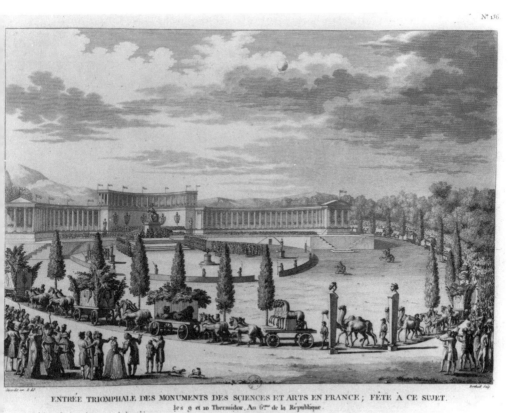

ENTRÉE TRIOMPHALE DES MONUMENTS DES SCIENCES ET ARTS EN FRANCE ; FÊTE À CE SUJET.
les 9 et 10 Thermidor, An 6.^{me} de la République

Figure 15. "Triumphal Entry of the Monuments of the Sciences and the Arts," the Fête de la Liberté of 27 July 1798. Personal collection of Patricia Mainardi.

of Antique Sculpture. Greece gave them up;/ Rome lost them;/Their fate has twice changed;/It will not change again." And along with the four bronze horses from Saint Mark's Cathedral in Venice—which in view of their importance and splendor got their own parade section—spectators were delighted with real lions and camels from Africa and one of the famous Swiss bears which had given Bern its name.

After the triumphal processions, the art from each new shipment from Italy was put on display in the Louvre. By the time of Napoleon's fall, over four hundred antique works of all sorts were already ensconced in the Louvre, which, Mainardi judges, "now possessed virtually all the most esteemed art in the Western world." [25]

After the defeat of Napoleon, the restored rulers asked their fellow monarch, Louis XVIII, to give back what the Revolution and the Usurper had taken. But with shocking lack of chivalry, the French king insisted that the treaties coerced from defeated brother rulers gave France the legal right to

retain the plundered art. For all the restored monarchs' efforts to show their "receipts" for the new French treasures, their petitions for the restitution of their captured heritages resulted in only about half the artworks taken, and probably a lesser percentage of books, manuscripts, natural history specimens, and the like, being repatriated. The rest remained in French hands. As Mainardi concludes, "Despite the restitutions, France retained enough art to ensure that the Louvre remained the major museum of Europe. Rome never reclaimed either all its art or all its glory. . . . Paris, despite its distractions (or perhaps because of them), became the art capital of the Western world, a position it retained until World War II." [26]

A glance at a painting of a king and a dying artist by a painter whose career crossed six regimes will help us better to understand the normalization of the interpenetration of art and the French state in the early nineteenth century. Jean-Auguste-Dominique Ingres's *Death of Leonardo da Vinci*, done in 1818 (figure 16), shows the stricken and weeping King François Ier tenderly embracing the dying artist. The protector and patron of the great painter is inconsolable at the loss. Beyond what we learn about rulers and artists in France from the circumstances under which Ingres painted *The Death of Leonardo*, in larger cultural terms, the work, to use Erich Auerbach's phrase, is "fraught with meaning." In the painting Ingres powerfully portrays the anguish of the artist's disciple (lover?), the sadness of the little girl and of both monk and church dignitary. The king's posture strongly signs his deep grief and his respect for the dying *maître*.[27] There are few other paintings in the Western canon such as this: a powerful head of state embracing, and weeping over, a dying artist.[28]

Of course, the event so movingly portrayed by Ingres never happened; King François was somewhere else that 2 May in 1519 when Leonardo died. And in fact, Ingres painted the scene not as a celebration of royal patronage of the arts, as his predecessor François-Guillaume Ménageot had done in his 1781 *Death of Leonardo*, but as a reproach to the new restored monarchy. Having so well glorified Napoleon, the last ruler, cost Ingres the patronage of Louis XVIII, the new one. The artist painted the work soon after the Restoration, while living in semi-exile in Florence. The painting, sending to the restored monarch the message "you'll be sorry when I'm dead," was a pictorial reproof to the king for not acting like François Ier, at least toward Ingres. Ingres specialists do not view it as one of his great works. But what matters for us is Ingres's assumption that representing this instance of royal reverence for great art would touch a certain value already held by those who might see the painting.

His own story has a happy end, for in 1824 Ingres returned to Paris where his *Vow of Louis XIII* won acclaim at the Salon of that year. He won favor successively in the courts of Charles X (Bourbon), Louis-Philippe (Orleanist), and Napoleon III (Bonapartist).[29] Unfortunately for the history of aesthetic opportunism, he died before the Third Republic was proclaimed,

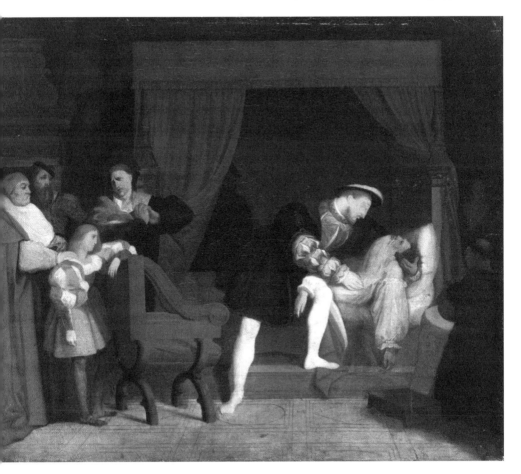

Figure 16. J.-A.-D. Ingres, *The Death of Leonardo da Vinci* (c. 1818, oil on canvas). Smith College Museum of Art, Northampton, Mass.

and was thus unable to continue one of the most remarkable streaks in European art history.[30]

Paths of Glory

The relative peace in Europe during the nineteenth century allowed for no significant additional transfers of cultural capital to Paris. In the first two-thirds of the century, with the accustomed path to glory closed for a time, France did what else it could to maintain its honor as cultural leader of Europe and the world.

An obvious and simple way to continue the discourse of French aesthetic

grandeur was *to write* about Europe, giving France the leading role. At the beginning of his *Histoire générale de la civilisation en Europe* (1828), the historian François Guizot insisted that neither an arbitrary decision nor convention caused him to make France "the center of this study"; rather it was the history of France which "put it at the center of [European] civilization." [31] In 1832 Edgar Quinet wrote of France having *already* fulfilled its destiny for two centuries as the "dominant instrument of civilization." [32] And even as he endorsed the cultural and national aspirations of the Polish people, the great universalist humanist Victor Hugo described the historic task of France as being "the missionary of European civilization." He judged this "great role" to be not only a spiritual force, but like "the power which Rome exercised in the Middle Ages." [33]

But by mid-century, industrial prowess had become another, perhaps an alternative, source of national glory, Britain's glory. Members of the French elite invoked the greatness of France's *civilisation* in the face of growing British industrial ascendancy. The importance of this move, which historically became a political habit, cannot be overestimated. Whereas the great eighteenth-century *Encylopédie* proudly included volumes of handsome plates detailing the latest industrial methods and processes, by the middle of the next century French policymakers had begun to take a more defensive attitude to the fruits of industry. To Britain's challenge to French industrial prowess, as manifested for example in the Crystal Palace Exposition, France in its fairs in 1855 and 1867 responded with art. British industrial goods were cheap, but nasty; great artistic achievement, finally, went the new French discourse, demonstrated the true merit of a nation. [34]

Around mid-century French artists and critics affirmed the existence of a school of French art. French artists were superior to those of other nations. This was so, according to art critics such as Théophile Thoré, not just because they did the best paintings in the contemporary world, but also—and more important—they *incorporated* the best of other nations' art traditions.

Early in his career, for example, Edouard Manet refused Italian influences on his work. He wished to work in a tradition of Frenchness; Watteau was his master. But by 1865 visual quotes from Italian, Spanish, Dutch, and Japanese painting can be found in his current work. He had found the new French style. It was a national recognition of the universal. Without firing a shot, Paris was on the way to becoming the capital of modern art everywhere. [35]

What military contests there were, France lost. The misfortunes which began with the defeat of Napoleon I continued half a century later with the failed Mexican adventure under Napoleon III, and then the humiliation at the hands of the Prussians in 1870–71. Once and for all, for France, the causal connection between the accumulation of military glory and that of additional European cultural capital was broken. Nevertheless, before the Prussian grenadiers cut off the supply of conquered treasures, consciousness

of the special place of France among civilized states was firmly embedded in the minds of most French thinkers. When the library of the Louvre was set ablaze in the last days of the Paris Commune in 1871, French commentators uniformly deplored the destruction as a *tragedy for humanity*, not simply for Paris or France.[36]

The Civilizing Mission

With the defeat in Europe, and the creation of the Third Republic, France's cultural expansionism—what Albert Salon has called its messianism[37]—turned in the direction of the colonial world. Since at least the sixteenth century the French church had been particularly observant of the Christian obligation to spread the faith. Losing the battle against disbelief at home in the course of the nineteenth century, the church stepped up its missionary efforts abroad. As in the explosion of overseas missionary zeal at the time of the Protestant Reformation, the nineteenth-century church worked to replace lapsed metropolitan believers with new converts in the colonies.

Much of the creation, and all of the consolidation, of France's overseas empire—especially Indochina and African possessions—was accomplished by the governments of the Third Republic. Despite initial domestic resistance, the new colonial empire became the pride of Third Republic politicians. Just as the new republican government tried systematically to secularize the educational system, the nation's cultural and political semiology, and even domestic aesthetic expression, it challenged the dominance of Christian missionaries as the representatives of France in the growing colonial empire. The "push" for cultural expansion in the colonial world emanated from French defeats in Europe. Colonial preoccupations, as Bismarck had hoped, to some extent took French policymakers' minds off the loss of Alsace and Lorraine. But the "pull" was in large measure republican efforts to challenge, or more accurately, to parallel, the missionary efforts of the church.[38]

Thus was France's famous *mission civilisatrice* advanced by the new republic. Significantly the cultural effort was named—*mission*—with the same word used for the religious missionary project.[39] With France's relative decline militarily, politically, and—with the anxiety-spreading depression of 1873–96—economically, in Europe in the last decades of the nineteenth century, this special secular mission grew in size and importance. It paralleled the better known republican effort at home in the 1880s to create a unitary culture state.

I will give France's cultural relations with the colonial world more attention later. Here the important point is that in its relations with urbanized societies, that is, primarily Western countries, France's cultural influence was henceforth—and had to be—a force replacing military prowess. The

ideological contestation surrounding World War I is a central illustration of this.

Civilisation against *Kultur*

The German military aggression in 1914 shocked many French intellectuals who had thought to learn lessons from German *Kultur*—especially from Kant. In December 1914 Henri Bergson counseled the intellectual elite gathered in the Académie des Sciences Morales et Politiques that it was time "to return home." As Martha Hanna has shown, this return to French values meant a return to classicism. In art, theater, and school instruction, for example, wartime France returned to its roots: away from Cubism (Germanic), to wartime revivals of Racine and Corneille and newly popular Latin classes in the lycées.[40]

When the bloody stalemates of trench warfare immobilized the contestants, it became evident that this would be no brief decisive contest as in the Franco-Prussian War. Motivating the newly named "home front" to hold out became the central *military* issue for all the combatants. That meant that the domestic populations were caught up in the war—a circumstance for which Raymond Aron coined the phrase "total war"—in a way unprecedented in the nineteenth century. Propagandists on all sides encouraged the soldiers and mobilized the civilians.

French academics began to call in their accumulated cultural capital from their Latin allies. For example, in February 1915, three thousand people attended an international conference at the Sorbonne where Greek, Portuguese, Spanish, and Romanian delegates heard French, Belgian, and Italian speakers invoke their common descent from ancient Greece and Rome. Fortunately for these defenders of Western Civilization, Italy, an ally of Imperial Germany and Austria-Hungary at that moment, would, in April, repudiate these obligations and join the French and British side.[41]

In 1916 Woodrow Wilson's request of all the belligerent to state their war aims and peace proposals initiated an outpouring of self-justificatory declarations from all the governments involved in the conflict. British ideologues and propagandists, invoking Herbert Spencer's ideal-types, denounced Germany as a Warfare State. Britain was, in contrast, the peaceable Commercial State which had been set upon by the other. With their own optic, French propagandists portrayed the conflict, rather, as between German *Kultur*—already seen by some prewar critics as a troubling source of intellectual corruption in the early Third Republic—and *civilisation*. For their part German intellectuals accepted the distinction. In 1914 Thomas Mann, an avid conservative nationalist, saw the war as the clash of reason with spirit, of limits with the demonic.[42] In these German anti-Enlightenment dichotomies, French reason and limits were understood as inferior to German Geist and the demonic.

The defense of British commercial interests and a suspect legalism—initially, the British claimed that they were fighting because the Germans had violated the 1830 treaty guaranteeing Belgium's borders—hardly likely to inspire redoubled efforts on the part of the British population, seemed equally improbable rallying points for the warm support of other nations, in particular, the United States. But the French appeal to a common Western Civilization played no small part in seducing the Americans to enter the war on the French-British side. (This French appeal to a common Western heritage, backed by U.S. State Department urging for American universities to teach students about our shared heritage, was the precise origin of the first "Western Civilization" course at Columbia University, and so of all its subsequent—frequently required—imitations at other universities.)[43]

Albeit barbarian in terms of the millions of lost or diminished human lives, Western victory was in French nationalists' eyes a triumph of *civilisation*. And the return of Alsace-Lorraine was a recovery not just of a vital part of France, but also of a part of Western Europe. The triumph of *civilisation* over *Kultur*, made the interwar years a time of glory for French aesthetic culture, if not for the French franc. There is no need to rehearse the writers, artists, actors, and directors who came from all over the world to create in postwar Paris. And whereas before the war the model of intellectual life in the United States had been the German university, in the 1920s Paris drew American writers and intellectuals: creators of the Harlem Renaissance, writers of the so-called Lost Generation, and of course, the cultural doyenne of the expatriates, and great appreciator of French art, Gertrude Stein.

The Birth of *la Culture Française*

Soon after the war (1920), in a two-volume ferment of sour grapes, Oswald Spengler published his *Decline of the West*. Here he translated the propaganda contrast between *Kultur* and *civilisation* into heady historical metaphysics. A *Kultur* is alive; it passes through a life cycle. Only when it begins to degenerate does it enter the stage of *Zivilisation*. This was an rather abstruse way of saying that, yes, France had won the war; it had a great *Zivilisation*. But it was decadent. Although Germany had lost militarily, its creative forces were still in their vigorous infancy. The influence of Spengler—and Nietzsche from whom Spengler had gotten his important ideas—was great in interwar France. In part, this was so because many French intellectuals feared that maybe Spengler was right about French decadence. Their first reaction was denial. Focusing on the dangerous words more than on the phenomenon Spengler was describing, they began to insist that France too had a young and vigorous culture. *Culture*, they reasoned, was after all an old and honorable French word, perhaps a better way to describe the French achievement in the arts and think of their future.[44] This

was the negative reason for the general shift of terminology among vocal intellectuals. But more concrete causes made for the triumph of *culture* over *civilization* in French discourses of the 1920s and 1930s.

There are two stories of French cultural defense and expansion in the interwar years. Of these, the project of Greater France is less well known than the cultural experiments of the Popular Front in the mid-1930s. Greater France (*La Plus Grande France*), was a new formulation of the relations of France to its colonies. The concept allowed for local values, sensibilities, and a degree of "evolution" of the local population. Greater France made possible the efforts of the Colonial Ministry and supporters of the empire to try to reshape some of the colonies on the model employed in refashioning the provinces in the nineteenth century. Central to it was the two-homelands idea. Each inhabitant of Greater France, like each Breton, Catalan, or Alsatian, was understood to have a natal *petite patrie* and a national *grande patrie*. In this way a True France could allow for a Greater France.[45] The ideological move here became the colonialists' preferred strategy for binding both actively and potentially insurgent colonial elites to France: it involved the transformation of the notion that France was the trustee of *civilisation* in Europe into a vision of France's *mission civilisatrice* in the colonial realm.

The two visions, or (better), projects, were linked. Historians have tied the strong revival of interest in empire after World War I to the role that colonial troops played in defense of their second *patrie*, to France's economic problems, and to the post-victory acquisition of the German territories in Africa. But of at least equal importance, perhaps even greater, was the opportunity for the validation of French *civilisation* after the ignominious defeat of 1870 and the horribly costly victory of the Great War. In the 1920s and 1930s the usage *la civilisation française* increasingly yielded to *la culture française* in government documents, journalism, and academic discussions and publications.

The word "*civilisation*" had begun to appear in intellectual language only in the late eighteenth century. Then it figured centrally in the discourse of civili*zing*, taming, an undocile people. This civilizing intent was primarily focused inward, on rural France; the *philosophes* showed great respect for the other (distant) *civilisations* of the world. Mirabeau, for example, wrote of the importance of religion as the "first and most useful brake for humanity: it is the prime agent of civilization." [46]

The significant postwar change of language from the old term to the more anthropologically tinted word was the discursive move that mediated the new consciousness promoted by the French government. The French were, after all, a colonial people. And the colonial peoples of Greater France were, or could be, French. In a word, *la culture française* was the *civilisation* for the new age of imperial democracy and of mass and class politics.

The second use of this linguistic transvaluation of the interwar years was to bring the metropolitan nation together. Here, too, *culture* was *civilisation*

in its new democratic incarnation. Nothing illustrates this transformation better than the domestic mobilization of progressive republican forces after Hitler came to power in 1933, and especially after the forming of the French Popular Front in 1935. The apogee of this campaign to democratize *the consumption* of French culture, to open the gates of the beautiful park to the working class, was reached in the context of this remarkable explosion of national solidarity and of what Jean Renoir in his films of the period, including *La vie est à nous* and *La Marseillaise*, celebrated as a special moment of fellowship.[47]

Defending the Culture

An international conference of writers held during the period of the Popular Front provides an illuminating moment in the process. On Friday, 21 June 1935, in the Mutualité auditorium in the Latin Quarter, André Gide convened a gathering of many of the *West*'s greatest writers and intellectuals. Model French intellectual that he was, he launched the first session with a paradox: "Literature has never been more alive. Never has so much been written and printed in France and in all civilized countries. Why then do we keep hearing that our culture is in danger?"[48]

So began—in Paris, of course—the first International Congress of Writers for the Defense of Culture. Clearly in 1935 the trope of "defending the culture" referred back to 1914–18 and the defense of the values of the West against German barbarity. And equally clearly, two years after Hitler and the National Socialists had come to power in Berlin, making culture the issue to unite anti-fascist forces allowed many non-Communists writers to participate without either fearing that they might be being used or sensing themselves in a condition of bad faith.

Among the French writers, Gide, who guided the conference, was most prominent, but also participating in important ways were André Malraux, Louis Aragon, Paul Eluard, Paul Nizan, Jean Cassou, André Chamson, Jean-Richard Bloch, Jean Guéhenno, and Julien Benda. Jules Romains, Henri de Montherlant, and Georges Duhamel had been invited but did not attend. André Breton, leader of the Surrealists, had had his invitation to speak withdrawn because some days before the opening session he had struck Ilya Ehrenburg for libeling both his movement and himself personally. In retaliation Ehrenburg had threatened to end the participation of the Soviet delegation if Breton were permitted to speak. But even given this bad political blood, Breton's friend Paul Eluard, former Surrealist, and now Communist, was allowed to read Breton's address instead. Naturally the writers of the far right such as Céline were not invited; nor were the frivolous, like Jean Cocteau.

The names of the foreign writers who were asked and came offers us a daz-

zling display of the literary culture of the West in the years between the world wars. Although neither Thomas Mann nor George Bernard Shaw could attend, they permitted their names to be included as members of the congress's Presidium. From England came E. M. Forster and Aldous Huxley. Exiled German writers were there in great numbers, including Bertolt Brecht (though only in the audience), Johannes Becher, Lion Feuchtwanger, Anna Seghers, and Heinrich Mann.[49] The Russians included Isaac Babel, Ilya Ehrenburg, Boris Pasternak, and Aleksei Tolstoi. But only Mike Gold and Waldo Frank, sent by the U.S. Communist Party, represented American letters.

That the defense of culture should be first mounted in Paris was by 1935 one of those things that went without saying among intellectuals in both France and the rest of non-fascist Europe. A Communist-organized "First American Writers' Congress" had preceded the Paris meeting in April of the same year, and in February 1936 the First American Artists' Congress convened in New York. But as is evident from the "American" designation for both meetings, the organizers and participants made no claims to speak for the West. The cultural leadership of Europe had for centuries been a part of French leaders' and intellectuals' sense of national destiny.[50] That *these* conference leaders were largely Communists makes little difference. They were *French* Communists; the cultural leadership of their land was readily endorsed by other European intellectuals, Communists and non-Communists alike.

Collapse of the Civilizer and of the Civilizing Mission

In 1940 France experienced its third German invasion in seventy years, and its second defeat. The humiliation of 1870 had brought down the regime of Napoleon III. In 1940 the political class experienced a parallel crisis. Moreover, many intellectuals shared a pervasive apprehension that the Third Republic was played out culturally quite as much as it was bankrupt politically.[51] The French State of Philippe Pétain replaced the demoralized Republic. But Pétain's efforts at renewing France were compromised from the start by his collaboration with the German occupiers. In fact, the German government cared little about French cultural decadence or revitalization as long as the country remained tranquil and delivered up farm and manufactured goods, and later labor, for the German war effort. Nevertheless, despite France's prostrate political condition, we know the awe and respect that Otto Abetz, German ambassador in Paris during the war, manifested for French art and literature.[52]

The conditions of war and occupation made possible, indeed necessitated, breaking the grip of Paris on national cultural life. With the country divided first into German-controlled and Vichy-ruled zones, and then fully occupied

by the German military, the regions in many ways—including culturally—had to fend for themselves. Moreover, Vichy authorities were interested in furthering regional culture and gave positive support where they could to the trend to decentralization. Provincial theater, for example, flourished as never before. It was at this time and under those conditions that Jean Vilar began his brilliant theater work. Regional art, both folkloric and more sophisticated varieties, also prospered.[53]

Most dramatically, suspicious that the Germans intended to steal France's colonial empire, the components of a future greater regionalism, both Pétain in Vichy and Charles de Gaulle in London did what they could to retain the overseas territories.[54] But in most cases the governors and military of French overseas possessions remained loyal to the continental government. From Britain de Gaulle issued appeals to the French for support of his one and only True France. From exile, what more could he offer his people but claims personally to embody the spiritual heritage of a France not defeated or corrupted by cooperation with the German invaders? Nor was this a strange or ahistorical megalomania. Pétain too, on taking office in 1940, had offered *his* person as a gift to the nation in its moment of need.

The expression of regionalism of the Vichy years was muted immediately after 1945. During the war years, a tiny but alarming minority of Breton and Alsatian separatists who had collaborated with the Germans had discredited cultural regionalism. Through the 1950s and 1960s, moreover, the challenge for all of France's political forces was not making place for possible pluralisms, but rather bridging the deep fissures that were growing in the society.[55]

After 1945 the civilizing mission collapsed too, finally bringing down the newly created Fourth Republic with it. There had been grounds for optimism in the war years. The Germans had not occupied all of Greater France. De Gaulle's claims to lead France had first been accepted by someone in authority in the colonies, Félix Eboué, a Martiniqué and the top French administrative official in Chad.[56] However, postwar demands for decolonization pressed by African nationalists stemmed in part just from this relaxation both of French political control and cultural hegemony in the war years. The weakened national state opened space for the growth of nationalist movements in most of the colonies and Algeria (which legally was three departments of France). Contained in the *civilisation française* exported to French dependencies were the values of the Great Revolution. Not only did indigenous intellectuals in Algeria, West Africa, and Indochina demand liberty and equality from the metropole; their nationalism grew much like that sense of identity which took form in Europe in the early nineteenth century as a result of the initial spread of the universal French Revolution. And so, with the break-up of France's colonial empire under Charles de Gaulle in the new Fifth Republic, France turned back to its historic role of being Europe's, and more, the West's, great cultural power.

De Gaulle, Heir to François Ier

We can trace the French cultural exception back very far. In the early Middle Ages French priests were the first to began giving sermons in the local language. And earlier than in other Romance-language regions, legal documents began to be written in a vernacular. But only beginning with the Renaissance did the special bond between the politics of the state and the arts become institutionalized. First, as we saw, French rulers wanted to participate in the glories of antiquity. But soon, becoming arbiters and even owners of copies of the great creations of ancient Greece, Rome, and Renaissance Italy, they began to claim the trusteeship of this heritage. By accumulating the originals, and linking possession of this art to universal political claims, the Revolution and Napoleon implicated the French nation in the project of the kings.

In two decisive moves initiated at each end of the nineteenth century, republican leaders turned this cultural heritage inward to unite the nation around common values. First with the Revolution, and then renewed and completed in the Third Republic, the international emanations of the arts of France became irrevocably intertwined with domestic cultural life. The worldly—military—words "international success," "triumph," and "leadership" were normalized in the discourse of French art. In the first decades of the Third Republic, in contrast to earlier centuries when France had been more successful in arms, French cultural expansion to other Western nations was stayed. But France found new, in many ways even more demanding tasks in its own house for its cultural élan vital. It pursued the twin civilizing missions of the late nineteenth century: turning provincials into French citizens and the indigenous peoples in the colonial empire into French subjects.

By the twentieth century France had a secure reputation as the great exporter of finely wrought, elegant consumer goods, wines, fashion, impressionist art, and tourism (tourism counts as an export in international balance of payments accounting). The accumulation and display (and sometimes the creation) of cultural capital for the benefit of the rest of the world had become seamlessly integrated into the doxa of France's national identity.

Defeat in 1940 gratified some, made others despair; but required all to rethink what was France and what place it could have in a new world. The decline of French great power status after 1945, serious internal social divisions, the dislocations of economic modernization, and the rebellions of colonized people who did not want to be part of any Greater France put into question all the French cultural truths which for at least a half century had been self-evident.

The new Fifth Republic of 1959 would not survive if it could not bring social peace, end the national disorder which colonialism had created, and—this was de Gaulle's special vision—make France once again great among the nations. Higher incomes for all by way of economic growth, an elabo-

rated welfare state, a certain idea of decolonization, and de Gaulle's foreign policy of *grandeur* were part of the solution.[57] Then there was the common denominator of all these grand projects, French culture. Here the new Ministry of Cultural Affairs created in 1959 would play an important role. The General appointed as its first head the novelist, art critic, military hero of the left and of the Resistance, temple-robber, and convert to Gaullism, André Malraux. Did the classicist Charles de Gaulle, with his sure sense of political power, really believe that this man, like Aeneas leaving Troy on his way to found Rome, his father Anchises on his back, could carry the heritage of centuries to a new place of beginning?

3 The Making of the Dandy-Übermensch

If Malraux were unique, as he tried to represent himself to be, his life would be *only* the stuff of literary biography. In this chapter I do not wish to contribute yet another such celebration of the great artist or even *the* great public personage. Nor is my intention to strip his story of its conceits and posturings to reveal the flawed human being hidden behind the Malraux-creation. Rather, I want here to use aspects of Malraux's admittedly fascinating true-invented biography, the mask he created for himself, to tell a grander story of the marvelous ways French intellectuals made and were made by French culture up to the late 1960s. Because Malraux the Dandy became Malraux the novelist, art writer, political idealist, Resistance hero, Gaullist propagandist, and trustee of the nation's aesthetic life, we may explore with him and through him important features of French culture in the twentieth century and the legitimation crisis it began to go through at mid-century. As Pierre Bourdieu has pointed out, often the telling biographical detail, the seemingly small incident, or quickly tossed off piece of writing, can open up rich historical perspectives on the era and the person. In this chapter, Malraux the man and legend, will be for us an artwork in its, or his, own right; as Jakob Burckhardt did with the Renaissance, we will read the age from contemplating the creation. With Malraux, as with many other intellectuals of his generation, life imitated art. The Malraux we know was very much a Nietzschean aesthetic project for a modern *Übermensch* or, to invoke another of his favorite authors, a twentieth-century Raskolnikov whose genius put him above the law and the rules.[1]

Specifically, I propose that Malraux found first in Indochina, then in the Popular Front, but finally in Gaullism, the Gaullist political vision, and the state it constructed, the way to bring back the lost aura of French cultural life. Neither politicized art nor social revolution in the Soviet Marxist sense would remove the determinacy-unto-death of our lives. Rather the state's encouragement of an aesthetic culture as the basis of the French nation acting

for all of humankind—the living the dead, and the yet unborn—would once again unite art and life, would restore the lost aura. And it was this special mixture of tradition, contemporary cultural production, and French social life that Malraux understood and lived and, as cultural minister, tried to save.

Rummaging for an Education

Despite later tropes in some biographies of a style of personal gravity native to northern France and of Viking roots—some of his family originated in Flanders[2]—André Malraux was born in Paris on 3 November 1901 at 73 rue Damrémont, appropriately and usefully at the foot of the hill of Montmartre. Fernand, his father, was a wheeler-dealer, bourse speculator, and sometime inventor, but finally a *raté*, that terrible French word conveying deep existential finality, a failure. He committed suicide when André was twenty-nine. But long before that, his father and mother, Berthe Lamy, divorced. The boy was brought up by his mother, her Italian-born mother, and his aunt Marie. Malraux began to write his role in the *comédie* over a grocery store tended by the women, about a kilometer from the railway station (16 rue de la Gare) in the ugly Paris suburb of Bondy. Paris was less than a half hour away by train. He later wrote that he hated his childhood—a violation of the great-man-biography formula—but, being the only male in a house of three women, in that time, how could he not have grown up an *enfant gaté*, a French prince?

As a boy he read widely and deeply, the way some children do to close out a dull or unhappy real world, and he soon came to love cinema and theater. While still an adolescent, moreover, Malraux began to teach himself how to earn money from culture for the sake of culture. To acquire some spending money for movies and theater tickets on days off from school, Malraux and his friend Louis Chevasson scoured the stock of the second-hand book sellers in the Latin Quarter and then resold their treasures at a profit, usually, to a more upscale bookstore. Bookdealers called such gatherers "chineurs." Because this activity proved easy, quick, and lucrative, Malraux practiced it more systematically as he grow older. As Jean Lacouture notes, it become for him a sort of métier, "the only one he worked at up to the age of twenty."

In 1915, just before he turned fourteen, Malraux entered an intermediate school in Paris which after the war would become the Lycée Turgot. After three years, he applied for admission to the Lycée Condorcet. He was refused. Thus at the age of seventeen he closed his formal education with no time in a lycée and no degree and, therefore, without the usual ticket of admission to a career in the world of learning and culture. A life selling carrots and bulk wine did not entice him. In his psychic economy, his comparative advantage lay with imagination and daring.

He threw himself full-time into his activities as a chineur, making an arrangement with René-Louis Doyon, a rare editions dealer situated in the

galerie de la Madeleine, to supply his shop with good finds off the quays. The economic disorder at the end of the war, the repudiation by the Bolsheviks of Imperial bond obligations, and fears of future uncertainties turned many French bourgeois to dependable investments at home. Though not so good as gold, rare editions of France's great writers—the masters of *la civilisation française*—were surely safe investments. Malraux worked for Doyon for a year and earned enough to move out of Bondy, away from the feminized petit bourgeois environment of his childhood, reaction to which may have motivated his later macho bent both in fiction and in arms. He found a room first in a Paris hotel, then a boarding house.

Early in 1920 Malraux started his literary career. The enterprising Doyon decided to found a review which took the name of his bookshop, *La Connaissance*. Malraux published his first piece in the first number, a trendy essay on the origins of Cubist poetry. Appreciating both young Malraux's entrepreneurial skills and his aesthetic judgment, the publisher Lucien Kra offered him editorship of a series. The publications Malraux chose to put out did well: he selected works by Baudelaire, Max Jacob, and some not very well known de Sade texts (with pictures). He then moved to the avant-garde leftist *Action*, controlled by Florent Fels, where he met and published many of the great contemporary literary revolutionaries: Jacob, Cendrars, Aragon, Cocteau, Radiguet, Eluard, Tzara, Artaud, Derain, Gorky, and Ehrenburg.

His most important connection came in September of that busy year. Max Jacob introduced him to the German-born art dealer Daniel-Henri Kahnweiler, who immediately took to Malraux. The dealer who specialized in the Cubists envisioned starting a series of quality arts books, and hired Malraux to edit them. This relationship with Kahnweiler and the contemporary artists he showed was key in Malraux's arts education. It taught him both art and the commerce of art, and it credentialed him in the small world of the Paris vanguard culture. We get a sense of the compelling charm, and perhaps talent, of the young Malraux when we see that Kahnweiler also published the nineteen-year-old's first book, *Lunes en papier* (1921), and that Malraux persuaded Léger to do original illustrations for it.

Employing the French intellectuals' trope of the-decisive-early-influences-on-my-life in a 1972 conversation with Jean Lacouture, Malraux positioned himself with the necessary impeccable pedigree of a young man on the cutting edge of the culture of 1920s Paris: at twenty, Apollinaire and Max Jacob had become his aesthetic guides; for the rest, he was a Nietzschean. Without enrolling, he attended a few classes in Chinese and Persian at the Ecole des Langues Orientales; from time to time he showed up at lectures at the Ecole de Louvre. He *lived* a feverish aesthetic vicariousness. As Lacouture summed up the young Malraux, "A cautiously subversive dandy, a poet alertly spacey, a talented critic, polymath, collector of rare sensations, an aesthete of unquenchable curiosity, he threw himself into the movement of the day."[3] But his deepest intellectual influences came from Germany via Clara Goldschmidt, his first wife.

While working at *Action*, Malraux meet and fell in love with Clara, daughter of a German-Jewish family that had settled in France before the war. Most French intellectuals had no knowledge of German; at the review she concerned herself with finding and translating materials from the fecund and feverish intellectual scene of the newly created Weimar Republic. In his first phone call with her, she already recognized "the value he attached to each word, the nuance which individualized for him this one, or discolored that one." Malraux courted her successfully, by telling her, among other little sweet things, that—after Max Jacob—she was the most brilliant person he had ever met. He also impressed the well-brought-up young bourgeoise by involving her in his adventuresome life. At one point, after Malraux had taken her to her first *bal musette*, a dive with dancing, some muggers attacked them as they left the club late at night. Malraux pulled out a pistol and exchanged shots with the criminals. He was hit, but the wound was minor. Clara took him to her home, to her room, to care for him.[4]

However, her educated and solid family saw little worth in the young French intellectual butterfly with no financial prospects. The couple eloped to Italy, from where they telegraphed Clara's mother news of their engagement. Soon after their return to Paris, they were quietly married in the mairie of the local arrondisement.

André Malraux and the Temple of Doom

The Goldschmidts were right: Malraux had no real prospects. Nor indeed had Clara been educated to do anything that earned money. Even with their moving in with Clara's parents, it became clear to the couple that they could not live from his enterprises in the arts, at least not yet in 1921. Malraux's efforts to distribute German films, those great expressionist silent films then being made in Berlin, commercially in France, failed for want of the necessary French government visas. He continued to make some money by publishing pornographic books. But in 1922–23 they lived by playing the stock market with Clara's money. They bought shares in a Mexican mine, which bountifully climbed in value during those two years, permitting them an almost carefree life in the Paris literary world and much travel. Alas, in early summer 1923, they learned that their stock had collapsed; they were wiped out, at least as *rentiers*. Malraux became so desperate for money that he agreed to write a preface to the novel *Mademoiselle Monk* by the Action Française leader, Charles Maurras! But even writing in appreciation of the anti-Dreyfusard, anti-Semitic rightist was not the strangest means that Malraux hit upon to keep afloat.

One day, soon after learning of their stock-market disaster, he proposed to the startled Clara that they steal and sell a Cambodian temple, or at least as much of one as they could carry out of the jungle. Already the aesthetic comparativist, Malraux reminded her of all the churches and chapels on the

long medieval pilgrimage route from Flanders to Spain—some famous, but some not well known anymore—which were mostly still intact and splendid. So what? Well, he went on (as Clara recalled), the Royal Road, extending from Siam to Cambodia, also had many well-known temples along it, the most famous of which was its terminus, Angkor Wat. But "there were surely others, minor ones, still unknown today." He proposed they go to Indochina. Along the Royal Road from Dangrek in Siam to the Angkor temples complex in Cambodia, they could surely find one of these minor temples no one cared about, now buried deep in the jungle. "Yes." Where's this conversation going, she wondered. "Well," he came in for the kill, "we'll take some statues, sell them in America. We could live comfortably for two or three years from the money." To her own amazement, Clara agreed to go.[5]

The details of this new adventure are not important here.[6] We understand that plundering the public art of conquered peoples for the glory of French internationalism was by then an ancient and much-practiced tradition. No longer possible for the French in Europe since the defeat of Napoleon, the enterprise could be kept alive only in the colonies. However, this incident is more nuanced. Malraux probably learned about selling art to American collectors from Kahnweiler, who had opened the American market to contemporary French art. But great "classical" art from anywhere under French rule should, by the normal practice, have ended up in the Louvre or, for Asian art, the Musée Guimet. Moreover, the colonial administration, beginning in the postwar years to think in terms of building a harmonious Greater France, just prior to the treasure-hunters' departure had promulgated stronger laws to forbid taking and exporting treasures of the cultural heritage of Indochina.[7]

Malraux, Clara, and the friend of his youthful adventures in the Paris arts trade, Chevasson, arrived in Saigon and, after some preparations, began a trip up the Mekong River. At a certain point they left their craft and for forty-five kilometers cut their way overland through dense forest growth. Deep in the jungle they finally came upon the small structure rumored to be just off the narrow path they had been following, the temple of Banteai-Srey, part of the larger Angkor Wat group. Malraux and Chevasson directed the laborers they had hired in first sawing and then, when the saws broke, breaking away from the temple facade seven pieces that made up four large and beautiful bas-reliefs. Loading the carts and returning to their boat near Angkor Wat proved to be the easiest part of the trip.

Their riverboat took them to Phnom Penh, where they anchored the day before Christmas. A knock on the door of their cabin announced three men in civilian clothes, who identified themselves as agents of the Sûreté; André and Chevasson were under arrest for stealing archaeological treasures. One of their guides had turned them in to the police. A week later Clara was also served with an arrest warrant. But after some months it was vacated by the judge, who ruled that she was clearly at her husband's side at the scene of

the crime as a loyal wife, not as a willful criminal. Immediately Clara left for Paris to mobilize help for the two men.[8]

Their trial began in Phnom Penh on 16 July 1924. Despite their feisty defense—Malraux lectured the judge on archaeology, and his attorney pointed out that the temple ruin had not even been important enough to classify as a historical monument—the French Indiana Jones and his side-kick were found guilty. Both men received prison terms: Malraux, three years; Chevasson, a lighter sentence. They appealed the verdict to the court in Saigon, which gave them some time free before they had to surrender themselves to begin their prison terms.

Meanwhile, Clara was rousing the avant-garde literary world of Paris in behalf of one of their own.[9] André Breton and his wife, Simone, took her in when she arrived at their apartment at dawn. They aided her efforts, and many other important figures in the arts came to the defense of the promising young writer in a letter-petition which they published in *Les Nouvelles Littéraires* of 6 September 1924. Among the most famous signers were André Gide, François Mauriac, Jean Paulhan, André Maurois, Jacques Rivière, Max Jacob, Roger Martin du Gard, Gaston Gallimard, Florent Fels, Louis Aragon, and André Breton. Taking the part of the young temple robber, and apparently oblivious to the possible irony of their words, they identified Malraux as one of "those who contribute to the increase of the intellectual heritage of our country." Malraux had already contributed much to French literature; execution of the sentence of imprisonment would prevent this young writer "from accomplishing all that we expect from him."[10]

In October the Saigon appeals court ruled that the young art lover and idealist, who came before the judge so well recommended by the leading literary lights of the metropole, should have his sentence reduced: Malraux's jail term was cut to a year and suspended. Chevasson's sentence was also suspended. Six years later, on another appeal, Malraux got the sentence voided, but could not get the highest appeal court, the Cour de cassation, to rule that the temple reliefs be returned to him, although he continued to insist that they were his property. In fact, they had been returned to their setting in Banteai-Srey, and may still be seen there today.[11]

Learning about the Metropole from the Colonies

This brush with colonial justice, his experience of the people and the country, and his new friendship with the Saigon lawyer Paul Monin, who was deeply involved in supporting the activist Indochinese (the Vietnamese in fact) in their resistance to French rule, moved Malraux to commit himself to the anti-imperial struggle. That such activity would allow him to get back at the colonial authorities who had both thwarted his collecting and attempted

to humiliate him by charging him with a crime surely made the enterprise even more compelling.

On his return to France, Clara was waiting for him at the dock, with her hurtful confession of having had an affair on the boat taking her from Vietnam to get help for her husband. Clara's having an affair with another man at a moment of Malraux's great stress, heroism, and fame came to be a recurring motif in their failing relationship. After a painful period of silence, they decided *this time* to go on together.

But Malraux also found his speculator father waiting for him, and ready to bankroll his return to Indochina. For the moment flush, he promised his son 50,000 francs to continue the fight against his colonialist enemies, as Fernand Malraux preferred to understand André's recent troubles. And the publisher Bernard Grasset offered him a three-book contract with an advance of 3,000 francs. Clara went with him when he boarded the vessel taking him back to Indochina.

In February 1925 the Malrauxs were welcomed on the dock in Saigon by Paul Monin, and installed in a hotel in the European quarter. Malraux and Monin immediately began planning the anti-imperialist newspaper they had decided to start in that city. With a fine sense of historical timing, Malraux had chosen the right moment to launch *L'Indochine*. The Chinese revolution was still unfolding. The Russian one was not a decade old. Young Vietnamese intellectuals—both the nationalists and communists—were beginning to turn their newly formed ideas of "national self-determination" to mobilizing their compatriots for the struggle against French rule.[12]

The colonial authorities gave them permission to publish a newspaper in French, which would surely have but a circumscribed and—the governor-general believed—a relatively safe readership, compared to one in the Vietnamese written language, *quoc ngu*. Funds came from the upper-class educated Vietnamese and from the large Chinese community of Cholon, which had been much influenced by Sun Yat-sen's revolution. In a microcosmic sketch of the most progressive French colonial thought of the day, *L'Indochine* gathered a talented team of Europeans, Vietnamese, and individuals of mixed ancestry to publish a French-language newspaper advocating greater rights for the people of Indochina. They published forty-six numbers in all, their first issue appearing on 17 June 1925. Each number contained an editorial by Malraux or Monin attacking a high government official for corruption or efficiency, cruelty or incompetence.

Neither editor envisioned an independent Indochina, however. Both wanted extended to the colony and its people the rights and privileges enjoyed by the metropolitan population. They saw the peoples of Indochina as future citizens of France, on the model of the Catalans, Alsatians, and the inhabitants of other regions annexed to the metropole.[13] Governor Cognacq finally closed down the newspaper by threatening its courageous printer, Louis Minh, both with not giving his shop any more legal notices to print (a

steady and significant income) and with a government-inspired strike of his employees. Malraux devoted an important essay in the last issue, that of 14 August 1925, to warning *the French* of the dangers of forbidding Cochinchinois and Annamites access to France and to French culture. Young Indochinese would leave and be educated elsewhere. Full of resentment, they would return hostile to the France that made them second-class subjects of the empire.

Some twenty-five years later, was Malraux's project for his Ministry of Cultural Affairs, his intense desire to spread the culture as widely and as far down the social ladder as possible, very different from the sense of his 1925 editorial? Malraux learned how shared culture brings social peace and solidarity, not during the Popular Front, as is often alleged, but in Vietnam in 1925. He learned much about how to be a minister of French culture in his time in Indochina.

Malraux and Monin did not quit with the loss of the press. They heard of a Jesuit newspaper in Hong Kong which was willing to sell some old type. André and Clara were sent to negotiate the deal and, while doing so, spent four or five days exploring the crown colony. That was Malraux's first and only contact with China in the 1920s; contrary to a rumor he later allowed to circulate, he was not involved with the Chinese communists, much less a participant in the Canton uprising of 1925 or that of Shanghai in 1927.[14] But he did get the fonts, and *L'Indochine enchaînée* continued the work of its suppressed predecessor. It was published from early November 1925 to the end of the following February.

Out of money, with a growing feeling that he should return to his own writing, Malraux was ready to sail for Europe. The Indochinese political situation had altered as well; even the new socialist governor-general, Alexandre Varennes, an intelligent man of good will, could accomplish little of a progressive nature given the encrusted structure of the colonial system. Malraux and Monin's agenda for imperial reform was losing its few adherents among both Vietnamese socialists and nationalists. "Their hopes disappointed, the anger of the Vietnamese turned into rebellion; they rejected any idea of collaboration with France," Clara commented in her memoirs of the period.[15] And indeed in the years 1930–31 both nationalist and Communist uprisings broke out in southern Vietnam.

Malraux wrote for the last issue of December 1925, on the eve of his departure, justifying his return to France as an opportunity to build support for the cause of the peoples of Indochina.[16] But Monin was angry at his desertion; they did not part friends. The paper closed two months later.

Malraux received his earliest, best, political education in Indochina. Well before the Spanish Civil War, he served his political apprenticeship as a champion of oppressed people in Saigon. In getting to know members of the Chinese community of Vietnam and during his five days in Hong Kong, Malraux the writer gathered the materials for *Les conquérants* (trans. *The*

Conquerors) and his later book on the Chinese revolution, *La condition hu-maine* (trans. *Man's Fate*)

On the boat returning to France, adapting the eighteenth-century literary genre of the foreign visitor commenting on French life in French, as in for example, *The Persian Letters*, he wrote sketches of letters ostentatiously showing his understanding of how the humanity of the Far East views the world and the West. Ascribing Cartesian *bon sens* to his Persian visitors, Montesquieu had used the form to criticize Western moral corruption. But Malraux's *Tentation de l'Occident* (trans. *The Temptation of the West*), al-though it showed better understanding of Asian philosophies, marked his clear rejection of Eastern notions of the dissolution of the self. Despite his deep sympathy for many of the East's qualities and the region's struggles for freedom, he reaffirmed his commitment to the West's development of the "*moi*".[17] But for Malraux, that "I" was a political consciousness, and, for all his cosmopolitanism, a French one.

Clara shared André's sense that only when turned into art could the lived, *le vécu*, have meaning for us, for humanity. In *Les combats et les jeux*, she wrote, "Our Indochinese adventures . . . would translate into great books which would make sense of what we experienced then."[18] She also had a fine sense of the role of their colonial experiences in fostering this metropolitan politicized *moi*. "For us . . . in Indochina some thousands of kilometers from France, we made discovery after discovery. Before then, we had been politi-cal innocents . . . ! In those two years we talked, we looked, and we made love; so, we got involved in other activities. The individualist revolt had finished in transgression, and our transgression led us to the problems of the epoch."[19] The years in the Far East were the decisive period of growth for Malraux as both a man of action and a writer. He was twenty-five years old when he returned to France.

Writer of Fiction

On arriving in Paris, Malraux threw himself into its literary world. He connected with, or strengthened his ties to, such literary stars as Paul Valéry, Emmanuel Berl, Louis Guilloux, and Roger Martin du Gard. With André Gide and Bernard Groethuysen he had more complicated relations. He met Pierre Drieu la Rochelle with whom he would maintain a friendship into the Vichy years, even after the other man became a supporter of Vichy and an ally of those dedicated to hunting down the resistance fighters among whom Malraux served. Drieu still considered Malraux a friend on the eve of his suicide soon after the Liberation. Perhaps, as well as their mutual literary re-spect—no small personal capital in France—each saw in the other a Super-man, a *Surhomme*, a fellow Nietzschean *übermenschlichen* searcher in a fail-ing civilization, looking for and finding a new morality in the age's colossally

seductive—for anguished bourgeois at least—grand ideologies of the left or of the right.[20]

Malraux did not immediately continue his campaign in behalf of his Indochinese friends, as he had promised in the last article he wrote in Saigon. Only in 1930–31 did he again write against French imperialism in Indochina, first in an essay against French brutalities in putting down the Vietnamese uprisings of those years and again in the preface to Andrée Viollis's *Indochine SOS*.

Nor did he join the most exciting culture rebels then scandalizing Paris, the Surrealists—and this despite (or more likely, because of)Breton's having rallied immediately to his support when Clara asked for his help. Lacouture dismisses Malraux's claim that it was just a problem of missed meetings, and suggests instead that André Breton was a man too much in charge, too dictatorial, to suite the other Nietzschean.[21] Perhaps. Certainly in that period Malraux shared many of the artistic and literary tastes of the group around Breton. But I would suggest that, still the upwardly mobile self-educated petit bourgeois, Malraux did not appreciate the Surrealists' attack on high culture, on the high tradition on which, for all his social and political rebelliousness, Malraux was staking his life and career. "More than they were . . . he was interested in keeping a large of part of the cultural heritage," is how Clara Malraux put it."[22]

From March to July 1928 the *Nouvelle Revue Française* published installments of *Les conquérants* , Malraux's novel on the Kuomintang-organized general strikes against imperialist domination in the summer of 1925. To write it he had drawn from his experiences, his reading, and his imagination—he had spent only those few days in China and none in Canton. Grasset brought out the book on his fall list. It was well received by the critics: here was a new voice speaking of a world not well known in France. In the same year, he published *Le royaume farfelu* with a new publisher, Gallimard. (France did not have, and still does not have, university programs for writers-in-residence. There are no MacArthur fellowships for novelists. Instead, proven young writers received no- or low-performance positions in publishing houses. Malraux had just taken such a position with Gallimard as "directeur artistique" with a tiny office under the roof and no clearly defined duties or hours.)

If the first novel expressed Malraux's committed and activist side, the book about the "fanciful or "crazy" kingdom was more surreal. Lacouture attempts to characterize the world of the latter novel as follows: "The fanciful Kingdom is a land of grimace, of nonbeing, of necessity [*le destin*], of the irremediable."[23] A novel of existential choice had been followed immediately by one of a world with no choices. Malraux was soon celebrated as a powerful literary voice of the left for the first work. The second would be used—in the sense of "farfelu" as nutty, crazy, mixed up, disorganized—to mock his new ministry some thirty years later.

Figure 17. Malraux autographs copies of *La condition humaine* after receiving the Prix Goncourt, 1933. Keystone-Sygma.

The new income flow once again revived his taste for travel. In 1929 Malraux and Clara began a series of voyages around the world. From that year to 1931, with only brief returns to France, they toured the USSR, Persia, India (twice), Afghanistan, Singapore, and finally continental China. They visited Manchuria, Japan, Vancouver, San Francisco, and New York. During these travels, Grasset, to whom Malraux still owed a third book, brought out *La voie royale* (trans. *The Royal Way*), the novel based on his temple-robbing adventure in Cambodia. It was a story of treasure hunters in Indochina, but also, in a sense, a work of repentance by the one-time get-rich-quick schemer, for its theme was that there is no royal road through alienation, violence, or injustice. The way is always hard; we move long the path only by struggling. This novel, too, was well received by critics from all camps and won Malraux the Prix Interallie.

In 1933 at the age of thirty-one, he published *La condition humaine*, the novel that would win him the Prix Goncourt in December of that year, and make him internationally celebrated as France's, and the West's, great, perhaps greatest, novelist of the left (figure 17). A novel centered on the Communist uprising in Shanghai in 1926 and the Kuomintang's bloody repres-

sion of China's most important urban and proletarian revolt, it had as a hero Kyo, a young Communist of mixed ethnic ancestry. In January 1933 Hitler had come to power. The Nazis had begun immediately to crush the remnants of the left opposition, a theme clearly paralleled in Malraux's narrative. This novel set in Asia but universalist in import and the human equality of the characters—no matter their ethnic origins or language or place of struggle—gripped progressive readers everywhere looking for hope in a black moment. The title, a reference to Pascal, evoked the seventeenth-century writer's sense of God's overwhelming power over human destiny. But as Malraux has Tchen say in the novel, "What to do with a soul, if there is neither a God or a Christ?" Even if neither God nor redemption determined our path in life, we were not free of the human condition: limitation-unto-death. Malraux's novel responded to Pascal's determinism by speaking of our need to struggle against our fate, to define our humanity by acting, even if the end for us all, finally, is death.

For the admirable figures in his novels—and for Malraux, I think—self-definition was possible only through fighting at the side of companions in arms. As Kyo says as he lies dying, "It is easy to die when you do not die alone." With fine accuracy, and not a trace of irony, Janine Mossuz-Lavau described the ideal of Malraucian existentialism as "a manly [*virile*] brotherhood at the service of a collective cause." [24]

Malraux once explained the novel as a study of the impossibility of communication; but like so many other French novels on this theme, the characters, nevertheless, go on endlessly in inner reflections and have interminable conversations about the possibility or impossibility of acting. In *Man's Fate*, however, the characters, finally, do define themselves by action: preparing an attack, an assassination, a rebellion. The novel modeled a political existentialism which, increasingly in the 1930s and 1940s, would mark Malraux's own commitments to the Popular Front, the Spanish Republic, and the Resistance.

Rebel Turned Revolutionary

Despite the great influence of his friend and political mentor Bernard Groethuysen, head of the *NRF* and member of the French Communist Party (PCF), Lacouture insists, to 1933 Malraux "remained a rebel much more than a revolutionary." [25] Hitler's coming to power in Germany marked the intensification of Malraux's political engagement, as it did for many of his fellow intellectuals. The change was evidenced by his participation at the 21 March meeting of the PCF-inspired Association des Ecrivains et Artistes Révolutionnaires. It was the first of many leftist political meetings in which he would participate before his switch to Gaullism. He ended what was more or less his maiden political speech with his usual sense of theater: he sud-

denly raised his clenched fist and announced that, in the face of fascist aggression, he turned "to Moscow, to the Red Army"—to be sure, as a fellow-traveler.[26]

The next year he was the only non-Party member invited to a writers' congress in Moscow. He met the luminaries of Soviet letters, and even Stalin briefly. His talk there mixed revolutionary social consciousness, bourgeois individualism, and insistent modernist aestheticism. "If writers are engineers of souls, let us not forget the highest function of an engineer. It's to invent!" His Soviet hosts found his ideas as annoying as respectable bourgeois did in France.[27]

Increasingly the 1930s were filled with political causes for Malraux. Lacouture points out, correctly, that none of them were particularly related to life and politics in France.[28] Under the auspices of the PCF, he visited Berlin with André Gide to urge the release of George Dimitrov, the Comintern agent imprisoned by the Nazis on the charge of having set the Reichstag fire. He made another voyage to Nazi Germany to try to gain the release of Ernst Thaelmann, imprisoned head of the German Communists. He participated as a member of the presidium in the 1935 Mutualité International Congress in Defense of Culture. In the left literary review *Le Crapouillot* he attacked as apologists of imperialism the rightist French intellectuals who defended Mussolini's invasion of Ethiopia. And he committed himself to the defense of the Spanish Republic against its military-fascist attackers. Yet although his writings in the period, both novels and essays, were in fact about everywhere but France, we will see that when he became cultural minister many years later, the domestic politics of the Popular Front—making the state responsible for the culture and for its democratization—stayed with him and deeply influenced his thinking and his policies.

In 1936 Malraux threw himself into creating a volunteer airforce for the Spanish Republic. Using his brother-in-law's business connections, and his own cultural capital with the government of the Popular Front, he brokered the Spanish government's purchase from France of some twenty used airplanes for the volunteer squadron España. On getting the planes to Madrid, he was named colonel in the Spanish airforce and given the right to recruit foreign flyers for his squadron.

That he had never flown an airplane, knew nothing about maintenance, navigation, aerial bombing, and combat, and, for that matter, spoke no Spanish seemed not to pose any problems for him. He flew on missions, often dangerous ones, as squadron commander and gunner. For seven months in 1936 and 1937 Colonel Malraux, very much acting out the multiple roles of Lord Byron and T. E. Lawrence, not to mention some created by the poet-aviator-fascist adventurer Gabrielle D'Annunzio, led his ever-shrinking squadron in sixty-five missions against Francoist targets. He was wounded twice. This combination of deep political engagement, great personal bravery, and aesthetic posturing was stunning to his contemporaries (figures 18 and 19). I

Figure 18. As commander of the squadron España, Spain 1936. Keystone-Sygma.

Figure 19. Still of aviators on a bombing mission from Malraux's film *l'Espoir*. Film Still Archives, Museum of Modern Art, New York.

have to confess, it still is stunning to me. But in February 1937, covering the Republican retreat from Malaga, the Escadrille André Malraux, as many in Spain and France came to call it, flew its final mission. Pressure from the Spanish military to regularize the air arm, lack of planes and parts, and the loss of many good aviators all combined to make that operation the last sortie of the squadron. Malraux returned to France, now a several-times-wounded military hero of the left.

In Spain, Clara, who had accompanied him on this adventure too, had had an affair with one of the squadron's aviators, and again she told him. They separated before the end of 1936. But this time their relationship was over. Her final judgment of him, written many years later in the second volume of her memoirs, *Nos vingt ans*, was harsh, perhaps vindictive, but it rang true: "My companion was a misogynist."[29]

The Aura of Art as Salvation for Our Times

Almost immediately after returning from Spain, Malraux, with his new companion, Josette Clotis, sailed to the United States to raise money for the cause of the Spanish Republic. On 13 March 1937 at the fund-raising banquet organized in New York by the *Nation* magazine, he spoke movingly about the heroic Spanish Republican resistance to Franco's troops, philosophizing about the suffering necessary for a good cause. And in a pithy phrase that he had learned from the German culture critic Walter Benjamin, he yoked his political message to cultural criticism of the fascists. He charged them with "aestheticizing war." [30]

Benjamin was then in exile in Paris. Hoping to break into their circles, he had sent important French intellectuals offprints of a piece he had just published (May 1936) in French in the exile edition of the Frankfurt School review. It was probably in this way that Malraux got hold of Benjamin's "Work of Art in the Age of Mechanical Reproduction." [31]

Reading it suddenly clicked into sharp focus Malraux's own new vision of the rapport of art and society. He seized on Benjamin's sweeping analysis. For Malraux it decoded his own life, an itinerary to that point guided, if the word does not suggest too much coherence, by instinct. He had first used the phrase "aestheticization of war" and some other key Benjaminian ideas in a talk he gave on "cultural heritage" in London a few weeks after the Benjamin piece came out (21 June). There he had sounded the basic themes of his sense of the meaning of art in the human story.

> The important thing was to possess the world of solitude, to transform it into a conquest for the artist, into the illusion of a conquest for the spectator, one freely accepted. . . .
> Art exists for its role of permitting men to escape their human condition, not by fleeing it, but by possessing it. All art is a means of taking hold of human destiny. And the cultural heritage is not the ensemble of works which men ought to respect, but of those which can aid them to live.[32]

Malraux's intellectual life was like a whirling pinwheel of incandescent thoughts. People who met him often commented on his ability to range with scintillating insights from topic to topic until the listener was exhausted. But Malraux held to just a few enduring ideas. We see the red thread of Benjamin's auratic theme woven into his subsequent political-cultural odyssey, and even in his memoranda to his staff when he became minister of culture. Let us take a closer look at the speech he made in London.

With his usual oblique brilliance, Benjamin had begun his discussion of contemporary culture in prehistory, with the assertion that making and

showing art arose in the context of community and ritual. For participants in the culture, the Gemeinschaftlich and spiritual setting gave the artwork its meaning, its satisfactions, and, as a creation of ritual, both its personal immediacy and at the same time its awesome majesty. He called that effect of immediacy/distance the work's "aura." In our secular age, art has lost that aura which the windows of the Saint-Chapelle in Paris, for example, had for a thirteenth-century Christian. But still today, we all can admire their fineness, richness of color, and glorious translucence. We both are drawn to them and stand in awe before them as a unique cultural creation.

But in the age of modernism, where art no longer has a context or content other than other art, the aura originates rather in the special rapport between what *live* artists do and the impact of their work on the feelings of members of the audience at the moment of performance, viewing, or creation. This is not community; it is only a moment of communion. And with mechanical reproduction—records, radio, photographs of artworks—even this kind of aura is lost. In the case of cinema, there is not even an original work of art to be *reproduced*.

Attempts to recreate an auratic art in our times, Benjamin concluded, had laid claim to a false community, lying unanimity, coercive harmony. This is the art of Nazi and Fascist rallies and parades, ceremonies and political symbols. Such false artists pretended to return to a true community when only Gesellschaft, and a damaged society at that, was possible. The *political* content of this art had to be exposed, in Benjamin's view, to unmask the cruelty hidden by the aesthetic.

Malraux's speech, which he published later in 1936 in *Commune*, the Communist literary magazine, echoed Benjamin's vision. "No one believes that reading a chanson de geste is the same as hearing a bard reciting it. . . . The finality [*le destin*] of art comes from the unique masterpiece, irreplaceable. [It is] diminished by its reproduction." Contemporary art cannot be given back its aura by an artificial connection to the Volk or the masses. Malraux would not defend "the old chimera" of art guided by the masses and submitted to them for approval, much less fascist art's fictional ties to the people's community (Volksgemeinschaft). Nor was he expressing nostalgia for a lost tradition of pious aestheticism. Rather, he wanted to tie the present to the past in a unique way: each art innovation of our day, he said, modifies the whole of the past heritage of the *civilisation* in which it is done. Deliberating echoing Ernest Renan's definition of the French nation as a daily affirmation, Malraux equated the fate of an organic France with that of its art, "It is by a daily act of will that a civilization gives to its past its particular form, much as by each brushstroke the painter changes the whole painting."

Art comes from, and belongs to, all of humanity in all its varied and dialectical manifestations. This both socialists and liberals understand. But Fascism and National Socialism, on the contrary, employ categories such as

"race" and" nation," positing essential differences, divisions, in humankind. The communion fascists seek can be realized only in a military order. "And fascist art, if such a thing exists, aestheticizes war." [33]

But here Malraux set off in his own direction. Benjamin's response to fascist aestheticization of politics was to call, at the end of his essay, for the politicization of art. He admired Brecht's plays and poems for doing just that. When Benjamin had arrived in Paris he had sought out the Surrealists, who in their own provocative way, were also working to unmask the social and political values that the bourgeoisie hid behind the aestheticized façade of high art. Paradoxically, Malraux proposed both a more existential-philosophical solution to the art/life conundrum and yet a more instrumental one. He imagined a kind of aesthetic immortality: we may die, but the great art we create continues and deepens the humanity of all past and future generations. He wanted all that made up *"le destin"*—a word he used to mean, depending on the context, all determinisms, all limits, fate, finally death—"transformed into human consciousness, awareness."

In this existential formulation of 1936, we already see his emergent vision of the importance of art for both the present and the future of humanity: art was the highest expression of the human, a liberation from the limits of the human condition. Once understood—*mastered* might better render his thought—we may use these limits, now no longer immobilizing us with a sense of our impotence, to become more human, to enrich the human enterprise. "For every great idea, every work of art, offers us infinite possibilities of reincarnation."

But how to carry out such a vast transvaluation? Here Malraux marked out his path for the rest of his life, one he stayed on honestly and honorably despite his transfiguration from militant Communist ally to fervent Gaullist loyalist. Toward the end of his meditation on the theme of the aura, he called for a new "idea, a new state structure, a heritage, and a new hope." Behind these abstractions, for him, stood Indochinese liberation, justice for workers, saving Spanish democracy, and not least, the cultural renewal of the French nation. In 1936, in the midst of the Popular Front in France and the civil war in Spain, he meant the triumph of a Communist state. Later, during the Resistance, the state began to mean to him something like the unity of the French people against foreign occupiers. But early in the war he had given up his hopes for political Communism. He judged that the world had changed. The Soviet Union was not endangered, but rather was a cause of danger to its neighbors. France needed another state which might restore the lost aura of the culture of the nation. Paradoxically, reading the Jewish mystic-Communist Benjamin put Malraux on the road where he would meet the nationalist-mystic Catholic Charles de Gaulle.

4 *Malraux and France as Works of Art*

On his return from Spain in 1937, Malraux mined both his own experiences and the war dispatches of his friend from *Paris-Soir*, Louis Delaprée, to write his last great novel, *L'espoir* (trans. *Man's Hope*). The next year with the encouragement of Spanish friends, the cooperation of the Barcelona government, and above all the warm memory of time spent with Sergei Eisenstein on his Russian trip, he began shooting a scenario based on selected episodes from the novel. The filming started in Catalonia (figure 20). But with the collapse of the Republican front, Malraux and his crew had to finish the film in southwestern France. He first called the film, completed in 1939, *Sierra de Teruel*. With a musical score by Darius Milhaud, it was shown in August in Paris at the movie house Le Paris on the Champs-Elysées with President Juan Negrin of the exiled Spanish Republican government in the audience. It was scheduled to be released commercially in September. But the introduction of censorship and the film's banning by Premier Edouard Daladier killed its distribution. Daladier had been once an ally in the Popular Front, but now he did not wish further to sour relations with the victorious Franco. The film, cut in length and renamed *l'Espoir*, was shown again only after the Liberation. Attendance then was large, and the audiences were fervid. I have seen it; it is a remarkably moving and well-made film.[1]

Taking advantage of a quiet moment in his life, Malraux was working on his much-postponed *Psychologie de l'art* in a pleasant hotel in Beaulieu-sur-Dordogne in the Corrèze when news came that Germany had invaded Poland. War. He and Josette Clotis returned immediately to Paris. The French airforce judged his previous military experience insufficient to enlist him. He thought of joining the Polish army. But instead, now nearly forty years old, he volunteered for service with a tank unit, the military arm in which his, father, now dead, had once served. His hero T. E. Lawrence had volunteered

Figure 20. Malraux directing the filming of *l'Espoir*. Film Still Archives, Museum of Modern Art, New York.

to fight in the ranks. Tanks were the land-warfare unit of the future. Charles de Gaulle was a tank officer; in the interwar years he had gotten into trouble with his superiors for too-zealous advocacy of building up this military branch. But Malraux hadn't yet heard of the career soldier.

Nor had the French had perfected the weapon. Unfortunately, this was the French army of 1940. The tanks in Malraux's unit were unfit for combat owing to lack of proper maintenance. The outfit fought the German invaders on foot. Malraux was slightly wounded, and on 16 June 1940 between Provins and Sens, not far from Paris, he was taken prisoner.[2] After some months in internment, Malraux in October used the opportunity afforded him and some other prisoners to help with the harvest in a village near their prison-camp to escape.

After considering and abandoning a plan to reach North Africa to continue fighting, Malraux wrote from southern France to General de Gaulle, at that

moment organizing his efforts in London, to offer his services. Perhaps the Free French airforce could use him. Receiving no response, he assumed that de Gaulle had snubbed him because of his left political engagements. In fact, the message never got through. Caught in a German police sweep, the courier had swallowed it to avoid arrest. Yet all through the war years, Malraux, being Malraux, nurtured a sense of resentment against de Gaulle over this apparent rejection.[3]

Meanwhile, he stayed in the south, first with the Clotis family and then in a comfortable house on Cap d'Ail, near Nice. Boris Vildé of the Musée de l'Homme Resistance group urged him to join them. In 1941 Jean-Paul Sartre, accompanied by Gide, came from Paris to recruit him to a group Sartre called Socialisme et Liberté.[4] But Malraux refused to take part in these and other Resistance efforts proposed to him. Rather, between 1940 and 1942 he devoted himself to his writing.

Malraux worked on three manuscripts in those two years of living in the unoccupied zone. He drafted some chapters of a novel based on his war and internment experiences, *La lutte avec l'ange*. These first chapters he called *Les noyers de l'Altenburg* and they are the only part of the book manuscript to survive the war. In mid-1942 he started a book on T. E. Lawrence, which he titled *Le démon de l'absolu*. And, as best he could without books, museums, and his conversation partners, he tried to work on his long-deferred study *La psychologie de l'art*.

The subjects and themes of these three books formed the trinity which would inspire the reborn Malraux of the postwar years. *The Walnut Trees of Altenburg* was the last novel he would write. In it he tells a not very deeply veiled story of the idealist Victor Berger's (Malraux's) disenchantment with Ottomanism (Soviet Communism) and its ruthless leader Enver (Stalin). The Lawrence book was, of course, a celebration of a Nietzschean Superman, an expression of Malraux's belief that only elite individuals (like Lawrence and who else?) could change the world. He introduced the same idea into a kind of Platonic dialogue he staged early in *The Walnut Trees of Altenburg*. And with the third book, art and writing about art replaced the epic novel in his search for the eternal and the universal.[5]

When in 1942 the Germans occupied the regions of the south and southwest they initially had left to the control of their Vichy collaborators, Malraux moved with Josette and their son, Gauthier (born while he was interned), to the relatively unpopulated Corrèze. There ensconced in a pretty chateau, he continued to write.

In 1943 their second son, Vincent, was born. Josette and André still were not married. From 1936 to the French defeat Clara had refused to divorce André. Now during the German occupation, mindful of her safety, he thought better of going through the legal system to obtain a divorce from his German-Jewish wife.

Colonel Berger

In late March 1944, assuming his rank from his days as a Spanish officer, and a nom de guerre from the hero of his *Noyers de l'Altenburg*, Malraux moved to the nearby Dordogne and joined the maquis operating there. It is not entirely clear why at this moment he turned from his writing to do battle with fascism once again. Perhaps it was the recent capture by the Gestapo of his half-brother, Roland, who had been active in the Resistance. Perhaps he anticipated the coming Allied invasion and wanted to do his part, now that it might count for something. Or perhaps his writing was not going well.

In any case, as was his habit, he created a new persona to take charge of the new situation: Colonel Berger quickly made himself head of a loose coalition of Communist, Gaullist, and British-run Resistance groups. He did this with his usual remarkable melange of competence, style, and charlatanry. He got himself up in his idea of a colonel's uniform, and smoking *English* cigarettes, he visited maquis units and demanded ceremonial review of their troops. He met with leaders of existing groups, handed around his cigarettes, and, apparently, knowledgeably, discussed manpower, strategies, supplies, and what "the guys" (*les gars*) in London were thinking. He declared wherever he was staying "the Interallied Command Post," a totally fictional entity, but one full of import and promise for the southwestern Resistance after the June 1944 Allied Normandy invasion (figure 21).[6]

In 1944, after the Germans had discovered the hiding place of some of the maquis's precious weapons, Malraux decided to check the security of secret weapons depots. In his *Antimémoires* even this mundane inspection tour receives the Malrucian eternalizing auratic reading. Some machine guns were stored deep in a cave discovered before the war by teenagers in Font-de-Gaume in the Dordogne. To get to the arms the Resistance fighters had to pass wondrous images of prehistoric animals drawn on the walls of the caverns located near the small village of Lascaux. Yes, the famous Lascaux. Here is how Malraux described the experience:

> The guides stopped. The beams of all the lights converged on a pile of boxes lying on red and blue parachutes spread out on the ground. Suggestive of two animals of some future era, a pair of machine guns on their tripods, like Egyptian cats on their forepaws, kept watch over them. On the ceiling, clearly visible . . . immense horned animals.
>
> This place had undoubtedly been sacred, and still was, not only because of the spirit of the caverns, but also because an inexplicable bond united these bison, these bulls, these horses . . . and these munition boxes, which seemed to have come here of their own accord, and which were guarded by these machine guns pointing at us. . . . The man next to me lifted the lid of a case of ammunition, and the flashlight which he put down cast an enormous shadow on the

Figure 21. As Colonel Berger of the Resistance of the southwest. Keystone-Sygma.

ceiling. Doubtless, the shadows of bison hunters cast by the flame of their resin torches had been the shadows of giants long ago.[7]

The sacredness of this place, the sacredness of their resistance, men bearing arms in touch with the sacred—he described this scene as a ritual, one performed over and over again in France from the prehistoric to the present.

Even when on 22 July Colonel Berger was wounded and captured by German soldiers—he was in uniform in a car carrying a Free French insignia, and traveling openly on a major highway, the N 677—he did not lose his audacity. After a faked execution ritual had been staged to frighten him, he was interrogated by a German enlisted man. Who was he? " 'Lieutenant-Colonel Malraux, called Colonel Berger,' replied the prisoner. 'I'm the military commander of this region.' What was the civilian profession of this unlikely soldier? 'Professor and writer. I have lectured at your universities. At Marburg, Leipzig, and Berlin.' 'Professor,' sounded serious." The soldier took him off to await interrogation by his superiors.[8]

When he was questioned further by the Gestapo in a Toulouse prison, the session ended in confusion. Paris had sent the dossier of his brother, Roland, by mistake; he was returned to his cell while the captors tried to figure out who they had. His fellow prisoners, at least those in nearby cells, learned who he was. But before he could be questioned again or tortured like many of the other prisoners, the fleeing Germans abandoned the city, and the prison. The captives broke out of their cells and milled about in the halls and assembly areas. Those who knew the man in uniform—unlike any other prisoner, he had been allowed to retain his—shouted "Berger in command! Berger! Berger!"[9] Even in prison and using a false name, Malraux was recognized as a leader. Of course, the hero of this incident is our only witness, and the trope of the hidden man of worth recognized—as Joan of Arc recognized the disguised king of France in a crowd of nobles—is an old one in epic literature. But, who knows, maybe the trope exists because such things happen. . . .

Or perhaps such fictions drive real history. Soon after the Toulouse jailbreak, with Malraux in liberated Paris rejoining his family and friends, the German commander in Brive in the Dordogne signed an instrument of surrender with Malraux's second-in-command, a professional soldier, Pierre Jacquot. Jacquot made it clear to the German officer, and had the surrender document drafted accordingly, that he was acting in behalf of Colonel Berger, head of the "Interallied Command of the Périgord-Corrèze-Lot Zone."[10]

This same Jacquot involved Malraux in his final wartime adventure. Many hundreds of men from Alsace and Lorraine were in the Resistance, or just in hiding, in the Dordogne area in the last days of the war. Some of their leaders hatched the idea of creating a unit to push to the east and liberate their *patrie*, which was still under German control. Perhaps with the war ending, Alsatians, whom the Germans had systematically drafted into their army, were especially eager to demonstrate their French patriotism. Bernard Metz,

a doctor and Resistance activist in Villeurbanne (and a great admirer of *L'espoir*), Pierre Bockel, a priest who had much appreciated *La condition humaine*, and Antoine Diener-Ancel, a schoolteacher who had served with Malraux-Berger in the southwest, decided to offer the leadership of the Brigade Alsace-Lorraine to Colonel Berger.[11] The Louvre's director, André Chamson, was in the south making sure the Paris art treasures sent there remained safely hidden. In mid-August he had several hundred men under his command, assembled by order of General de Lattre de Tassigny. Chamson offered to add his troops to those André Malraux now commanded.[12]

At the end of September 1944 in Besançon, the 2,000-strong Brigade Alsace-Lorraine was armed, formed into three battalions, and ready for battle. Actually, only a minority of the volunteers were from the occupied provinces; most had been recruited in the southwest and were accordingly natives of Périgord and the Garonne. Only the third battalion had many men from Alsace and Lorraine, and in even in this unit they were outnumbered by Savoyards.

The brigade was sent immediately into battle in the Vosges mountains, historically the sometime barrier, sometime gateway to Alsace. They did some hard fighting and sustained significant loses. They fought for and took Dannemarie in late November. Soon after that they entered Strasbourg. Malraux put his friend Pierre Bockel in charge of the cathedral and reopened it for religious services. The brigade participated bravely in defending the city against the German counterattack—known in the United States as the Battle of the Bulge—in late December and early January. In March 1945, having liberated Colmar and Sainte-Odile the previous month, the brigade ended its march to the east in Stuttgart. At its disbandment on German soil, General Lattre de Tassigny decorated Malraux and his men for their part in the liberation of the national territory of France.

1945

With the coming of peace France had to find a government. Defeat and shame had discredited both the Third Republic in 1940 and l'Etat Français of Marshal Pétain in 1944. It was a moment of creation, and creation at this juncture in French history was closely linked to fiction. A new France had to be imagined. Two epic narratives met and melded in the task. How did the man who was the disembodied radio-voice of a fictional Free France (what territories did it represent?) unite with the Promethean-Nietzschean artist-soldier that Malraux had made of himself?

First, Malraux's path to de Gaulle: In 1945 he was finally ready to break openly with the Communists. Of course, in the interwar years Malraux had never joined the PCF; he had never put himself under their discipline. In the Resistance he had chosen to associate himself with the Gaullist and British-

run groups rather than with the Communist FTP-Front National units. Yet he had never spoken critically of the PCF in public, nor of Stalin, nor even of the Hitler-Stalin Pact of 1939. If we do not count the coded *Walnut Trees of Altenburg*, the public break came only during the first Congress of the Mouvement de Libération Nationale (MLN), which opened in the Mutualité in Paris on 25 January 1945.

In some ways, this meeting became a trial constitutional convention for the new France. For the two thousand delegates representing perhaps a million political activists, were divided between those who favored the Communist-supported resolution to fold the MLN into the Communists' front organization, the Front National, and those who wanted perhaps a country fit for its workers, but not a Communist France. Finally, on the third and last day, Malraux, back from the eastern front, still in uniform, wearing riding boots, rose to cast his spell.

"The MLN is a conscience for this country," he began. However, immediately he went on to declare, "General de Gaulle's government is not only the government of France, but that of the Liberation and of the Resistance." So much for any fantasies of joint power on the part of the Communists, as in the first few months of the Russian Revolution. Malraux came down against the idea of fusion, and in effect discounting the vast amount of moral capital the Communists had accumulated during the war, he called for a "new Resistance."

The congress voted overwhelmingly not to support the fusion of the MLN with the Front National.[13] Malraux's ties and friendships within the PCF ended with that vote. As he explained his own sense of the meaning of his move many years later (October 1968) in an interview he gave the left-leaning *Nouvel Observateur*, "I replaced the proletariat with France."[14]

By means of the new postwar political necromancy, in which the pronunciation of the magic word "totalitarianism" transformed anti-fascists into anti-Communists and former enemies into friends, all understood that his "new Resistance" was aimed at the PCF at home (replacing Vichy) and Stalin's expansionist Soviet Union (replacing Germany). In the postwar years, too, there was born yet another Malraux in the new Fourth Republic.

How did Charles de Gaulle find Malraux? Apparently, neither of these two proud and famous men could imagine presenting himself to the other uninvited. And Malraux, despite his respect for de Gaulle's politics, still nursed a wound to his pride from the war years. In his *Antimémoires* he tells of the meeting as a result of manipulation by their mutual friends and admirers. Briefly, in March 1945 an old aviator friend of Malraux, Edouard Corniglion-Molinier, now an airforce general in de Gaulle's inner circle, introduced Malraux to the general's close adviser, Gaston Palewski, and the General's aide, Captain Claude Guy. At dinner at Palewski's soon after, Malraux impressed everyone with his knowledge of Asian political affairs, in particular his talk of Ho Chi Minh, a figure still largely unknown to most

French politicians, but already—again, really—a threat to France's weakened grip on its colonial empire in Indochina. One summer night, Palewski showed up at Malraux's door to ask/tell him, "In the name of France, General de Gaulle asks of you if you are prepared to aid him." Several years late, but publicly renewed at the MLN Congress earlier that year, Malraux's wartime offer of aid to de Gaulle seemed finally to have gotten through.

Malraux was driven to meet the General. The conversation with de Gaulle rambled around French history from the Revolution to the contemporary political situation, as Malraux recounted it some twenty years after the event in his *Antimémoires*. Neither man mentioned the arts or culture. De Gaulle was more interested in discovering if this recent friend of Communists was what the General called "national." Yes, Malraux confirmed that, above all, he had "wedded" France. And de Gaulle showed himself to the Nietzschean writer as a Superman capable of battling the most powerful—including Stalin—in behalf of France.[15]

Clearly de Gaulle could lead the political and economic rebirth of the nation. But Malraux was asking himself whether the General was capable also of empowering the cultural renewal of France, Seeing before him an incarnation of a Nietzschean transvaluator of values, Malraux trusted so. Both men passed the job interview.

In a modern variation on a very old French theme, the arts went into the employ of the state. The modern version was a bit more ethereal than the seventeenth-century one: France's greatest *literary* myth went into the service of the nation's greatest *political* one. Perhaps Benjamin had been wrong; perhaps the aura could be revived both in the mystique of the nation and in the spell of culture—short of fascism.

On 6 November 1945, in his new capacity as de Gaulle's "technical adviser" (on questions of airplanes? military tactics? colonialism? Cubism?), Malraux attended his first meeting of the provisional government's cabinet. Some days later the Chamber voted to ask de Gaulle to form a government that would include the major parties: Gaullists, Socialists, and Communists. On 21 November the new government was constituted. André Malraux took up his first political charge; de Gaulle had named him minister of information—his spokesperson, keeper of his myth. Pierre Viansson-Ponté, writer for *Le Monde*, meant no disrespect when he labeled Malraux "Minister of the Word."[16]

The reality of politics, however, was less grand. Malraux's main job was to put out the press release after the meetings of the cabinet. His other task was to distribute newsprint, in short supply, to the revived press. But de Gaulle was quite able to manage his own myth. The post, in principle giving Malraux great power over the French journalism, didn't interest him; he delegated it to a subordinate. In any case de Gaulle soon resigned, and his cabinet with him. It was a political move calculated to increase his power, but the

gamble failed. For the moment France could do without him. He sat down at his desk in Colombey-les-deux-Eglises to write his memoirs, and to wait.

Malraux, too, went back to his books. He moved to Boulogne-sur-Seine to live with his new wife, Madeleine Lioux, his half-brother Roland's widow. Personally, the last few years had cost Malraux dearly. While she was on a trip to Paris just after the war ended, Josette had been killed in a railway accident in the south. Both his half-brothers had died in the war, one in the Resistance, at the hands of the Gestapo; the other on a prison ship mistakenly bombed by Allied planes. In 1948 the two survivors, Madeleine and he, married.

Crossing the Desert

Neither of these self-created mythic beings, De Gaulle or Malraux, had given up the will to power. In the years 1946–47 the French political situation was still fluid, not to say confused. De Gaulle planned his return, leaving open the question of whether he intended to gain power legally or by other means. And Malraux continued to meet regularly with both Gaullist intellectuals, the most notable of whom were Raymond Aron and Jacques Soustelle, and the Gaullist "barons," such as Gaston Palewski, Christian Fouchet, Jacques Chaban-Delmas, Roger Frey, and the *dauphin*, Georges Pompidou. The proclamation of the Fourth Republic forced the hand of the Gaullists: for the moment, they would follow the parliamentary route rather than attempting to be Napoleons.

Malraux did not want to be isolated as one of the few literary intellectuals drawn to Gaullism. Of France's other well-known writers, only François Mauriac had rallied to the General. In that moment of the apogee of the French intellectual, the hostility of that tribe could be politically costly—because intellectually embarrassing—in public life.

Arthur Koestler tells of a meeting he set up in the spring of 1947 to which he invited Simone de Beauvoir, Jean-Paul Sartre, and Albert Camus. These were to speak with Malraux, perhaps to compose the political-intellectual differences which had opened between him and his former left literary comrades. The discussion, Koestler hoped, would give Malraux an opportunity to make them, too, understand France's need for a new movement of public safety and new Resistance—against the Communists now. But the conversation did not start off well. "'The proletariat . . . ' began Camus." [17] Malraux blew up. He would not listen to these undefined words being tossed about. The meeting went downhill from there. Sartre in his turn got angry. Disaster. No writers were won to Gaullism that day—or in many later days of the movement.

When in April 1947, standing on the balcony of the city hall of Strasbourg,

de Gaulle announced the creation of Rassemblement du Peuple Français (RPF), Malraux was just behind the general, next to Jacques Soustelle, sometime minister of information himself and an anthropologist of standing. Malraux was to be de Gaulle's public relations expert, or, in the language of the RPF, "délégué à la propagande." The inner circle of the new party came from the traditional French right of the grande bourgeoisie. The electorate, or at least the political base targeted, Malraux characterized in a pithy phrase: "the RPF, that's the metro." He meant white-collar employees and clerical and some manual workers, in brief, the old and new middle classes of France.[18]

The party propaganda, as Malraux organized it, gave off echoes of the mass movements of the 1920s and 1930s. The magazines and reviews he tried to launch were successful neither intellectually nor in circulation figures. But, the head of Gaullist propaganda proved himself a master at staging the great savior of France. All his own sense of drama, plus what he had learned about orchestrating great French spectacles from the Communists and perhaps also from the Fascists and National Socialists, he employed to produce the public appearances of Charles de Gaulle—lights, flags, balconies, short powerful slogans, all very well done, all a bit too familiar, disquieting to many observers. These Gaullist celebrations were for Malraux a part of the national-political solution to the challenge of reviving the aura in the age of industrialism.

It would be an error, however, to confuse Gaullist means and the movement's goals. Indeed, there were echoes of fascist mobilization in the Gaullist campaign years, as there would be echoes of the Popular Front in the policies of Fifth Republic Gaullism. Yet taking certain ideas from the right and the left, an eclecticism of means, we will see, was characteristic of Gaullist political culture, and of French culture as understood by the Gaullist André Malraux. This style of political ingathering made sense given the heterogeneous nature of the Gaullist movement.

The affinities of the propaganda of the years out of power, to rightist mobilization stemmed from Gaullism's having to face a problem of political communication not dissimilar to those faced by both Mussolini and Hitler. Like Hitler, for example, the Gaullists were without networks of affinity groups, closely connected factory-based trade unions, or neighborhood or town political organizations like the SPD and KPD in Germany, or the SFIO in southern France and the PCF in the factories and suburban red belt around Paris. The networks of the left were well established and dense both at the workplaces and in worker and peasant communities. Rallies, the sophisticated use of media, referenda—moments of political excitation and unity of will—replaced in popular Gaullism the organizational forms that could not work with its highly individualistic, scattered, and cross-class constituency. In the conception of its leaders, Gaullism was an effort to arouse the French people to face up to the crisis of the French nation; it was a new

committee of public safety. Even the use of the word *Rassemblement*—they wanted to avoid "party"—suggests a rallying around, not a bureaucratic vote-producing machine. In French it also suggests a military parade, with a leader reviewing the marchers as they pass, or perhaps marching at the front. Gaullist organization, political work, and propaganda in the parliamentary democracy of the Fourth Republic were constituted to seize the day in a bold media-informed gesture when the short-sighted parliamentarians once again brought the nation into danger, as they surely would.[19] Although it was not to Malraux's taste, nevertheless, de Gaulle and his companions began first by playing the parliamentary game fairly and energetically. (Malraux never in his life ran for, or served in, an elective office. He may have been a leftist, but was never a democrat.)

Between 1947 and 1953, however, if democracy in France did not work well, it nevertheless neither collapsed nor brought many recruits to the Gaullists. Their popular vote in various elections—never reaching 50 percent in this period—fell steadily. Claiming a political impasse in France, de Gaulle decided to tip over the chess board in May 1953 by ending RPF participation in the debates of the National Assembly. He withdrew the party from future electoral contests. Democracy had failed the General.

The Museum without Walls . . . or Foundations

Malraux spent the years out of power writing about art. He had written his last novel. While living in the south during the Occupation, he had tried to make progress on his "psychology of art," but without museums and books the work went slowly. Then came the Resistance and postwar political engagement.

While serving as de Gaulle's minister of information in the immediate postwar period, he had initiated a project of photographing something like a hundred works of art with the intent to blanket the provinces with copies so that these masterpieces might be appreciated beyond Paris. Distribution of the first two had just begun when de Gaulle, and Malraux with him, left power.[20]

Now with de Gaulle out of office and the movement largely demobilized, Malraux could take some time to return to the much-put-off project of writing about art. *Les voix du silence* (trans. *The Voices of Silence*), the 1951 revised version of the three-volume *Psychologie de l'art* (1947), developed his most important art idea, the "Museum without Walls." (He used the phrase interchangeably with "the Imaginary Museum" in his later writings.) Sometimes Malraux meant by the Museum without Walls our collective (Western) memory of all the paintings and statues we have seen, cathedrals and temples we have visited, works of architecture we have admired. Sometimes he meant the photographs, or descriptions in books, of the arts of the world.

This imaginary museum was not, however, a jumbled mental catalog of masterpieces of the world's art. It was rather a French modernist vision— expressed in Malraux's usual mystifying and dramatic literary voice—of formalistic correspondences of the arts from different cultures. At a certain moment, for example, African forms begin to appear in Picasso's paintings, as in his famous *Demoiselles d'Avignon*. Malraux's idea was that because of the European painter's visual appropriations, we first began to *see* the magnificence of the African statues. Picasso, the Catalonian artist working in France, placed African art into Malraux's Imaginary Museum.

Malraux here and in subsequent writing on art was expanding France's historic mission as controlling trustee of the European art heritage to become the imagined trustee of the world's cultural treasures. "It is in terms of a world-wide order that we are sorting out, tentatively as yet, the successive resuscitations of the whole world's past that are filling the first Museum Without Walls." The statement is both multiculturalist and universalist, but is not about art appreciation. This is an act of appropriation of others' heritages, non-European others who need the French judge André Malraux to tell them what they had created was art. Recall his intimidating stroll with Jacqueline Kennedy through the National Gallery. Think of a Louvre without walls, and now because imagined, able to hold all the world's treasures. "With the result that a large share of our art heritage," Malraux wrote, "is now derived from peoples whose idea of art was quite other than ours, and even from peoples to whom the very idea of art meant nothing." [21]

Reading Oswald Spengler (or more likely having Clara, who bought the German edition on one of their trips to Berlin in the early 1920s, digest it for him) had taught Malraux to value living *cultures* over ossified *civilizations*. Equally important, Malraux took from the German's *Decline of the West* his (Malraux's) project of making from so many different, separate cultures a totalized aesthetic universe. Spengler had used the evidence of divergent arts traditions as proof of the impenetrability of one culture by another. For Spengler the uniqueness of the arts of each of the world's cultures was an important principle because its art represented, summarized, the culture. A culture's art was the prime clue in his hunt for national essences. Knowledge of the spirit of a way of life allowed Spengler to make judgments about whether it was a decadent *Civilization* or a young vibrant *Kultur*. [22]

In *The Voices of Silence*, Malraux asked rhetorically, "Why has the German theory of culture [meaning civilizations regarded as independent organisms that are born, live, and die] won so much favor?" Because it allowed Spengler to downgrade the importance of religion in the world's cultures, he answered, and it avoids the need to explain the survival of arts after the end of a civilization. But the origins of art in religion, and the transmutation of both in the nation, were important transvaluations for de Gaulle's future culture minister. In his response to Spengler we see the quintessential Malraux striding around the world in seven-league boots crafted of the bits and pieces

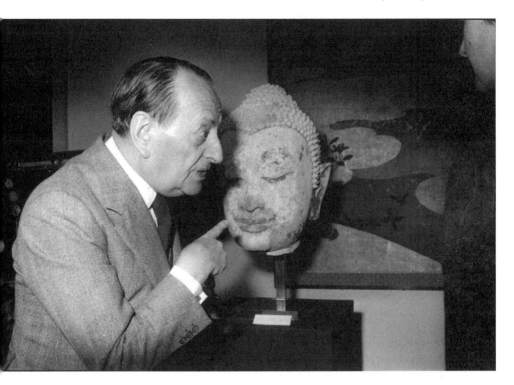

Figure 22. At the Biennale Internationale des Antiquaires, October 1974. Keystone-Sygma.

of his eclectic self-education (figure 22). "Though the Wei Bodhisattvas and those of Nara, Khmer, and Javanese sculpture and Sung painting do not express the same communion with the cosmos as does a Romanesque tympanum, a Dance of Siva or the horsemen of the Parthenon, all alike express a communion of one kind or another, and so does even Rubens in *The Kermesse.*" [23] So religion does matter; it is a point of commonality, until it disappears leaving only art to mark its passage.

In the introduction to his second most important statement on art from those years, *La métamorphose des dieux* (1954, trans. *The Metamorphosis of the Gods*), he repeated the views he had earlier expressed in *The Voices of Silence*. Again he took the world as his smallest unit of analysis, and he returned once more to Spengler's challenge to find unities in the worlds of culture. Malraux responded with a religious metaphor: "The many art worlds of the past were self-contained, mutually exclusive, as are religions; our modern art world is an Olympus where all the gods and all the civilizations welcome all who understand the language of art." [24] The religious content of the art of other cultures, and that of Europe for that matter, is transformed by Malraux's gaze into the sacrament of aesthetic modernism, the

idea that art does not copy nature but rather other art. The many are made one. God is a formalist of the international school to whom no art is alien. Ernst Gombrich has called Malraux's take on modernism "the distance from appearance." [25]

The theme learned from Benjamin connected the world's art to its religions for Malraux. All great works of religious art of the past "are, for the first time, united in a world in which the dying fetishes are given a new lease on life such as they never knew before; in a world where, also for the first time in history Time is vanquished by the images that human hands created to defy it." [26]

When we speak of museums, even ones without walls, we must ask about viewers. Where is this all-seeing eye that it can take in the world's art? Where must Malraux stand to see the arts of cultures on the other side of the globe or those dead many millennia? His implicit answer: France; more exactly, Paris—where else? [27]

In his *Tête d'obsidienne*, on his friend/enemy, Picasso, written in 1974 after he had left public life, Malraux repeated many of the themes of the earlier works. But he also gives us another bit of evidence of the role of art in the making of André Malraux. His books had characterized the special feature of modern art as not being representational in the realist sense. Yet, his own tastes did not run to abstract art. He wanted to see the body and, above all, faces, however altered or distorted. Malraux liked that bodies and faces were always there, somehow, in Picasso in all his periods. Picasso once told him that he was trying to paint the outside, not the true being behind it or some such impossible quest to capture essences, but the surface, the persona available to see, "the mask." [28] Picasso had long ago stopped drawing on African art for figures in his work; if he had meant *that* kind of mask, it was only a minor part of his thought. More likely he was expressing his harmonic resonance with the writer and former cultural minister. More or less consciously, each man, in his way, had confected a public self, a mask, that became the man.

The Fifth Republic, Made in Algeria

French colonialism had been central at crucial junctures of Malraux's life. We have seen how in the mid-1920s Indochina gave Malraux his first political experience, a world-view he would retain, and the stuff of two of his best novels. In the postwar years, it was once again the colonial world that tested Malraux and laminated another layer to the persona. During the immediate postwar period, rather shamefully for him, he went along with the Gaullist party's support for holding on to the empire and crushing the Indochinese insurgency.

While Gaullism was "crossing the desert," as Malraux characterized the

years between the Gaullist withdrawal from open politics in 1953 to the return to power in 1958, the colonial empire increasingly moved to center stage in French politics. Premier from July 1954 to January 1955, Pierre Mendès-France, moved like de Gaulle by a sense of crisis in French society, in the economy, and in relations with the colonies, tried in his democratic-socialist way to move the nation forward out of the political impasse. He successfully ended the colonial war in Indochina—after the French defeat in Dien Bien Phu, to be sure—with an honorable French withdrawal and the granting of independence. An off-duty Gaullist at the time, Malraux welcomed this act of decolonization.

But at the end of 1954 Algeria rebelled. Nearly a million European settlers (*pieds noirs*, Algerians called them, for their curious habit in that climate of wearing black shoes) lived there. It was completely integrated into the French economy. New, large, oil deposits had just been discovered under its sands. The three *départements* of Algeria were part of France. Deputies sat in the French legislature as representatives of the settlers. Algeria was not Indochina. There is no need to rehearse the ferocious and tragic war conducted by the French state against both the Algerian revolutionaries and its Arab and Berber people in the years after 1954.

Perhaps, as both French and foreign critics have charged, French intellectuals let the anti-Communist insurgents of Eastern Europe down in the 1950s and 1960s—although, to recall Stalin's definition of power, we should keep in mind that Sartre and his friends had even fewer divisions at their disposal than the pope and so could not have been much help. In any case, the misconduct of the French military in Algeria became the intellectuals' cause; most of them proved extremely principled in condemning both the war itself and the methods being used by the French "paras." They documented the torture of National Liberation Front prisoners. They fought the censorship of news items and books about the crimes of the French military. As political authority collapsed and was on the verge of being replaced by the more authoritarian Gaullist regime, the disaffection of French intellectuals with the brutal colonial anti-insurgency liquidated any remaining moral capital the Fourth Republic may have accumulated on the Left Bank.

Henri Alleg's 1958 book on the torture used by the paras in their interrogations, *La question*, was banned by the censor. (This censorship was to continue throughout the de Gaulle-Malraux years. Only in 1974 did conservative President Valéry Giscard-d'Estaing finally abolish it.) With Roger Martin du Gard, François Mauriac, and Jean-Paul Sartre, Malraux signed an open letter to René Coty, then president of the Republic, protesting the police's confiscation of Alleg's book. They demanded an investigation of its charges of brutal misconduct by the French pacifiers. In the name of the rights of man and of the citizen they condemned the use of torture by the French state. The letter was published in the French press on the 17th and 18th of April 1958.[29]

Had Malraux come back to the left? Since his Indochinese days, he had remained critical of the brutalities of French colonialism. In conversations with members of the Gaullist entourage, including Gaston Palewski, as early as 1945 he explained to them the inevitable fall of the old empire: "If you're looking for a way to keep Indochina. I have nothing to suggest, because you won't keep it." But added the future minister, "The only thing we can save is a kind of cultural empire, a domain of values." [30]

Nor did the General feel irrevocably loyalty to the colonial empire. It had been largely created by the discredited Third Republic, most of whose politicians—whom de Gaulle blamed for France's 1940 disaster—had been very proud of it. Even before decolonization he, like Malraux, looked beyond direct political control of the empire, to a greater Francophone cultural and economic *communauté*. He wanted to keep the colonies, if it were possible; they were a part of French grandeur. But when he was forced to, the General could drop them from the Gaullist *imaginaire*.

Was the manifest incapacity of the Fourth Republic to manage France's colonial empire the object lesson that the French people required to understand their need for the return of General de Gaulle? As the experience of colonialism introduced Malraux to politics, the Algerian colonial crisis brought him into government.

In May 1958 under heavy pressure from the insurgent *colons* and the threat of a generals' coup, the legislature of the Fourth Republic did call de Gaulle back to power. He went to Algeria and spoke to the settlers, who looked to him as their "national" savior. Thousands of them cheered him when in the Forum of Algiers he held up his hands and told them, "I have understood you." And then he ended the bloody Algerian impasse by accepting the sovereignty of the Arabs and Berbers. He maneuvered brilliantly between a metropolitan population wishing to cut their losses, calling it peace, and the *colons* and military wanting to stay on top in a French Algeria. He signed a peace accord, but kept the oil rights. But his most pressing reasons for making peace, finally, I think, were neither military nor economic, but rather cultural. The Algerian struggle, like all the other colonial risings, was a crucial piece of the prehistory of France's new cultural project.

Key to French willingness, finally, to concede independence to insurgent Algeria had to do with who the majority of Algerians were. Always the clear-headed realist even if he expressed himself sometimes in the language of Cyrano de Bergerac, de Gaulle realized the inclusion of Berbers and Arabs in the polity, making them all French citizens, was the only possible hope for keeping Algeria French. Understanding, in other words, that a viable peace meant that France had to accept about one hundred North African Muslim deputies sitting in Paris legislating for the people of metropolitan France, he opted to cut Algeria loose, to concede its independence from France. [31]

Why was this cultural, rather than a simple calculation that these deputies would not support Gaullism, or might act like the Irish delegation that

plagued British parliamentary politics with its demands and obstructions in the decades before World War I? When Alsace and Lorraine were returned to France in 1945, there was no talk of excessive German or Protestant influence coming into France. And many in France were deeply disappointed that the largely German-speaking Saarlanders voted to be West Germans, not French, at the end of the same war. Nor had the annexation of Nice and Savoy nearly a hundred years before been the occasion for French worries about too many Italians becoming French citizens and voters.

But Muslims were, and to some degree still are, seen by some French conservatives as very difficult to make French, perhaps—as Jean-Marie Le Pen says loudly in behalf of a silent minority—impossible to assimilate. Peasants into Frenchmen—after some generations—yes, of course. Spanish, Italians, Poles, and (today) Portuguese into Frenchmen, why not? But Arab Muslims into Frenchmen—ah, that sounded, and still sounds, hard to some French ears. Better they leave France than that France change to accept them, de Gaulle reasoned.[32]

The unity of French culture was tested in the wake of the Algerian war in another way as well, one that we need to appreciate to understand the urgency of developing an active ministry for culture in the days of the dying French empire. An important legacy of this decision were the more than a million *Europeans* who left Algeria for France in the wake of independence. These were certainly devoted—if a few of them possibly treasonous—French citizens. But this was the first time many of them, of Spanish, Greek, Italian, or Maltese ancestry, had been to metropolitan France, let alone lived there. Their France was Algeria, in important ways a new settlers' culture.[33] *They* needed assimilation to French culture too—but not in a way that would single them out institutionally, as, for example, Israel did with its new Jewish settlers. The Evian Agreement of 1962 ended the war and swelled the "return" of settlers, whose ancestors in many case had not come from France. A culture defined as truly *national* which they could assimilate to, invisibly, we could say, was the ingenious solution of the new cultural institution of government that de Gaulle created. Since 1959 Malraux had been at work in a new ministry trying to foster such a culture.

The young man who grew up above the grocery store in Bondy fashioned from the cultural materials available to him the brave, dashing, literary, André Malraux. But he did not learn how to act like a cultural minister either in Bondy or at bookdealers' stalls, or even at his writing desk. There are two important caveats about the making of a persona that historians must keep in mind. First, unlike the psychoanalytic model, which posits deep early-acquired character traits that manifest themselves in various ways throughout a lifetime, an individual's persona changes with different historical circumstances. Second, and by far more important, to understand Malraux's mask we must not be satisfied with others' stories of personal en-

counters, reports of his adventures, and his own writings. That may do for the biography of a writer—although I doubt it—but it is inadequate to understanding a public intellectual, a maker of cultural policies.

André Malraux, minister of cultural affairs, was made as much by the organizational structures of his departments, by the clauses of his annual budget, by his appearances before the National Assembly to justify his policies, and by the budgetary hearings of the Assembly's finance committee. Not that he was talented in all these realms. As we shall see, he was a lamentable administrator. The grilling by finance ministers, especially the mean-spirited Giscard d'Estaing, filled him with fear before and trembling after. The new setting required him to appropriate new materials to make the new persona. He and they fashioned "the minister" of the new public identity. Nevertheless, he was more than "the regime's bard," as Pierre Cabanne cruelly caricatured him.[34]

We now must see what the hero turned chief administrator wrought, and what the workings of the organization made of him.

5 *Ministering to the Culture*

1958. The hope of republican politicians, Algeria's European settlers, and the rebellious generals, General de Gaulle, had come back once more to save France from its follies. With him came the indispensable André Malraux. By bringing the Fourth Republic to the brink of civil war, the settlers and insurgent military officers in Algeria had ended the Gaullists' inner exile. Alarming those trying to save the republic nearly as much, the Communists demanded that guns be issued to the workers so that they might go the airports to repel putschist paratroopers. A rumor was about in metropolitan France that the paras were on their way from Algeria to impose a military dictatorship. The expiring legislature's naming the hero of the last resistance to lead the state followed the politics of the lesser evil, but in doing so, it completed the discrediting of France's Fourth Republic. De Gaulle wanted a new Fifth Republic which would give the president enormous powers. He wanted a seven-year term to exercise them. Once assuming office, he brilliantly outmaneuvered both the rebel generals and the angry *colons* who wanted to retain French control over Algeria, or as they insisted, to keep Algeria French.

The Algerian crisis, following hard on the loss of Indochina, had cleared a path and provided the means to create the Gaullist state. On the night of 1–2 June 1958, De Gaulle set up his new order. "André Malraux, writer," was listed as a member of the new government, but without specific responsibilities. Malraux had wanted a powerful post, Interior, perhaps, or responsibility for Algeria after the departure of Soustelle as its governor general.[1] But once again he was put in charge of Information. As with many literati, the stunning phrase or the compelling principle often triumphed in his public utterances over the obligatory double-talk, verbal misdirection, or just silence required of a government spokesperson. Recall that in April, just before the Gaullist legal coup, Malraux, together with Martin du Gard, Mauriac, and Sartre, had signed the letter denouncing torture by the paras in Algeria.[2] Only

Heaven knows, worried both the conservative and the judicious Gaullists, what further embarrassment that virtuoso tongue might cause the new regime from the platform the Information post gave him. The nervous Gaullists prevailed. On 7 July Jacques Soustelle, scholar and team player, replaced him at the Information position. But what to do with Malraux?

A Pillar of National Hope

DeGaulle understood that Soustelle would be more reliable as official spokesperson. But the novelist was needed. Except for François Mauriac what other literary intellectuals had rallied to the Gaullists? Françoise Sagan's support was, to say the least, a mixed blessing. The finest representatives of literary humanism were fiercely in opposition. And that was too much negative capital in France, where past governments had cringed at—had even been greatly weakened by—the verbal whippings of writers and artists. After Daumier caricatured Louis Philippe by drawing him to look like a pear, soon just seeing the drawing of a pear was enough to make people laugh at the Orleanist monarch. The plump pear fell in the revolution of 1848. And then Victor Hugo had fastened the humiliating label "Napoléon le Petit" onto the nephew of Napoléon le Grand.

De Gaulle's interest in having French letters represented in his government should not be understood as an attempt at decor, like Lyndon Johnson's inviting artists to the White House. Son of a teacher, Charles de Gaulle had deeply immersed himself in French literary culture. He was a man of public life and of action first, to be sure, but, as Jacques Rigaud, a later official of the Culture Ministry, put it, one "for whom literature was not a form of amusement or of escape, but rather something which resonated with combat and action, and finally, his means of transcendence."[3] Starting from the opposite place, from the realm of literature, Malraux had come to the same vision of the relation of life and art. And by 1958 the relation between the two, eleven years apart in age but companions for a dozen years in the political struggles of the postwar years, was, to employ André Holleaux's apt phrase, "somewhat feudal."[4]

In addition, more was at stake for de Gaulle than character formation through culture, what the Germans call *Bildung*. In a dark hour of the war, taking time from his military and political duties in Algiers to honor the sixtieth anniversary of the Alliance Française, de Gaulle had said he put his faith in "the two pillars of national hope" that will never give way. One was certainly the "blade of our sword" (*tronçon d'épée*), but the other was "French thought" (*la pensée française*).[5] Rhetorically, at least, de Gaulle, the career soldier, set culture equal to the sword as the hope for a reborn France.

On 8 January 1959, de Gaulle reconstituted his government. He called in the hardheaded technocrat Michel Debré to be the new premier. "It will

be useful for you to keep Malraux," de Gaulle told him. "Carve out a ministry for him, a regrouping of services, for example, something you could call 'Cultural Affairs.' Malraux will raise the profile [*relief*] of your government." [6] On 24 July the decree creating a new Ministry of Cultural Affairs was published.

But the real creation of the ministry was left in Malraux's hands. How was he to go about it? What should constitute a ministry of culture? To begin with, what was to be its purview? The national theaters and museums, surely; but regional culture? or the modern media? How should it be staffed? What was the right balance between preservation and innovation?

Malraux probably himself drafted the decree defining the new ministry's responsibilities. Its charge read in part: "The Ministry of Cultural Affairs has as its mission to make accessible humanity's greatest masterpieces, and especially those of France, to the greatest possible number of French people; to reach the largest possible audience with our cultural heritage, and to promote the creation of works of art and of the intellect which will further enrich it." [7] Thus initially he took up a task which might be best characterized as primarily museum administration. Make the masterpieces available to the people—the old cry of the Popular Front some twenty-five years before. Aid the French people to appreciate the great civilization into which they were born—again the unfulfilled agenda of the mid-1930s. Certainly, "largest possible audience" foresaw a passive relationship to culture for most of the population, but it also suggested that part of an expanded appreciative public might lie beyond the boundaries of France. Finally—or maybe better said, last—the new ministry was charged with "promoting" new works of art and intellect by French but also by foreign creators.

What was organized, or rather reorganized, in the portfolio of the new ministry and what was created, if anything? Was this an unplanned administrative reshuffle of a few agencies concerned with cultural matters or the express creation of an important new arm of the state in cultural life? The sociologist Geneviève Poujol, who has made the closest inquiry into the beginnings of Malraux's new ministry, leans toward the first description. [8] Nevertheless, despite improvisations in the beginning, more purpose was manifested—and needed—at that historical moment, I think, than the idea of drawing new lines on an organizational chart suggests. For one thing, immediately after Malraux left the Information post, but before he had been designated minister, the president named him his adviser for "carrying out various projects . . . in particular, those concerned with the growth and diffusion of French culture." [9] More important, there is evidence of some prior thinking at the highest levels of government about the needs of French culture, rather than just about a job for Malraux. On 10 September 1968, the austere and very deliberate new prime minister, Couve de Murville, presented the parliament with a five-year plan for his government's intended attention to "cultural growth." That it represented the beginnings of a systematic commitment

of the French state to the health of the *high culture as a whole*, one that in recent decades it has honored by often devoting 1 percent of its annual budget to expenditures in this area, is surely the most important fact about the founding of the new ministry.

Yet initially the state's taking on this new responsibility was neither obvious nor even certainly permanent. Malraux got only bits and pieces of French civilization to worry about. "Cultural Affairs? Oh, that's just the old Beaux Arts plus Malraux," was the wisecrack going around in political circles in 1959, even among some Gaullists. Others, more literary, preferred to call the new ministry, after *Le royaume farfelu*, Malraux's early novel about an irrational and unpredictable kingdom, *le ministère farfelu*. *Farfelu* is a word which friendly spirits could understand to mean "fanciful," or even "imaginative." But skeptics describing Malraux's new venture meant something closer to "bizarre" or "unreal."

A bit of history of the state's concern with cultural matters will clarify what was new and what was not, in the new ministry. In 1535, to further his plans to make France culturally the new Rome, François Ier created an office to oversee royal architectural and art treasures, the Surintendance des Bâtiments Royaux. Building on his work, Cardinal Richelieu created a system of royal academies to regulate the arts. The state commissioned works from the artists whose inclusion in the academy of their art made them licensed arts provisioners to the crown The Revolution abolished the system of royal academies. In the autumn of 1789, in the first moments of intoxication with a new liberty, Jacques-Louis David helped organize the artists of Paris in a self-governing "Commune des Arts." By 1793 its membership was so greatly expanded that its members renamed it the Société Républicaine des Arts. But from that year the task of overseeing art in the nation was entrusted first to the new Education Ministry and then in the Year III (1795) to a Ministry of the Interior. The new constitution of the Year III called for the creation of an *institut national*, a self-perpetuating arts governing body. In 1803 Napoleon organized the Institut into four divisions, one of which was Beaux Arts. Painting, sculpture, architecture, and music were all jumbled together under the rubric of beaux arts. With the return of the Bourbon monarchy in 1815, Napoleon's divisions were relabeled *Académies* in keeping with the attempt to renormalize the vocabulary of the old regime. More important, nonartists could now be named to the academies, attenuating the artists' fellowship of power with the admixture of government hacks. These academies conferred status on artists, in effect set the official arts styles, and dominated what the state bought and showed at the new institution of the Salon. As monarchies, empires, and republics succeeded one another, the title of the offices evolved, but the task of supervising the use and maintenance of the king or state's arts heritage remained the same.[10]

The modern genealogy of something like Malraux's office began in January 1870, when Napoleon III combined two offices of his Household, the

Directions des Bâtiments Civils and that of Sciences et Lettres, into a Ministry of Arts. His fall from power in September of that year led to the redispersal of these offices. In 1881, under the newly founded Third Republic, Premier Léon Gambetta appointed Antonin Proust head of a Ministry of Arts. Gambetta believed that the state's promotion of the arts would benefit French industry, which had been surpassed by the British and, as the recent war evidenced, by the Prussians as well. But Gambetta's government, too, fell, and with it went his Arts Ministry and the experiment of state-encouraged art, whether in the service of industry or just in that of the Salon.[11] Subsequent ministries of the bourgeois-dominated Third Republic showed little interest in formally restoring the state's historic position as arbiter of French arts production. Although subsequent regimes were deeply concerned with shaping the direction of French culture, neither the Popular Front nor Vichy added new centralized state organs to manage the national artistic heritage.[12]

Not until just after the Liberation, in November 1944, was a new Direction Générale des Arts et Lettres (DGAL) organized within the Ministry of Education. It was divided into offices concerned with the plastic arts, national museums, performing arts and music, state libraries, and literature. In April 1947 the parliament of the Fourth Republic briefly set up a Ministry of Youth, Arts and Letters. But the death of its energetic new head, Pierre Bourdon, in October sank the office. Its pieces were distributed to other ministries, and once again culture had neither an administrative entity nor a spokesperson.

We come now to 1959 and the Malraux project, when some of the pieces were moved again. Transferred from Education to Cultural Affairs was the Direction Générale des Arts et Lettres. The DGAL was responsible for the state museums and *le service de l'enseignement et de la production artistique* (the Beaux Arts school), and had a subdirector for theater and dance, and for music. In addition, the Direction of the Archives of France, and the Direction of Architecture were added to Malraux's portfolio. From the Ministry of Commerce and Industry the new ministry received the Centre National de la Cinématographie (CNC). So what Malraux began with was mostly the old fine-arts administration plus a jumble of other minor offices, most of them cut from the ample flesh of the Education Ministry.

Evidence of Things That Didn't Happen

In philosophical explorations we learn a great deal by studying the not-said and the not-done, *le non-dit et le non-fait*. Such a strategy is also valuable when we look at administrative history. Let us ask about this "culture" Malraux was to watch over, what offices were *not* given to the new administration? The new ministry's gaining control over the Bibliothèque Nationale, also certainly appropriate to its mandate, was checkmated by its imperious

head, Julien Cain, who wanted to maintain the ample freedom of action he had won from the Education Ministry.

Nor did Malraux get the Youth and Sports Service of the Education Ministry, which would have given him an institutional means to reach young people with his cultural project. The attempt at negotiating the transfer in 1959 failed for reasons not entirely clear. It appears that Debré wanted, here too, to keep Malraux's responsibilities, and opportunities, limited. We will come back to the implications of Malraux's failure to add this agency for cultural outreach when we look at his grand plan to build Houses of Culture all over France (Chapter 6).

To Malraux's regret Michel Debré also barred his annexing the Direction Générale des Affaires Culturelles et Techniques (DGACT), the cultural affairs and exchange arm of the Quai d'Orsay. At the founding of the ministry, as Debré rather disingenuously expressed it in his memoirs, "It seemed to me absolutely necessary to maintain unity of action in our foreign affairs. His [Malraux's] genius did not need these services [the DGACT] for him to affirm French culture beyond our borders." [13] Nevertheless, despite the weak formal ties, Malraux managed to work out a good liaison with the DGACT. And, as we will see, he did conduct his own personal international cultural policy.

The Education Ministry, surely by any standard central to preserving and passing on *la civilisation française*, remained out of Malraux's reach. It was too important and too administratively powerful to be given to a relatively untried administrator. Only after their intoxicating victory with its promise of a new France in 1981 did the Socialists place the two ministries together for the first time under Jack Lang. After the election of President Chirac, with conservative Gaullists forming the government, they were again separated and the Culture budget began to decline each year. Since the Socialist victory in May 1997, Catherine Trautmann, the Socialist minister of culture and communication and the government's spokesperson, deals with radio and television, but does not have the Education portfolio.

The exclusion of radio and television from Malraux's ministry appears most glaring, but need not surprise us when we think of 1959 Gaullist France. In fact, those decisions were overdetermined. In 1959 only about 9.3 percent of French households possessed television sets. By 1968 the number had risen to 61.9 percent, but by then the Gaullists were on their way out. [14] From 1959 to 1969 the Culture Ministry added only the new competencies it invented for itself, such as the Houses of Culture and the office to compile the first grand inventory of national treasures.

Like many of his educated contemporaries, de Gaulle did not associate the modern media with the best that had been thought and written in French civilization. For de Gaulle radio and television, both of which we know he played like the great political artist he was, were either just entertainment for the people or, more important, a platform for political speeches to the nation.

In any case, at the outset of the Fifth Republic French radio and TV stations were state-owned and state-managed, and their programming—especially the news—state-guided. Malraux had just been pushed out of the Information post; the Gaullist leaders saw no point in courting troubles by allowing him control of the electronic mass media, so important to the Gaullist style of political mobilization. Finally, de Gaulle regarded saving the print culture as the main task of his culture minister, not developing new media.

Perhaps because they were largely out of his reach, perhaps to give a rhetorical boost to his experiment in creating Houses of Culture, perhaps out of conviction—or some of all of the above—Malraux attacked many aspects of contemporary film, radio, and television. "We have invented the most monstrous factories of dreams humanity has ever known," he told his listeners at the inauguration of the Bourges House of Culture in April 1964. "If we wish to combat this most detestable cinema and television . . . it is necessary that all the young people of this town be brought into contact with things that matter at least as much as sex and blood." At the opening of the Amiens House of Culture in March 1966 he again denounced the manipulation by cultural profiteers of our deepest feelings about sex, blood, and death. He repeated his warning against the dream factories and added a denunciation of the "merchants of dreams" when he inaugurated the Maison Française at Oxford University in November 1967. Meanwhile, he made sure that the Houses of Culture would have cinema clubs which would show series of classic films.[15]

Nevertheless, despite the things that did not happen, the offices that were entrusted to Malraux multiplied and prospered. An organizational overview of the new ministry from 1959 to 1969 shows that, a healthy administrative newborn, it grew, taking on size, weight, and strength with the years. Three snapshots of its *organigramme*, as the French call an organizational chart, tell a bureaucratic success story. In 1959 two Directions (Architecture and Archives), and one super-agency, called a Direction Générale (Arts and Letters) reported to the minister. By early 1969 the number of Directions had grown to six with the addition of those of Theater and Houses of Culture, of the Museums of France, and of General Administration. The expanded archaeological service of the museum administration showed the new interest of France and the ministry in preserving the nation's prehistoric heritage.

In mid-1969, just before his departure, a last realignment in its constitution demonstrated that Malraux wanted the organization of the ministry he had built to signal a complete break from the old Beaux Arts, the house for the preservation of old treasures, and instead to show his commitment to a vital new national cultural life. The inherited Direction Générale des Arts et Lettres, still in many people's minds the "Beaux Arts," was dissolved. It was replaced by a new Direction de l'Action Culturelle. This branch had a research arm, regional offices, and systematic relations with the Youth and Sports service of the Education Ministry, the electronic media, and the cul-

tural exchange service of the Foreign Ministry. Plastic Arts was combined with Museums (which, technically, was thereby demoted) in a new Direction of Plastic Arts and Museums. Finally, performance arts, music, and letters were in turn combined into yet another Direction (figures 23–25).

African Genesis

Organization charts tell only part of the story of the structuring of the new ministry. Who sat at the desks and helped Malraux decide what French culture was, what it should be, and what was to be done to revitalize it? Staffing posed serious problems. In principle, with the offices and Directions should have come the personnel. Since most of the large administrative units Malraux inherited had been under the Ministry of Education, he should have gotten much of his staff by way of personnel transfers from that ministry. But compared with something as solid and rooted in republican ideology and institutional life as Education, Cultural Affairs seemed too improvised, too evanescent. Many Education administrators refused to move; they had that right. The new ministry was to be headed by a writer-adventurer who larded his impassioned speeches with metaphysical speculations about death and the transcendence of art, but who had no administrative experience unless the "Squadron André Malraux" and the Brigade Alsace-Lorraine were counted. In some ways more embarrassing for Malraux were the people who worked briefly for the new, unorganized, and at the same time, disorganized, ministry, and then cried "Ministère farfelu" and returned to their safe jobs and pensions in the Education bureaucracy. Nor did many volunteers prove willing to come from other parts of the government apparatus. No graduate of the top schools that trained civil servants, the *Grandes Ecoles*, joined the Culture Ministry in its first years. Graduates of the prestigious ENA, the National School of Administration, only began accepting positions in the ministry in 1967. Moreover, even if more transferred or newly graduated civil servants had wanted to join and to stay, it is organization-destiny that newly agglomerated offices in new settings always require additional people. Once established, the ministry would certainly grow. Where would the people come from?

Many thought the solution Malraux found to staffing was just another one of his adventures with a band of stalwarts. Once more the colonial empire, or rather now the empire in political dissolution, came to the aid of the mother country. In the years 1958–60 not only did Indochina win its independence but most of the French possessions in Africa voted to end French rule. Most of the *fonctionnaires* of the Colonial Service, France d'Outre-Mer (FOM), some 3,800 in number, suddenly found themselves downsized by nationalists in the colonies. As redundant civil servants, they had the right to take up employment in state service at equivalent ranks and positions if

Ministry of Culture 1959

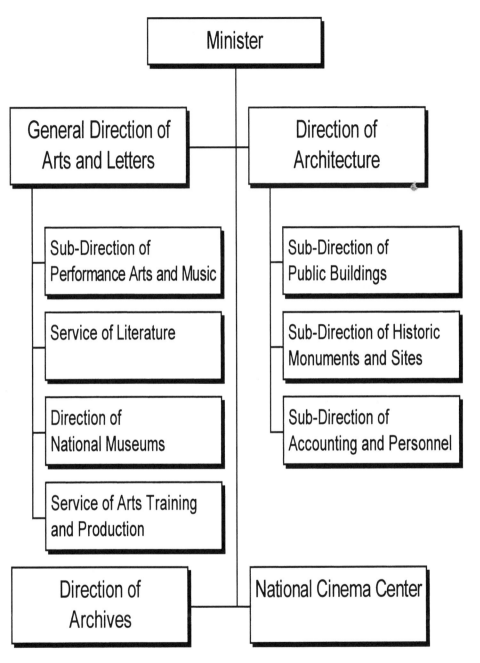

Figure 23. The organization of the Ministry of Cultural Affairs, 1959.
Source: Notes d'information du Ministère des Affaires Culturelles, 2ème trimestre, 1969. Cited in Geneviève Poujol, "Eléments pour la Recherche sur la Création du Ministère des Affaires Culturelles, 1959-1969," mimeographed (Paris: Ministry of Culture, December 1990).

Ministry of Culture 1969

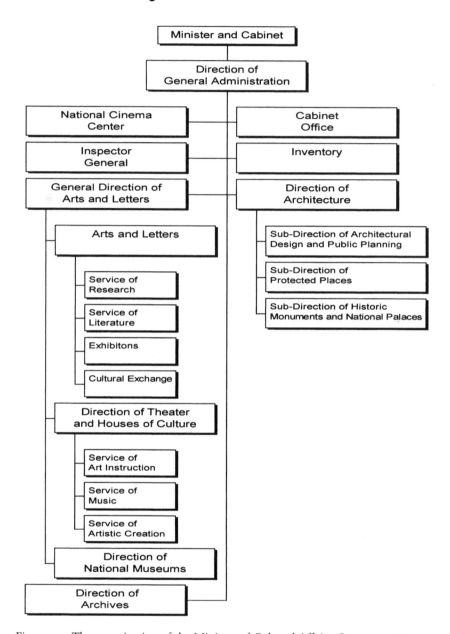

Figure 24. The organization of the Ministry of Cultural Affairs, January 1969. *Source*: Notes d'information du Ministère des Affaires Culturelles, 2ème trimestre, 1969. Cited in Geneviève Poujol, "Eléments pour la Recherche sur la Création du Ministère des Affaires Culturelles, 1959-1969," mimeographed (Paris: Ministry of Culture, December 1990).

Ministry of Culture April 1969

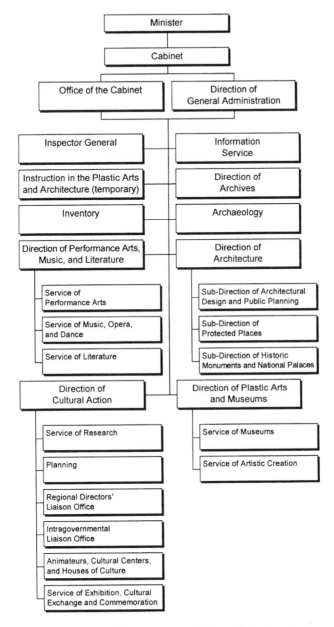

Figure 25. The organization of the Ministry of Cultural Affairs, April 1969..
Source: Notes d'information du Ministère des Affaires Culturelles, 2ème trimestre, 1969. Cited in Geneviève Poujol, "Eléments pour la Recherche sur la Création du Ministère des Affaires Culturelles, 1959-1969," mimeographed (Paris: Ministry of Culture, December 1990).

they could find openings. The new ministry needed staff, hands-on administrators, people good at coping in new situations with limited and perhaps unorthodox means.

Malraux had met a dynamic, blunt-spoken colonial officer on one of the man's trips back to Paris. Emile Biasini would be the right man, Malraux thought, to help expand the activities of the new agency.

What You Did with the Africans, Why Not Do It in France?

After completing his studies in the Ecole Nationale de la France d'Outre-Mer, the renamed Ecole Coloniale, Biasini had begun a successful career in the African colonial administration. His forte was traveling to the villages of his district to settle some local dispute or to end practices that disturbed the public order, and so to win the local people's admiration for French authority. In the last days of the Fourth Republic, Hubert Maga, who later would become the first president of the Republic of Dahomey, was serving as under-secretary of state for labor in the government of Félix Gaillard. The African-born cabinet officer contacted Biasini, then stationed in Brazzaville, and asked him to join him in Paris to become chief of staff of Maga's French administration. After the collapse of the Fourth Republic, Biasini stayed on in Paris to serve the provisional government of the Fifth Republic in the Ministry of France d'Outre-Mer. But soon he returned to Africa. The newly independent former colonies needed sympathetic French aides—de Gaulle had immediately and brutally pulled most French administrators from the states which voted for separation from France— and Biasini agreed to return to Africa for a short period to work for the new state in Chad.

While Biasini was completing his term aiding the transition to independence of the new African government, Malraux , who had met him on one of his trips back to France, invited the old Africa hand to join the new ministry as his adviser on a special project. Would Biasini be willing to set up a House of Culture in Fort Lamy, Chad—as Biasini later unself-consciously put it, "a center for [French] culture"? Fort Lamy would be a good place to reknot French-African ties; Félix Eboué, its governor in 1940, recall, had resolutely chosen to follow de Gaulle rather than Vichy. The government of the new African state would supply the land and the local labor. Le Corbusier agreed to design the building. The ministry would pay for the construction of the center.

To support his request for this special funding, Malraux went before Valéry Giscard d'Estaing, the hard-nosed, intimidating, and unsympathetic minister of finance. After Giscard had humiliated the inexperienced minister a bit, he authorized the asked-for sum. But the authorization was in African francs, Malraux had actually gotten only half of what he needed. Further, the minister of cooperation, successor to the colonial minister, complained

to the prime minister that he didn't want Malraux trespassing on his turf. Malraux abandoned the effort. However, this undertaking in Chad was, in Biasini's words, at least "on paper . . . the first planned house of culture."[16]

Although frustrated in this colonial venture, Malraux asked Biasini to stay on in Cultural Affairs. He had another idea. "What you did with the Africans, why not do the same in France?" Biasini, with years of experience of novel and improvised duties in the bush, agreed with his new minister that it "was only a matter of adapting." He leapt into his new work of spreading French culture in France.

"By devoting themselves to 'cultural action' [*l'action culturelle*], Biasini and his coworkers "discovered—at least administratively speaking—a new world to explore," in the words of Francis Raison, one of the higher civil servants who had joined the new institution and who himself was not one of the old colonial hands. Raison, who succeeded Biasini in 1966, found the transferred colonial administrators as a group quick both intellectually and in dealing. They also possessed good powers of empathy with "the Other" (*les autres*). Biasini's very French project for *l'action culturelle* in Africa, to implant "the cultural basis for the democratic progress of the individual," needed no redefinition for his new work in France. "Only the level was different," he judged; "the end remained the same." Malraux agreed.[17]

Biasini invited scores of out-of-work colonial civil servants to join the metropolitan *mission civilisatrice*. These veterans of Africa and Indochina were the main cadre of the new ministry in its first years. Their earlier careers had prepared them well for the work. They knew, Biasini quipped, how to conduct a "steady fight against complacency become habit, ancestral rites, tribal structures, ignorance of modernity, or the influence of powerful shamans [*sorciers*], who still held sway in many towns and whole provinces of France."[18] Of the first fifty administrators employed, twenty came from the colonial service. From the beginning, many of the important senior staff members had first practiced administration in the colonies. There was Biasini himself, who served first as Malraux's close adviser (*conseiller technique*), then as inspector general of administration, and finally as head of the theater administration and creator of the Maisons de la Culture. Jean Autin, who had been chief fiscal officer in the Colonial Ministry (Aide et Coopération), became director of administration. Guy Brajot assisted Gaëtan Picon at Arts et Lettres. Jacques Alluson was second in command to Marcel Landowski in the task of reviving and promoting music in France. In the first decade of the ministry's existence over fifty of its senior staff were men who had begun their careers in the FOM; four directors, six associate directors, and almost all the inspectors general came from the ranks of former colonial administrators.[19]

The people from the former colonial ministry brought a new and precious dimension to the task assigned to Malraux. Neither educators nor artists, they came to their new jobs with neither of the didactic baggage of the first nor the sensitive egos of the second. Having been trained in the tasks of part-

creating, part-administering an ill-defined postwar colonial policy, they were open to the task of creating and administering a new cultural policy for France.[20]

The personnel numbers for the new ministry are elusive. It both kept growing and kept losing people, who left to return to their old jobs in the Education Ministry, for example. But several statistical snapshots taken in the summer of 1959 including all Directions, shows the professional staff at around 550, the greatest number of whom worked for the cinema administration and the Archives Nationales. These were very modest beginnings—not many hands for the task of reviving a civilization.[21]

"For the Price of Twenty-five Kilometers of *Autoroute*"

In a famous speech before the Assembly in 1966, Malraux argued for the budget of his plan to build Houses of Culture all over France by comparing their expense to what the new national highway-building program was costing:

> For the price of twenty-five kilometers [15 miles] of *autoroute* we submit that the France which, in its day, had been the cultural leader of the world [and] which is now in the process of recreating its cultural excellence, [a project] the whole world is watching, in the next ten years, for this measly sum, this France could once again become the cultural leader of the world.[22]

This passage gives us a sense both of how important the Houses of Culture were in Malraux's overall plan for the future and how close to ground-zero the ministry's financing had begun. It is also an example of why, when he spoke in the National Assembly, the seats were always packed with parliamentarians eager to hear his convoluted rhetorical style, with clauses nested in clauses creating dizzying, intoxicating sentences. And Malraux's challenge (or would plea be more accurate?) to the legislators makes a point about a major discourse of culture: that of its costs.

Ministries, including cultural ministries, run on money. In this realm the movement of money signals approval, disapproval, or indifference quite as much as other kinds of language and signs. Few politicians ever take stands against culture per se; like the family and national defense, culture is sacred. The fights, as in the United States lately, are always about which culture and how much the cost. So we must also read the bookkeeper's tale about the ministry—here, as in literature, abandoning disbelief and not giving up when we come to the slow parts—in order to witness a dramatic numerational turn in the discourse of state funding of culture in France.[23]

The means Malraux was given in his first budget were slight. Even as late as 1966, as he begged the parliament for funding for the Houses of Culture,

he tried to galvanize (or shame) the deputies by using the autoroute metaphor. He got the money, and the autoroute network continued to spread from Paris to the provinces. So it never came to a real test of whether French males loved their cars more than their Molière.[24] Other ministries—Commerce and Education, for example—had given up functions to the new entity, but cutting a new wedge in the state's money pie—the *gateau* as writers on budget call it—without increasing its size was another matter. And then many of de Gaulle's most powerful "companions" (as his inner circle was called), especially the RPF ministers, were initially skeptical about putting serious money into the hands of this artist and his crazy ministry, the upper staff of which had apprenticed for their new work amid rice terraces, yam fields, or bush.

The creation of the new organization fell late in the fiscal year, so its budget for 1959 could only be hastily improvised. It was apportioned 3.15 percent of the total amount reserved for permanent capital investments (*equipement*), 2.78 percent of the pool for operations, and 0.88 percent of the year's credits budgeted for personnel.[25] In terms of its tasks, most of the money assigned to it was already earmarked or obligatory. The biggest fixed items were running state-owned buildings of some historical significance (Bâtiments Civils et Palais Nationaux), and the maintenance of historical monuments,

It should be noted that the subsidy to the national theaters equaled the funds for the upkeep of the monuments. Although part of this sum went to the Paris Opera and the Opéra Comique, it will be important to remember when we look at the hierarchy of the arts later that the French state loved the arts of language above all the others. Budgetarily, language was where its heart lay. Servicing the other arts had a much lower priority.

No funds were provided specifically for the encouragement of new art, although fellowships, state orders for art works, and subsidies to various arts enterprises totaled the respectable sum of nearly a million francs (938,830 F). Over half a million of that (636,891 F) went to subsidize theater productions, festivals, musical groups, scholarly publications and translations, and the like. However, most items under "Arts et Lettres" represented annual support for ongoing arts and intellectual enterprises.

To put the state's cultural priorities in 1959 in perspective, we should note that the part of the budget from which funds for intellectual and artistic innovation were largely drawn (fellowships, state purchases of art works) equaled something less than the French state's share in restoring Versailles. (American Rockefeller Foundation money paid for most of the restoration, in fact.) But, blessedly for the honor of contemporary French arts, more— just a bit more—was spent on encouraging new art than on putting the glorious but ancient fountains of Versailles in working order (fellowships and state purchases: 301,939 F; the Versailles fountains: 272,500 F) (table 1).

In his ten years at its head Malraux could not get for his enterprise the

Table 1. Ministry of Cultural Affairs, budget 1959 (selected items)

Public buildings and national palaces	3,000,000 F
Maintenance of historic monuments	2,200,000 F
National theaters	2,369,000 F
Art education and production	89,415 F
Education in music and dramatic arts	108,200 F
Arts and Letters:	
Fellowships	160,520 F
State art commissions	141,419 F
Subsidies, performing arts, music, literature	636,891 F
Restoring Versailles	341,000 F
Water services [mostly fountains]	272,500 F

Source: Archives Nationales (Paris), Series F21, Beaux Arts, Jacques Jaujard, carton 11, folder "Budget 1959."

budgetary holy grail he sought: 1 percent of the state's annual budget. For 1960, his first full year of operation, he obtained something like 0.41 percent of the annual budget for his work. With a few dips, the percentage rose to slightly more than 0.50 percent by 1969 (figure 26). Yet France's state budget was large in those years of economic growth and the creation of the Gaullist independent *force de frappe*. And underfunded though he was—as which ministry was not?—with the means he received Malraux was able to carve out a permanent and growing place for "culture" in the Fifth Republic.[26]

Jean-François Chougnet, a creative—in the good sense—student of state budget policy, suggests a useful way of approximating the evolution of the ministry's funding. If one looks at just the absolute numbers (budgetarily only a metaphor), the part of the state's annual expenditure which went to the culture agency multiplied by a factor of 47 between 1960 and 1990. In contrast, the numbers for the total state budget only rose 20-fold in the same period. In constant francs for the same years, while the ministry's resources multiplied by 7, the state's budget went up only 2.8 times. Either way of representing what happened shows the ministry's budget growing more than twice as fast as the state's other expenditures.

As Chougnet points out, this rapid and large increase in the funding of a state agency was not unprecedented in France. During the height of the growth of the Republican School of Jules Ferry, in 1880–90, the percentage of the total budget of the Republic spent on education nearly doubled, rising from 3.7 percent to 7.1. In his talks Malraux often compared his work with the national education revolution launched by Ferry.[27]

Another valuable perspective that deconstructing the discourse of budgets gives us is on the *aesthetic* priorities of the ministry: what activities grew more and which less? The answer to this question will demonstrate to what extent Malraux was just a managing inherited offices and to what degree he was connecting the nation-state to a living culture in new ways. The ministry's

Percentage of French Budget Devoted to Culture

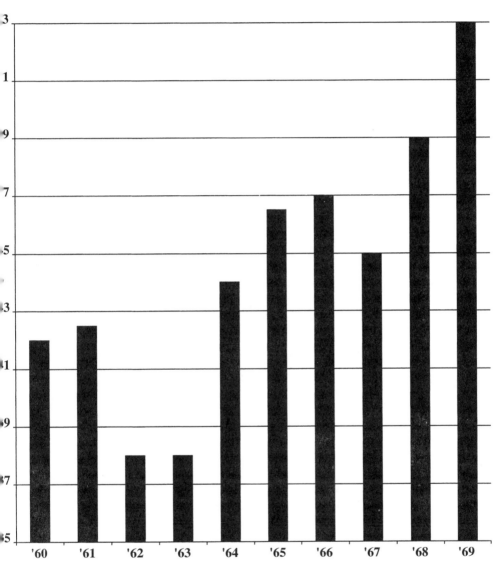

Figure 26. Percentage of French budget devoted to culture, 1959-1969.
Source: Jean-François Chougnet, "Un essai d'histoire budgétaire," Ministère de la Culture et de la Francophonie, Comité d'Histoire, ed., *Journées d'étude sur la Création du Ministère de la Culture, Document Provisoire* (Paris, 1993), 241.

Table 2. Ministry of Culture budget, 1960 and 1970 (breakdown by title)

	1960			1970		
	Constant francs	Current francs	%	Constant francs	Current francs	%
Title III	899.4	129.1	57.8	1404.3	303.9	51.8
Title IV	140.3	20.1	9.0	436.2	94.4	16.1
Title V	435.2	62.5	28.0	771.7	167.0	28.5
Title VI	80.8	11.6	5.2	99.4	21.5	3.7
Total	1555.6	223.3	100.0	2711.6	586.8	100.0

Source: Ministère de la Culture et de la Francophonie, Comité d'Histoire, ed., *Journées d'étude sur la création du Ministère de la Culture, Document Provisoire* (Paris, 1993), 242.

budget is divided into fiscal categories called titles. The two we are interested in here are:

III. *Moyen des services*—costs of administration of public institutions like the Louvre, the Opera, the Comédie Française, and the state porcelain factory, la Manufacture de Sèvres.
IV. *Interventions publics*—direct subsidies.
 V. *Investissements de l'Etat*—direct state investments.
VI. *Subventions d'investissement*—subsidies to investments managed by non-state bodies (municipal governments and later the Establishment of the Grand Louvre and other Grands Travaux of the 1980s and early 1990s).

The funding in these categories shifted. The costs under Title III, to cover the expenses of the state-owned and operated museums and art institutions, which the Republic had inherited—ultimately—from the ancien régime, diminished from 1960 to 1970 (from 57.8 percent of the ministry's means to 51.8 percent). Meanwhile, subsidies of arts projects of every sort, Title IV, increased by roughly the same percentage (9.0 percent of the total in 1960 to 16.1 percent in 1970). To put it another way (table 2), the resources devoted to running the state's archives, classified buildings, and museums fell in the course of the Malraux years, while monies furthering the publication of French books, and new work in the plastic arts, theater, and cinema grew. Music, the sick art in France, as we will see, got no larger a slice in 1970 than in 1960.

 In a word, the role of the ministry as keeper of the old treasures of France—what Chougnet calls the traditional "regalian" functions—was giving way, slowly, to Malraux's more activist ventures in the contemporary arts scene. These trends begun by Malraux—both the decline of the old Beaux Arts focus and the increase of new initiatives—have continued to recent years.[28] So, even better than the rhetorical fireworks of its famous minister, the analysis

of the languages—both words and numbers—of budgets gives the lie to the canard that the new entity was just the Beaux Arts plus de Gaulle's house intellectual.

Malraux, Bureaucrat

Malraux, this marginal political figure, was given some functions, a few staff members, and a handful of francs to create a new ministry devoted to preserving and furthering French culture. Gaullist wisdom—as we can detect in the judgments of Debré for example—saw the task of *really* creating a major ministry as too daunting for this posturing, often flamboyant, artist. De Gaulle, the embodiment of *la France*, may have formed a special bond with Malraux, the embodiment of *la culture*, but most Gaullists found him more useful as cultural cover for the grande bourgeoisie that dominated the RPF. But only just useful; he ran his office poorly.

By all creditable accounts Malraux was a terrible administrator. As minister he attended all the cabinet meetings. He said very little, and as his colleagues reported, discussed, and strategized, he sat bored (figure 27). Often he doodled. Indeed, he did so many of these crude absent-minded drawings—there were a lot of meetings—that a Japanese admirer recently exhibited them in a private gallery in New York[29] and printed a handsome catalog for the show.[30] As I write this, on my desk next to the computer is a handsome crystal paperweight from the exhibition with one of Malraux's "dyables" titled "Miroir du Monde" engraved on the bottom. We have to ask the admittedly unanswerable question, how much better would his ministry have fared had he paid more attention to the business of the meetings? (figure 28)

Many of France's historic buildings were in poor repair. Early in his administration Malraux decided that seven—Versailles, the Grand Trianon, Vincennes, Fontainebleau, Chambord, the Invalides, and the Rheims Cathedral—should get the restorers' first attentions. One workday afternoon he got up from his desk, walked out of his office, and had his driver take him to Rheims. He wanted to see with his own eyes the condition of the cathedral. It still showed heavy damage from the German shells that had showered on the city in World War I. Was this visit evidence of a hands-on minister of culture? Not at all. Thinking about restoring the building in his office had made him suddenly yearn once again to see the statue of the charming "Smiling Virgin" on the facade. The work is truly splendid: Malraux gets high marks for taste, we (I, at least) think the better of him for this adventure. But what about the people waiting in Paris to talk to him about ministry business?[31] So with his voyages to the United States and Asia: they spread the fame of French culture, but they took him away from his desk for long periods.

He had no head for numbers; his appearances before budget commissions

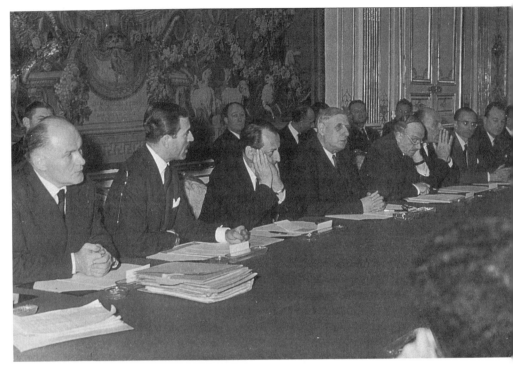

Figure 27. Malraux seated at the right hand of the president at the weekly meeting of the cabinet, 1958. Keystone-Sygma.

or the finance minister filled him with fear. He did not do his ministry proud in such settings. And since he had no interest in details, his subordinates had a great deal of freedom in their tasks.

He almost never held meetings of his senior staff. He preferred one-on-one conversations with subordinates, where his volubility and charisma could carry him over the administrative bumps and across the factual chasms. Of course, this way of proceeding made coordinating their work harder. But he didn't avoid meetings in order to divide and conquer as in certain styles of compartmentalized administration. It is not possible to imagine Malraux as the brilliant manipulator of his staff, sitting in the middle of his web, in control.[32] As a leader of comrades, as we saw in his earlier life, he inspired deep admiration and loyalty. But that personal style of leadership—where faithfulness counted more than critical intelligence—was sometimes destructive in a bureaucratic organization: he was also capable of abrupt, even brutal, acts, including summarily firing his most important coworkers, Picon and Biasini, in 1966, when he decided they had been disloyal to him.[33]

As the workload and the tensions of his life wore him down, his facial tics, which often distracted people speaking to him, became worse; and he began

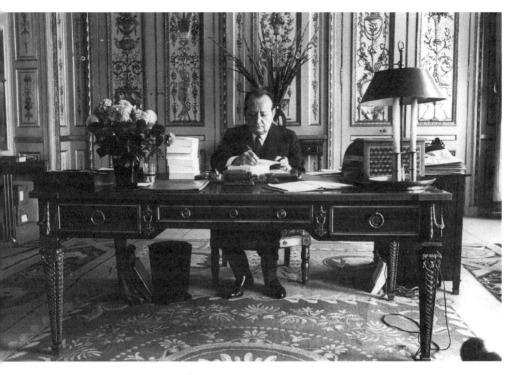

Figure 28. Malraux autographs copies of his books at his desk in his ministry office, 1967. Keystone-Sygma.

a cycle of taking stimulants and then depressants to keep going.[34] De Gaulle sent him on a good-will mission to Asia in 1965 in large part so that he could detoxify and dry out on the long ocean voyage. Malraux turned it into a personal and publicity triumph, culminating with a summitlike visit with Mao Tse-tung.

Yet, despite all the manifest ways in which he was unsuited for his post, I propose that it was just Malraux's suspect personal qualities that launched the ministry and made of it a serious enterprise. In fact, the ministry's greatest asset was this amazing man who at one moment was ordering the cleaning of the facades of the capital's public buildings, at another hiring Chagall to paint the ceiling of the Opera house. He could reminisce with Nehru about the days of the Spanish Civil War, and impress the wife of the American president by giving *her* a guided tour through the National Gallery. With de Gaulle as his friend and admirer, he could sometimes get around the barriers set up for him by other ministers, especially the inquisitional finance minister, by using that personal relationship.[35] And when Debré was replaced as prime minister by Georges Pompidou, a man who had edited an anthology of French poetry, collected avant-garde art, and been an early

supporter of a new culture ministry with Malraux at its head, the ministry's fortunes rose. In a way unusual for modern governments, the fate of the ministry was deeply intertwined with its writer-chief.

Any organizational history which left out this factor X—the vast *human* capital in the sense of Chicago economic theory and the *symbolic* kind of Pierre Bourdieu—that Malraux represented would be unbalanced. Moreover, his grand-gesture style as minister, certainly the product of his huge ego, was at the same time a most intelligent and, I would say, well-chosen strategy for the head of an unknown office, entrusted with a vague mission and few resources. Everything done had to be a sample, a promise, of what might be accomplished with more support and money. For Malraux, seduction was the best policy.

Now we must look at what the ministry actually did. For in its works, finally, lies the concrete answer to the question of whether or how Gaullism succeeded in administering the aura. During ten years in office, Malraux started or continued many projects. But the project into which he put his greatest energy and hopes was the Houses of Culture. In many ways their creation and spread serve as an index of his work. As minister, Malraux inherited the obligation of funding existing cultural institutions. Whatever the national theaters were producing, their staffs had to be paid, the buildings heated, the roofs repaired. So, if truth be told, then as now, most of his ministry's budget was earmarked for constant and recurring expenditures; he had relatively little in real discretionary funds. The Houses of Culture were one of the few large initiatives he proposed and carried through. They were the only new institutions he managed to realize with a potential to reunite the nation: Parisians with people in the provinces, artists with their potential audiences, and the people of France with the aura of French art.

6 *Abolishing the Provinces*

What would André Malraux have become if he hadn't grown up so close to Paris? What about all the other clever young people who lived much further away from the cultural capital than the short train ride from Bondy? Because Malraux believed that humankind by nature needed aesthetic culture, very much in the way Aristotle believed we were necessarily social beings, the *unavailability* of the cultural advantages of Paris in too much of France to his mind cheated provincials of a part of their humanity. Speaking at the inauguration of the House of Culture in Amiens, he described this institution, along with the others he intended to found all over France, as his main instrument for "for abolishing this hideous word 'province.'"[1] Along with many later commentators, Malraux, saw the creation of the Houses of Culture as his major achievement as minister.

The Maisons de la Culture he planned were buildings housing a large hall, or sometimes several stages, for theater, film showings, and lectures. Often there was a space for exhibiting art, and record and book libraries as well. Malraux thought it essential that they be separate structures, not annexes of existing cultural institutions.

His ministry offered the municipalities he targeted, ones receptive to the idea of having a Maison de la Culture, half the costs of construction, and also promised to cover half the ongoing operating expenses. He offered the local mayor and city council a say in the management decisions. Compared to the usual arrangement of the period in which Paris offered a municipality only 30 percent of the costs of constructing a municipal theater and no operating funds, building a House of Culture—which might support a good number of municipal cultural activities—was a great temptation for an ambitious mayor.[2]

This mode of funding and reporting set up a inevitable three-way tension, which erupted into conflicts (and sometimes gave rise to alliances). Studying

how these conflicts developed will let us see something of the dynamics of the interaction among the institutions' staffs (drawn from the world of the arts), the ministry (with its national-cultural goals), and the local authorities (who often just wanted more "culture" in their town, in the middlebrow sense of the word). Seeing how the Maisons de la Culture worked—or didn't work—will also give us some understanding of who was the public, the *recipients* of what the Maisons dispensed.

The towns of France were not in fact cultural wastelands in 1959. They never had been. They just were not Paris. There was the system of nonacademic evening courses, called *l'éducation populaire*. Besides the local professional and semi-professional musical groups, municipal theaters, and public museums, France, like the United States and, just on the other side of the border, Germany, was—and is—densely filled with clubs, circles, associations, and more formal societies. The members were overwhelmingly amateurs, many of them highly unskilled, but, as is not uncommon with such voluntary engagements, many were deeply committed to cultivating, or advancing, some aspect of local cultural life.

The amateur cultural associations welcomed the possibilities the planned Maisons de la Culture offered for carrying on their own activities—with office space, meeting rooms, and exhibitions halls. The Maisons, members of some local societies hoped, could provide meeting places for organizations deeply embedded in the old cultural hierarchies, rehearsal and performance spaces for amateur musical and theater groups, and venues for literary lecture series and local history societies. There were also more culturally advanced local societies like the ciné-clubs of film fans or associations of jazz lovers, which had proliferated in the postwar years—for example, the Hot-Club of Bourges.

Finally, there were the associations tied in with the cleric/laic division which historically had cut through French society. The array of ideologically laic and republican hobby and arts clubs, scouts, reading circles, and so on confronted an equally elaborately organized constellation of parish associations of hobby and arts clubs, scouts, reading circles, and so on. Old rivals for the souls of the people, priests and religious workers confronted republican teachers and anticlerical volunteers.

An Opportunity Missed?

After a short tug of war in 1959, the Haut Commissariat à la Jeunesse et aux Sports, which worked with many of these amateur cultural associations and oversaw nonacademic extension education, had remained with the Ministry of Education. This office had been founded at the moment of the Liberation. Its first head, the writer Jean Guéhenno, wanted above all to reacculturate the young to the French heritage—as left republicans understood

it—after the years of Vichy ideology and German occupation. He envisioned the schoolteachers of postwar France, beyond their basic teaching work, as acting like a kind of relay team with the first republican teachers of the 1880s, to serve as the principal transmitters to the young of a renewed French culture. Guéhenno's early death and the subsequent loss of interest in his project within the huge Education Ministry prevented any follow-through on his ideas. Such idealistic projects had to wait, in the thinking of most educational administrators, until the regular educational system, still in shambles, had been set right.

Ironically, the office of youth and sports did encourage culture, but it was *physical* culture it promoted. The Popular Front had introduced physical education into the schools. Vichy continued the classes. The postwar Education Ministry continued to foster physical education and sports in the schools and its recreation centers. All the money went for that; the cultural part of popular education was financially starved, in a country in which state support made the greatest difference between failure and success.

So why not give the cultural side of the work to Malraux, we could wonder? Michel Debré, the prime minister, just did not want the writer-turned-politician involved in anything as politically delicate, potentially touching so many people directly, as adult education.[3] But why not just bypass the official office and subsume participating cultural organizations directly to the ministry? In 1961 Emile Biasini assumed his new charge as head of the ministry's office for the Maisons de la Culture to spread French culture to the provinces. As he had been taught in the school of colonial administration, Biasini sent inspectors around the country (into the bush?) to investigate the goings-on in the various culture organizations (tribes?). Such a survey would accomplish a reasonable preliminary reconnaissance so that the ministry could come to a decision about taking these regional bodies in charge.

The sociologist Philippe Urfalino has studied the inspectors' reports and cites generously from them. For example, Biasini's people visited Chants et Danses de France, which the choreographer Jacques Douai had founded to perform the musical arts of the various regions of France. Too amateurish, ruled the inspector. The Burgundy Cultural Association offered its 20,000 members jazz and film clubs, theater and concert tickets, driver education and crafts courses. It was the subject of an inquiry. No coherence, the report concluded. The European Congress of Leisure in Strasbourg was a network of Catholic social clubs and activities. Religious uplift, went the dismissive verdict. There was a report on La Confédération Musicale de France, which ran musical competitions for children all over the country. Its letterhead included as honorary sponsors President de Gaulle and the composer Arthur Honegger. Good outcomes, remarked Biasini's man—and in fact, many of its prize winners went on to pass the rigorous examinations to enter the Paris Conservatory—but the general sense of the write-up on this body was "the place for little Jacques's first recital with-proud-family-looking-on." In short,

Biasini and his team found most preexisting grass-roots organizations too lightweight or otherwise inappropriate for the task of bringing the French people what they deserved: the very best of the great culture, presented at the very highest professional level possible.[4]

Although it is not at all clear that Malraux was capable of the politicking needed to gain it, the main chance for an admittedly prefabricated popular base for his project was thereby lost. Perhaps a better word might be "skipped." In his recent study of the creation of Houses of Culture, Urfalino counts this failure to connect to grassroots arts-teaching and art-making as the major flaw in Malraux's project, indeed in the whole conception of the cultural ministry from the time of Malraux, the worshiper of culture, to that of his heir, Jack Lang, the flamboyant populist. Specifically, Urfalino charges that this formal separation of grassroots arts groups and popular education from the out-reach efforts of the ministry, made the ministry an *office for artists* rather than one serving the cultural growth of the nation. To evaluate this charge we must first look at how the Maisons de la Culture were organized and how they functioned.[5]

New Cultural Capital

Suddenly in the 1960s the state began dotting the regions with new start-up cultural capital. But at the same time it was trumping the existing institutions and groups with a new *state* cultural project. The Maisons de la Culture brought to towns new state-invested cultural capacity in fields where all three extant kinds of cultural associations—the ones organized around religious ideology, the old-line bourgeoise cultural associations, and the new-culture ones—had competed before and, together, dominated the cultural field.[6]

The forms of interaction between the state's new implantations and local cultural initiatives already in place varied greatly. Biasini, strongly seconded by his minister, wanted the Maisons above all to transcend localism, that is, to promote the *national* culture where it had not been available before, and at its highest (i.e., Parisian) level, where only amateurish indigenous groups had performed before. Years later Biasini defended this stance. "There were no Sunday painters in the Houses of Culture. However, we thought it important that the Sunday painters come there to discover another kind of painting, and for them to try to model their own work on it."[7]

Some local directors of Houses of Culture—a minority—would have nothing to do with local associations. They took the project of bringing professionally produced high art to the "people" seriously. Malraux's imperative spoke to the artist-creator in them. Others welcomed to their halls only the more hip local groups, film and jazz fans, and cut out the culturally old-fashioned bourgeois crowd. But many more directors welcomed all comers,

and made up their annual programs with a mix of activities initiated by the Maison staff and others initiated by various local associations. Operationally in their programming, then, if not ideologically, the Houses of Culture showed a certain respect for local interests, despite Malraux and Biasini's contempt for amateurs and their own grand national plans.

At the same time, as Jean-Jack Queyranne, who has systematically compared the programs of the various Maisons, points out, the annual offerings at every new center were very much the same.[8] Part of the reason was simply convenience. A touring theater troupe, dance company, or symphony orchestra, for example, could readily be booked into a circuit around the country which included all the Houses of Culture. But a greater part of the reason was the announced motif of cementing a national (high) culture. On this goal the left-leaning directors of the Maisons were as clear as the Gaullist André Malraux.

The socially radical nature of the Maisons was graphically underscored to local notables and new cultural activists alike in Malraux's construction planning. Some of the cities of northern France, in Normandy especially, had been severely damaged by bombing and the fighting in 1944. The old theater of Caen, for example, a charming legacy of nineteenth-century rococo style, had been destroyed. Instead of proposing to help restore it, Malraux offered the town authorities a modern Maison de la Culture in its place. Would the new building recreate the glories of the nineteenth century? The local notables thought not. Malraux hoped they were right. So instead of a monument to the golden age of the local bourgeoisie, Caen received the first (actually built) new Maison de la Culture. The Gaullist barons were not wrong to suspect this writer who subverted a local elite's intention of celebrating a certain sense of the past with the gift of a museum dedicated to state-sanctioned culture.

Theater and Community

This issue of what purposes and whom the various interested parties involved considered that the Maisons de la Culture should serve brings us squarely to the contradictory goals of Malraux's cultural policies as crystallized in the Maisons. Justified politically by Malraux as bringing culture to the nation, the Houses of Culture privileged theater and theatrical expression. With the exception of the first Maison head, René Arnould of the Le Havre Museum, all the directors came from the world of theater.

But the tasks of *spreading culture*, sometimes called "animation," or what we can only poorly render as "cultural action" (*l'action culturelle*), and *encouraging regional theater*, were not, and are not, the same projects. In a deep sense Malraux had recreated the old tension between art as the work of artists versus art as what a public desires or can appreciate. Malraux, Biasini,

and the directors and staffs of the Houses of Culture, Philippe Urfalino has charged, put their efforts into encouraging theater at the expense of cultural animation, although they intended theater to be "the principal vector of cultural action."

There were, I think, two important reasons for the decision to emphasize drama as the chief art promoted in the Houses of Culture. First, of all the arts reaching out to the rest of France, the theater had been the earliest and the most active. Even during the war years regional theater companies had begun to grow. After 1944 the success of Jean Vilar with the Avignon Festival had shown the wide interest in good theatrical productions in the regions of France. Others elsewhere in the country emulated him. In the late nineteenth century, republican school teachers had spread the print culture in French towns and villages. When Malraux had to choose agents for the diffusion of the aesthetic culture, he found the people who had organized and worked in the regional theaters most suited for the new task. And like the teachers of the Third Republic, they were devoted cultural missionaries.

In their past lives as directors of regional theater companies, they had often had to make do with poor facilities, if they were lucky enough even to have had a home theater. Now as the directors of the Maisons, they saw the new facilities, halls, and budgets as blessings falling from heaven. With that desperate opportunism arts people must sometime allow themselves when faced with the choice of closing a budget shortfall or closing down, they reasoned that anything which advanced theater and enlarged its public was permissible, even supping with the . . . Gaullists.[9]

The new postwar regional theater companies had challenged in ways both aesthetic and social the established place that for many decades the municipal theaters of the provinces had occupied. The local theaters built by and for the nineteenth-century bourgeoisie reproduced the hierarchies of the society in what they performed—and even in their seating plans. Like the apartment buildings of the era, the seats descended in worth as one ascended the stairs. At the top, in "*paradis*," the reader who has been lucky enough to see the film *Les Enfants du paradis* might remember, sat, or stood, the poor and marginal. As for the occupants of the good seats, they went as much to be seen as to see. In some houses, like Paris's nineteenth-century Opéra, one's view of people sitting in other boxes was much better than one's view of the performers on stage.

Of course, plays can be understood in many different ways and artists' intentions and audience understandings are rarely in phase. So the poor actors, students, or petits bourgeois up in "heaven" might take away impressions of a play different from those of the solid bourgeois below. But to an amazing degree, established theater before World War II purveyed a vision of the culture tilted toward the maintenance of what was. Bourgeois provincial theater had no interest in raising questions about established aesthetic values or in probing the "seating plan" of the larger society.[10]

This is not to say that the theater companies of the Maisons de la Culture played exclusively, or even primarily, avant-garde works. In the mid-1960s approximately half the plays done in the Maisons were from the classical repertory. Molière and Shakespeare were the most frequently performed authors. And other classical French authors—Racine, Corneille, among others—were produced along with foreign classics by Sophocles, Aristophanes, Chekhov, and Schiller, to name a few. Among what might be called modern classics, we find some Brecht, of course. But there was also Camus, Durrenmatt, Lorca, O'Casey, and Pirandello. Anouilh, too, was done a lot. Finally, a certain number of contemporary playwrights, many of them foreigners, were performed. Translations of plays by Arthur Miller and Arnold Wesker could be seen at one or another House of Culture, alternating with works by Armand Gatti, Michel Butor, G. Foissy, and Aimé Césaire.[11]

Clearly, the choices of theater pieces were both eclectic and mainstream. But the Houses of Culture left it to the avant-garde companies and houses, primarily in Paris, to play authors of the theater of the absurd, like Ionesco or Becket. Nor did they do the politically provocative plays of Genet, although he was performed—with great scandal, as we will see—in state theaters in Paris. Following the ideological lead of Jean Vilar, and with certain qualifications, of Malraux too, the theater company directors expressed their politics in just making available to "the people" professional performances of works selected from the theater canon.[12]

Once on the job, how did the new directors find working for a Gaullist cultural project? Well, as long as it was good for theater and not blatantly in violation of their left principles, they continued to tell themselves. . . . In fact, the Gaullist and left theater projects converged in their common interest in reaching new audiences in a new economic and social world. Most agreed with H. Gignoux, head of the Maison de la Culture in Rheims, that the battle had to be fought on two fronts: "against the old structures of culture, which still have considerable power, and against mass culture. Between fossils and barbarians the room for action is narrow."[13] The uprising of May 1968, which *all* the directors of the Maisons de la Culture joined, proved the gap too narrow to navigate very far.

The second reason for the preeminence of theater in the constitution of the Houses of Culture is at the same time philosophical and biographical. As minister Malraux could act to satisfy his thirst for modern surrogates for community and ritual as the meaning-giving context for art. In the 1930s he had thought to find a lost comradeship or community in the ranks of the fighting left. His novels all portray an idealized bonding of men in a political communion. His disappointment with the possibility of real left comradeship, especially with the brutal and opportunistic Stalin directing things, became more clear to him in the war years. The Spanish Civil War and the Resistance had been for him a kind of socialist "front experience," the unity of men offering up their lives for a humanistic and just cause which bound

them together. Gaullism was his new attempt at (once again, male) commu-
nion around the nation. And the spread of the nation's aesthetic culture was
to be for him another means to rally the divided French people to a new
unity and new historical tasks.

What more social an art was there than theater? It unites its audience
in language—the language of the French nation—and in ritual. What is
more evocative of the aura of communion than the rapport which develops
between actors and audience? It was not important *what* was played—
although Malraux had very strong opinions on what the Comédie Française
should play, and as minister sent off memos proposing programming changes,
What he was after, rather, was that many French people experience the bond-
ing of being part of the powerful emotional field of good theater. In twentieth-
century France, theater was the art closest to religious ritual.

Some twelve Maisons de la Culture had been built or dedicated before the
end of Malraux's ministry killed the enterprise. Malraux had had concrete
plans for at least ten more. In the long term he wanted a House of Culture
planted in every department of the country. Many of the projects Malraux
initiated in his ten-year ministry continued after his departure, but soon af-
ter he left office the Houses of Culture, one after another, began closing or
radically changing their activities. What went wrong?

Political Recycling

Malraux did not invent the idea of the House of Culture. The Soviet gov-
ernment had opened such institutions soon after the 1917 Revolution, and
they continued to function into the 1960s. On a trip to he Soviet Union when
he was minister, Malraux specifically asked to visit several of them. He may
have seen some when he was there in the 1930s, too. But he did not have to
go so far. In the era of the Popular Front, following the Russian example, the
French Communists created in Paris and some provincial cities more or less
well-functioning Houses of Culture for left theater, films, and lectures.

The French Communist cultural organization, the Association of Revolu-
tionary Writers and Artists [Association des Ecrivains et Artistes Révolu-
tionnaires], created in 1932, founded the first Maison de la Culture in 1934
in Paris. The association was nominally headed by Maurice Thorez, leader
of the Party. Most of the prominent members were PCF intellectuals, in-
cluding the writers Louis Aragon and Paul Nizan. Malraux himself actively
participated in the planning and programming of the Paris Maison. It offered
audiences weekly lectures on cultural topics (Malraux and Le Corbusier
spoke there), musical evenings (by "antifascist" *chansonniers*, and choral
groups), theater (the company "Octobre"), art shows, and films.

In a kind of radiation from this first House, local activities were sponsored
in various parts of the city as well. In the highly politicized spring and sum-

mer of 1936 Houses of Culture sprang up in Rouen, Rheims, Nice, and Cannes in metropolitan France, and in Tunis and Algiers in North Africa. At that moment, the Party strongly encouraged cultural work—recall the conference in defense of culture—as a key means of winning over more bourgeois supporters and neutralizing enemies of the left.

Jean-Jack Queyranne cites a confidential PCF position paper on the Houses of Culture prepared in 1936 to guide internal party discussions on how to react to the new institutions. The Party shared Malraux's belief—he, in fact, acquired it from them—that culture was a crucial battlefield for society's active and potential class antagonisms. "It is especially by means of cultural organizations," the Party memo reminded militants, "that the reactionaries, the Catholics, the Masons, and the Socialists maintain a decisive influence over the petites bourgeoises masses, workers or peasants." Accordingly, members were urged to see the Houses of Culture as "essential bases" for spreading Communist ideas in the intellectual strata and among professionals.[14]

The culture that the 1930s Houses of Culture wanted to diffuse was of course that of the nation. And like the nation, that culture included all the people. Popular culture, according to René Blech writing in *Commune*, is a "shameful vulgarization" which underestimates the cultural level of workers and peasants. "There is just one culture, to which the working masses have as much right as the intellectuals, the artists, and the technicians."[15] The Vichy regime closed down the Communists' Houses of Culture, but undertook an active cultural policy of its own. Vichy emphasized faith, order, and roots, which we must admit, were also part of the French cultural heritage.

So when on assuming his new office, Malraux announced his intention of planting Maisons de la Culture throughout France, most people had some understanding of their leftist historical origins. Communist cultural initiatives they had once been, but certainly not *counter*cultural ones. Like the Popular Front Activists of the 1930s, Malraux wanted to spread *the* culture of Paris to all the French throughout the country. Adapting the socially vertical project of the PCF to Gaullists' development strategies, he strove to spread the culture horizontally as well. But clearly, *changing* the culture was part of neither the Communist nor the Gaullist project.[16]

The work of creating the regional emanations of Paris culture started immediately. Put in charge by Malraux, remember, because of his prior experience, Emile Biasini in 1962 wrote a kind of manifesto for the project, the title of which played on the radical restarting of the calendar during the French Revolution, *Action culturelle, An I* [Cultural Action, The Year I]. Biasini took Malraux's lead: he intended the Houses of Culture "to transform a privilege into a common possession."[17]

In the 1960s, as Malraux dedicated Houses of Culture, one after another, in different parts of France to provide local people the theater, arts, music, and classic cinema that in the past had been accessible only to Parisians, the armature of a truly national French culture began to take form. In significant

ways, their creation aided the transformation of the nation P. J. Gravier had characterized in 1947 as Paris surrounded by a French desert, into a multi-centered, interconnected nation, though steered—still—from Paris.[18]

Culture for All: The Technocrats' Version

At this point we should ask why, after so many centuries of gifted provincial intellectuals "going up" to Paris to make their mark, it was suddenly so important in the decades after World War II to bring the culture to the hinterlands. There were, I believe, at least four reasons.

First, for the sake of the further integration of the French nation, Malraux wanted to complete the task of creating a national intellectual culture that had been begun in the schools of the Third Republic. Each child in the same grade everywhere in France read the same bits and pieces of the great works of French literature, studied the same history of the nation from its supposed beginning in Rome and Gaul, learned to admire the same heroes of national life, and thereby assimilated the new civic culture of the new republic. In an astute accommodation with the church, on Thursday mornings (now Wednesdays) the schoolchildren were given time off for religious education. In this way the church continued to supply the necessary moral education of the young republicans which the secular schools could not.

Civic education was focused on the word: in the first instance the French language, then literature, speaking skills, and for the advanced students, philosophy. Mathematics and science were taught and honored, but the best were encouraged to do philosophy in their advanced studies. Music, art, and theater were not part of the school curriculum.[19] Malraux wanted especially to bring to the people these parts of the high culture neglected in the schools. "We have to create a situation in which each French child has the same right to paintings, theater, and films as now she has to the alphabet."[20] By the mid-twentieth century, with the "paganization" of the population, Malraux wished to use art, or more broadly the culture, to replace the spiritual and communal role of the church.

Second, with their mystical sense of the destiny of France, the Gaullist leaders saw the task of increasing the portion of the population touched by the national culture as especially pressing because they understood the deep fissures the 1930s and the Vichy years had uncovered in French society. The political and economic penalties for the cultural divisions of Italy—especially the north-south divide—were a warning to other lands bordering on the Mediterranean. French postwar social and colonial struggles intensified domestic conflicts to state-threatening levels. We have to remember that de Gaulle's Fifth Republic came into being as a result of a major crisis of the state—including the threat of a military coup and possibly civil war—over the political fate of Algeria.

Philippe Cerny has plausibly argued that de Gaulle's foreign policy of *grandeur* was framed more to unite the French nation than to regain France's lost international glory.[21] If it is arguable that the intention of healing French social divisions to some degree drove foreign policy, isn't it likely that Malraux's drive to create national cultural unity—whatever his own subjective intentions—might have served the same end?

Yet, although the causes I have mentioned were important, probably a more compelling reason for spreading access to the culture throughout the land had to do with modernizing the country. The nation was becoming increasingly urbanized, with the greatest internal migration occurring between 1962 and 1968. From 1949 to 1968 people working in agriculture declined by 46 percent. In the case of textiles, clothing, and leather the drop was 36 percent. The labor force in highly mechanized and electrical industries increased 45 percent. Small workshops yielded to large modern industrial plants. Aggressive and efficient large retailers, like Eduard Leclerc, challenged small merchants' profits and therefore livelihoods. Self-employed workers declined while white-collar employees (*cadres*) increased in numbers. Foreign exports moved from the protected colonial market to a highly competitive international arena.[22]

Postwar France's amazing thirty years of rapid and deep economic transformation inevitably encountered constraints and impediments. Serge Berstein has identified several brakes on growth in the postwar years: inflation; weaknesses in France's foreign trade position; regional imbalances in population and urbanization, the flight from the country, especially by the young; and in the 1950s and 1960s, the favorite of the American critics of French "backwardness"—the persistence of old ways of thinking and doing.[23]

But to this list we have to add an important cultural concern that Gaullist planners saw as putting the progress of internal modernization at risk. Increasingly in this century officials dedicated to developing their countries economically have realized that the educated and very skilled had to be able and *willing* to move to where the jobs were. This free flow especially of managerial and technical workers, both domestically and, more and more, internationally, serves as a major geo-economic underpinning of any modern state's economy. Whereas socialist idealism or Stalinist terrorism could move millions of people around the USSR to implement the five-year plans of the 1930s, French planners, even under de Gaulle, had no such powers. The mayors of many of the cities where Houses of Culture were built welcomed them as sources of attraction for *cadres* in the worlds of both public administration and business.[24]

European visitors to the United States often remark on what seems to them the short-term and assembly-line mode of constructing houses. To their eyes these are not seats of family life meant for the generations. And they are not. It is rare in America that we live, or die, in the houses of our parents. European commentators in the first postwar decades saw Americans as modern

nomads. Thankfully, the introduction of the free movement of labor within the European Community has stopped such uncomprehending observations. To state it more positively, the willingness of American workers to move to new jobs—either as immigrants from abroad or inside the country—has been one of the great historic assets in the comparatively even regional development of the modern American economy.

In nineteenth-century industrial society the economic whip made people go to where the jobs were. But shaping motivation in a high-technology and information-driven society is more complex than that. In the United States, alas, the assurance that there will be nothing new in the new environment makes moving around the country less frightening, if less an adventure. We know that in our new locations we will find the same houses equipped with the same appliances, the same quick food and "continental" restaurants, the same packaged supermarket items, the same films, radio music, and—above all—the same television channels. But that is not enough for those with pretensions to a good life. The more educated will want to find the Public Broadcasting TV station and the local National Public Radio outlet. Will a touring theater or opera company come through from time to time? Can you hear live music—a symphony or rock groups? Are there good restaurants? Does the local college or university offer public lectures, art films, or interesting general education courses? Are the schools good? Can the children get into good colleges from them?

There are certainly other important considerations for Americans; for example, climate, places of worship and sociability, ethnic environment, and closeness to important relatives. We shuddered along with the campers from Atlanta at the psychic deformation of the locals in the Georgia woods in the film *Deliverance*. Woody Allen's rootedness in New York—a specific, Jewish-WASP upper–East Side middle-class claustrophobic New York— makes us laugh because we see his loyalty to place, his provincialism, as humorous in this age. In both cases it is the peculiar ties to region which drive the plots, loyalties which are for many of us now strange. The point is that questions of cultural situation are important in *locating ourselves* socially, and even psychologically.

How much more true this has been in France. The definition of inclusion— the "republican contract"—stipulates that being French means being able to navigate *the culture*. The economic and regional decentralization started under the Vichy regime and its continuation after the war made for much population movement, especially among postindustrial workers. But even more significant were the changes in education. The modernization of the postwar years made educational attainments more important for more people than ever before. The new jobs needed better-educated workers, and the better educated wanted to parlay their abilities into social mobility. In a law passed in 1959 (which went into effect only in 1967) the school-leaving age was raised from fourteen to sixteen. The number of students who won

baccalauréat (high school) diplomas doubled from 1961 to 1971. In the 1960s this diploma was an automatic admission ticket into a university, and so the population of university students expanded rapidly, more rapidly than either teaching staff or facilities.[25]

Accordingly, a final connection between the state-sponsored Maisons de la Culture and the new skilled middle class was this stratum's relatively novel capital holdings. In the nineteenth century, one usually followed the family path in the choice of careers. If your father was a lawyer, you (a male) had a leg up in the career; you had his money to pay for the lycée and the higher education; you had his books, and you could serve his old clients or their children. The same was often true in medicine, university teaching, farming, or even skilled crafts. Economic and educational-cultural capital roughly coincided.

It was true that a poor but clever provincial who had learned to write or speak, or perhaps paint, could hope to realize in an improved lifestyle usually in Paris some of the value accumulated in his human capital. In France, if you were not from a comfortable background, betting on culture—education, to begin with—was the safest wager for making it. But in the new modern France of the post-1950s, Balzac's *Lost Illusions*, about the young provincial inventor and intellectual who tries to make it in Paris, and *La Bohème*, about struggling artists and writers, did not even faintly speak to many young people of modest origins. Thousands of graduates with degrees in engineering, finance, or management from state-funded institutions of higher learning who were looking for work in large corporate firms, willing to relocate if there were chance for advancement. These young *cadres* had much cultural capital, if little of the economic sort. They hoped to parley that educational-cultural wealth into better lives, in all senses of the word. For them, the Maisons de la Culture were not just places of entertainment.

Imagine being new in a town, perhaps working for IBM de France in Grasse or in the regional offices of some supermarket chain, or as a supervisor in the new Kodak plant just built. What do you do after work? There's the new tennis club, biking, the American import of jogging, maybe reading, and watching old movies on TV. What about your mind? How do you keep it alive now that you're no longer going to school in Paris, Toulouse, Lyon, or Strasbourg?

The new middle class of the French economic miracle, educated, eager to anchor their new status by embracing contemporary culture, new in town, wanting to be with like-minded people, embraced the Maisons de la Culture as their cultural home. Queyranne reports a study of those who attended the new theater in Aix-en-Provence in 1967. The town had not yet gotten a full-fledged Maison de la Culture, but the new institution very much fitted the slot for which the Maisons were meant. Teachers, engineers, both senior and top managers, medical and social workers preferred the new theater to the stodgy old municipal one. The majority of these were new arrivals in town.

They were joined, however, by many long-time resident professionals and managers who told interviewers that they welcomed an alternative cultural institution. They had mostly stopped going to the old municipal theater because of the small-town smugness, the social and aesthetic conservatism, and the local class pretensions which were played, and played out, there.[26]

And like-minded locally elected officials, although certainly attracted by the generous state subsidy which came with a Maison de la Culture, also saw the intellectual and developmental benefits the institution would bring with it. The planning for the House of Culture in Chalon in Burgundy shows how this process worked. In 1965 this town of 63,000 inhabitants elected René Legrange, a Socialist, its new mayor. Chalon's population was growing at the rapid rate of 3 percent per year. But the region around it was economically depressed. The metallurgical industry of the town and of nearby Le Creusot had begun the permanent decline which marked the end of the coal and iron industries in France. But Chalon did not suffer from the fall of the region's old industries. It had just gotten a Kodak film plant, which by 1965 employed more people than the steel mill did. Several other high-tech firms increased the town's population of *cadres*, engineers, and technical personnel. In 1960 the town had created a municipal office of culture, so Legrange could build on an emerging consensus as to the need for a cultural life appropriate to the growing town. Even after the great questioning about French culture began in May 1968, in a newspaper interview in November Mayor Legrange reaffirmed his belief that the planned Maison de la Culture, "will have a definite influence on economic development; *cadres* no longer see Chalon as a cultural Siberia."[27]

French advertising in the 1960s, trying to keep up with the changes going on in France, produced, among other things, the famous TV and print ads in which la Mère Denis, a ruddy, hearty peasant woman, the sort one still saw doing their wash in the public basins in small towns after the war, extols the virtues of the new electric washing machines. How wonderfully this new technology has improved the quality of her life, the ad tells us. But the postwar French economic miracle which distributed commodities plus leisure throughout the society, if anything, sharpened the growing crisis of an inherited culture formed at a different moment in a different material world.

Pierre Moinot, who in October 1966 became head of Arts et Lettres in the ministry, understood the gap between material and spiritual culture. The ministry was created in 1959, he told reporters at his first press conference, "to respond to the problems which the economic circumstances of our society pose for peoples' lives."[28]

The Gaullist strategy for development by regional decentralization was not much different from what had gone before in, the Fourth Republic, and what came after 1968. Economically, it multiplied, or duplicated, the capital city throughout France. And, so Gaullist thinking reasoned, that required creating cultural Parises everywhere in France. Like the routing strategies of

airlines, building Gaullist cultural hubs would, it was thought, both concentrate and deploy the national culture everywhere.

In his first career as an official in West Africa, Emile Biasini had gained the recognition of his superiors by his ability to bring the *Pax Gallica* to factious communities, tribes, and families of his district. Bringing France to the bush created social peace where before there had been division and parochialism, or so went the old colonialist trope that we can still find in Biasini's autobiography. The seasoned district administrator brought the mindset that had worked so well for him in Africa to his new job. In an interview published in *Le Figaro Littéraire* Biasini described his cultural work in the down-to-earth language of the man of action: "Culture is like a plant; doesn't it needs roots to prosper? I am a bit like the traveling salesman who will spread the seeds."[29] Traveling salesmen usually do not garden while on the road, but Biasini's intent is clear enough. And as to how the French Peace might work in the motherland, he concluded *Action culturelle, An I*, "*For, as varied, as multiple in its diversity as it may be, deep down this country is solidly united*; beyond doubt, its [accumulated] cultural capital has been the most binding cement of a community which appears so factious on the surface."[30]

Whence this sudden talk of a "varied" nation, "multiple in its diversity?" Why did Biasini need to assure readers of an official report that "deep down" the country was not divided? This was not General de Gaulle's "certain idea of France." Rather, this was a way of indirectly evoking a thing-not-said, that the new states of Africa, torn apart by the vast social transformation they were experiencing, might serve as a warning to a France caught up in not dissimilar internal conflicts. The task of bringing unifying cultural capital to the capital-deficient regions of France was urgent. It was Year I of a great social transformation, Biasini urged in an administrative report gotten up to read like a revolutionary manifesto.

Building Houses to Contain Culture

When Malraux began creating Houses of Culture, France had a real shortage of large public spaces. This fact once again underlines the importance for the public sphere of the café in the years before the war and, especially, of the meeting rooms that provincial cafés often made available for gatherings and entertainments.

Malraux was in a hurry to get this project started. Even before he could get an allocation for construction into his annual budget, he began to found Houses of Culture. As a result, the first Maisons dedicated were not expressly built for that function. In the years between 1961 and 1966 a museum in Le Havre was renovated into the first one created. In Caen the building intended to house a new municipal theater was transformed into a House of Culture. Bourges and Thonon started with unfinished social halls. In Firminy

a former youth center, redesigned by Malraux's friend Le Corbusier, became the Maison de la Culture.

However, from 1966 to 1968 structures expressly built as Maisons de la Culture—with multiple-use facilities central to their design—began to open their doors. The Maisons of Amiens, Grenoble, Rennes, Rheims, Nevers, and Chalon were entirely new buildings budgeted by the legislature for this new institution. A Maison was built in St. Etienne, but never functioned as such because in the wake of the May 1968 explosion the local government took it over.[31]

Three sets of overlapping considerations guided the Cultural Ministry's decisions about where to erect cultural centers. First, and most important, were the cities that already had resident regional theaters. Biasini expected that the directors and staffs of these companies would form the nuclei of the new multifaceted cultural institutions. This was the case of the House of Culture in Caen, which was founded in April 1963 and housed the resident Comédie de Caen. The institution in Bourges opened at the same time, with the Comédie de Bourges installed. In late October 1965 a Maison de la Culture was started in Rennes, in relatively backward Brittany. When it opened its doors in December 1968, it integrated the existing Comédie de l'Ouest. The Comédie des Alpes in Grenoble, that rapidly growing technology center, was housed in the Maison de la Culture conceived in June 1966 and finally opened to the public in February 1968. Not to neglect Paris, in October 1963 the Théâtre de l'Est Parisien (TEP), an old movie theater in the poorer, eastern part of the city, was given the status of a Maison de la Culture, although it functioned only as a theater.

There were, second, the municipalities which requested a Maison de la Culture and, after some scrutiny by the roving Biasini and his coworkers, seemed likely to be able to carry off the venture along the lines envisioned by Malraux and Biasini. Once new Maisons were announced, Malraux wanted quickly to create faits accomplis in the provinces. In May 1961 Le Havre was just about to open its new municipal museum when it agreed to contract with the ministry to turn it into the first Maison de la Culture. The mayor and city council of tiny Thonon (with just under 21,000 inhabitants) were very eager to create a Maison de la Culture. With everyone—local officials and the ministry staff—pulling in the same direction, the planning went quickly. Chartered in 1965, it opened its doors in June 1966.

Finally, there were the towns and their hinterlands targeted by the ministry people as important places in which to have centers for the good of the nation. Here should be mentioned the Maisons de la Culture at various stages of discussion or planning, but not yet opened before the collapse of Gaullism in 1968–69: Sarcelles, Angers, Lyon, Marseille, Strasbourg, Longwy, Pau, Créteil, Chambéry, Besançon, Brest, La Rochelle, Clermont-Ferrand, Macon, Mende, Valenciennes, and Nantes. Representatives of the ministry, primarily Francis Raison, who replaced the dismissed Biasini as

chief administrator of the Maisons de la Culture in 1966, were involved in preliminary negotiations with many other municipal governments as well: Ajaccio in Corsica, Bordeaux, the industrial complex of Lille-Roubaix-Tourcoing, the aerospace center Toulouse, Dijon, Limoges, Nancy, Perpignan, Poitiers, Mulhouse, among others. In many ways as cut off from the culture of the capital as many of the more distant places, the working-class suburbs of Paris were also targeted for Maisons de la Culture. And, in keeping with the old imperialist language which spoke of the "immaturity" of colonial populations, in cooperation with the Ministry of Youth, Houses of Culture *and* youth activities were envisioned for the Overseas territories that had chosen to remain with France: Réunion, Martinique, Guadeloupe, New Caledonia, and Cayenne.[32]

Building an Audience

In the Malraux years, France was literally on the move. We have noted the great displacements from 1962 to 1968. Grenoble, where one of the earliest Houses of Culture was established, increased its population by over 27 percent in those years. During the same period Caen grew 25.8 percent; Rennes, 19.5 percent; Chalon, 17.6 percent; Thonon, 17.5 percent; Rheims, 16.8 percent; and Bourges, 16.7 percent. Other cities where Maisons de la Culture were established grew too, if less dramatically.[33] There was no doubt in Paris that, all over the country, many French people were lifting their roots and moving to new places and unaccustomed environments. The new inhabitants did not know the old local notables, or owe them any allegiance. They did not necessarily care to follow the local patricians' pursuits or tastes in recreation, or even food. The nouvelle cuisine—with its lighter, Asian-influenced, and non-region-specific values—although invented in the Burgundy region, suited the nontraditional eating patterns and culinary values that grew out of this time of transformation in France.

We know something about the individuals who became members of local Houses of Culture, because most filled out questionnaires on joining. The Maisons "animated"—that French idea of eliciting action and pointing the direction—the new, modern France[34] in a specifically generational way: In the decade of the 1960s the age group under thirty made up around 60 percent of the members of the new Houses of Culture. That age-pattern makes logical the finding that the biggest group of adherents to the Maisons were students at all levels of study, who constituted on average a third of the members. Surely many of this number were dragged to the Maisons de la Culture by teachers. But even if a school trip was a young person's first contact with the culture house, that in itself gives us insight into the constituency of the new institution. For after students, the largest occupational group who joined were teachers. Schoolteachers, who more than any other part of the

population had guided the cultural initiation of the nation for the preceding three-quarters of a century, strongly supported the new cultural project. White-collar employees in significant numbers also joined, as did professionals and people working in middle management. Of the occupational categories of the members of the Maison de la Culture of Grenoble (1966–68) (to be sure, an especially active center of economic growth in the 1960s), 14.3 percent were middle management, 19.3 percent teachers, 35.8 percent white-collar employees, and 10.5 percent technical supervisors. No one conversant with the methods of social history would take the total of nearly 80 percent as a serious index of the part of the supporters of the Houses of Culture who belonged to France's new middle class. But still, many, many of them were manifestly of the new social strata, and seen as such by the planners of France's new cultural policy.[35]

Those who did not join, for different, if parallel, reasons were at the bottom of the social ladder—workers and farmers—and, at the top—employers in industry and commerce. In 1964–68 employers, admittedly a tiny percentage of the population, ranged from only 3.3 percent of Maison membership at the highest level of participation (Le Havre) to 1.4 percent (Caen) at the lowest. The Théâtre de l'Est Parisien, the Paris theater given the status of a House of Culture, had as many as 3.7 percent of its members designating themselves as employers. But the Paris grande bourgeoisie was—by both definition and tradition—not provincial.

The point here is that the established upper bourgeoisie, however loyal to political Gaullism, did not see Malraux's Maisons de la Culture as *their* institution. They liked neither its radical origins nor its democratic goals. They could easily get on a fast train or into their cars and spend time in Paris theaters and museums. Many could stay in the pied-à-terre their family kept in the capital for such trips. Nor did they like the aesthetics of the new theater productions, the Brecht plays that toured, or the classics played to emphasize modern problems. As Jean Vilar, Malraux's friend and sometime aide and the leading proponent of contemporary French popular classicism, put it: "The problem of Cuba is treated in Corneille's *Nicomède*, the problem of people's rights before the law is treated in *Antigone* by Sophocles. General de Gaulle's problem with the rebellious generals is perhaps handled in Corneille's *Cinna* and Zalaméa's *Alcade*."[36] Moreover, with a municipal theater playing the comfortable and, occasionally, the naughty classics as well as the good old repertory of operettas, why create a rival cultural pole and with that, cultural confusion, or—that most terrible word for this older generation of French businessmen—competition? They saw the Maisons de la Culture at best as ignoring their values, and at worst as openly challenging them. They were not at home in these houses.

Neither workers nor farmers felt that the Maisons de la Culture were their places. In questionnaires from 1964–65, only 5.6 percent of the members in Bourges identify themselves as workers; in Caen, 0.3 percent; in Le Havre,

1.0 percent. Surveyed again in 1966–68, Bourges now attracted 7 percent of its affiliates from the working class, Caen had moved up to 0.8 percent, and Le Havre now drew 7 percent workers. In those years, too, the Maison in Amiens reported 1.3 percent worker-members and Grenoble, 3.5 percent. Although located near working-class neighborhoods, the TEP could not attract more than 6.3 percent of its audiences from proletariat Paris. The workers most likely to be involved with the Houses of Cultures were also often relatively well educated trade union militants, political activists, or members of other voluntary social organizations. The only place that farmers broke above a 1 percent rate of participation was in the small town of Bourges (1.2 percent) Elsewhere where we have data, their degree of participation remained under 0.5 percent.[37]

If workers attended any staged performances it was most typically the frothy operettas loved by their bosses too, and, necessarily, in the old municipal theaters. Some liked grand opera too, even more than the music halls, surveys seem to show. At the very bottom of their list, as with their employers, were the new plays that were the glory of the French theater renaissance of the 1960s.[38] Both workers and employers wanted hummable music, plays with stories (funny or edifying), and art you could recognize, realism (photographic if possible). Satisfying these tastes, pandering to them, he would have said, was not what Malraux had in mind for the Maisons de la Culture.

When asked about their attitudes toward the new institutions, workers, unlike employers, did not see the Houses of Culture as a threat to what they had, but rather as remote places too difficult to get to and foreign to their world. Seeing performances there meant eating quickly, cleaning up, dressing, going to an unfamiliar part of town, sitting among strangers, and getting home very late on a workday evening. Some French commentators focused on this sort of inaccessibility as the most important reason for workers' absence from theaters and concerts. To try to overcome such barriers to creating a real people's theater, Jean Vilar often started his plays earlier than the usual 8:00 or 8:30 and offered cold boxed suppers to anyone who had not had time to eat.[39] But in research conducted during the Malraux years, Pierre Bourdieu and his collaborators found a more fundamental sort of inaccessibility. Workers (and probably farmers, although there were too few to yield significant samples) nowhere learn the keys to the codes which might unlock the sanctuaries of high culture for them. With no experience of live theater from their upbringing or school, they did not know what they were seeing on stage. They had no knowledge of the conventions of theater, nor where and when the viewer was expected to suspend disbelief. Offenbach and Bizet, with their lurid depictions of big, obvious, emotions and their pretty arias, were not so mysterious.

In art museums the problem of impenetrable secret codes loomed even larger. When in the late 1960s Bourdieu's investigators asked workers what museums felt like when they were inside, many of their answers clustered

around responses of the sort, "like in church." For those not provided with the magic eyeglasses, which only accumulated cultural capital could supply, an art museum was a place of mystery and authority, evoking perhaps fear, or a sense of duty, maybe awe, but rarely pleasure.[40] In his report to the Ministry of Education, written in those more innocent days just before the May 1968 explosion of young people against inherited cultural authority, Bourdieu proposed helping the workers, or at least their children, *see* like bourgeois museum-goers by having the schools offer arts appreciation courses. It was the old and well-tested republican formula: have the schools make up for the cultural, intellectual, and social shortcomings of the family.

Museum attendance in France today is way up, as seems to be true in most other Western nations. Perhaps Bourdieu was right, at least about cultural barriers to the aesthetic heritage of France. As the labor force has become increasingly brain workers and less and less manual workers, the life-style barriers to cultural access seem to be falling too. Going to see blockbuster shows in museums in New York, Washington, or Paris has, like weekend brunch, become part of the habitus of the middle class. Maybe, too, the several-generation orgy of television watching has privileged the visual in every form in Western cultures. Maybe more people have learned to see better.

Popular Culture?

Whatever differences their explanation of cultural barriers manifest, neither Queyranne nor Bourdieu proposed that the problem lay in the conflict between a high and a *workers'* culture. René Kaes's investigations in the mid-sixties asked workers about their belief in or interest in building a proletarian culture in France. Only 9 percent of those he asked showed any interest in such a thing. They did not want to be ghettoized outside of what they considered the mainstream of French cultural life. But they did want their levels of learning and knowledge to be taken into account in the Maisons' offerings, and the trade unionists among them, in Grenoble for example, overwhelmingly wanted to see more values important to workers incorporated into programs. Many were especially critical of the Maisons de la Culture for not fostering popular education.[41]

How much truth is there in the vision of the wonderful social theorist Michel de Certeau—that people on the bottom of society, workers among them, pick through the culture coming down upon them and construct their own culture worlds with pieces they choose for their own expressive and creative purposes?[42] De Certeau, I think, is more read and appreciated by intellectuals in the United States than in France because his ideas make better sense in our more pluralist society. Look, for example, at the way African American young men "sampled" records to make new music, or the way

they turned prison wear—no shoelaces, no belts, baggy clothes—into fashion statements. Never mind that it is the genius of American consumer capitalism to harvest the cultural adaptations/inventions of lower-class ethnic minorities and repackage them as profitable commodities. In the story cycle of cultural invention, hegemonic projects are systematically undercut by acts of empowerment, which are then recuperated by the powerful to start a new round.

But the picture is not so clear for France. Perhaps we haven't been asking the right questions about French culture. Perhaps the places for maverick cultural expression there are fewer and more isolated. Or perhaps high culture is still the only game in town (Paris, that is) What was certain, at least until May 1968, was that Malraux's Houses of Culture were not part of such a culture cycle of hegemony-empowerment. The directors of the Maisons tried to address differences in taste by mixing their programs of plays, films, and art shows to present a spectrum of old and new, relatively digestible stuff as well as heavy fare. But leftists though most of them were, they dictated the programming. *They* knew what was valuable and progressive in the culture, and besides, there was no workers' project, or anyone else's for that matter, for cultural empowerment.[43] This was the story of cultural power until the rebellion of May 1968 challenged the rules governing the directors' relationship to the state. But May 1968 signaled more a legitimacy crisis concerning the state's role in the national culture than a specific questioning of that culture's class content.

Supply-side Culture

Malraux never used the word *participation in relation to the Houses of Culture*, nor did he encourage it. His idea of outreach was to create audiences, not active participants. He rejected amateurism in art and nonprofessionals deciding about access to it. In a policy directive written in July 1967, his confidant Pierre Moinot could not have been more explicit: "The public . . . can have no important role in the management of the House of Culture. It's normal that its members would want what they know, that they would favor the old war-horses [*valeurs sûres*]. How could it [the public] invent what it doesn't know. . . ?" Nor could leaders or representatives of local cultural associations be involved in any important role. Under the banner of "full independence of the artistic sphere," Moinot barred any interference with the state administration of the Maisons de la Culture.[44] As authoritarian as in governing style, Gaullism refused any direct role for citizens in the management of the Houses of Culture.[45] In the words of Jean-Jack Queyranne's brilliant thesis on the Maisons de la Culture, "The Houses of Culture became a privileged space for the recuperation of a diminished desire for celebration; the place where dreams were emptied of their energy and

of their force to conform them to a system of values expressed in the confining structures of the buildings."[46]

The operational premise of Malraux and the majority of his coworkers in the Houses of Culture—at least until May 1968 made them rethink—was an idea associated with the glorious days of French *civilisation* in the nineteenth century. The grande bourgeoisie, which was both the audience and, for much of the century, the most important economic support of the arts, believed in the truth of an economic formula named after a famous economist of the age, "Say's Law." This rule stated that supply creates its own demand. Consumption and consumers need not enter the thoughts of manufacturers or policymakers; that side of the economy took care of itself. The industrialists' demand for resources of all kinds needed to make a commodity *automatically* put money into the hands of raw material producers, middlemen, merchants, and of course workers, and created the purchasing power for what the industrialists made. The manufacturers needed only to make things, this formula showed; the customers would surely appear.

Interestingly, the formulation of Say's Law in the 1820s heralded the triumph of French aesthetic modernism later in the century. The aesthetic version of the economic paradox that supply makes its own demand might be rendered "new art creates its own new public." Of course, there is no text that puts it so crudely. But, historically, it is the unstated assumption of modernism in art. The aesthetic economy of modernism always promised success for innovative producers. Everyone knows the hallowed tale: despite an entrenched and powerful old guard, an insensitive public, cabals, and personal agonies, the works of modernist artists in the end triumphed. Even poor Vincent van Gogh, who sold one painting in his lifetime—and that to his brother—has, in public esteem, triumphed over the academic artists who painted when he did, or so the metanarrative of modernism has it.

For Malraux and the theater people who directed the Houses of Culture, the only important consideration was increasing aesthetic supply to the provinces. They could then wait for the demand to emerge. But they waited in vain for some segments of the population. In its contemporary regilded version, supply-side economics, Say's Law is nonsense. When their purchasing power is weak, customers do not materialize, money in hand. Nor did the Houses of Culture reach those in the regions or on the social ladder with limited cultural resources. Malraux built twelve Houses of Culture for them, but they did not come.

Early in 1968, General de Gaulle decided to attend the inauguration of the Grenoble House of Culture. This of course was a special honor; normally he let André Malraux preside over these ceremonies. But it was also the occasion of the Alpine Winter Olympics held nearby, so there were large crowds in the area, with media, press exposure, etc.

Once there, the General asked that the revolving stage in the new theater, a wonder of modern design, be run for him. He and his accompanying staff

mounted the stage, and it began slowly to turn. As Francis Raison recalls the scene: "One rotation, two rotations, ten rotations. The General began to find the time dragging. You could see, he began tapping his foot." An upset stage technician rushed up and stuttered into Raison's ear, "M . . . , Monsieur le Directeur, I can't stop the machine." More turns. "For a few seconds," Raison remembers, "I imagined the General and his distinguished entourage turning on that stage forever, living symbols of the immortality of culture. . . . Cold sweat ran down my back." The stage crew finally stopped the runaway apparatus. The ceremony to inaugurate yet another regional flywheel of the eternal culture of France continued with no further mishaps.[47]

Malraux's Houses of Culture discomforted the established local bourgeoisie, eager to reap the benefits of the promised decentralization. The powerful state was reaching into their local world of both class and aesthetic values in this new way. When the Maisons' directors sided with the 1968 rebels, it gave the local notables the opportunity for which many of them had been waiting, to take the institutions over or close them down. This was understandable. The Maisons de la Culture had been the most important new state organ for managing the nation's aesthetic culture since Cardinal Richelieu had founded the Academies. They had become a major field of battle between the state's cultural administration and the aesthetic masters of the civil society. Let us now look more closely at the public/private division of cultural institutions. The interaction of the two spheres was sometimes antagonistic, sometimes symbiotic, but always problematic as the state took on new cultural missions.

7 Public and Private

Many, many, things went wrong in the first ten years of the new ministry. Some were laughable, but others were serious problems. De Gaulle had entrusted it with a new, very grand but very vague mission, and not much money. The staff was inexperienced, at least in managing Europeans. It was the first ministry ever to be run by a macho existentialist novelist. Even more piquant for critics, Malraux's appointment put a convicted archaeological thief in charge of guarding the treasures of France. Malraux and his people worked in the sometimes intoxicating, sometimes discouraging, but normally disorderly, world of the arts. The friendly skeptics weren't entirely wrong to think of it as the fanciful ministry. But behind the chaos of new beginnings by new people we find a profound transformation of the relationship of the aesthetic sphere to the French state. That important and very messy change will be the theme of this chapter.

When Malraux assumed office in 1959, a private culture sector co-existed with a three-hundred-year-old outsourcing scheme first put in place by Cardinal Richelieu. At the beginning of the Fifth Republic the French state itself *directly* controlled relatively few cultural institutions: remember the jokes about "the Beaux Arts plus Malraux." In the ten years of the new ministry, and continuing under Malraux's successors, most actively the Socialist Jack Lang, the division of labor among cultural institutions shifted markedly. The private sector remained and even prospered. But the power of the system of special statuses and autonomous academies had been dealt a death blow.

This chapter then is about two countervailing processes. The first is Malraux's implementation of the dream of the more utopian thinkers of the Popular Front: the state's taking on direct responsibility for the nation's aesthetic culture. He nationalized French culture. As in the case of some banks and in-

dustries of France, he put key cultural institutions under direct state control. The second story, however, is about the often stormy negotiation of a new modus vivendi between the private and state culture precincts in ways that enriched the private and limited, even disciplined, the power of the state culture apparatus. Both processes are best seen at their moments of intense interaction. Normally, in France, that means moments of scandal.

Piquant Tales for Historians

Fortunately for writers of current history, reports of accidents, government crises, and scandals often light up the hidden workings of a system. Even with attempts by the authorities to keep what is going wrong a secret, or to deploy damage control measures, both the media and more informal information networks sometimes allow the public glimpses into the secret workings of power. In a more peaceful moment—after the drama is over—scholars learn details about the decision-making process of the powerful and their ways of acting. They can look at how those in charge were, or could be, responded to by those with no offices, budgets, or police, but with other forms of symbolic capital.[1]

Think of what we learned about the workings of government from the publication of the Pentagon Papers or the discovery of the Watergate break-in, or the mistake—in several senses of that word—of the French General Staff's accusing Captain Dreyfus of being the German spy in their midst. But, contrary to conspiracy theorists' articles of faith, not all obscure workings are bad. Certainly, studying the disasters, blunders, and tests of the Malraux years will tell us a great deal about the pathologies of state-managed culture. But it will also show us some of the benefits from the French state's involvements with the arts.

I will argue that *all* the horror stories I tell here, and the stories of some of the events that ended well, are the likely, and *acceptable*, consequences of circumstances of creativity in which the government—not elite self-perpetuating academies, patrons, or consumers—pays most of the bills. The benefits to France made the troubles endurable. A major feature of the society which has protected, and will continue to save French state-sponsored cultural life from becoming what Stalin's Zhdanovism created in Russia and Eastern Europe, I will propose, is the existence of an alternate public, namely the nonstate cultural sphere in France. This coexistence—and even interpenetration—of state and public spheres generated the force that drives, yet at the same time restrains, French culture wars.

Three questions might be kept in keep in mind as a kind of grid to lay over the series of accounts of exemplary incidents, problems, and struggles in the new ministry. (1) What was the price that art had to pay to be aided,

and therefore to varying degrees, to be managed by the state? (2) Did the benefits of the relationship outweigh or at least equal the losses? (3) What new dynamic balance between the state and culture producers came out of each, and from the sum of their collaborations and conflicts?

What trial? What errors? What benefits? The list is long, and the stories—many of them—are spicy. I have selected the most instructive cases. First came the fight about whether Marcel Landowski or Pierre Boulez was to become, in effect, France's commissar for music. Each had a different sense of the place of music in national culture. This event tested the ministry's will-to-creation versus its imperative to spread culture—in this instance, musical culture—in France.

Could the government improve the training of artists and the quality of art making? Here we must look at the not always successful attempts to make various aesthetically challenged arts institutions—the Opera, the state theaters, the Comédie Française, the Beaux Arts school—function, or function better. The attempt to reform the Opéra Garnier in 1968 is instructive about the problems in this area.

Then, inevitably, if the government pays, someone offended by the artwork subsidized will step forward and demand its defunding. We Americans know a great deal about this kind of arts-censorship-by-budget. For the French version, we will look at a legislator's demand that the production of Jean Genet's radical *Paravents* (*The Screens*) playing at the Odéon state theater be suppressed.

The fate of cinema in the Malraux years gives us two issues to address. First, did the government recognize new talents and encourage them? Here the efforts of the writers of the *Cahiers du Cinéma* to become filmmakers known collectively as the New Wave, or Nouvelle Vague, is the story to tell. But there is a also an instructive scandal: Malraux's (shameful) firing of Henri Langlois, the founder and director of the Cinémathèque. Many of the cineasts of the Nouvelle Vague had spent their adolescence watching and learning from the old films they could only have seen in Langlois's vital, if messy, museum.

Finally, the permanent question, in our time posed with increasing directness, of whose responsibility the culture was, anyway: the state's or the ancient academies. Recent disputes offer a good perspective on the running fight because contemporary French cultural conservatives have singled out this issue to attack what Malraux started in 1959. In an echo of the American debates about the canon and public funding of the arts, the specialist on seventeenth-century rhetoric at the Collège de France, Marc Fumaroli, published a famous polemic. He dedicated his *L'Etat culturel* to exposing the long-term plot he traces from Malraux to Jack Lang, the conspiracy to take French *civilisation* away from its learned guardians and nationalize it as if it were some auto plant or failing computer company.

Dissonance

Because the stakes were the future of French musical culture, we begin, in the middle years of the Malraux era, with the ferocious fight about the direction the new ministry should give to music in France.[2] A bit of context, first: In the postwar years, by the measures of both creativity and performance, French music was not at its height. Important composers were working in France, including Olivier Messiaen, Francis Poulenc, Marius Constant, and Maurice Duruflé. Darius Milhaud, although he spent much of his time as professor at Mills College in California, was often in France. But the most prominent musician was the brilliant composer, conductor, and powerful champion of a French version of Schönberg's twelve-tone system, Pierre Boulez. He fought hard to institutionalize serial music in France, although he himself had not—has not—completed many works in this style. Marcel Landowski also composed, but when Malraux first met him he was the director of the Conservatoire de Musique in Boulogne-sur-Seine, the suburb just outside of Paris where Malraux was living in 1960.

In contrast to other major cities in the West, Paris had no regular symphony orchestra. The musicianship of neither the Opera nor the radio orchestra was equal to the standards then expected in Italy, the two Germanies, Britain, and the United States. Other than these two Parisian bodies, the only other full-time French orchestra was in Strasbourg. The rest of France's musical organizations hired musicians just for the six- or eight-month season and then closed down. There were thirteen professional orchestras of this type. In additional the ministry counted about sixty semi-professional groups with regular, if short, seasonal programs, as well as an assortment of military bands.[3] In contrast, in the mid-60s London alone supported three of the world's greatest year-round musical organizations: the BBC Orchestra, the London Symphony, and the Royal Philharmonia. In 1966 there were eighty-eight full-time orchestras with their musicians on annual salaries in West Germany.

With most professional musicians performing, in effect, only part-time, the quality of French musicianship suffered. And as a result of such haphazard apprenticeships, musicians invited to play with the country's three full-time orchestras were less seasoned than instrumentalists in many other lands of Europe. Moreover, French musical training was terrible. To be sure, there was the Paris conservatory, which was funded by the state. It trained musicians competently for the few low-paying jobs that death or retirement might make available. But much of French musical education took place in the provinces. The local conservatories were run and largely funded by regional governments or municipalities. Some ranged from good to adequate. But others were badly underfunded, ineffective, and too often staffed by the musically inclined wife of the mayor or an unfortunate cousin of some munici-

pal councilor who didn't make enough from giving private lessons. In 1966, at the moment a Service de la Musique was created in the ministry, France had forty-four municipal music schools that were called "national." They received on average 1 or 2 percent of their budget from the state.[4] France suffered from an institutional domino effect in the realm of music. Poor training made for poor performances, which in turn formed a public with low or no expectations. Music was not part of the school curriculum. Demoralized and underpaid musicians disrupted the season with work stoppages.

Malraux himself was below average in openness to music even by the low standard set by most French literary intellectuals of the era.[5] But by 1962 the poverty of French music had become a public scandal at home and a dishonor to the nation's cultural reputation abroad. In that year Malraux appointed a commission to study the problems. It was chaired by Robert Siohan, a civil servant, and by Emile Biasini, whose office had been entrusted with music issues. Reporting in 1963, it most notably recommended the creation of a full-time Paris orchestra. Remarkably, the most important justification for such a group was that it could be sent on international tours to be, in the words of Marcel Landowski, a member of the commission "an ambassador of French music."

Nothing was done in 1963 or the next year. The ministry's 1965 budget proposal still did not request new funds for music, nor make provisions for a Paris orchestra. In 1965 a protest-petition signed by thousands of French musicians was presented to the ministry. The "Call for the Defense of Music in France" was the extra push needed. The time had come to appoint someone in the ministry whose prime concern was fighting for French music.

By any measure, Pierre Boulez was France's most famous musical personage. As a music student in the early fifties he had terrorized the established avant-garde with his brilliant polemical attacks on their lack of aesthetic boldness. In his 1951 article "Schönberg Is Dead" (toned down and published in England, but never published in the original French), for example, he had accused the composer both of failure to develop serial music to its full possibilities, and even of having retreated to older, exhausted, forms.[6] The next year, he declared the work of nonserialist contemporaries "useless." Speaking with the authority of the *Zeitgeist*, he declared their "whole work is irrelevant to the needs of [the] epoch."[7]

In 1954 Boulez founded the Domaine Musical, a private society, as a setting in which he could play both contemporary and little performed older music for a limited, musically sophisticated audience. Schönberg had resorted to such a solution to deal with the hostility of general concert audiences to serial music: he had created his own audience in a private musical society. The Domaine was at the center of French new music in the late 1950s and throughout the 1960s, and Boulez served as its main conductor and principal driving force until he left the country in 1967. The Domaine Musical was notable for its musical elitism, so it was the more remarkable that Boulez

early found private funding for the society's concerts. He first floated the project with subsidies from the Barrault-Renaud theater company, of which he was then the musical director. But soon Suzanne Tézenas, wife of a wealthy Parisian industrialist, took up Boulez and the cause of neglected and new music, and helped him raise the money to run his venture. In some ways more important than her own money was the eighteenth-century kind of salon she created, where Boulez and his culturally advanced friends met her advanced wealthy friends. There appreciative patricians consorted with, and heartened, French abstract painters and marginalized avant-garde musicians.

This means of spreading his influence and of financing kept the Domaine Musical afloat until Boulez could begin to attract some state funds. On assuming power, the Malraux ministry began to give a little; by 1963 the state was contributing a modest 11 percent of the budget. More impressive for a French cultural venture, in the same year private donors put in 57 percent of the operating budget.[8]

At Madame Tézenas's salons Gaëtan Picon, a long-time literary champion of Malraux's novels and his first director of Arts and Letters, met Boulez and took up his cause. In 1965 with pressure mounting to do something about France's forgotten art, Picon urged Malraux to create a post in the ministry for Boulez. Biasini, his deputy, volunteered to carve out a separate office for music from his own administrative area for Boulez to head. Both Boulez and Biasini saw the Houses of Culture, which Biasini directed, as the places to begin the musical reeducation of France.

Malraux, however, wanted Landowski. A tug of war began, which quickly degenerated into a nasty fight. The causes of the conflict were overdetermined. Boulez was a charismatic, difficult, dominating figure; Malraux wanted to reserve that role for himself. Boulez was a firebrand, rumored to be close to the Communist Party. Moreover, he was, for some tastes, excessively cosmopolitan; he was always traveling around the world to conduct major orchestras, and he spent his summers in Darmstadt teaching at the International Summer Courses for New Music.

Landowski was politically safe, even conservative. He directed a local conservatory. He came from a well-known artistic family. In the days of the Third Republic his father had been a prominent French sculptor of monumental statues which had won him election to the Academy, where his son Marcel would follow him.[9]

But in terms of the future of French music, probably the greatest difference between the two candidates was Landowski's interest in spreading or enhancing musical education through the existing music and public schools versus Boulez's strong commitment to encouraging making new music and reeducating public taste in the framework of new institutions. In the language of an earlier French cultural revolution, Landowski played the Girondist while Boulez was proposing musical Jacobinism. In his memoirs, Landowski described the choice for Malraux and France as between encouraging de-

mocracy and eclecticism in music everywhere or following "an elitist policy, Parisian, of an exceptional quality surely, but oriented to promote and to valorize only the avant-garde."[10] The Gaullist project, Malraux's project, focused primarily on spreading the culture through France horizontally and downwards in society. Was this a task to entrust to Boulez?

The tone of the conflict grew increasingly bitter. Of course, the newspapers of Paris, where important cultural disputes are front page news, covered the battle stories and carried the exchanges of salvos. Bernard Gavoty, conservative music critic of the conservative *Figaro*, celebrated Landowski as the right man for the task and denounced the "Hitlerian methods" of the Boulez camp. In response Boulez heaped scorn both on the critic and on Landowski's talents. Finally, on 4 May 1966, Malraux announced Landowski's appointment.[11]

In the intellectually leftist *Nouvel Observateur*, a furious Boulez attacked Malraux with a scornful open letter to Darius Milhaud, new president of le Comité National de la Musique, which had opposed his appointment. Titling it, not completely accurately, "Why I Said 'No' to Malraux," he wrote woundingly of Landowski. The post needed a person of special talents, Boulez declared, not one of France's "failed composers." He announced his immediate resignation from all his commitments in the official French music world, abandoning his Domaine Musical and his connections with all French orchestras, including his conducting post at the Opera. Calling his actions "going on strike against the French musical establishment," he announced that he was leaving for Germany.[12] Rather than stay in the French state that had snubbed him, he ostentatiously took up a conducting post with the good, but provincial, orchestra in Baden-Baden.[13]

The passions and recriminations of the public dispute flowed back over the ministry. Malraux became so angry at Biasini's opposing him on this appointment that, soon after naming Landowski, he summarily fired his director of Theater, Music, and Cultural Action. Also a partisan of Boulez, Gaëtan Picon left the important post as director general of Arts and Letters at the same time. Both men had been early hires; they had built the ministry with, or one could even say, *for* Malraux. He had kicked out perhaps his two most talented coworkers. Malraux's act was seen in the intellectual community as shameful. It was.[14]

Landowski set immediately to work to reform French music performance and teaching. He began with little means and with a shadow still hanging over him as the second-best candidate. Moreover, his portfolio did not include the Paris Opéra or the Opéra-Comique, or the other opera companies in Lyon, Toulouse, Bordeaux, and Strasbourg. He was given no role in directing the Paris Conservatory of Music or the music department of the national radio and television administration (l'ORTF). But he did command the state-controlled municipal music schools and regional conservatories.

And he was entrusted with subsidizing private musical groups and festivals, and with awarding state commissions to composers.

His first highly visible move was the creation of a full-time Paris orchestra. Although setting up this body had been the major recommendation of the stalled Siohan report, for Landowski it was an ironic first act. In the contest over the music post he had rejected Paris musical elitism. Moving quickly, he began putting the orchestra together in June 1966. Like small merchants in a neighborhood resisting a new competitor, some musicians, especially those of the Opera orchestra, closed ranks against the well-funded intruder.[15] Jacques Allusion, his second in command, did most of the planning and organizing to get the new orchestra started. In the colonial service, he had learned how to "bullshit your way through" (*se démerdait*). "We had to learn not to slavishly follow rules. If I had been a metropolitan lawyer, I would never have been able to organize the Paris orchestra the way we did."[16] To his credit Landowski prevailed upon the excellent Charles Münch to return to France to become the first conductor. The first performance of the new Orchestra of Paris took place in October 1967. Malraux attended the opening, one of his very rare appearances at a musical event.

Having announced himself with the sound of a new orchestra, Landowski turned to carrying out his intended long-range reforms. He set out first to spread musical culture in France while at the same time enhancing its quality; and second to create in the regions what he called "complete musical entities." These configurations were to comprise at least "a conservatory of quality, a symphony orchestra of quality, an opera house of quality."[17] As a first step to fulfill his promise to spread and improve the music available in the land, he sent the new Paris Orchestra on tour to many of the Houses of Culture.

And after long negotiations with the Ministry of Education, he got an agreement to bring music into the French school curriculum, taught in a lively way. Youngsters were to be encouraged to sing songs, rather than the solfege, sounding notes up and down the scale, that had been beginners' musical education. But after a show of cooperativeness, the Education bureaucrats began dragging their feet when it came to implementing many of the other measures about which Landowski thought they had an agreement.[18] Nonetheless, the small changes that remained in place aided the rediscovery of music of all sorts among the young in the subsequent decades. And the rich musical culture of present-day France owes more than a little of its beginning to the plodding Marcel Landowski and the largely tone-deaf civil servants and intellectuals of the Malraux ministry. Musically, they were ahead of many of the adult population.

Fiery intellectual polemics in France are often more family quarrels or theater than real grudge matches. The famous exile Boulez went on to conduct the BBC Orchestra and the New York Philharmonic, and to serve as

musical adviser to the Cleveland Orchestra. But the scandal of France's greatest musician living and working abroad was quickly repaired, although not at Boulez's first asking price of making an especially severe—and perhaps exhausted—version of the twelve-tone system the state-approved form of French composition. Some months after the drama about the music post, Malraux asked him to serve on a major board of inquiry on the Opera, and Boulez accepted. The state's apparent rejection of the enfant terrible began to be repaired.

When Georges Pompidou arrived in the presidency in 1971, one of his first acts was to invite Boulez to create his own musical center—what in 1977 became the Institut de Recherche et de Coordination Acoustique/Musique (IRCAM)—in the planned modern art complex to go up at Beaubourg. There Boulez resumed his project of making Paris the avant-garde center of modern music by making himself contemporary music's pope. The IRCAM gave public performances of many pieces written under its aegis—though usually the premiere was also the last performance of these difficult works.

Boulez's creativity was not lost to French national culture. Is it a surprise that, with his productive period largely behind him, this great troublemaker campaigned successfully for election as one of the forty Immortals of the French Academy? Landowski had preceded him by only a few years.

"Anti-French? Why It's Anti-Human": The Art of Jean Genet

In the fall season of 1966 Jean Genet's *Paravents* (*The Screens*) opened at the Odéon, renamed the Théâtre de France. Criminal, blatant homosexual, leftist, anti-imperialist—and someone who made great literature from all this—Genet in life and art tested the limits of tolerance in the Gaullist era. The issue this time was continued state funding of art that many viewed as noxious.

When Genet was about to be imprisoned for life after being convicted of a fourth criminal offense, literary Paris, led by Sartre, organized a successful campaign to get him pardoned. While the rebel was marching at the head of an illegal demonstration, the police commander on the scene infuriated him by addressing him respectfully as "Cher maître." But this "anti-French" and "anti-human," play, in the words of André Malraux, its defender, was perhaps over the top.

Les Paravents is set in Algeria during the Algerian War. The simple and powerful staging uses only screens put up at various levels. Characters stand before, hide behind, and write upon them. In seventeen often brutal scenes the work confronted the audience in the state theater with the cruelty, torture, greed, obscenity, lust, and shame of the Algerian War. Because of French society's tendency to handle shameful and divisive issues by, for as

long as possible, not speaking of them, Genet's play, staged just a few years after the fighting had ended, was especially provocative.

The French characters are horrible, although Genet is not very sentimental about most of the Algerians either. The roles include Algerian men and women, as well as French players in the world of imperialism: soldiers, of course, but also a judge, a nobleman, a member of the Académie Française, a missionary, a European prostitute, and the living and the dead (with the same actors doing people of different sexes). A lot of the action is set in or in front of a brothel run by Algerian women for combatants on both sides.

The piece mocks patriotism and reverence for war heroes. Buttoning up his fly as he walks out of the brothel, an Algerian combatant rhapsodizes to his friends: "Boys, I recommend tearing off a piece during the unveiling of a monument to the war dead, while listening to the patriotic speech!" It also revels in scatological moments; for instance when a dead French lieutenant cannot be taken back to be buried in his native soil, his men—who come from all over France—fart upon his corpse to connect him with home. In a kind of funeral oration the character Jojo says: "If he's not buried in Christian soil, at least let him die breathing some air from home." Another French soldier tells how he died: with his pants down in a latrine, he was killed by Algerian rebels, "the very moment I was squeezing (laughter)." [19]

Not far away from the theater in the Latin Quarter, in the Assemblée Nationale, the annual budget of Malraux's ministry was under consideration. Questions about the play were asked in the hearings of the budget committee, on the floor, and in the press. Breaking ranks, the Gaullist deputy Christian Bonnet read the script of the officer's unusual memorial service into the parliamentary record. The Catholic intellectual Gabriel Marcel had just decried the growth of such putrefied writing in a number of the *Nouvelles Littéraires*. In his influential column in the *Figaro Littéraire*, François Mauriac assessed as very high the price a people must pay, especially its youth, if it succumbs to Genet's mockery of our metaphysical sense of good and evil. Another Gaullist deputy, Bertrand Flornoy, joined Bonnet's attack on the state's subsidization of *The Paravents*, and, for good measure, added *Marat-Sade* to the list of offensive plays unfit to benefit from state aid. Genet was destroying morality and abasing all that was great in French letters. Conservative legislators didn't want to censor the work, no. But why was the state subsidizing this filth (*pourriture*)? Bonnet simple wanted the play's production costs, some 270,000 francs, excised from the ministry's 1967 budget.

Malraux hurried to the Assembly to respond. "Freedom," he said, addressing the legislators, " . . . does not always have clean hands. . . . Other great artists have gone too far: Goya, Baudelaire." Even if you find your sensibilities offended by the play, "it's unreasonable to forbid it. What makes better sense is for you to go somewhere else." This piece is not the only work

Figure 29. Malraux with General de Gaulle at the Théâtre de France for the premier of Paul Claudel's *Tête d'or*, 21 October 1959. Keystone-Sygma.

performed in the state theater; they play Shakespeare too (figure 29). Ending the subsidy for Genet's work would affect all the productions. In any case, if *Paravents* were closed at the Théâtre de France, it would reopen in a private theater. And because of the scandal surrounding it, it would assault good taste for five hundred more performances. "We didn't authorize *Les Paravents* for what you criticize in it, perhaps rightly. We allowed it to be played despite that. . . ."

Malraux's spirited defense and, probably, party discipline won. Flornoy and many deputies who agreed with his criticism first declared that they would go so far as to vote for removing the play's costs from Malraux's budget. But finally Bonnet himself withdrew his amendment. *Les Paravents* continued to play, continued to receive its state funds, and continued to shock.[20]

Fixing the Opera: "Not Just Another Plaster Job"

Everyone offered plans to heal the ailing Opera, the costly, terrible, and uncreative old monument to fashionable nineteenth-century Paris. Soon af-

ter the ministry was created, Maurice Fleuret, a young leftist musician who worked with Jean Vilar in the early 1960s, proposed an evening in which the public would be offered a kind of opera sampler, an act each from *Faust*, *Carmen*, and *Jeanne au Bûcher*. The production would follow the populist-accessible style of performing the classics pioneered by Vilar at his Théâtre Nationale Populaire.

Fleuret was ushered into Malraux's office to present his plan. A long silence. The facial tics that had become a part of Malraux's appearance intensified. Finally he spoke, "I won't democratize the Opera." That ended the interview. Fleuret resigned his post in the just-formed music administration. He reentered it only in 1981, with Jack Lang and the Socialists.

Fleuret, like Boulez, was perhaps too left and too aesthetically provocative to serve the Gaullist ministry. He had also brainstormed a scheme for better diffusing high culture by having classic works of literature printed on rolls of toilet paper. It was flushed down by Jean Rouvet, Vilar's chief administrator and Fleuret's boss, just before they were to launch the ad campaign for the new editions.[21] Nevertheless, something had to be done with the sick old Opera. Malraux turned to other dissidents. Less than a year and a half after his definitive "non" to Malraux, Boulez agreed to serve on a discreetly constituted committee the minister had impaneled to help reform the "bankrupt"—the adjective contemporaries usually added—Paris Opera. A second innovator named by Malraux to the committee was the theater wonder-worker Jean Vilar. In February 1963 Vilar had startled Malraux, the public, and the two hundred workers on his payroll by dissolving his theater company at the Palais de Chaillot. Meager funding from the ministry, he declared had made it impossible to continue. Now some five years later, Vilar too was willing to try to work with Malraux and the state once again.[22]

The corps de ballet of the Opera had also become lame. Malraux persuaded France's preeminent ballet director, Maurice Béjart—at the time in his own self-imposed exile in Brussels—to agree to work with Boulez and Vilar in formulating recommendations for changes.

What energy and imagination these three great artists brought to planning the revival of the Paris Opera! The conservative Gaullists were horrified that these three troublemakers were laying hands on a monument to the old culture. Vilar chaired the group. They gained the good will of the current director of the Opera, who was prepared to go along with their recommendation. Then came the May 1968 explosion. It slowed their work, but, they continued it through the politically hot summer.

Vilar sent Malraux a draft report in September. It was devastatingly critical. The committee called for better planning of all aspects of the Opera's activities, from scheduling rehearsals, to commissioning new works, to state financial input. The organization had to work more effectively: there had to be more rehearsals, and an adequate rehearsal space had to be found. The various crews had to cooperate better with the goals of the institution. The

productions, Vilar wrote, should no longer be regulated by what he called "codes of laziness." If these improvements were made, Vilar and his colleagues anticipated that more operas could be performed per season.

To improve quality, the investigators wanted first to get rid of the mediocrities and replace them with "world-class performers" (*acteurs mondiaux*). They also wanted the tired repertory updated. Music and dance should be placed on an equal footing, Béjart got into the report. A school of musical research should be associated with the establishment, was Boulez's contribution.

As for audiences, the Opera had to reach a greater public. That was Vilar's interest: he wanted the performing arts to reach what he called the vast "non-public," the members of society thus far excluded from access to high culture. Better attendance would help keep prices down. Several solutions were possible. A new, bigger hall might be built. Or the government could dedicate another theater to opera. But not the Opéra Comique, it was too small, and the committee wanted it closed in any case; it was beyond reforming. A road company might be created, so that one troupe could perform in Paris and the other always be on tour, bringing opera to the provinces.

Vilar concluded the report's proposals by asking rhetorically whether as a consequence of "the accident of May 1968" these important reforms would be shelved. He and his colleagues hoped not. They did not want just "a new plaster job on the Opera, but rather the creation of a Popular Lyric Theater." [23]

But soon Malraux left office with de Gaulle, and there was no one to receive the final report. The minister who asked for it was gone. The investigators disbanded. Many years later President François Mitterrand had a second opera house built at the Place de la Bastille. He justified it as an opera house for the people. It has plenty of rehearsal space, everyone can see the stage well, and it is well located. But the tickets are very expensive. The performances have not been equal to those of the other opera houses with which it might wish to compare itself. And there have been constant quarrels and scandals, with resignations and firings of the house leadership. Meanwhile the old Opéra Garnier, now primarily dedicated to dance, continues to drift rudderless. Perhaps President Chirac might consider appointing a commission to study how to make the two houses work better?

French Film: Take 1, The Nouvelle Vague

Historians have always had difficulty predicting the coming of a golden age in the arts. We are not bad at what Donald McCloskey called "postdiction." [24] Before and during, however, waves of creativity are a kind of divine surprise—although the funding of them follows more earthly rules.

The 1960s was one of France's greatest innovative periods in film. The

New Wave in French cinema reached its height during the Malraux ministry. Did he have anything to do with this renaissance? Here we see a significant departure from Malraux's initial mode of conserving and protecting old things. Building intelligently on earlier governments' work, he nurtured the small but creative new trend in filmmaking and helped finance its aesthetic development.

In 1946 the postwar government began a system of subsidies for quality films, creating as its administrative agency the Centre National de la Ciné-matographie (CNC) to replace a similar Vichy body. The Crédit National in conjunction with the CNC loaned companies advances on box office receipts under certain conditions, but only up to 25 percent of the cost of the production. Half the films made in 1947 received such aid, covering on average 22 percent of the production costs. With the increase in the number of films produced (72 in 1947, 111 in 1954), their greater cost (individually as well as overall), and perhaps with the change in the political climate resulting from the Gaullist-Communist split and the PCF's departure from government, the Crédit National advances became much less significant. In 1947 the CN had put up a total of 3.35 million francs, aiding about half the films made. In 1954 the 98 films made cost together 110 million francs; but the CN advanced only 18 percent of them a total of 3.67 million francs, representing only 3 percent of the overall costs. Malraux's ministry dropped the "avance du Crédit National," by then deemed useless, on 1 January 1960.

Additional aids to cinema were put in place in the immediate postwar years. A law providing state subsidies for French filmmakers (loi d'aide) had passed the Assembly in 1948; between that year and 1953 it pumped 13 million francs of governmental financing into the making, distribution (at home and abroad), and promotion of French films. Between 1954 and 1959 nearly 4.6 million francs from Fonds de Développement de l'Industrie Cinémato-graphique went into all phases of the industry, from production costs to advertising, distribution, and technological upgrading.

In the 1960s coproductions of the French and Italian film industries increased in frequency beyond even the regular collaborations of the 1950s. The pooled resources of the two governments, it was hoped in both nations, would better compete with the slick and expensively made Hollywood films flooding into Europe. So in part the subsidies and the coproductions were measures of economic nationalism created to bolster a cultural nationalism.

Yet American films were not the only challenge the French film industry faced. The last good financial year of French cinema was 1957. After that the inroads of TV began progressively to reduce the audiences and the profits. Television showed only old films. Still, lots of cheaply made films continued to be shown—you had to put something on the screen each night in a movie theater—even though the audiences shrank each year. Where was seed money to come from to aid the new young *auteurs* who had edited film magazines like *Cahiers du Cinéma* while waiting to become filmmakers?

Tickets to entertainments have always been taxed in France, often to pay for social services, a practice going back at least to the ordinance of 24 April 1407 of Charles VI, who taxed minstrels and musicians a part of their take to support the Hôpital Saint Julien. The practice really took on a modern form in the Royal Ordinance of 25 February 1699, which to help fund the Hôpital Général de Paris levied a tax of one-sixth of the total receipts on performances. In 1716 a surtax of one-ninth was added for the support of an additional hospital, the Hôtel Dieu. This archaeology of taxes on entertainments was rationalized in the case of movie tickets only in 1954 with a simple sliding-scale tax on box office receipts. The tax money was given as a subsidy to both art and commercial films, with relatively little concern about quality or future profitability.[25]

Upon taking office, Malraux changed film funding. He initiated a policy of more selectively turning some of this tax money, as loans, over to the film-makers—13 percent of the taxes paid on admissions, if it were reinvested in another film. More precisely, he had the CNC target for the bulk of these box office tax revenues films "of special cinematic value," as the legalese of the funding formula put it. After viewing a sample of the film, the CNC would decide whether it should receive a state subsidy and, if so, how much. The grant was defined as a loan against the film's future revenue. If the film made a profit, the advance had to be paid back, to be then loaned to other filmmakers.[26]

In mid-November 1961, Malraux established a specially beneficial tax and fiscal category of "art and experimental movie theaters" (*théâtres cinématographiques d'art et d'essai*). By 1969 there were three hundred of these art houses in France.[27]

Most New Wave films benefited from the funding and subsidy arrangements Malraux worked out. Colin Crisp has concluded that "this system proved extraordinarily effective in introducing new blood into the industry, and must be considered a key factor in the development of a Nouvelle Vague of young filmmakers."[28] That didn't mean, of course, that the *auteurs* were understanding about Malraux's own worries or solicitous about his projects. The contrary was true. They joyfully attacked him during the scandal over Henri Langlois and again during the May events. Loyalty to their art came much before any feelings of indebtedness to the Gaullist minister.

French Film: Take 2, The "Affaire Langlois"

Henri Langlois was, in the words of the *Nouvel Observateur*—which admired him—a *fou de cinéma*, "a film nut."[29] He cherished the images, the stories, the filmmakers, even the actual celluloid material through which the light passed to create the shadows and light on the screen. Since 1934, single-mindedly, almost single-handedly, and with no aesthetic prejudices, he had

devoted his life to preserving the world's film heritage. Since 1936 he had been putting on public showings of his found treasures.[30] The original stock on which the films were printed was as precious to him as the images on the rolls. "We have to try to preserve everything, save everything, take care of everything," he wrote. "We are not God, we do not have the right to believe in our own infallibility."[31]

He stored his ever-growing archive of the filmmaker's art everywhere he could find space, including in his apartment in Paris. The works, many the only extant prints of classic films and most on the old, highly flammable, celluloid film-stock, overflowed his bookcases, his closets, the space under his bed. We get an idea both of his mania for collecting and of his personal fastidiousness, from a famous photograph of the bathtub in his apartment overflowing with film cans. It was included in the first, French, edition of his biography but piously suppressed in the second, American, one. Even under the German Occupation he continued to gather and to shelter old films, using, among other means of transport, a baby carriage with the treasures swaddled in blankets. Not entirely play-acting, Langlois moved his beloved films around Paris for clandestine showings or better storage by doing the proud father out for a walk with the baby.[32]

The war's end allowed Langlois to do more collecting and showing of classic films, in particular American ones, which no longer had to be screened secretly and, of course, illicitly, in heavily curtained apartments. He found a screening room in the Avenue de Messine, the first address of his Cinémathèque. There members of the city's cultural elite sat in the dark with young future French critics and filmmakers, then students.

The tiny auditorium (in the words of Georges, his brother, and Glenn Myrent, his long-time American coworker and biographer) soon became something of a cultural salon. Seated among the students one might spot Gide on one side of the room and Malraux on the other. Braque came fairly often, and Fernand Léger came all the time. Sartre and Beauvoir sometimes showed up.[33]

The adolescent François Truffaut was always there. By hiding in the toilet stalls between showings he could stay all day to see the films over and over. Here, and a bit later at the left-bank showing space on the Rue d'Ulm, he, and his friends, Jean-Luc Godard, Jacques Rivette, Eric Rohmer, and Claude Chabrol, the creators of the *Cahiers du Cinéma*, discovered and studied the art of earlier *auteurs*. The journal served as the place where they wrote down what they learned at the Cinémathèque and in the long café discussions between screenings, before they themselves became France's newest filmmaking avant-garde. Langlois's Cinémathèque even helped form their style: the *Nouvelle Vague* directors' practice of visually quoting from or referring to earlier films in their own productions came from the endless hours they sat in the dark admiring, and learning their future crafts.[34]

And the Cinémathèque educated their first appreciative audiences as well.

The images from old films formed many members of their future publics, penetrating the young viewers as they sat in the dark, bringing them into the film, proposing identities for them. In the dark hall, they became private detectives, gangsters, cowboys, musicians in a seedy club, the personage of the external voice-over. After perhaps the fifth viewing they could disengage and become assistant directors apprenticing with Alfred Hitchcock or John Ford. From the hours and hours spent together-but-alone in the screening room of the Cinémathèque grew the new film culture. These, Henri Langlois's "children of the Cinémathèque," formed the vanguard and nucleus of the public for the emergent renaissance of French film.

So by the fifties everyone in Paris, and many people in the rest of the world who valued the seventh art, acknowledged Langlois's contribution to film culture. In the late 1970s I took my two young boys to the Cinémathèque to see a series of Buster Keaton films. I myself had never had an opportunity to see any of them before, and all the kids were delighted. In the course of that sabbatical year my research on French commercial policy suffered from my captivation by the Cinémathèque. Finally I had to become a cultural historian and to write about films and the Cinémathèque to justify the time I had invested there.

But many also knew of Langlois's daily travail to find funds for the institution's collecting and showings. The long, demanding hours, and overeating, would end his life early with a heart attack. Malraux respected the art; he knew something about it. His film on the Spanish Civil War, *l'Espoir*, made while the fighting was still going on, had shown a remarkable (as in everything he undertook, a self-taught) capacity for the craft. Opening the Cannes Festival soon after being named minister, Malraux announced, "Before the year's end, the Cinémathèque will have become the Comédie Française of cinema." [35]

It seemed the perfect private-government cooperation: the visionary creates the institution, and the understanding and grateful state takes over its funding. With the agreement of Langlois, who was made its state-appointed director, Malraux had the Cinémathèque installed in a newly renovated space in a wing of the Palais de Chaillot. Much of Langlois's precious collection began to be moved to a newly built storage and restoration facility in Bois d'Arcy, outside Paris. France's film heritage was now—rather belatedly— safely under the wing of the state.

Sometime in 1967, however, the government decided that that heritage was not safe with Henri Langlois. Clearly Langlois's love affair with film had not prepared him to be a civil servant, even of art. His slovenly storage methods continued, and he ran the Cinémathèque in a haphazard way. He had never been good with money, but now it was the state's budget he mishandled. To young cineasts and film lovers he was wonderful and giving; to officials, impossible. Always ready with a piquant characterization, Jean Cocteau called him "the dragon who guards our treasures."

The Ministry of Finance, then under Michel Debré, was especially keen to domesticate this dragon. One lit cigarette—and fires did occur—or an over-zealous cleaner could destroy a rich heritage. The archive-fortress outside Paris was meant to protect the collection, but apparently the archiving methods Langlois employed there approximated those of his bathroom. Was Langlois's collection safe with Langlois?[36] His removal gives us a fine example of the wonderful workings of the French bureaucracy as it attempted to shape an art institution to fit its formulas.

Early in 1967 the legal status of the Cinémathèque was altered. From 1959 to that date, like the Comédie Française, the Cinémathèque had remained a private association funded almost entirely by the state. Malraux's cinema administration saw to its funding and very loosely monitored its operations. But that year the ministry reorganized it as a public body (*établissement public*) now reporting to Pierre Moinot, the director general of Arts and Letters. In effect, this made the Cinémathèque a nationalized entity something like the Renault automobile company, which had been confiscated from its private owners after the war, or the Crédit Lyonnais.

In December Malraux asked Langlois for an increase in the ministry's designated members on the institution's governing board. This restaffing gave the government-appointed members of the board a stronger voice—under certain circumstances, a majority. Langlois trusted Malraux. He agreed to the change as a minimal way for Malraux to propitiate the Finance Ministry's heavy pressure for more responsible control.[37]

But this concession was not enough for the government's money-and-order people. On 9 February 1968 the augmented board managed to pass a proposal to remove Langlois as director. Langlois's opponents didn't have a majority of seats, but by a naive miscalculation, Langlois's friends and allies—among them François Truffaut—refused even to cast a vote on such a monstrous proposal. Immediately a cold war began.[38] On 10 March Malraux informed the deposed director of the Cinémathèque that continued state support (some 2.5 million francs in 1968) depended on his agreement to cooperate in further reorganization.

These changes put Pierre Barbin, a civil servant from the ministry with, to be sure, a certain acquaintance with cartoons and short subjects, in charge of the financial and administrative affairs of the institution. Langlois was invited to remain as the honored founder with the title "Artistic Director" and much reduced decision-making power.

Based on a Vichy-era law authorizing the creation of a legal depository for film, on the model of the National Library's role for the book, the changes of 1967–68, culminating in this last ultimatum, carried out in effect the nationalization of Langlois's creation. The once-supportive state had fired the creative oddball for violating the state's rules on managing French culture. A few days after Langlois's departure, the Cinémathèque's approximately sixty employees received letters from the ministry summarily firing them all. The

house would be reorganized, at which time "certain coworkers" would be rehired in the "newly reconstituted organization." Pending the changes, the theater's two halls, at the Palais de Chaillot and in the Rue d'Ulm, were locked.

The intellectual community of Paris immediately rose up to condemn the minister. It was the kind of scandal French intellectuals have always loved: a bohemian creative person—Moinot called him "the rag-picker of genius"—against the overweening pretensions of what in France is scarily called "the Power" (*le Pouvoir*). Langlois and his chief public advocate, François Truffaut, organized his victimhood brilliantly. Truffaut's headquarters for the struggle, naturally, were the offices of the *Cahiers du Cinéma*.[39]

Immediately, magically, most of France's major filmmakers, beginning with Truffaut and including Abel Gance, Alain Resnais, Jean-Luc Godard, Claude Berri, Eric Rohmer, Agnès Varda, and many others, signed an open letter to Minister Malraux demanding the return of the films they had entrusted to Henri Langlois. They asserted that they had given copies of their works personally to Langlois, not to the French state. With his firing, the Cinémathèque no longer existed, so they wanted their property back. Nor would they would send copies of future films to that defunct institution.[40]

By 13 February, sixty writers and actors, most of the great names of French film, had joined the protest. To name just some, Jean-Paul Belmondo, Jeanne Moreau, Catherine Deneuve, Delphine Seyrig (whose father, Henri, was head of the state museums in the ministry), Jean-Pierre Léaud, Michel Simon, Simone Signoret, Yves Montand, and Marlene Dietrich signed and sent to the press a collective letter calling for the reinstatement of Langlois. Foreign filmmakers also deluged the offices of *Le Monde* with telegrams associating themselves with the stance taken by the French directors. Nicholas Ray, Joseph Losey, Fritz Lang, Vincente Minnelli, Roberto Rossellini, and Robert Florey protested the removal of Langlois and asked for their films back.[41]

Daily, additional French and foreign directors registered their outrage with the French government and their support for Langlois. Charlie Chaplin, Carl Dreyer, Luis Bunuel, and Orson Welles had joined the protest, *Le Monde* reported one day. The next, Louis Malle, Claude Lelouch, Yves Robert, Marcel Ophuls, and Erich von Stroheim added their names. Great stars of the classic age of film, like Arletty, protested. Brigitte Bardot joined the movement to save the savior of France's film heritage. And, as reported in *Le Monde* for 2 March, the much-admired Jerry Lewis forbade the showing his films at the Cinémathèque in solidarity with Langlois and his world-wide supporters. Jean Renoir became honorary president of the quickly formed Comité de Défense de la Cinémathèque. Alain Resnais, whose wife, Florence, was Malraux's daughter, was its president. Henri Alekan and Jean-Luc Godard served as vice-presidents, Pierre Kast and Jacques Rivette as treasurers, and Truffaut and Jacques Doniol-Valcrose as secretaries.[42]

On 14 February, a 2,500-strong demonstration on the plaza of the Palais de Chaillot heard famous directors give rousing speeches attacking the Gaullist state—in front of all the tourists. "Malraux démission!" ("Malraux resign!") *Le Monde*'s man (gleefully) reported as one of the most frequent slogans. Thirty busloads of police cordoned off the area. The state television had sent no one to cover the story; evidence on tape might prove awkward, and why give these troublemakers airtime? When a group of the cultural agitators tried to break one of the police lines, the forces of order pulled out their clubs. At the front of the crowd, Godard and Truffaut took hard blows. Blood ran down Bertrand Tavernier's face. Anne-Marie Roy broke her wrist. The wife of Yves Boisset was beaten by policemen as she lay on the ground. As darkness approached, Godard finally called for the demonstration to end.[43]

Perhaps most dismaying for the government were the criticisms coming from its friends. Claude Mauriac, one of the few important writers supporting Gaullism, but also a man of principle, called on the government to reverse its ill-advised action. Marcel L'Herbier in *Figaro* described Langlois as "precursor, a visionary, such as we need." And Hervé Bamberger in the Gaullist weekly *Notre République* wrote that the firing was "both unjust and a bad move."[44]

And, as a kind of presage of the explosion that would begin in May, various student groups—including representatives from the Grandes Ecoles, provincial universities, and even lycée students—gathered at the offices of the Union Nationale des Etudiants de France to register their protest against the heavy-handed Gaullist state. The UNEF, as it was known, would be one of the important organizational forces of the student uprising a few months later.

Of course, in France humor is the cruelest and most powerful weapon of attack in civil society. In an interview he gave to *Life* magazine, for example, Langlois drew on his own nutty self-serving reading of history to make his case. "After all, it wasn't the Barbarians who caused the Fall of Rome," he explained to the American reporter, "but rather the fact that they had too many bureaucrats." In a telegram from Switzerland Jean Anouilh joined the Langlois forces: "Request my name be added to the theater list protesting the arbitrary dismissal of Henri Langlois—Stop—Personally vouch for signatures of Sophocles and Shakespeare so often invoked by cultural ministry." When Malraux visited to Grenoble to honor Stendhal, a native son of the city who died in 1842, the Langlois forces got the satirical weekly *Le Canard Enchaîné* to print an agitated telegram from the great author:

Having recovered from my astonishment, I am obliged to protest most strongly against the dismissal of Henri Langlois and to prohibit until further notice, 1) showings at the Cinémathèque of films based on my works, and 2) the use of my name in ministerial speeches.

Stendhal.

Then there was the story the Langlois forces planted in *Le Monde* that Charlie Chaplin had queried the government's new director of the Cinémathèque as to whether he intended to send him back his films by boat or airplane. When Chaplin was shown the forged message upon which the news account had been based, he immediately signed it and sent it to the illegitimate keepers of the Cinémathèque in Paris.[45]

How could a French government win against bands of intellectual irregulars firing scorn and quips at its balance sheets and press communiqués? Through March and April the supporters of Langlois kept up the demonstrations in Paris and in the provinces. The stars came out to join the filmmakers. On 19 March Jean-Pierre Léaud, who had grown from young boy to adult in a series of Truffaut films, read a manifesto supporting Langlois at a five-hundred-person demonstration in front of Langlois's headquarters/apartment. The next day Michel Simon and Marie Dubois addressed a thousand demonstrators in Grenoble, which had modeled its own cinémathèque on Langlois's prototype.[46]

Finally, an honorable government surrender was arranged. A special meeting of the Assemblée Générale of the Cinémathèque was called for 22 April. The Langlois forces still retained their clear majority in that body. On 9 April the government leaked a story to the press that it would be willing to allow Langlois to take up his old post but would henceforth terminate its subsidy. By the 20th the details of the peace had been fleshed out. The Cinémathèque would be reprivatized. Both state interference and the subsidy would cease. However, paying a only nominal rent to the state, the Cinémathèque would continue to occupy screening rooms at the Palais de Chaillot and the Rue d'Ulm. Revenues from tickets sales belonged to the house. The government would create a "public service" center for film conservation. Anyone, the Cinémathèque included, could avail itself of its services.

Nearly free rent and continued access to the film conservation service—not a bad result for Langlois. Of course, the defense committee would now have to transform itself into a fund-raising body to replace the lost state aid. The Langlois forces announced themselves prepared to recommend this solution to the General Assembly meeting.[47]

On the evening of the 22th, that body agreed to the proposed resolution of the battle for the Cinémathèque. The members of the General Assembly accepted the resignation of the state-appointed members of the executive committee, and voted unanimously to make Langlois secretary general of the association.[48] The next day he reentered the film house that he had built. The government occupiers had slipped away leaving the big ring of keys on the floor of the lobby. The screen that had been dark for forty days once again carried the flickering shadows which so moved the people who watched it. But like an apparently extinguished forest fire which travels under the groundcover to burst out again elsewhere, the students' May explosion a few

days later demonstrated that the Langlois Affair was only the first blaze of a greater firestorm.[49]

The Challenge to the Culture Guilds

In his 1992 book of that name, Marc Fumaroli denounced what he called the "culture state" (*l'état culturel*) as at the same time repressive and clownish. His main argument—an attack on the way of working of the Ministry of Cultural Affairs—was largely lifted from Jean Dubuffet's scathing 1968 attack on the Gaullist culture state, *Asphyxiante culture*.[50] But where the artist intended to expose the conservatism of the government, Fumaroli recycled the antistate polemic in behalf of the prerepublican ancien régime. His book attacked the very idea of creating the Ministry of Culture, which he charged had debased and corrupted French *civilisation*. In the era bounded by the ministries of André Malraux and Jack Lang, that is, roughly from the 1960s through the '80s, a new totalitarian religion of culture had grown in France. Taking the figure of a new state religion from both Dubuffet and the French Communist press of the mid-60s, Fumaroli subtitled the book "An Essay on a Modern Religion." In it he nailed Malraux's messianism by calling him the "prophet of Culture." Still mindful of the revelations about Stalin's camps, his French readers were meant to understand his criticism of the state's cultural administration as a Gulag, a spirit-killing prison.

Eclipsing a serviceable office of Arts and Letters, he argued, Malraux and his successors had rapidly created a state-cultural monopoly that vulgarized and politically manipulated the French heritage. Fumaroli described the Malraux work as "a great labor of massifying culture," in an overweening project to create "the social and political ties of an organic society." And he dismissed the new focus on spreading culture as political manipulation: "Culture is another name for propaganda."[51] So according to the exasperated and witty commentary on Fumaroli's charges against Malraux by Jacques Rigaud, a high administrator under the two subsequent cultural ministers who was himself a Fumaroli target, Malraux-Lang had brought French *civilisation* to "somewhere between the Soviet gulags and Las Vegas."

For Fumaroli, culture was individual cultivation and great learning, something few were capable of. One's inclusion in this elect had to be proved and certified by masters of learning. A Calvinist of culture, Fumaroli rejected the false tidings of "culture for everyone." Only a few are, or can ever be, chosen vessels.[52]

Here, given a French twist, was the American 1990s defense of the canon. Taking his cues largely from the philosopher Leo Strauss and his culturally conservative disciples (especially Allan Bloom), Fumaroli grieved at the passing of French cultural elitism, much as the right-Aristotelians from the Com-

mittee on Social Thought of the University of Chicago had deplored the decline of Cultural Standards in the United States. Of course, for Fumaroli, the cultural fall of France was more terrible: the government itself had brought it about behind the slogan "cultural policy." For the specialist on seventeenth-century rhetoric, the noun "policy" contradicted the adjective "cultural."

Yet, mean-spirited and obsessively ad hominem though it was, Fumaroli's book should not be dismissed as only another noisy literary polemic by a canonist who finds the young no longer attracted to him. Fumaroli's complaint should be understood, too, as yet another sign of the ongoing institutional crisis of literary humanism in France. As Foucault among others had pointed out, the Classical Age was at an end. In this instance, that meant the brilliant word-conjurers, the masters of obscure books, and brilliant repackagers of traditional literary-philosophical truths—left-bank intellectuals—no longer spoke to the French, or for France. Fumaroli saw the crisis as a renewed war of the Ancients versus the Moderns. In contemporary language, he was reacting to the culture state's dethroning of France's old culture guilds.

In 1637 Cardinal Richelieu founded the Académie Française. Since the seventeenth century, some version of the elite self-regulating and self-renewing Academies and Institutes have acted as the arbiters of *la civilisation française*. To be sure, the French state had granted them their monopoly. But their members decided who would be counted among the cultural "Immortals" of their generation; who were to be crowned as the greatest artists, writers, and scholars of the age. These bodies, to which we should add Fumaroli's place of work, the Collège de France, were homes of France's original culture arbiters. Well into the twentieth century, Academicians painted the state's art, carved its historical monuments, wrote the books read by people of breeding, and composed the little music the state required. The Academies petrified aesthetic style and guaranteed employment for their members and protégés.

Occasionally, usually amid great struggle and resistance, the government turned some of the culture regulating over to the market place. Napoleon III, for example, had allowed a show of the new artists *refused* by the officially designated Salon. After his fall in 1870 the Salon, as the showcase of art capital, declined rapidly and finally was abolished in favor of the new network of dealers and exhibitions. The marketplace governed art standards powerfully only at the end of the nineteenth century, in the early decades of the bourgeois Third Republic.[53] The leftists of the Popular Front, rebelling against the power of economic capital in the market of culture, suggested that cultural direction could and should come from the democratically chosen government, and not just from those with wealth or a small politically and aesthetically reactionary group of state-sanctioned cliques.[54]

Increasingly as post–World War II France modernized, administrators-cum-politicians trained at the National School of Administration made decisions in politics. Physical and social scientists dominated the world of learning, and—Fumaroli's special bugbear—state officials, not the old in-

tellectual guilds, steered and spread a national culture which was no longer a guild mystery. Like the Renaissance humanists who disdained the new democracy of knowledge made possible by the printed book, some of France's contemporary humanists, like Fumaroli, repudiated the new modalities and institutions of knowledge which threaten to eclipse their mandarin role in the society.

Interestingly, de Gaulle never entertained the idea of membership in the Academy. On the culture guilds, he and Malraux were on precisely the same wavelength. After de Gaulle's resignation from government in 1946, he invited Claude Mauriac to join him and Madame de Gaulle for dinner one evening at Colombey-les-deux-Eglises. At table, Mauriac asked the General, now that he was no longer "the head of the country," might he want to enter the Académie Française? " 'No! I'd never accept membership in the Academy,' " de Gaulle responded decisively. " 'Look here, when one has become one [*incorporé*] with a nation, after that, one can no longer identify with just one sector of it.' " [55]

But Fumaroli wanted to identify with the worthiest sector of the nation. And he got his wish. In 1995, just three years after the publication of his defense of the culture guilds, he himself was invited to become one of the forty Immortals of the Académie Française.

Private and Public

Malraux did not make French culture democratic. In fact, he made the same error as the idealists of the Popular Front: both thought that wider diffusion of the culture was the same as its democratization. But building on the heritage of the experiment of the 1930s, he did dethrone the cultural notables. And this was a major new culture fact in French history. Most strikingly, for example, using the May '68 agitation of the students of the "Ex-Ecole Nationale Supérieure de Beaux Arts," he summarily ended its governance by the autonomous Academy of Fine Arts and put it directly under state control. He disbanded the two governing bodies for architecture as well. He also seized the moment to abolish the both laughable and unfair awards of Prix de Rome. Since the Renaissance, this free study year in a grand state-owned villa in Rome had given many dull young French artists and architects—all trained by Beaux Arts Academy insiders—a head start in their unremarkable artistic careers. In the course of the centuries, they so favored loyalty to old forms in the arts and architecture that when we come upon examples of innovative work—the Pompidou, the Louvre pyramid—amid the old, we are shocked. [56]

We might call Malraux's trimming the institutional power of the aesthetic Old Regime a "democratization" of culture if we were willing to extend the word also to the plebiscites with which de Gaulle periodically reinforced his

authority. For both cases were top-down, take-it-or-leave-it, offers to the people of France by a leader who know what was good for them.

But even if the *state's* alternative to the mandarins of the Academies became former colonial administrators and the cultured technocrats of the Ecole Nationale d'Administration, can the consequence of multiplying and spreading cultural access be bad? Moreover, as Fumaroli himself points out as part of his attack upon state-directed culture, since at least the start of the Third Republic, France has had a rigorous and creative independent cultural sphere—publishing houses, theaters, newspapers, and reviews—alongside the state sector. This independent sphere has served, and continues to serve, to protect French society against the possibility of the authoritarian culture state, in fear of which Fumaroli beat the alarm gong. Pierre Boulez could make his case against Malraux in the press and continue his project in his privately funded circle while he awaited the day that the French cultural climate would change. Malraux could use the prediction of a long commercial run for the Genet play—fueled by the scandal—as a defense for allowing it to finish its limited engagement at the state theater. Henri Langlois and his state-subsidized filmmaker friends could fight the government to a stalemate by means of the theater of their protests.

Both the scandals and the aid to the young filmmakers of the 1960s help us to understand better how French state-sponsored culture worked and what its limits were. Despite the teeth-gnashing of cultural conservatives over the drop in the value of their cultural capital, no Soviet-style Zhdanovist imposition could or can dominate in the arts in France. The rhythm of French culture has been, and probably will remain, this lurching from crisis to crisis, scandal to exposé, quarrel to reconciliation. "C'est logique," as infuriating French friends tell you when you do not understand how conflict unites the society and makes it run better—especially in the realm of culture—rather than exploding it.

Like Jürgen Habermas's public sphere of political conversation, the French culture sphere is the arena for the life-world of creativity to be expressed without constraints, if often also without funding. There the one-time powerful culture guild continue to exist for the readers of *Figaro*, alongside of bohemia, various avant-gardes, popular entertainments, and foreign imports to make the complex cultural mix that has enriched the spiritual life of both France and the world.[57]

Sometimes the rulers of the Fifth Republic saw what was created, that it was good, and aided or took over the activity. And sometimes—as with national music policy or the Cinémathèque—the state acted crudely or stupidly. But the existence in France of other alternatives has so far limited damage. And, I think, with that countervailing culture-supporting power of a vital independent sector, the involvement of the state has been on the whole beneficial to activities that would not have been possible if the society had had to wait for private benefactors or the recognition of some ancient Academy.

Why "so far" qualifies this sanguine judgment is of course the changes the media have wrought in making and diffusing French culture. Their vast requirements of economic capital, their deep psychic impacts, their omnipresence have changed the rules. They do not challenge the Academies, they ignore them. Nor does the state control television, for example, the way Malraux directed the Houses of Culture.

Both Jean Baudrillard and his Canadian guide Marshall McLuhan have taught us that the media express a kind of power over our lives that neither Hobbes, nor Marx, nor even Foucault, has successfully described. It is the ability to create a world in which *simulation* is our experienced reality. Life itself, as represented on television—the love stories, the adventures, the news of wars in distance places—has become more like a collection of created works of art than like information. Fiction has taken over the everyday. The worse fear of the members of the Frankfurt School, that the aesthetic risked being collapsed into the everyday and therefore losing its aura or its world of values apart from imposed capitalist reality, has come to pass since the beginning of the Malraux years. What role can culture play in the formation of citizens in this newborn world? Malraux's ministry, despite its nonparticipatory vision of culture and its cultural elitism, at least was an attempt to address the problem by means of state officials who were, if not elected, at least ultimately responsible to the citizenry. The United States has yet to devise a countervailing power to protect our commonalties from commodification.

In the final two chapters, on Fifth Republic France's exports of culture and the French language, we have to return to the international arena in the Malraux years. In this way, the old international cultural activities which we traced from the Renaissance, and the modern cultural internationalism of the Gaullist era, will serve us as book-ends.

8 *The Power of Art*

"The power of a state should not be measured solely by the numbers of its divisions or its Gross National Product. It can be assessed also, and above all, by the spread of the influence of its culture. True power is and remains spiritual."[1] Speaking at the gala international conference held at the Paris headquarters of UNESCO in November 1990 to assess, as well as to celebrate, the impact of Charles de Gaulle on history, Gilbert Pilleul, the one-time head of research at the Institut Charles de Gaulle, put the premise of Gaullist foreign cultural policy most succinctly. Certainly de Gaulle gave great attention to increasing France's GNP. And, even better than creating many divisions, he brought France into the exclusive nuclear club. But the spread of French culture as a means of enhancing France's international power, an old tradition as we have seen, was not simply a rhetorical flourish or an ideological cover for baser motives.

The international role of that culture was a proof—in the meaning both of a test and of evidence—of the power of rhetoric in the broadest sense, of language, to make history. Now "*the* culture" is too big and too multivaried to allow us to say anything useful about *its* workings in the international sphere. In the next chapter the international influence of the French language will be at issue. Here I want to speak of the international language of art. A strong continuous thread will guide us through the labyrinth of art exhibitions sent from France to countries developed and developing and the exhibitions of others' art in France. In this chapter, I focus on the French claim to a plenitude of symbolic capital in the visual arts, the discourse of French "cultural leadership" in art.

The French Comparative Advantage

The concept of comparative advantage in international trade theory suggests that a nation should export things that it makes using factors of production relatively abundant in its society. The logic of the theory directs a nation to specialize in making and exporting what it does best at lowest factor costs, while purchasing from abroad what would be too expensive to produce locally. So historically the United States has exported agricultural products (we are rich in good farm land) and manufactured goods (capital has been comparatively cheap). However, the United States has suffered historically from labor shortages. In terms of this model, labor-intensive production was relatively costly. Ergo, our historic openness to immigration and the early labor-saving or labor-multiplying push to industrialization.[2] We can enrich this narrow idea of differential strengths in international relations by factoring in the power of military might, colonial resources, and—here, above all—cultural prestige.[3] Although the economy continued rapidly to modernize in the Gaullist years, French costs of labor, land, and capital were still not low enough to make its exports of nonluxury goods particularly competitive. Nor, despite de Gaulle's aspirations for French *grandeur*, was the Fifth Republic (yet) politically a major force in the world. France set out to deploy its ample cultural capital to gain an edge in as many of the ways that international power is measured as possible.

The historical conjuncture which brought the Cold War stalemate of the 1960s was a boon to Gaullist aspirations to world power. The military and political deadlock in those years made cultural policy more important than ever before: what one well-connected commentator at the time called the "fourth dimension" of foreign policy, equal to diplomatic, military, and economic strategies.[4] With most of the European belligerents still nursing fragile economies, with the proliferation of atomic weapons, and power-bloc diplomacy giving nations little free play or room for error, ideas moved to center stage for possible and important contestation. Moreover, both decolonization and the consequent political rise of the so-called Third World made contests over the hearts and minds of people central in the postwar years. And cultural display, sparring, and influence were the weapons of choice.

The postwar world everywhere was modernizing. In the realm of communications that meant that the image and sound were beginning to challenge the printed word in the most developed nations. It also meant that, with the mobilization of often semi-literate populations in the new nations, pictures and the electrically reproduced human voice were increasingly instruments of political power too. In the 1950s one American modernization theorist proposed shortcircuiting the difficulties of bringing nonliterate populations

into the twentieth century with a flick of a switch by dropping transistor radios from planes onto isolated villages and nomad camps. Radio and film had been at historical moments highly politicized media, and were so again in the Cold War years, although de Gaulle was slow in adapting his unique speaking style to television.

An increasing taste for distinction, combined with the crudest of market forces, increased the worth of France's treasures. The originals of old European art, as housed in the Louvre—the *Mona Lisa* for example—constituted ever more valuable cultural capital in a world increasingly given over to replication and simulation. But, could *new* art be a diplomatic weapon?

The Great Art Robbery: Jackson Pollock Implicated!

Though France was liberated in the late summer of 1944 and the Allies accepted the victorious nation of the Gaullist *imaginaire* as one of the postwar deciders of Europe, France's old military and diplomatic preeminence had been lost. Its cultural hegemony in the West had also come into question. A triumphant United States proclaimed itself leader of the West, or the Free World, as our phrasemongers preferred to say. Having defeated powerful enemies in both Europe and Asia, only this nation was strong enough and resolved enough to defend Western values against the dangers of newly expansionist international Communism.

So in 1945 France was no longer the political capital of the West. At the same time, to recall the politicized language of the day, the *capital* of modern art moved from Paris, where it had originated and resided for over a hundred years, to New York. Both American and French observers understood these political and cultural changes to be connected. In 1970 in *The Triumph of American Art*, the influential American art historian Irving Sandler at the same time expressed and promoted the spirit of competition from the American side with his celebration of the rise of Abstract Expressionism.[5]

In the mid-1970s Serge Guilbaut, a young French art historian who had come to the United States to do a thesis at UCLA—one he could not have done in France at the time—wrote a fascinating reply to the triumphalism expressed by Sandler and other members of the American modern art establishment. Guilbaut connected America's postwar drive for hegemony in world politics to the rapid triumph of the new American art vanguard, specifically the New York Abstract Expressionists. In *How New York Stole the Idea of Modern Art: Abstract Expressionism, Freedom, and the Cold War*, published as a book in 1983, he disputed the accepted understanding of why, after World War II, the center of modern art making, selling, and critical writing passed from its traditional home in Paris to New York.[6] Guilbaut took aim at the dominant aesthetic and economic reasons proposed at the time for the changing of the (avant)-garde: (1) the American Abstract Ex-

pressionists were just doing the most inventive and best new art in the West and, according to canons of modernism, they had a right to lead, as Sandler had argued; and (2) the Paris art scene of painters, dealers, and customers had been badly disrupted, scattered, and impoverished during the war, leaving a vacuum for the Americans, with their entrepreneurial ways, to fill in.

Rather, the French art historian thought the story was not about recognition of the best art, or even about the current disarray among French and foreign artists working in Paris, dubbed by French critics the Ecole de Paris. Nor did he credit the weakness of the postwar French art market for the aesthetic fall of France. In the 17 February 1941 issue of *Life*, Henry Luce, its publisher, had proclaimed in an editorial that this would be the "American Century."[7] In Guilbaut's reading, this powerful press magnate was articulating a new agenda of U.S. world domination in the twentieth century, as Britain and France had dominated the nineteenth century. And, imagine, Luce voiced his nationalist manifesto nearly ten months before the attack on Pearl Harbor brought the United States into what became World War II, and well before the United States was in a position to turn classic Yankee jingoist journalism into global policy.

The United States emerged from the war victorious, undamaged, with an atomic bomb. Guilbaut names the twin strategic thrusts of America's move for postwar world dominance as, of course, the Marshall Plan and NATO. Let me nuance this important historical issue. We must be careful not to fall into what historians call the Whig interpretation of history: reading history backwards so that outcomes are interpreted as intentions. It is unnecessary to assume, as Guilbaut does, that there existed a grand American plan— *a policy*—for world domination as far back as the depression year of 1940. Moreover, it is a serious mistake to undervalue to what degree policymakers' paranoia about the spread of international Communism drove much of U.S. international cultural policy during the Cold War.[8] That said, Guilbaut's military-political point, that after World War II the United States leadership, more or less consciously, more or less systematically, steered the nation to a power position unique in the century, is right. Exploiting others' weakness and entrapped in ideologies of "American national interests," postwar American leaders amassed a degree of international influence and direct power not seen in the West since the reign of Louis XIV or Napoleon.

From the time of François Ier to the present, as we saw, the great thing-not-said, the *non-dit*, of French cultural thinking—perhaps because for so many in France the idea had passed into the thing-not-needing-to-be-said, the doxa — was the assumption of the close causal relationship between great military-diplomatic power and great cultural authority. In the normative political-cultural metaphor of the post-1945 era, this relationship was referred to as "cultural leadership." As de Gaulle himself put it long before he became the leader of the French state, "There has never been an illustri-

ous captain who did not cherish the heritage of the human spirit. Behind the victories of Alexander, we always and ever find Aristotle."[9]

Just like *winning* or *losing* in cultural contests, the notion of cultural *leadership* shows a faulty understanding about the avenues of cultural capital flow. "Cultural leadership," is, of course, a metaphor, a figure of speech at the same time both self-evident to some French commentators—François Ier, for example—and untrue, we know, for example, in the case of the Italian Renaissance, when small, weak, divided states and principalities were homes to one of the world's great periods of aesthetic creation. Or we could point to eighteenth- and early nineteenth-century German-speaking Central Europe: brilliant literature of both German classicism and *Sturm und Drang* came from a politically fragmented and weak region. Only after 1870 did Prussia-Germany rise to great power status. But Bismarck sponsored no new Goethe. And during his creation of a new powerful Germany, in their sleepy little Swiss college town both Nietzsche and Burckhardt turned their faces *and theories* away from the new imperial bombast.

However, this competitive language was shared both by the French Communists and the Gaullists of the postwar decades. Sandler had also embraced it, to be sure; but he did so because at the end of World War II, French art was still hegemonic in the American imagination. Specifically, Guilbaut charges that, aided and encouraged by the alliance of the United States Information Service and the Museum of Modern Art, the artistic American avant-garde—the New York School of Abstract Expressionists—was the cultural manifestation of American's new claims to a new hegemony in the West: "The unprecedented national and international success of an American avant-garde was due not solely to aesthetic and stylistic considerations, as both European and American commentators frequently still maintain, but also, even more, to the movement's ideological resonance."[10]

That resonance was, according to Guilbaut, with a certain Cold War liberalism of the sort articulated by Arthur Schlesinger in his 1949 book *The Vital Center*, which informed the American contest with Soviet Russia. And indeed, in this Guilbaut is right. As Arno Mayer has persuasively argued, the discourse of "totalitarianism," in the era of the Cold War, gave liberal ideologues a language for changing enemies and allies without seeming to change principles. In this new discourse, both totalitarian Nazi Germany and totalitarian Communism were enemies of freedom as American liberals understood that word in the postwar years.[11]

Guilbaut shows how this American idea of freedom offered a space both for the individualism and subjectivism *and for the nationalism* of the new American art.[12] He especially marvels that (in so aesthetically backward a country as the United States, also a thing-not-said of his analysis) very early both *Life* magazine and the U.S. Information Service took up Jackson Pollock, Mark Rothko, Barnett Newman, Adolph Gottlieb, Robert Motherwell, and their friends, and displayed, reproduced, and generally promoted their remark-

able nonrepresentational works. So, perspicuously, Guilbaut sees more here in the two-dimensional surface of the avant-garde paintings than is apparent to the politically innocent eye.

Abstract Expressionism lent itself especially well to expressing the mix of American values. Of course, it was nonfigurative, which led to dumb jokes of the kind, "my kid can paint as well as Pollock. . . ." But it was just this covering a canvas with abstract forms and lines or blocks of color that allowed social and political meaning to adhere to the same surface. Most of the American Abstract Expressionists considered themselves men of the left (and as a group they were as macho as they were leftist). Pollock, for example, was troubled that his works were too formal to be of much use in advancing revolutionary ideas. But then neither he nor his friends could imagine themselves painting images of the heroic welders of Magnetogorsk or of smiling girls driving mighty combines through golden fields.

Meyer Shapiro, the brilliant art historian and critic and an important New York socialist intellectual, helped to ease their consciences by pointing out that their painting styles promoted the just cause. By making possible the direct expression on canvas of the deepest feelings of the individual, the emotions and energies readable from the drips, swirls, and splashes of a Pollock painting, Abstract Expressionism advanced the democratic project of the American left. It was a contribution to humanism.

But the same nonrepresentational surfaces could serve as a Rorschach for any viewer's imagination. For example, *Life* and *Vogue* early featured Pollock's work. The former promoted it as *American* art; the latter used it as a backdrop for models dressed in what was currently *Le Look*.[13] Like jazz, also an expression of the artist's feelings and the will to freedom of the oppressed, this aesthetic formalism could be shown to the world—on Department of State-sponsored tours—as evidence both of American freedom and of American culture. With Guilbaut, we should understand the success of Abstract Expressionism as an instance of the ways cultural capital was employed in political contests, and of the role of political capital in the aesthetic field, at a key historical moment.

However, we need to supplement Guilbaut's valuable account. If "New York Stole the Idea of Modern Art" . . . *from Paris*, we need to know more about how the theft was accomplished. Was it surreptitious? Did the U.S. government do it? Were works of French art taken to the United States? Were there any mistakes made in French cultural policy in the immediate postwar period to make the theft easier? Did France leave the "idea" of modern art unguarded? Or did the French not value it anymore? Were there— possibly the most heinous treason—French collaborators who aided in the commission of the crime? If French policymakers believed that France was and should be the leader of modern art, shouldn't we expect a strong French response to the alleged felony? What was it?

We know little of the French side of the story. To answer these questions

we must first ask what actors in the world of the arts thought about the incipient international culture war. Also we must look at events in Paris.

Early in his work Guilbaut embraces Pierre Cabanne's diagnosis of postwar France's aesthetic troubles. Cabanne scornfully judged that, "the whole free-masonry of paralysis and fear made its choice to stick with the stagnant conformism of the good old Ecole de Paris." Writing a year before the May '68 explosion overturned nearly ten years of Malraux's efforts to breathe life back into inherited French culture, Cabanne offered his own exasperated wake-up call: "What Sleeping Beauty needs now is not Prince Charming but a good hard kick in the ass." [14] It's a great *bon mot*, if an incomplete analysis. French cultural contestation abroad in the postwar years, especially when de Gaulle and Malraux teamed together for the task, makes a fascinating, but complex, story. I decided to write this book, in part, so that I could investigate what France did in the decade of the 1960s to regain a hegemonic position over both the inherited culture of Europe and modern art. [15]

Improving American Minds

Did contemporary French policymakers perceive the United States as having launched its aesthetic offensive? On the basis of what information? Let's first ask the cultural attachés; tracking the international fate of French culture was their job. Because France's postwar diplomatic correspondence was a privileged place for members of the foreign policy elite to think aloud, reading in their notes and memos we can glimpse the other side of the medal of France's cultural-mission discourse. Much like Guilbaut, we find French diplomats assuming that culture is, among other things, a competitive activity, a contest with winners and also-rans.

René de Messières, cultural attaché to the French embassy in New York, reported back to Paris in December 1949 on the relative merit of contemporary American art versus French painting. "American painting," he judged, using the language of the race track which his aristocratic ancestors had frequented, "is still inferior to French painting, but has begun to close the gap. . . ." [16]

It was important to promote French art in the United States, argued a French visitor, Jacques Dupontin, in 1953: neither the Alliance Française nor other nonschool activities encouraging the French language had found much resonance in the United States. However, he pointed to "the extraordinary influence of French art." He wanted to organize an exchange of privileged admissions between the Amis du Louvre and the similar members' organizations of major American museums. Yet he was disappointed that, although the Metropolitan Museum in New York, for example, was willing, the Amis du Louvre had shown little interest in the arrangement. He called for more frequent exhibitions of French art in the United States, and he urged the cultural service of the Quai d'Orsay systematically to inquire of Ameri-

can modern art museums what contemporary French artists they might want to borrow and show. His insightful remarks were passed on to the cultural service.[17] Such notes prepared the way for Malraux's sending the *Mona Lisa* to Washington and New York some years later.

In 1967 Annmarie Pope, head of an American family foundation with substantial means, proposed to the French government a touring exhibition of the best French modern painting currently held in both American and French collections. She envisioned a traveling show of approximately 150 French paintings opening in Washington's National Gallery late in 1968 or early 1969 and then moving to New York, Chicago, Boston, and San Francisco. It would be called "Painting in France."

Pierre Moinot, who in 1966 had become the new head of "Arts et Lettres," in the culture ministry, strongly urged Malraux to get the agreement of the appropriate people in France: "This exhibition is a very important event. We are so deeply interested in supporting the American champions of the Ecole de Paris that we will waive additional financing from the American side."

The cultural attaché in New York, Edouard Morot-Sir, gave his full support. "Here in the United States," he wrote Moinot, "we expect a great deal from this art show. You know that for a decade now New York has been claiming to be the world capital of painting. We would love this exhibition of French paintings to be a striking demonstration of the vitality and youth of the Ecole de Paris."

"One hopes [the School of Paris] is not yet ready to be dethroned by that of New York," Moinot replied. "We selected the paintings with this contest in mind. Let me add that, conscious of what was at stake, the artists themselves have tried to select particularly important canvases from their oeuvres, or in some cases, even to paint new ones specially for the occasion."

Like the *Mona Lisa* show, this ambiguously named exhibition, "Painting in France," came at a tense time in U.S.-French relations. Early in June 1967 the Arab-Israeli War broke out. The United States and Britain supported the Israelis. Ever since meeting Clara, Malraux had been strongly philo-Semitic and after 1949 he was pro-Israel. But France had important interests in the Middle East, and in the wake of decolonization was positioning itself in the West as the special friend of the Third World. President de Gaulle embargoed French arms and airplane shipments to Israel. Pro-Israel sentiment in the United States, especially among American Jews, intensified. Hostility to France followed the same curve. In December 1967, a year before the exhibition was to open, a number of angry Americans reenacted the Boston Tea Party, but this time by dumping French currency into Boston Harbor. An American conductor—the diplomatic letter doesn't say who—canceled a concert engagement in Paris. A major organization of American fashion buyers advised its members to boycott Paris fashions. In January 1968 the Los Angeles County Council voted a boycott of French products, and organized an anti-de Gaulle letter-writing campaign aimed at the White House and the State Department.

Pierre Moinot feared for his exhibition. What if, as it traveled around the country, it became a focus of anti-French demonstration? "Certain American art circles," he wrote Malraux, "would not be unhappy to see this happen." He feared that the American art market would close to the Ecole de Paris.

Would Malraux go to Washington to open the exhibition on 17 February 1969, Moinot queried? You are "the sole French personality so admired and respected internationally that you are not touched by the current [anti-French] feeling in America." I think Malraux would have made a difference. But the escalating collapse of Gaullism made it impossible for him to work his magic in America one more time. The Gaullists, and with them Malraux, were fighting at home for their political lives. The great art of France would have to represent the nation's grandeur in his place. In any case, no incidents marred the exhibition.[18]

Perhaps a note on Piet Mondriaan to Malraux from Pierre Moinot can serve as a microcosm of the big dilemmas French policymakers faced when they tried to bring the international culture war, if not to American homes and hearths, at least to our museums. Mondriaan, who had been born in the Netherlands, had died in New York in 1944. But he had lived and worked in France in 1912–1914 and again for the period between 1919 and 1938.

Moinot wrote Malraux on 20 November 1967 to urge that 600,000 francs be provided to the Musée Nationale d'Art Moderne to buy a Mondriaan that had just come on the market, the "Composition Rouge Jaune," done in France in 1928. To his dismay he had discovered that there was not a single painting by Piet Mondriaan in a French museum nor had there ever been a state-sponsored exhibition of his works in France. We could buy it, he proposed, so that "this work could be sent to the United States for the exhibition 'Painting in France,' and serve as evidence of our desire to avow France's vocation as the international center of creation for the plastic arts."[19]

Too expensive; not a French artist. They didn't buy it. However, when a year later James de Rothschild tried to buy, and take to England, a self-portrait in pastels by the eighteenth-century painter Jean-Baptiste-Simeon Chardin, the French museum administration invoked its right to buy the work. Although the Louvre had two other Chardin self-portraits, in the same style, done in the same period and also in pastels, the National Museums bought the painting for 680,000 francs.[20]

What Is *French* Art?

The United States Information Agency (USIA) softened up other nations' museums with Jackson Pollocks. Malraux counterattacked by dropping the heavier *Mona Lisa* on the challenger's political and cultural capital cities. The exhibition of the *Mona Lisa* in the United States and later in Japan was

only a special instance of a general policy of exporting culture. And, as we saw, in various ways French leaders have always strived to make France itself the homeland of Western culture. Today, for example, statistics show that the cultural sites of France are the leading tourist destination in the world. And my own participant-observer experiences suggest that on any summer day but Tuesdays most of these visitors seem to have converged on the Louvre.

What other weapons of culture war were available? As well as sending exhibitions abroad, another way France has strongly defended its claims to the cultural trusteeship of the West has been to sponsor important international art shows. But trying to be at the center of the world's contemporary art scene in the mid-century could sometimes be like seeking security in the eye of a hurricane.

Take for example the storm over the first years of the Paris Manifestation Biennale et Internationale des Jeunes Artistes. Encouraged by Malraux even before he assumed his new post, the Biennial was meant to reach out beyond the frontiers of France to artists under the age of thirty-five from all over the world. The jury was also made up of international figures in the arts. The best new art would be honored in Paris, and in turn Paris would be honored for providing the welcoming venue. In a sense founded out of a concern for French loss of leadership, much as Guilbaut would impute a decade and a half later, the Biennial was part of Malraux's project to make Paris, if not once more the capital, at least the gatehouse of new art.

The Biennial organization was run out of the new Culture Ministry. Jacques Jaujard, member of the Institut (the Academy of Beaux Arts), once a major administrator in the old cultural apparatus, and a man unappreciative of abstract art, was its president. Soon after taking up his post, Malraux had kicked Jaujard upstairs by making him secretary general of the new ministry.[21] But because of his contacts among the Paris patriciate, the minister also gave him delicate diplomatic tasks to do, including liaison with the cultural service of the Foreign Ministry and running the Biennial.

The Biennial council met at the ministry's headquarters in the Palais Royal, 3 rue Valois. Its members were officials of the city of Paris (which paid half the Biennial's expenses) and of the Regional Council, and higher civil servants representing the state, some connected with the arts: Raymond Cogniat and Pierre Lamy (each an inspecteur général des Beaux Arts) sat on the council, as did Henri Seyrig (director of National Museums) and Jean Cassou (head of the museum of modern art in the Palais de Tokyo). Raymond Janot, directeur général of the Radiodiffusion Télévision Française, sat for that organization. Jean Basdevant, head of the General Direction of Cultural and Technical Affairs (DGACT), spoke for the Foreign Ministry.

At the closing ceremony of the first Biennial in 1959, André Malraux, just named to his new office, rose to speak before the prizes and recognitions were conferred. He noted with pleasure that forty-two nations had sent six hundred paintings chosen by national juries from the work of their young

artists. But with so many works selected from so many different places, he expressed surprise at the number of *anti-form* works (*l'informel*) in the show. Malraux here used the label that Georges Bataille had given a movement against form in art which he had promoted in the 1930s and which was then showing a resurgence, likely to become the next thing in painting after 1950s minimalism.[22]

Another surprise he remarked on, with the exception of the French submissions: "the dearth of figure painting." Actually this difference between new painting in France and elsewhere was causing divisions in France, but in 1959 Malraux could finesse the conflict: "I'm excluding the French section," he noted during his evaluation of styles; "it was organized in another manner." By the second Biennial, however, conflicts over the French selection threatened to blow up the exhibition.[23]

On a Friday, 28 July 1961, the governing council of the Biennale des Jeunes Artistes gathered in a hurriedly called emergency meeting to deal with a crisis. What issue was so important that these busy civil servants had be summoned to an extraordinary sitting on the last workday before the grand August vacation exodus? We are in France: a dispute about art styles!

Jacques Jaujard thanked the members for coming on such short notice and at that time of year, and then explained that he had called the special meeting because a representative of the city of Paris, Mr. Giraud, had just resigned from the council over the selection of young French artists chosen to show in the 1961 exhibition. Moreover, Madame Becourt-Foch, another member of the council, had at the same time sent him, Jaujard, a letter which read in part, "My colleagues, members of the Council of the Biennial, deplore the fact that [works] representing certain schools or tendencies have been systematically rejected by jurors, and ask that certain forms of expression not be subject to a kind of interdict."

First covering himself by invoking the rules, good French civil servant that he was, Jaujard began by reminding the council that they had been operating with guidelines which stipulated that each participating government was to select and send works done by young artists which "were the most representative of the new trends emerging in their country." "In the first Biennale de Paris [1959] the majority of the countries invited had sent works of abstract art, but . . . almost alone, the French entries included figurative art along with abstract pieces." In their reviews of the 1959 exhibition, he added defensively, "the critics had made a point of noting that France had made a fair selection." He wanted the 1961 Biennial to be as representative of French "new contemporary currents" as the previous one had been.

But Giraud had resigned from the council because, with others, he was disappointed at what he considered the still poor representation of French figurative work in 1961. An old cultured patrician, Jaujard did not feel that such questions should, or could, be decided by elected majorities or their representatives. As far as he was concerned, the mix of abstract and figurative canvases in 1961 compared favorably to the 1959 selection.

Raymond Cogniat, inspector general of the Beaux Arts and art critic, who in 1959 had also managed the French jurying process, waffled: among the forty canvases selected for inclusion in the French group in June, there were twenty to twenty-five paintings clearly figurative in style. He pointed out that the choice had been made by a jury of young painters and artists, and that *they* had been criticized by some for picking *too much* figurative art to represent France. His private conversation with Mr. Giraud, who claimed to be speaking for many of the representatives of the Paris municipal council who sat on the Biennial committee, convinced him that some council members wanted a French selection that *represented* a body of French work—in this case figurative art—even if some experts, jurors included, judged the paintings not the best art then being done in France. Perhaps the way to resolve the dilemma of aesthetic judgment versus representativeness, Cogniat offered, was next time to ask the city of Paris to designate a dozen or so paintings as its choices to join the other works picked by the jury of professionals at the Musée d'Art Moderne.

Jaujard considered this solution "unthinkable." It would violate the relations worked out between the city, the regional council, and the central government. Decoded, the response meant: Such a change in selection procedures would weaken the power of both the old and the new cultural establishment to decide questions of culture. It would open a wedge for the entry of an inappropriate democracy into high cultural matters. He indirectly threatened the dissidents with the power—or the withdrawal of support—of the state: such a change would jeopardize, he warned, other public/private collaborations which received many foreign visitors, like the Théâtre des Nations or the musically avant-garde Semaines Musicales. He also strongly denied that, in the case of the 1959 show and the present one, anyone had vetoed any of the works submitted, and that any painting style had been purposely excluded. No changes could be made for the 1961 show, scheduled to open in the fall; but (being a foxy bureaucrat) he promised to review the procedures for selecting works for the 1963 Biennial. The attack of the champions of the French figurativists had been deflected. The moderate cultural conservatives had driven back the arts reactionaries for the moment.[24]

But the aesthetic of I-know-what-I-like, or perhaps of just plain cultural demagoguery, could not (and cannot ever) be kept out of politics. In 1966 during the debate in the National Assembly on the ministry's 1967 draft budget, Deputy Paul Mainguy, to the applause of fellow members, expressed unhappiness about the increasing prominence of abstract art in state buildings and other public places. Many contemporary artists and a significant number of the arts audience were still interested in figurative works, he believed. He called on the state, on Minister Malraux, to support and buy in equal numbers works of both kinds.

Malraux answered in the discourse of smart-aleck modernism: Today, all over the world, most young artists are working in nonfigurative ways. If at exhibitions people stop to admire famous figurative works, "it is because

they are 'naive.'—Not the viewers, the paintings (Smiles in the Chamber)."
Actually, Malraux concluded, M. Mainguy was asking for more historical
research, he was not making a judgment on contemporary art. Wickedly,
Malraux solemnly promised to fund historical studies of figurative art, when
the opportunity arose.[25]

We see from this episode that if France wanted to lead art in the West it had
to be open to what was art in the mid-twentieth century. In the nineteenth
century, French art was accepted by Europeans and Americans as the most
interesting and innovative. But by the 1960s it was proving very difficult to
incorporate the contemporary art of the West and at the same time promote
the leadership of *French* art. Invented in nineteenth-century France, modern
art—modernism with its logic of unrelenting innovation—was now recre-
ating itself in the vast empty aesthetic spaces of America.

France, Trustee of Third World Art Too?

Just before the late August 1961 meeting of the Biennial committee ended,
Michel Plouvier, a high government finance official (conseiller-maître à la
Cour des Comptes) had asked why none of the countries of Black Africa
were represented in the show? Cogniat responded that despite his repeated
requests, the current political instability of much of Africa—many countries
had just recently gained their independence—made participation impos-
sible for any of them to organize. Jean Cahen-Salvador, the other high state
official (conseiller d'état) on the council, asked if anything could be done to
add African artists to the current Biennial. Cogniat didn't think there was
enough time to make any changes in the 1961 show, but he accepted Cahen-
Salvador's offer to put him in contact with African representatives in Paris
when planning future Biennales.

I do not know if later Paris Biennial and International Exhibitions of Young
Artists included examples of African art. But in 1966 with great ceremony
and publicity Malraux visited Senegal. The president of the new nation,
Léopold Senghor, one of the founders of the movement of *Négritude*, and at
the same time one of the most French of African intellectuals, had invited
him to participate in the inauguration of the first ever World Festival of Ne-
gro Art [Festival Mondial des Arts Nègres]. It opened in April 1966 in Dakar
and then was moved in June to the Grand Palais in Paris.[26] And soon after,
still using France as a model, independent Senegal created the first ministry
of culture south of the Sahara (figure 30).[27]

The French enterprise of becoming the champion of Third World art fits
very much into the nineteenth-century pattern: when French policymakers
found resistance to French cultural trusteeship or leadership in Europe, they
increasingly turned to the (former) colonial world. *Magiciens de la terre*, the
fabulous and very expensive show of Third World art sponsored by Jack Lang

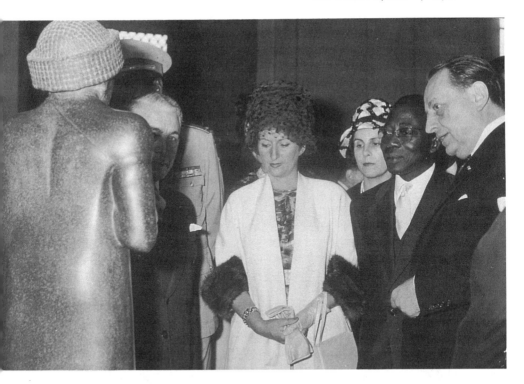

Figure 30. Malraux escorting the president of newly independent Senegal, Léopold Senghor, around the Louvre, April 1961. Keystone-Sygma.

and the Centre Pompidou which opened in conjunction with the celebration of the Bicentennial of the 1789 Revolution, consciously continued the tradition inaugurated in the Malraux era. In the summer of 1989 the installations, sculptures, and paintings filled the vast exhibition space in La Villette in eastern Paris. Holding the show, especially in that year, powerfully signaled that France still wanted to be the patron of the world's great art.[28]

The Traveling Salesman of French Culture

Although France had long had an active cultural service in its diplomatic arsenal, André Malraux was France's not very secret new weapon (figure 31). On the model of de Gaulle presenting himself abroad as the voice of the essential French nation, Malraux made himself the embodiment of France's civilizing mission. He was a performance artist long before we found a label for the art form, and he played all over the world.

He always had liked to travel. In the 1920s, whenever he and Clara could put together enough money, they had taken grand trips around the world.

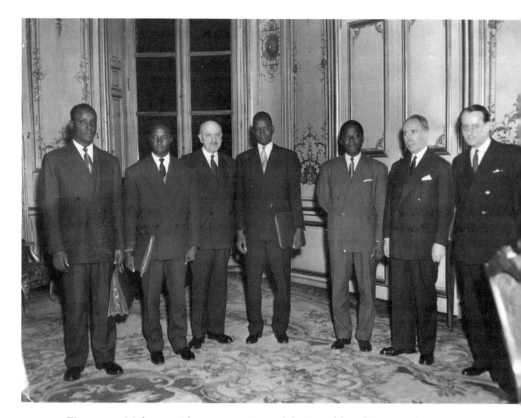

Figure 31. Malraux with representatives of the Republic of Guinea after signing important financial, economic, and cultural agreements between France and the new nation, 7 January 1959. Next to Malraux is French finance minister Antoine Pinay. Keystone-Sygma.

In 1959, even before the creation of the new ministry, Malraux had embarked on another of these voyages, but this time at the expense of the French government and for a more serious purpose. He toured many of the French colonies that were about to vote on whether they would remain with France or become independent.

He stopped in Martinique and Guadeloupe to persuade their people to vote for continued union with France. In Martinique he spoke with Aimé Césaire of their common French heritage. As a young poet in Paris in the 1930s Césaire had been a member of the founding group of the Négritude movement. Négritude, unlike some varieties of contemporary American Black nationalism, was not necessarily separatist. It had a place for French culture despite its anticolonial impulse.

Until his resignation over the Soviet invasion of Hungary in 1956, Césaire had been a member of the Communist Party. For many years he had served as

mayor of the capital of Martinique, Fort de France. Despite political differences, he shared the platform with de Gaulle's representative. Malraux could be incredibly seductive: "Monsieur le Maire, you realize that, only in France and only in Martinique, could it happen one fine day that a writer named André Malraux, could, in his capacity as a government Minister, respond to a poet named Aimé Césaire"(applause).[29] Césaire supported remaining with France. Malraux visited Guyane as well. The people of Martinique, Guadeloupe, and Guyane voted to remain with France.

However, France's African territories, including Senegal, home of Léopold Senghor, poet and inventor of the idea of international ties through *francophonie*—a vision of French culture not dominated from Paris but shared by equals in a community—voted for independence. But Malraux visited many of them also. Moments before the legislators sitting in Fort Lamy voted the formal declaration of Chad's independence, on 10 August 1960, Malraux spoke warmly to them of his hopes for continued *fraternité* between their nation and France.[30]

And he tried to placate important Third World countries not at all happy about France's recent colonial war in Indochina and its current one in Algeria. In 1959 he visited Brazil and praised Oscar Niemeyer's architecture for the new capital, Brasília.[31] He visited India, where he reminisced with Nehru about Spain during the Civil War. They had first met in Paris in 1936. Malraux had just left the hospital after recovery from wounds received while commanding a airstrike of his squadron; Nehru had just been released from of a British prison. Despite an angry "anti-imperialist" Indian press campaign, Malraux secured the Indian leader's understanding and neutrality on France's current colonial war and recent tensions, with colonies and former colonies.

At a dinner held on the eve of his departure he and Nehru talked about culture. If we credit his own account in the *Anti-Memoirs*, Malraux lectured Nehru on his view of art as the last hope of humanism: "The revived works [of great art of the past], which would once have been called immortal images, alone seem powerful enough to withstand the powers of sex and death." Malraux reports a Nehru who spoke—improbably—as a Malrucian: "And yet we are the managers of the biggest dream factory in the world." "Obviously culture cannot replace the Gods, but it can reveal the heritage of the nobility of the world," added Malraux. "I'm a little puzzled," responded the president of India finally, parting the European's metaphysical fog a moment. "Our problems are of a different sort. There is illiteracy. . . ." But then at the end of the conversation Malraux reports him voicing a Malrucian vision of the future of Indian culture: "It's a question of making the past of India present, as nobly as possible, for the greatest number of Indians. It isn't easy but it isn't insurmountable. Perhaps I should like to advance with India toward the whole of the world's past, but I would want to be sure of not losing her on the way."

Malraux used his visit to arrange for 1960 what would be the biggest exhibition of Indian art ever to be shown in Paris. And back in France, he offered Premier Michel Debré his own double-barreled policy to win India over: "India could become an important market for France. While at the same time, Hindu spirituality is ready to receive France's cultural message." [32] In 1974, two years before his death, Malraux returned to India, where Indira Gandhi awarded him the Jawaharlal Nehru prize for international understanding. The Indian prime minister too had fallen for the intellectual seductions of the one-time Asian treasure-hunter. At the ceremony she said: "Few contemporary authors had done as much as he to kindle in European thought a consciousness of the dimensions of Asia. Profoundly influenced by Hindu and Buddhist scriptures, Malraux, the self-proclaimed agnostic, reveals a 'Hindu atma' in his writings." She was probably wrong about his knowledge of Asian canonical texts; but there is no doubt about the good will he had engendered in India. [33]

Malraux continued to act as France's most important cultural ambassador and through the 1960s. In 1960 he visited Mexico and Japan. In 1961, at the start of the planning for his French Houses of Culture, he toured the Soviet Union's regional cultural centers. In 1962 he was in Washington where, as we saw, he awed Jacqueline Kennedy and her entourage with his trenchant judgments on the art works in the National Gallery. In 1963 he returned, this time, in the company of *Mona Lisa*. And in 1964 he went to Japan with the *Venus de Milo*.

In some ways these trips were important therapy for him in the alienating world of budgets, reports, and cabinet meetings. By 1965, as we saw, Malraux was so stressed that he could function only by doping himself with a dangerous alternation of mood-depressing and mood-elevating drugs and was also drowning the end of each day with endless glasses of scotch. So de Gaulle and his doctor sent him on a long tour of Asia. With the sudden gift of free time, he wrote the *Anti-Mémoires*. He also turned the rest cure into a triumphal series of visits and conversations with the great leaders of Asian nations, many of whom had read his sympathetic novels when they were young leftist intellectuals in the 1930s.

To make sure he would take a long boat ride, de Gaulle had entrusted Malraux with a personal letter to Mao Tse-tung. Celebrated in the People's Republic for his novel of the Chinese revolution, *Man's Fate*, Malraux also met with the foreign minister, Marshal Chen-yi, and President Liu Shao-ch'i as well as Prime Minister Chou En-lai.

He made the pilgrimage to the caves of Yenan, where the retreating Eighth Route Army had found refuge before regrouping to begin the last victorious phase of the Chinese Revolution. That smudgy (more admiring readers might say "universalizing") sense of history that we see in his writings on art marks his description of the Communists' mountainous redoubt: "Here, then, is Sparta." On seeing the display in the Museum of the Revolution of Mao's ink-

well and the stuffed body of the horse that had carried the Chinese leader on the Long March, he invoked the names of Napoleon, Balzac, Henri Monnier (whom Balzac had read), and, most wonderfully, "*Orlando Furioso* as presented by Sicilian puppeteers."

On his return to Peking (Beijing) Mao received him warmly. They spoke at length of the Chinese Revolution, of how much there was still to do, of Russian revisionism, and of China's Western enemies (of which France was not one, in Malraux's account of the Chinese leader's remarks). In a Gaullist vein Malraux meditated on national identities, proposing that, despite the apparent Americanization of Japan, "the truth is that, in spite of appearances, the Asian nation has remained profoundly Japanese." As for China: "'You are in the process of restoring Greater China, Mr. Chairman; that is evident in the propaganda pictures and posters, in your own poems, in China itself. . . .' Here the ministers, sitting in a circle, prick up their ears," Malraux wrote. "'Yes,' [Mao] replied calmly." [34] Here, as in the conversation with other national leaders to whom he spoke on his travels, the grandeur of a people and even of a revolution took on the particular Gaullist meaning of returning to the essence of the historic nation. Malraux could appreciate the special spirit of other nations—through their cultures above all—because he so cherished historic France.

So even this voyage, which had started as a rest and detoxification cure, he managed to transform into yet another enhancement of both French international standing and his own—which, like his friend Charles de Gaulle, he sometimes confounded. It was perfectly natural, then, for Pierre Moinot to think of asking Malraux to go to Washington to save the French art show, when French-American tensions once again threatened to injury the basic amity between the two powers. President Kennedy's joke at the National Gallery Opening in 1963 about the *Mona Lisa* being France's own "independent Strike Force" could as well have been applied to Malraux himself.

Four Million Japanese See the French Flag Hung behind the *Venus de Milo*

By the mid-fifties it was clear that Japan would once more become a major power in Asia. France put special effort into knotting closer ties with this society which so appreciated French classicism and taste. Curiously, considering the few French-speakers in the country, here too the Direction des Relations Culturelles wanted to "make a special effort with [French] books and publications." And in a dispatch to Paris on French cultural activities from February to September 1955, Ambassador Daniel Lévy reported the great success of the exhibits of French books in Tokyo, though, since he did not supply details, it is hard to appreciate what he understood by "success."

Malraux, even before assuming his new post, intensified the wooing. Late in 1958, heralded with great media attention, he went to Japan to strengthen French-Japanese cultural ties. He publicly announced the return to Japan of important pieces of art, the Matsukata Collection, which, in the old tradition, France had confiscated as a result of the war; he did not announce that the last government of the expiring Fourth Republic had already promised to return the art. Ceremoniously he visited the construction site of the museum that would house the collection, and then went on to lay the cornerstone of the new Maison Franco-Japonaise in Tokyo.[35]

Soon after its creation, the new ministry, in collaboration with the Foreign Ministry, organized what we can think of as a French cultural invasion of the Japanese islands. In October 1960 an exposition on the French school of decorative arts opened in Tokyo. In 1961 alone, the Japanese could attend a French film festival, a performance of *Carmen* by the Paris Opera (their first ever performance outside France), the ballet of the Opéra Garnier performing at the Festival of Osaka, and concerts by the band of the Garde Républicaine.[36]

From early November 1961 to mid-March 1962, first in Tokyo and then in Kyoto, Japan's ancient cultural capital, a total of 1,470,000 Japanese visited the vast (480 works) exhibition "French Painting, 1850–1950." The 300,000 catalogs sold continued to radiate French culture in Japanese homes long after the show closed. The Cultural Ministry staff on site were delirious with delight at the success. But Bernard Dorival of the Paris modern art museum, the man in charge of the exposition, urged caution in proclaiming victories in the international cultural war. His own final report on the exhibition acknowledged that, at the moment, for the Japanese, "France is the land of choice for fine arts. . . . But, we have to be on guard. Japan is changing, and very rapidly. . . . And today certain countries are promoting their own art very actively: I have in mind in particular Germany and Italy."[37]

In 1964, once again against the better judgment of the curators, Malraux sent the *Venus de Milo* to Japan, where moving sidewalks whisked millions of viewers past this other famous treasure from the Louvre. On his return in November from the triumphal tour, he stirred the members of the Assemblée Nationale: "Four million Japanese saw the French flag hung behind this statue. In Japan as in Brazil when people come to applaud France, they come to applaud the greatness [*générosité*] of spirit expressed by the French genius."[38] Malraux here both retroactively conferred French citizenship on the Greek statue, as he had done for *Mona Lisa*, and at the same time reaffirmed before the legislators who voted on his budget France's special cultural mission among the nations. But this time the worries of the conservators were borne out. The statue came back from its long voyage slightly damaged. Heroes have died for the nation, but *Venus de Milo's* sacrifice was less stirring: chipped *pour la gloire de la France*.

As François Ier had taught his heirs, art was a powerful weapon of international diplomacy. Malraux, especially, was a master at deploying it. The Louvre was a mighty armory for old art. But finally the Ecole de Paris was not France's last best hope in the struggle for the most international symbolic capital. The French language would be the Maginot Line of the second half of the century.

9 The Language Holds
 Everything Together

Finally, and always, when we study the history of French culture and of its diffusion, we must come to the WORD. When de Gaulle was out of power in the 1950s, and spending his time at his desk in Colombey writing his memoirs, Albert Camus asked him how he believed a writer could serve France. "'Every man who writes' (a hesitation) 'and writes well, serves France.'"[1]

I find remarkable this linguistic patriotism, more, this special love of and at the same time thraldom to language that French intellectuals suffer. The psychoanalytical metaphor of the classic sadomasochistic relationship is one way to describe the bond between the language and some of its native and even adopted speakers. But a Freudian metaphor may mislead here. Since Foucault we have come to think of external power as the creator of the psychic, rather than the other way around. So I will treat the language as a historical force, and ask: In the 1960s what were the pervasive power issues of French language politics at home and abroad?

How did the language work to enhance French national power in both the domestic and the international fields? There are two issues there. First, how did policymakers use the language to give France greater authority in world affairs? What price did French culture have to pay for what was, to use a metaphor from economics, linguistic dumping? Specifically, I will analyze the surprising and fateful ways that policymakers in the postwar years privileged the French language over French culture.

Second, in the years of the Malraux ministry, intellectuals' movements of cultural resistance at home took the French language as their field of battle, not to capture its high ground, but to destroy its hegemony, the power of the social rules it carried, over French minds. Examining the meaning of French intellectuals' cries of the tyranny of language at the moment of structuralism and their critiques of the unreliability of language in the era of deconstruction will help us better to historicize Foucault's scary idea of diffuse unfocused

178

power making us say things in certain patterns — the power of discourse to shape life. It helped to be a refined product of French literary culture — of the Ecole Normale Supérieure, in Foucault's case — in theorizing this notion of the domination of discourse. But first, let us look at French as *the* international language.

Universal, Yet Unique

A few years ago I attended a graduation ceremony at my university at which a recently immigrated, Russian-born mathematician was to receive an honorary degree. This great scientist had been asked to give the commencement address. He rose and with, "I am here to address you in the international language of science," he began. The humanists in my row moved uncomfortably in their seats. It looked as if we would have to listen to yet another tedious celebration of the wonders of mathematics and the natural sciences under the hot sun. But what did this pompously heralded international language sound like? "Heavily accented English," the Russian told us, proving his point by simply pronouncing the words. And while this charming man crashed ahead trampling down our deceptively simple English garden of grammar and pronunciation, I had leisure to meditate about why French was *not* the international language of science, or diplomacy, or commerce, or art, or even of airports.

We Americans have no moral concerns about the promiscuity with which our language picks up foreign words. A nation of immigrants, we tolerate — indeed, at this point in American language education, can scarcely distinguish — curious usages and faulty grammar. We do not worry much about mispronunciation. Unlike the British, we do not code social status according to accent. Having carefully honed their language skills, passengers from abroad disembarking at JFK have difficulty finding anyone with whom to speak English, let alone any English-speakers who speak as correctly as they do. English-only movements show up from time to time, but, as I argued in the Introduction, these are more about political patronage than about the magic of language. As the record of American assimilation shows, the exclusionists are destined always to lose politically as new Americans, or their children, learn English. French is different.

In the seventeenth century the crown created an Academy, the chief function of which was to keep French pure, ordered, and uncorrupted by Italian, then its chief rival as the culture language of Europe. Such concern for the correct usage, and thus control, of the language became the paradigm for the future, no matter the form of government. The need to police French does not follow from the possibility that highly inflected and stressed languages like the Romance group become confusing if used badly. Spanish-speaking cultures, in both Spain and Latin America, did not develop such controlling agencies. Nor do Italians show signs of experiencing a nervous breakdown

when their beautiful language is abused. They love to add new foreign words to the vocabulary. When they do, no one speaks of Dante turning over in his grave.

For many individuals educated in French culture this need for control is self-evident, a thing-that-goes-without-saying, a doxa. For all his fascination with the power of discourse, Foucault never thought to investigate the micropower exercised by the French language police the way he investigated prisons, mental hospitals, and the biopower of the confessional. Perhaps this was so because he saw the enforcement of linguistic orthodoxy over the speakers of the language as natural or, at least, necessary.

So French is different. Somehow there seems to be a deeper connection between the identities of French speakers and their language than between those of other cultures. Jean-Paul Aron in his widely sold manual on the nature of French culture, understood the connection this way: "French culture is a language [*langage*], and this language transcends political, economic, and social differences."[2]

But this structuralist metaphor hides important intellectual elisions. First, when we speak of language we must speak of society, where discourses intersect actions. Aron's formulation closes off investigation of how language connected French society with the project of regaining French influence in the world. Second, Aron's claim that the culture is a language, or like one, is wrong. Born of the French structuralist turn, the equation impoverishes our understanding of both. Moreover, by the Malraux years the language and the culture were well separated.

Fortunately, the spread of the fame of French civilization did not depend just on Malraux's episodic, if headline-grabbing, foreign appearances. In an ironic way, Premier Michel Debré, who had had serious doubts about Malraux's competence for his post, evidenced the importance of the work of the Foreign Ministry's own cultural arm, the Direction Générale des Affaires Culturelles et Techniques (DGACT) by keeping it out of the hands of the writer. Nevertheless, Malraux by his force of personality cemented good working relations with the senior staff of this agency. And the DGACT seconded Malraux's own efforts.

He used Jacques Jaujard, with his high position of secretary general in the ministry but also connections to the old cultural elites of the Institut and the *Grandes Ecoles*, as his go-between. In 1959 Jaujard became head of an Association Française d'Action Artistique the main function of which seemed to be to allow the new Culture Ministry to spend the money of both the Foreign and Education Ministries on sending French art, music, and theater on tours around the world. This body put on the biennial show of young artists, which, we saw, led to a dispute about which painting style best represented the nation. In 1964 its budget was over 5.7 million francs. Of the total, 5.1 million came from the Quai d'Orsay; 120,000 from the Office for Algerian Affairs. The next year the Foreign Ministry increased its payments

to 6.2 million francs, the Algerian office to 250,000. There is also an item in the budget of a subsidy of 250,000 francs from Cultural Affairs. The total for 1965 had jumped to 7.1 million francs. In 1967 Malraux authorized the creation of a new Service des Échanges Culturels with formal ties to the Foreign Ministry for bilateral international contacts. He put his new director general of arts and letters, Pierre Moinot, at its head. The de Gaulle government fell from power too soon afterward for anyone to tell how well it worked. But the state had not always taken so large a role in the diffusion of French culture abroad.[3]

A Little History

In 1883, after the creation of the Third Republic, a group of private individuals founded the Alliance Française to win more overseas "Amis de la France." They wished to fill a gap that they feared the new republic was allowing to open. Immediately the government saw the value of the effort. The next year the director of political affairs of the Foreign Ministry urged his ambassadors to support the new institution for the spread of French culture: "In view of the patriotic nature of the work undertaken by this association, I readily authorize you officially to support its development by whatever means seem to you appropriate."[4] Through most of its existence, the Alliance focused its energies in developed countries.

So even in the relatively nonstatist days of the Third Republic, the governors of France decided that private initiative was not enough. In 1909 a Service des Écoles et des Oeuvres Françaises was created within the Foreign Ministry. In the years before World War I this office was staffed by just two administrators. However, these two (both *normaliens*, to be sure) were given 10 percent of the Foreign Ministry's annual budget to spread French *civilisation* abroad. Part of this sum came from the state's receipts from the national lottery.

In 1909 alone, the Ministry of Interior, which administered the lottery, turned 150,000 francs over to the Service to build the French Institute of Madrid. By 1913 losing French bettors were furnishing 1.2 million francs, or 52 percent of the funds the Foreign Ministry dedicated to its cultural service. Before the Great War, the Republic put most of its culture funds into its Middle East and North African spheres of influence, the largest portion going to Morocco. Europe and the Far East were a distant second. And North and South America were left to the local Alliances Françaises.[5]

The first modern attempt directly to coordinate the overseas cultural initiatives radiating from various ministries occurred during World War I. Since the sense of this book has been to show that politics has a cultural component and that the arts are political activities, it should not surprise the reader that the initiative for setting up an overseas arts coordinating agency did not

come from the Quai d'Orsay, but rather from the Beaux Arts administration. Paul Léon, minister of war at the time, took up the proposal and founded a Service d'Études et d'Action Artistique à l'Étranger within the War Ministry. Alfred Cortot became its first director.[6]

After seeing the powerful role that propaganda had played in shaping policy during the war, President Raymond Poincaré and Georges Clemenceau, still the premier in 1920, authorized the expansion of the Foreign Ministry's small Bureau des Oeuvres into a Service des Oeuvres Françaises à l'Étranger. The writer Jean Giraudoux was made its postwar head. In the interwar years this service invented and staffed the position of cultural attaché in every major French embassy. Held by diplomats charged primarily with increasing the cultural capital of France in the host country, this post was a first in French diplomacy, and a first among the major powers, too. As befitted an innovation of the Third Republic, the Service spent 80 percent of its budget on education, republicanism's deeply held rationalist mystique for human transformation. It funded French schools overseas and added state-managed French institutes to the network of Alliances Françaises and the schools of the religious orders—including the Alliance Israëlite Universelle—already in place. It also supplied foreign universities with teachers of French.[7] But the effort was overwhelmingly focused on spreading the influence of the French language, not French science or technology.

The outbreak of war in 1939, followed immediately by the German Occupation, ended any idea of spreading French cultural influence. On the contrary, French artists were invited to Germany to view and learn from the achievements of Third Reich artists like the sculptor Arno Breker.[8] It is true the German ambassador in Paris, Otto Abetz, was a great admirer of French culture. But by and large, German occupation policy focused on extracting supplies and workers from France. Except for a not very diligent arts censorship, it ignored Parisian cultural life. As much to affirm the continuing vitality of French aesthetic life under German rule as to protect themselves from conscription into the German labor service, nearly all of French cinema talent assembled in occupied Paris to make the wonderful and escapist *Enfants du paradis*. In a kind of French "inner immigration," Sartre wrote *Being and Nothingness* while the Germans occupied the city. And according to Laurence Bertrand Dorléac, some of the painters of the Ecole de Paris who remained in France during the Occupation used blues, whites, and reds in their work to make a contribution to sustaining the French spirit.[9] Certainly, General de Gaulle's French-language broadcasts from London were as much cultural proclamations as political gestures. But unlike China's gradual cultural assimilation of its Mongolian conquerors, and so in a sense their disarmament, the French had to wait for the Normandy invasions finally to dislodge the influence of German Kultur.

When intellectuals and the government of the United States had to con-

front punishing Ezra Pound's treasonous wartime broadcasts from Fascist Italy, he was quietly committed to Saint Elizabeth's Hospital in Washington where he was allowed visitors and could complete *The Cantos*. His literary admirers managed to pass him off as perhaps demented yet harmless, a poet who had wandered into politics over his head. It is, by contrast, a mark of how fully the values of print culture were embedded in the life of the French nation, that after 1944 the *Epuration*, "cleansing" of intellectuals and persons in the arts, specially in literature, who in their writings or activities had aided the enemy was especially zealous. The very old Charles Maurras was put on trial, found guilty of treason, and sentenced to prison. Robert Brasillach, too, was found guilty of collaborating with the enemy of France. Despite pleas for a pardon for him from both Mauriac and Camus, de Gaulle allowed the sentence of execution to be carried out. After several failed attempts, Drieu la Rochelle, to his last days a friend of Malraux, finally committed suicide. And Céline fled into exile. Priests of *la civilisation*, they had betrayed their higher vocation by choosing barbarism.[10]

The Foreign Ministry's Cultural Policy

Before the demise of his first government in 1945 the General had authorized the resuscitation of the Foreign Ministry's cultural agency. Of necessity, Marshal Pétain's government had allowed this office to atrophy. In the governmental offices set up in the Hôtel du Parc in Vichy, the Foreign Office's cultural service staff of four or five persons was allotted a bedroom in which to work during the day. At night the room reverted to its original function. Without records or archives, it was not hard to clean up and leave at the end of each day's work.[11]

In April 1945 the successor organization in the Foreign Ministry was renamed the Direction des Affaires Culturelles et des Oeuvres. One of its charges was to monitor the victories and defeats of French culture abroad. The success of the language was very dear to its staff members. For example, Pierre Donzelot, cultural attaché in New York, wrote happily to Georges Bidault, serving in February 1954 as foreign minister, that the number of students majoring in French in American colleges and universities had jumped in the years between 1950 and 1953. More pleasing still was the news that the number of German and Spanish majors had declined in the same period. French was winning.[12]

In 1956 under the Fourth Republic the Quai d'Orsay's culture arm was transformed into the DGACT. In the period of France's rapidly sliding international reputation—resulting from its conduct of the Algeria War— outgoing Premier Guy Mollet expanded and refocused the activities of the agency.[13] As de Gaulle was settling into his new powers as president of the

Fifth Republic, and in keeping with the recommendations of a panel of high civil servants Mollet had appointed to advise him, the DGACT was mandated to put its principal efforts into (1) modernizing the ways and means of spreading French culture abroad; (2) training more foreign teachers of French and increasing the number of fellowships for study in France; and (3) increasing scientific exchange and overseas technical collaboration. The first two directives required improving what was in place. But appropriate to the French spirit of modernization and of economic growth, the interest the government manifested in bilateral and multilateral scientific and technical cooperation was new. Although in fact relatively little was done in this area in the first decade of the life of the Fifth Republic, the *formal recognition of science as part of French culture* was an important departure for the French state. It is instructive to recall that, when in 1958 Malraux was first offered a position as head of a new government office of scientific research, he refused. He was concerned for the life of French culture. Science was something else. For him, and many others in France, not only did the idea of culture not include science; culture was anti-science.

Establishing one's moral superiority over the opponent is a classic strategy of every kind of competition. French policymakers back home were advised by their diplomats in the United States not to shrink from manipulating Americans' bottomless cultural naiveté. Denise Ravage, cultural attachée in Washington during the first years of the Cold War, urged Paris to do more about promoting French books in the United States. For the book, she wrote, is the "medium of thought; it expresses the intellectual, artistic, and scientific life of a people." Willing to mix metaphors to promote national grandeur, Ravage insisted that more French books abroad would "once more allow [France's] voice to be heard." "Use the women," too, she counseled; take advantage of "their somewhat infantile desire . . . to improve their minds." And, of course, "play on the Americans' great depths of snobbery, and the reputation France has for quality." [14]

By the end of the de Gaulle/Malraux years two-thirds of the annual budget of the Ministry of Foreign Affairs went to fund the activities of its cultural service. In 1959 the DGACT spent nearly 80 million francs or, counting activities in Morocco, Tunisia, and Indochina, just under 160 million. By 1969 the cultural arm was budgeted at 610 million. In 1956 France awarded foreigners 1,500 fellowships, worth the equivalent of 3.5 million francs. In 1959, the numbers had increased to 2,400 fellowships worth 4.4 million francs. And in 1969 5,900 fellowships totaling 46.7 million francs brought foreign students and scholars—some from the former colonies or dependencies—to live and study in France. These figures do not include study visits sponsored by foreign universities or governments, like the American Fulbright program.

The network of state-to-state cultural contacts was greatly expanded. Be-

tween the end of World War II and 1969, France signed a total of 75 cultural agreements of all kinds with other states. It signed 64 of them in the de Gaulle/Malraux years. By 1969 over 30,000 people—25,000 teachers and nearly 6,000 scientific and technical experts—worked abroad spreading French cultural influence.[15]

That France had a special obligation to the nations, a "messianic" cultural mission, to use Albert Salon's word, was, despite different spheres of formal responsibility, as self-evident to the cultural attaché in New York, for example, as it was to the writer turned cultural minister. Moreover, like fine wines and military weapons, French culture had to be sold abroad in order for it to be economical to make at home. French authors like Sartre, Camus, or Genet could live, or live better, from the royalties the American translations of their books brought in. Think of the thousands of American students in the sixties who read their works in French civilization classes or the courses on Existentialism popular in the era. For a time Boulez funded himself and his French projects from his income from conducting the Cleveland Orchestra.

The French Linguistic Turn

As I read Malraux's memoirs, his speeches abroad, even his novels all set in foreign places, I was impressed by the linguistic transparency of his world. He was a man who spoke—as far as I can determine—no foreign tongue, but language never seemed an impediment to him or his heroes, whether in Indochina, China, Spain, Germany, the USSR, or the United States. When in his travels he engaged in one of the summitlike conversations he describes in his writings, there were usually translators present. But Malraux writes as if he communicated his sense directly, no matter what the language differences. Perhaps because he had not suffered much of the French educational system, the language was not for him a frightening, challenging, high mountain he had to surmount to continue his personal and intellectual development. Paradoxically for an author, language for him was neither a problem nor necessarily, as we saw in the case of his art writing, the key medium of culture.

In late September 1968, in an important address before the organizing meeting of the International Association of French-Speaking Parliamentarians, he spoke at length about the "heritage of the world" being entrusted to each of the members' nations, and of the menaced cultural values they must stand together to defend. But he did not fetishize the language. He melded language with culture as he had always done; language for him was just one of the mediums in which culture was expressed.

Speaking in February 1969 to a conference of representatives of French-speaking countries in Niamey, New Caledonia, he gave substantially the same

talk. He added his now regular attack against the "dream factories" and made his usual plea to oppose authentic culture to manufactured dreams. And in front of this body organized around the shared French language, he invoked the great art of *The Cid*, of *Macbeth*, and of *Antigone*. Here his foreign cultural policy differed remarkably from that pursued by the Quai d'Orsay in the 1960s and, I believe, still today.[16]

From 1945 the *normaliens* who ran the Foreign Ministry's cultural service tacitly began to interpret their charge as primarily to promote the spread of the French language abroad. This was true of the historian and friend of de Gaulle, Louis Joxe, its first director (1946–52). Joxe's successor, the writer Jacques de Bourbon Busset (1952–57), who was elected in 1981 to the Académie Française, actually first articulated this policy. Roger Seydoux (1957–60), Jean Basdevant (1960–66), and Pierre Laurent (1966–74) kept to the course de Bourbon Busset had charted.

Driven both by the desire to regain what had been lost during the war and also, more urgently, by the menacing spread of English in the world, this language policy had two phases. In the early postwar years, in the words of the semi-official history of the cultural arm of the Foreign Ministry, the operative premise was that "the spread of French culture abroad is identical to the expansion and spread of its language." Accordingly, language training was "the base upon which our foreign cultural policy rested."[17] Money was put into encouraging students in other lands to learn French in high schools and then to use it in their higher education. Only fourteen cultural officials served in French embassies abroad in 1949. By the end of the 1960s there were eighty. By the time the de Gaulle/Malraux regime had fallen at the end of the 1960s, 59 French institutes and 150 cultural centers existed outside the country. There were 177 French lycées abroad offering programs of study conducted partially or completely in French. Their budgets supplemented by the DGACT, 800 Alliances Françaises in 85 countries offered French language instruction. The Foreign Ministry picked up, but distorted, Henri Langlois's idea: it sponsored 109 cinémathèques outside of France, but only French-language films were shown. Seeing the 225,000 indigenous French teachers in other lands as potential fifth columnists in the war against English, the ministry created programs both to encourage them and to help them improve their teaching.[18] In my own French classes (and probably those of most readers of this book), it was made clear that the language bore the *civilisation*.

But with just so many staff members and just so much money, policymakers have to make hard decisions. Language and culture—since at least the nineteenth century in French discussions as inseparable as Siamese twins with one heart—had to be parted. In the 1950s English seemed to be winning over French in the world (as so many French intellectuals understood the relation between the two languages and nations), and France had not yet recovered much of its past glory. On taking office as the new head of the DGACT in 1952, Jacques de Bourbon Busset posed the difficult choice: his

bureau must promote either the French language *or* French culture. The tradeoffs were painful to contemplate,

> We confronted two major options. Either to concentrate our efforts in spreading French culture in all its forms at the price of using English, the dominant language, as its vehicle. Or, regardless of the penalties, to put our efforts into propagating the French language throughout the world, at the price of sacrificing opportunities for disseminating our culture. I decided on the second course.

Falling into an old pattern of the primacy of foreign policy, de Bourbon Busset added the logical corollary to his decision about the international role of French: promoting French abroad "makes it absolutely incumbent on us to use French as the exclusive means of expressing our own culture."[19] It was *internationally* important, then, that nothing compete with French at home as the prime means of expression.

De Bourbon Busset's policy was followed by his successors and eager volunteer helpers from the ranks of the endangered humanists. In 1963 the scientist-turned-culture-critic René Etiemble published his famous indictment of the corruption of French by the admixture of American words, *Parlez-vous franglais?* He blamed the corruption of the language directly on the spread of American economic and military influence in Europe. He chided Malraux for not including defense of the language in his 1962 monuments protection law. Not enough was being done to safeguard French from creeping debasement, he charged. The book served as a powerful call to arms to all defenders of the language. Etiemble wanted the government to set up a new body to save French.

Responding to the public alarm and realizing that the Immortals of the French Academy were not up to the task, the Gaullist government created a committee. In 1966 (fittingly, in the same month that France withdrew from the integrated military command of NATO) the government formed the Haut Comité de la Langue Française to regulate good usage. It was made up of a mixture of businessmen and officials, with just a few academics. Only two members of the Academy were named members. The Haut Comité did not report to Malraux at the Culture Ministry. Georges Pompidou, the prime minister, who spoke at its first meeting, directed its work. Clearly, language was too important to leave to the writer who headed the Ministry of Cultural Affairs.[20]

A few years later, in 1971, soon after the departure of de Gaulle and Malraux, French state radio and television were reorganized. With May '68 exploding in between, we may take those years as good symbolic dates to bracket France's entry into the media age. We saw the rapid increase in households with TVs in the 1960s. A new programming committee was set up with twenty-four members. Two were scientists, one a musician. The rest, in Aron's words, were "lawyers, administrators, writers, forming a bloc, guar-

antors of the correct usage of the language."[21] What was the committee's key function? In effect, to block, in the broadest sense of the metaphor, anything like our scientist's heavily accented French.

In important ways the separation of language and culture had been forced upon Paris by the continuing process of decolonization. In the 1960s Léopold Sédar Senghor of Senegal, Hamani Diori of Niger, and Habib Bourguiba of Tunisia—each the head of a new nation—discussed the constitution of a "communauté francophone." In 1962 Senghor published his landmark article in the Paris review *Esprit*, in which he described *francophonie* as "an integral humanism, which forms bonds around the world." Rather than as any kind of residual loyalty to metropolitan France, he and his partners saw *francophonie* as a way of linking former colonial peoples together for better cooperation. In Senghor's view and that of other foreign intellectuals attracted to the movement, if France wished to be a player on the new field of *francophonie*, it could no longer assume its linguistic hegemony.

By the 1970s, Pierre Grémion has noted, a French language detached from the French literary heritage was systematically being promoted in the outposts of the world of *francophonie*. To recapture French dominance in that world, especially in the realm of technoscience and, of course economic relations, a (horrors!) "français fonctionnel" was diffused. It is not that the literary language was abandoned as a valuable export. But like the automakers Renault and Peugeot and the shippers of wines, France was putting out different qualities of the same item to reach different market segments.[22]

Traveling Language

In the 1964 budget of the Association Française d'Action Artistique approximately half of all expenditures went to sending theater companies abroad. Art and music together did not command as much as went to fund the theater tours. The next year theater took 62 percent of the total allocation. Art (1.07 million) and music (.91 million), the next best funded categories, together got about 2 million francs, only 28 percent.[23]

Admittedly, the travels of theater troupes are expensive to finance. But that is not enough to explain the higher allocations. Despite the Culture Ministry's influence over this organization, it was the Foreign Ministry's money, and its thinking—especially with the Academician Jaujard at the head of the Association—which put the emphasis on the language arts.

France was the land that had impressed the world with its finely crafted luxury goods. Normally we understand *articles de Paris* as leather goods, jewelry, silks, and the like. But new specialty items could be added. Early in 1967 Pierre Moinot, who was in charge of the Maisons de la Culture and of the national theaters, met with Jean Basdevant, director of the DGACT. Since Moinot was relatively new on the job, the two men had decided to meet to

effect an even closer collaboration between the two ministries. They quickly agreed that it was important for the directors of the Houses of Culture to produce plays "which seemed to them the most readily exportable, or even to create plays in France with an eye to their potential for exportation."[24]

What of French culture in the former colonies? As we saw, Malraux believed in the universal appeal of great works, no matter from what time or place. Jean Vilar's itinerant regional theater was for him an example of how well-performed classics could reach all audiences. Vilar and his Théâtre Nationale Populaire had traveled all over France performing classics and modern pieces to appreciative local audiences. They had done Corneille's *Le Cid* to the applause of Renault automobile workers. The great Jean Dasté had played Molière in a circus tent in isolated and backward regions of the Auvergne. Speaking before the National Assembly in defense of his budget, Malraux reminded the deputies, "Molière is played in Africa. Today, the great French classics can be performed without hesitation, anywhere. They have immense appeal."[25] To make sure, France sent teachers ahead.

By 1968 some 6,000 of France's teachers active overseas worked in the French-speaking countries of Africa and in Madagascar, which is to say largely in former French colonies. Although this was a bit more than a quarter of the overseas teaching corps, the number is not high if we consider the historic French influence in these areas. Moreover, it represented a drop since the years of decolonization at the start of the Fifth Republic.[26] De Gaulle's initial policy—reversed by subsequent governments—was to turn his back on the former colonies. When a colony opted for independence, he had French personnel—including teachers—immediately recalled to France. Following the traumatic wave of decolonization, France began to reach out more energetically to the countries of Latin America, Eastern Europe, the Middle East.[27]

Current attempts to increase French influence in the world remain largely language-centered rather than oriented to spreading the culture.[28] For three reasons, this made as much sense at mid-century as it does today. First, after decolonization the French language, rather than culture, became the more likely route to keeping former colonial elites in the French orbit. The values of France's classical age, of 1789, of the Commune, of nineteenth-century impressionism, of 1950s existentialism were becoming increasingly less relevant to the postcolonial nations. Anyway, it was usually just a tiny segment of the elite that had any facility with French culture.[29] A case in point: in 1967 Malraux and Moinot decided the Grand Prix National des Lettres should be awarded so as to strengthen the linguistic alliance of *Francophonie*. What about Aimé Césaire? An anti-Gaullist; he won't do, Moinot decided. Anyway, not a writer of the first rank, he added guiltily. Léopold Senghor would be much better. We have to ask him if he'd accept. If so, Moinot "would see to it that the jury's vote was unanimous, and that the prize ceremony would be quite elaborate."[30]

Second, there are considerations of international trade. As the historians

of the culture service succinctly put it, "Where they speak French, they buy French."

But the third ground was, and still is the most important. "The language is and remains," in the words of Bernard Pigniau, one of the authors of the history of the Foreign Ministry's cultural arm, "what holds everything together." [31]

Subverting the Language at Home

But if in France language "holds everything together," then, history no longer does. We are now able to assess an important feature of the French intellectual tradition and its transformations, which I think helps explain the successive explosions of structuralism, poststructualism, and deconstruction in the second half of the twentieth century. History and historical symbols have long been the repository of traditions. When a French thinker wishes to say something new, he or she usually begins with a *relecture*, a rereading, of a canonical work. Sartrean existentialism, for example, represented at the same time the last rendering and the exhaustion of French classical humanism. Even the radical intellectual innovators of the period 1950–80 began this way. Louis Althusser anchored his case for a new structuralist Marxism as a corrected rereading of Marx. Michel Foucault did his dissertation on Kant and early offered a *relecture* of the Enlightenment. Jacques Derrida's first major work featured his reconsideration of Rousseau's solitary vices.

In the 1950s and 1960s how might a new start be made? The historical culture weighed on the brains of French intellectuals, but the pressure did not extrude ideas for its continuation. The intellectuals were ready to make one of those daring and dazzling jumps in thinking that we have come to recognize as their method of attack on so thick-walled a culture. The turn to structuralism in the 1950s allowed a new beginning, one unhindered by history. By the time of the Malraux ministry, structuralism had grown into a powerful domestic intellectual force. By adopting a style of analysis that modeled itself on the timeless fixed relationships within a language to understand—among other things—the relations of power in a culture, Lévi-Strauss, Barthes, Foucault, and Bourdieu, to name just a few of the thinkers labeled "68ers" in France, enabled themselves to think real new beginnings in sociocultural criticism. [32]

But having torn down the outer battlements of history/tradition, structuralists had to confront the fortress of language directly. Radical thinkers now turned on what they saw as the conservative and recuperative functions of a unified linguistic field. Structuralists could easily demonstrate that our thoughts, and our labels for them, were not necessarily connected in our minds to the same referent, or indeed to anything. Saussure had taught them, for example, that neither the word "horse" nor the conception of such an

animal in our heads has anything necessarily to do with any animal in the world. And confusion about "horses" is harmless compared to the demate-rialization of "justice," or "duty," or even "la France."

Then poststructuralists proposed that even the possibly stable connection between signifiers and that which they signified—"horse" and the idea that the word conjured in our thoughts—was neither sure nor knowable. Build-ing further on this abyss, Jacques Derrida, and those who followed his lead, undertook to dissolve the certainty of any text. Derrida showed in one bril-liant book after another that texts contained their own denials, refutations, invalidations. The literary canons of the powerful had been undermined. The field of language had been cleared. Thinking the new was now completely possible. But with what to think? And with what common intent?

"Language . . . holds everything together," we can now see, is an accurate statement about French history, but only a longing for some living in the present. In the international sphere, the language has been separated from its twin, the culture—with all the risks this kind of surgery entails for both survivors. Domestically, the French culture wars have pitted those who fight to keep the language in control against those who have sought to destroy its power over the new, above all the image.

We can now close the circle this book has drawn which began with Mal-raux sending the *Mona Lisa* to the United States and ends with the Quai d'Orsay's commitment to sending the language abroad. Malraux wanted to extend French *culture*—but the visual even more than spoken arts—to all citizens. He fought to save French *culture* and its standing in the world. But France changed in part because of the developmental policy of Gaullism. And France's position in the world changed, in part because it no longer pos-sessed the various capital resources of a great power. Malraux's project did not succeed, is not succeeding, in the new Europe. The fortress—or is it a prison-house?—of language was the place chosen by others to defend.

Power to the Imagination

The student uprising in May 1968 signaled that time had run out for Mal-raux's rescue mission. The student cultural revolutionaries were not specifi-cally antistatist, but they did try to topple the government that had ruled France for a decade. The 68ers championed participation in the arts against top-down leadership. The short-lived and activist nature of their movement did not give them enough time to elaborate a new cultural policy, nor, in any case, did most of them want to do so. The long tradition of undemocratic de-cision making in the arts, and the consequent protest (*frondeur*) mindset of most of the young activists, did not encourage formulating anything as sys-tematic as "policies."

Proclaiming "Power to the Imagination," the students challenged the state's

cultural project. They literally toppled the houses of culture that Malraux had built. In late summer the directors of all the Maisons de la Culture met in Villeurbanne, where they unanimously condemned the undemocratic nature of cultural policy in the last ten years. The directors announced that, above all, they wanted to bridge the chasm between artists and their audiences. And they endorsed the students' protest.[33] The young artists of the Beaux Arts school made revolutionary posters in the ateliers of what they had renamed the Ex–Beaux Arts school. Still, invention coming from the cultural patrimony had been exhausted. The students could reject, but neither their education nor their desires could supply the material for major new surges of creativity.

The students also occupied the Odéon National Theater, nearby in the Latin Quarter. But like the anxious revolutionaries breaking the faces and arms of religious statues during the French Revolution, they acted to drive out the last remaining magic in the institution, not to acknowledge its hegemony. For some days students occupied the Théâtre de France, where they heatedly debated the politics of art among themselves and with members of the resident company. Finally, Jean-Louis Barrault, the theater's director, stepped to center stage and dramatically declared Jean-Louis Barrault dead. He had surrendered to the aesthetic luddites. He had abdicated his authority. De Gaulle was incensed. If Barrault is dead, get him out of the theater, was his response. Malraux had to fire France's greatest living actor.

The Death of the Author

But in the face of the student explosion, it was (fittingly) the Louvre, of all of France's cultural institutions, that Malraux thought most important immediately to defend. Like the students, he didn't see the print culture as the place of defense. I think he would not have minded if they had invaded the Institut, the seat of the Académies, not far from the heart of the student district. But they didn't even take the trouble.

Malraux had nearly finished the project of dethroning the old idols. But he could not reinvigorate the historic print culture with the means he was given. And the rebellious young intellectuals who helped defeat him in 1968 were sure that the old culture was oppressive and had to be brought down. But they themselves, it turned out, didn't trust the French language as the vehicle to move them toward France's new culture.

Roland Barthes marked May 1968 as a watershed in the history of writing. In an essay (published in 1969) "The Death of the Author," he offered a brief and, in view of the heavy implications of his argument, a remarkably dispassionate, history of the author as creator of the world, of his death in May 1968, and of his replacement by the reader. With the demise of its creator died the world he (rarely, she) had made. The reader was now in command of the text.

But was he? Mandarin critic that he was, Barthes described the newly victorious reader—the dissident students of May—who now made the texts, as having no history, no values, no traditions.[34]

If the reader was incapable of rebuilding the world alone, who would lead? Barthes's conclusion—decoded—made the critic guide to the reader. In his important article "From Work to Text" (1971), Barthes was more explicit—might I say, more imperialist: "Today, only the critic *executes* the text (I admit the play on words)."[35]

So it was not exactly that the language was on its own, that it spoke itself, and only about itself as structuralists seemed to be saying. After May 1968, the critic took power over the language, but not as its new ruler, rather as its *eminence grise*. Henceforth in the new world of criticism, the language no longer expressed the culture. In a gesture at the same time of power and of apprehension, like that of the policymakers at the Foreign Ministry, literary theorists of the subsequent decades collapsed the culture into the language. For them there was no culture outside of the WORD.

Conclusion: Deaths and Resurrections

The disturbances in the Latin Quarter began to spread to other parts of the city. The minister of cultural affairs called one of his rare meetings with his department heads to discuss what needed to be done. The students had passed from building barricades in their student district to attacking "symbols." They had set fire to the Bourse the day before. Where would they attack next? Pierre Moinot, who was in the room, remembers these words from Malraux:

> "Take a symbol more spectacular than the archives or the Gobelin tapestry works," he said, "take the Louvre. What if they attack the Louvre as the symbol of the culture . . . " And all of a sudden [Moinot sensed that] Malraux *saw* the Louvre besieged, the rioters pouring in through the Sunday [free] entrance, invading Classical Antiquity, surging toward the great stairway. "We'll let them get that far," Malraux continued to speak; "none of the statues down there are fragile, we have lots of copies; we can let them get that far. But at the stairway, before the [statue of the Winged Victory of] Samothrace, I'd be there on the stairway. All of you would be behind me. We'd be there, arms extended. . . .'"

Moinot's reaction: "Confronting the mob of idol smashers, in front of the Samothrace, protecting this cold but divine stone, A. M. imagined his own death." [1]

In 1968 Malraux died, Christ-like, in his imagination, defending the treasures of the civilization entrusted to France, and by France to him. But the physical sacrifice was not necessary. The students spared the Louvre and the ossified Comédie Française, as well as the Académie Française. Instead, after they vandalized the Stock Exchange, they occupied the places where the old

culture was dispensed to them: the university and the art school. Then, as we saw, they went after the temple of the spoken word in their Quarter, the Odéon theater.

A few days later after Malraux's staff meeting, General de Gaulle unsheathed the powerful weapon of his own charisma. He now deployed it not on the radio as he had done from London in 1940; rather, he appeared on television to call the nation to rally behind him. He promised reforms. Parliament would be dissolved. The Gaullists wagered everything on the new elections. Malraux threw himself into the campaign (figure 32).

In voting held on 23 and 30 June, the Gaullist party won an absolute majority in the legislature. The parties of the left lost heavily. The non-alternative of the students and some of the young workers they tried to win over had been resolutely repudiated by the French electorate. But when on 27 April 1969 the voters were asked once again to endorse the regime, this time in a referendum on the proposed reforms, they surprised everyone by using the opportunity to repudiate the government's attempt to reconsolidate its authority.

De Gaulle resigned the presidency the next day. After a short interim administration, on 20 June 1969 Georges Pompidou was elected president. He named Jacques Chaban-Delmas his prime minister. Malraux's loyalty was to de Gaulle. His power had come from de Gaulle. He resigned his post on the 23rd.

The General spent the last year of his life back at Colombey. Malraux often visited him. He wrote about their conversations in his *Felled Oaks*. In an early visit Malraux reminded the General of the vision for France he had articulated some twelve years before, at the moment of the collapse of the Fourth Republic: "We must know whether the French want to re-fashion France, or to take to their beds. I cannot do it without them. But together we can bring institutions to life, gather around us once more what used to be called the empire, and give France back its nobility and its rank."

Defeated, sitting in the parlor of his old farm house, the ex-president listened sadly to his words being recalled to him. "When I'm gone," Malraux has him say, "perhaps the age will have played out its role." So deeply had the General's thought—French thought—absorbed the mission of civilization, of being the inheritor of classical antiquity, that in a later conversation between former savior of the culture and the former redeemer of the nation, Malraux reports the General's continuing meditation on the same theme. "It is strange to live with the awareness that a civilization is ending! That hasn't happened since the end of Rome" (figure 33).[2]

Gaullism, the political movement, continued with substitutes. But routinizing the charisma was not easy. And a little over a decade later, in 1981 the Socialist-Communist coalition under President François Mitterrand finally came to power. Jack Lang was appointed minister of culture. President

Figure 32. Malraux with other Gaullist notables leading march in support of the government, 30 May 1968. Henri Bureau–Sygma.

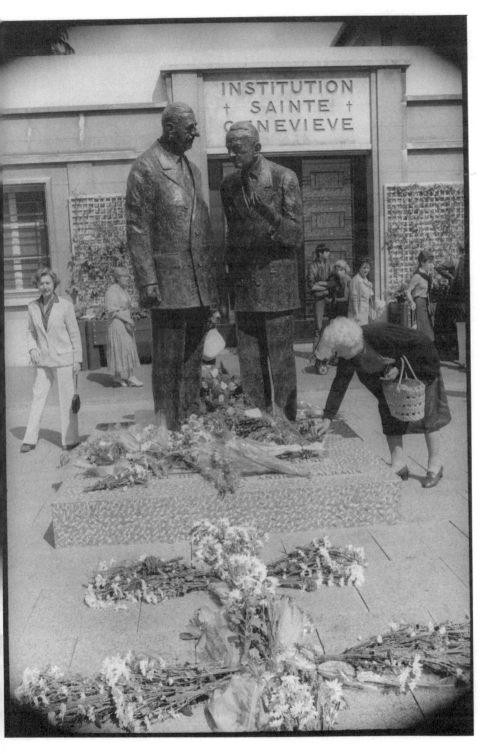

Figure 33. Sculpture of Malraux explaining some point in art to de Gaulle, by Charles Correia, Asnières. Photographed 18 June 1982. Keystone-Sygma.

Mitterrand entrusted him with what Malraux could only dream of: 1 percent of the state's budget. Lang was a media sponge, for which he was criticized. But the job was hard and did not come with great power. Like Malraux, he had to create what symbolic capital he could.

The General died on 11 November 1970. Malraux came late to the simple funeral ceremony in the village church of Colombey. When he arrived he seemed unfocused, unsteady on his feet, distraught, at least.

The Legitimation Crisis of the Culture State

By the mid-1960s, the structural changes French society had undergone were remarkable. In 1945 France had been a society with a significant peasant population, primarily small industrial firms, many local merchants, and a protected export market in its colonies, all held together by a state apparatus dominated by a highly trained administrative elite drawn largely from the Paris bourgeoisie raised on a rich literary culture. Two decades later, as we saw, the country had become a highly urbanized, technology-driven society with growing numbers of technical and managerial white-collar workers. With decolonization, its captive export markets had disappeared; big industrialists were casting about for new outlets. The drive for economic modernization—which de Gaulle hoped would restore France to Great Power status—broke the historic bond between society and culture.

Refined and republicanized from the sixteenth through the nineteenth centuries, the inherited literary-humanist culture was out of step with the industrial society emergent in the mid-twentieth. That culture, as we have seen, was serving its historic functions, both of national and social unification and of assuring international grandeur, ever more poorly. Although the problem was evident to many postwar observers, the solution was not. Already in the brief years of the Fourth Republic, literary intellectuals were filling the reviews and book racks with gloomy essays on contemporary intellectual life and the culture. What was existentialism, if not a stricken literary human-ism's confrontation with death?

What to do? By itself, the private sector was too weak. The old culture guilds had become irrelevant to anything going on in the arts, but still could exercise a braking effect on cultural invention. But the historic culture of France could not just be written off as old-fashioned, as we periodically do with much of the American Way of Life. It was left to the state to act.

The most common form of cultural support, and the surest, even in the years of the Fifth Republic, continued to be some combination of the limited public which could pay the price of tickets of admission and government patronage. There is no tradition in French history of business underwriting the arts. It is just beginning now. With the spread of capitalism into the

arts in the course of the nineteenth century unhappy artists began to think about guarding their work from falling into the status of commodities. The constant risk of doing art in a capitalist society, of being devoured by the double-headed monster, the fickle public and the cruel market, finally crystallized the principal social axiom of aesthetic modernism, that art was independent of society.[3]

Their shared faith—that the public authorities ought to shield art from becoming commodified—united the culturally conservative General with the one-time Popular Front intellectual. Each man, in his special way, also believed in the relative autonomy of the state; that is, each wanted a Fifth Republic which could act for the good of the nation, independent of the society's dominant economic and social elites. Malraux wanted to employ the state to bring back the aura that industrial capitalism had nearly extinguished. The culture would have a people again; and the people would possess a unifying culture.[4]

De Gaulle, the soldier, Catholic, and nationalist, wanted art not beholden to the market because, for him, the arts were major transmitters of the traditions of France. Keeping the aesthetic culture relatively unsubservient to capitalism while at the same time having the state control it was as reasonable to him as it had been to Louis XIV. That is why, when Jean-Paul Sartre tried to provoke arrest by selling the banned student leftist newspaper *La Cause du Peuple* on the street, de Gaulle reacted with horror to the suggestion that he be locked up. He is said to have explained to the head of the Paris police, "You don't arrest Voltaire." For him, the free critical intellectual, the writer, was part of the *mise-en-scène* of French cultural *traditions*. Arresting the most famous one of the age was dangerous for both the French cultural heritage and a leader's political career. De Gaulle read history: Victor Hugo's mockery had taught Napoleon III this lesson. With the support of de Gaulle, Malraux *nationalized* the culture.

For the sake of saving the culture and itself, the Gaullist state decided to play the decisive role in the funding, elaboration, and direction of the culture. The state apparatus continued to be dominated by bourgeois educated in classical French culture. Contrary to some modernization models which make too rapid economic change the source of social tension, the problem in France lay in what did not change.[5] If something went wrong in the cultural realm—the mess at the Opera, scandalous leftist plays produced in state theaters at government expense, the malfunctioning of the Cinémathèque, and so on and so on—the problems translated immediately into politics. Cultural crises brought into question the validity of the government, even that of the state itself.

Consider the state legitimation crisis from the side of the culture. Since French art—especially the art sent abroad—was representative of that state, the risks of encouraging safe mediocrity or its sibling, mindless sensational-

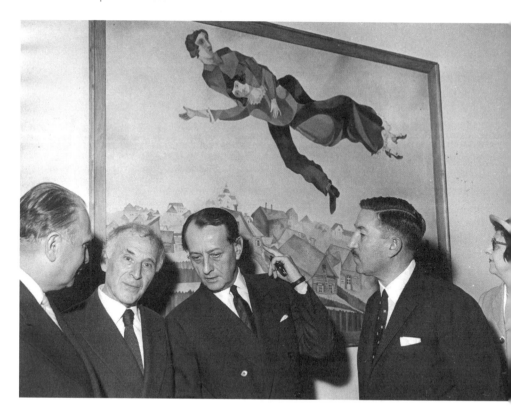

Figure 34. Malraux explains Chagall to Chagall, at the opening of the Chagall exhibition at the Museum of Decorative Arts. From left to right: Ambassador Vinogradov of the USSR, Chagall, Malraux, Claudius Petit. Keystone-Sygma.

ism, were equally great. As the acknowledged biggest actor in the arts, the state was often the de facto arbiter of arts trends. Sometimes this led to Braque, Masson, and Chagall painting the ceilings of historic buildings and the appointment of France's greatest actor and its greatest film buff to head prestigious national institutions. But the best work of all three painters was behind them when they executed Malraux's commissions.[6] And both Barrault and Langlois were summarily fired when they came into conflict with the state (figure 34). So the state's embrace could put cultural creation at risk too.

Sometimes the nonaction of the government, when only it could act, caused the problem. The postwar creation of a serious museum of modern art was, in part, stalled because a Communist, Jean Cassou, headed the modern art museum in the Palais de Tokyo. Only Cassou's retirement and the remarkably single-minded devotion of the new president, Georges Pompidou, got a

new modern art museum for France. The Pompidou Center, the most visited museum in France, has been good for France's balance of payments. However, completed only in 1970–71, it came too late to legitimate current modern French artists the way the Whitney and the Museum of Modern Art in New York had been doing for decades with contemporary American art. Because of the necessary intertwining of culture and state, each sphere experienced escalating crises in the decade of the 1960s which automatically involved its partner.

In his ten years Malraux had tried to manage, to steer, the culture's growing crisis of legitimacy. What were the results of that decade's efforts?

First, the negatives: He could not increase the audience for the high culture. Nor could his ministry, wedded to older aesthetic forms, easily mediate the emergence of new art or of new art forms. Although he had both interest and plans, Malraux's ministry was barred from participating in the development of the powerful new media of radio and television. He early showed interest in using his ministry to reconnect France with sectors of the populations in the former colonies, but de Gaulle allowed the minister of cooperation to block his efforts. Malraux had been given a bag of offices that served existing arts institutions. The innovation he considered his most important project, the Houses of Culture, changed little in France before their delegitimation as a result of May '68. In short, his administration sparked no new aesthetic departures, nor did it enhance the population's participation in *the culture*. It did not end France's cultural crisis.

On the positive side, Malraux and his coworkers made order in the state's jumble of cultural agencies, inventoried its cultural treasures, defined protected architectural zones, and—by means of the persona Malraux—gave the concerns of culture both domestically and internationally a visibility and excitement unparalleled in the twentieth century. Even if their beginnings preceded his taking office, he had helped the New Wave filmmakers financially. And if the state could not find a way to encourage another generation of talented young cineasts after them, Malraux's financial aid to those he found working when he took office—if not his treatment of Henri Langlois—deserves credit. Philippe Urfalino charges Malraux with having created a ministry for artists rather than for the nation. I think this criticism is substantially correct. Yet I would add, Malraux gave the arts a seat in the meeting rooms of political power. As one witnesses the debacle of government funding of the arts in the contemporary United States, it is hard not to be envious of what Malraux could do with so little. And the walls of Paris continue to be the beautiful gold-white sandstone colors that Malraux's cleaning uncovered.

Most important, Malraux established the principle that the state has a responsibility to the cultural life of its citizens, just as it does—at a different level of funding—to their education, health, and welfare. As an American,

I can be only envious of this, Malraux's new doxa of the elected government's cultural obligations to the citizenry.

The Malraux ministry, finally, did not become the place where the culture was redefined for the new lives that people in France lead in the late twentieth century. Contrary to the self-serving preachments of cultural conservatives, the sure sign of vitality in a culture is not its fixities and idols, its classicisms. Rather a culture's future lies in its ability to change, to invent, and at the same time, also to be open to—and selectively to appropriate—things of value from other cultures. The young people's rejection in May 1968 of what de Gaulle and Malraux honored in the French heritage showed that restoration and conservation—and the *hope* of innovation—had not been enough to save historic France.[7]

Waiting for the Barbarians

Critics' painful soul-searching about what will become of them, and therefore of France, had already attained the status of a literary genre before the Malraux Autumn of 1996. In recent years France has seen many, many books about the end of the book. Back in 1979, Régis Debray divided the history of the French intelligentsia into three ages. From about 1880 to 1930 the university intellectual ruled French thought. About 1930 the Sorbonne lost its place of honor. From that date and extending to their own dethronement in the early 1960s the writers were hegemonic. Like the young Malraux, they surveyed their territory from the bastions of the Latin Quarter publishing houses. In 1968, according to Debray, began the current age of electronic media and of media celebrities.

Debray, that brilliant, unpredictable intellectual, has often been a little ahead of his contemporaries, and of the story too. But he omitted an important stage in the history of the French intelligentsia: it was not true that after 1968 the media replaced the writers. The literary critics and philosophers did. Debray had been misled by the elision of the writer into the critic. In the cultural sphere, today's mortal struggle is not between the novelists and the media. The novelists just write fiction; I have read no manifestos by young writers cursing television or hacking out a new literary field. The electronic media are challenging the claims of the critics and philosophers to speak for France.[8]

Today sales both of thoughtful meditations and jeremiads about the future of French culture has become an important source of income for a book industry in great economic distress. The year before the Malraux Autumn, for example, Jean-Marie Domenach published his own (provisional) requiem for the French novel, *Le crépuscule de la culture française?* (The twilight of French culture?). In the same year, French readers could read Jacques

Rigaud's defensive defense of France's cultural exception among the nations, *L'exception culturelle: Culture and pouvoir sous la Vᵉ République.* Also in 1995, Fabrice Piault elaborated the implications of his judgment, *Le livre: La fin d'un règne* (The book: the end of a reign).[9]

For some decades now, Pierre Bourdieu has been theorizing a general sociology of the French intelligentsia. Clearly in our media age, the project, as he understood it at the outset of his work, requires further thinking. In a recent little book on television, he has begun the painful process. Bourdieu has little good to say of the new medium. It is ruled by the ratings, rather than by intellect or democracy. He calls it a daily "plebiscite of commerce." In a new twist on "the treason of the intellectuals," the professor at the Collège de France denounces certain French intellectuals for writing books for the sole purpose of being invited on television to talk about them.[10]

Yet the metaphor of the waning of a culture—and that's all it is, a manner of speaking—does not suggest that in the postwar years French publishing houses closed their doors, that artists stopped painting, that the Louvre functioned only as a snack bar and sales center for reproductions, that the restaurants of Lyon competed with each other not over who could make the most interesting versions of regional dishes, but rather over the garniture for hamburgers. The schools continued to teach the classics of French literature and philosophy. The Opéra Garnier performed its repertoire of nineteenth-century hits. On the radio, France Musique played some symphonic music between the lectures and interviews. The Comédie Française, which on taking office Malraux had tried to control and where he was soundly defeated by the resident guild, kept alive the culture's ties to seventeenth-century theater. In fact, theater (of the absurd) and filmmaking (the Nouvelle Vague) experienced renaissances precisely by finding aesthetic materials in the absurdity—anomie, Durkheim had called it—of the contemporary culture world.

In brief, in the first decades after the end of World War II, the institutions of artistic production resumed performing the major task society assign to them. To be sure, they offered pleasure and entertainment, but also cultural continuity and social cohesion to as many as were able to gain access to their languages, forms, and holy places. This function of cultural production was even more important than in the past, because France had just passed through a dark night of national humiliation, internal division, occupation, and the retrenchment or crippling of much of its accustomed cultural life. And Malraux made this French culture work better. He in culture and de Gaulle in politics healed many of the old wounds.

However, the word-centered culture that has held modern France together for over a century no longer *defines* the nation's values. Domenach speaks of the "tight bond between the novel and a civilization." The print culture that made France no longer unites contemporary France, not the modern nation.

In the most elegant or most obscure prose, critics in France are describing,

dissecting, and lamenting the death of literary France. Just as Renaissance humanists rejected the book printed with the newfangled movable type as a threat to their precious hand-written manuscripts and their hard-won status as masters of the written word, so too France's current literary humanists are resisting their dethronement. However much their activities have been intertwined in the nation's recent history, their current troubles are not forever, nor for certain, those of France. Domenach comments that in Europe, not just in France, whenever there is "a change in the configuration of a culture—we are coming to such a moment—many voices loudly decry the disaster." But his proposal, a return to the classics—like his analogy of television and nineteenth-century door-to-door vendors of cheap books and pictures—seems to miss the specificity of this moment. This special time of risk is also a special moment of opportunity for French culture.[11]

Paths

In recent decades, governments of France have dealt with this legitimation crisis in the world of the arts by continuing to spread a watered-down version of the old culture more widely over the new electronic media; by dethroning literature and philosophy in higher education and making science and mathematics the basis of elite education; by jealously trying to guard the nation from foreign cultural pollution; and by blaming others. But the dilemmas of the Malraux era remain: the culture that many French statesmen believe is crucial for the safety and stability of the nation is losing both validity and resonance with the population. I think the perplexity raised by this dilemma is displaced, in part, into the intense concern, especially among the most culturally conservative parts of the population, about Islamic and African immigration, the new Europe, and overweening American cultural marketing. But the future is open, nothing is forever in the development of cultures, most certainly not in France's.

I can think of four ways in which French culture can be, and to varying degrees, is being, renewed: rethinking the role of writing, reaching out to French speakers abroad, broadening the idea of the culture, and most important, taking advantage of the new electronic media. First, as Mark Twain once remarked about rumors of his own death, stories of the death of literacy are exaggerated. The roles of writing and of the book have changed. Without doubt, the depression in the French book trade is not forever. Authors will continue writing great novels and they will find even more readers than in the past. The theater can revive as well. After all, opera did not disappear after its golden age in the nineteenth century. But a condition for the renewal of the arts of the word has to be to put the world and the real France—not the True France—in the novel and the play.

A common feature of the flourishing of the novel in Latin America, the Caribbean, Africa, and even the United States is the liminality both of the authors and of many of their readers. Author and publics live in traditional worlds *and* in the intensely modern. Think of Balzac writing brilliantly and venomously about the creation of bourgeois France in his day, or Zola scaring his readers with a vision of the complete otherness of the new working class and of the urban underclass. Recall the brilliant novels, poems, and plays that came from the industrial and commercial American New South in the 1920s and 1930s. Salman Rushdie, Chinua Achebe, V. S. Naipaul, Gabriel García Marquez, James Baldwin, Maxine Hong Kingston, Timothy Mo, and Antonine Maillet to name just a few well-known writers, have made great fiction from being caught betwixt and between. They found a public, some of which shared their raw feelings, eager to read narratives that touched their dilemmas, troubles, and hopes as authors and readers were challenged by new environments, new work, new identities. Today, there are a few such writers and their reading public in France. In 1993, the Haitian Patrick Chamoiseau's *Texaco* and *Le rocher de Tanios*, by Amin Maalouf, of Lebanese heritage—both recent winners of the Prix Goncourt—led the fiction best-seller list. The extreme transformations of modern French life, I think, will continue to create both authors and audiences for the fiction of liminality.

Second, and related, there is the way of *francophonie*. It started in the 1930s as a movement of young writers from the colonies. At first only a few left-wing French intellectuals, most notably Sartre, showed interest. After decolonization, *francophonie* became a field of cultural power where former colonials and colonialists contested the uses of the French language and revolutionary heritage. The population of France is about sixty million. Forty million more people in the world speak French as their first or second language. Today, the French government puts lots of energy into keeping the ties with nations where French is spoken or widely taught.

The British literary magazine *Granta* recently dedicated a number to francophone writers—of Haitian, Algerian, and Belgian ancestry—who have, in the words of Ian Jack, its editor, "put the world back into the book." [12] Children of immigrants or French authors from abroad are beginning to write the most interesting fiction in the French language. They have readers all over the world. Jean-Marie Domenach puts his main hope for renewal of the novel in the francophone authors who live and work outside of France. [13] But if *francophonie* is to save the language and the literature, French authorities—of the state and of the literary canon—have to give up any lingering desires for an Académie Française–like hegemony over the world's French-speaking cultures.

A third way open in contemporary France leads to further democratizing the culture. Here I do not mean the idea that Malraux tried, and did not

achieve, of *making the culture accessible* to more of the population. I mean both modification of its top-down organization and greater social diversity in its manifestations. This has begun to happen. Since the statist days of de Gaulle and Malraux, Paris's dominion over the culture has yielded to more democratic management. Actually, because he negotiated the state's and localities' financial roles in funding the Houses of Culture, Malraux should be credited with at least taking a step in the direction of local empowerment.[14] Today, the Ministry of Culture is still steered from the capital, but most of the discretionary cultural budget is spent by regional councils and mayors.

I don't know if France has what we would call a vital "popular culture," the way, for example, Britain and the United States have. At this moment, I think not. Jack Lang tried to include aspects of popular aesthetic forms and entertainments in the state's bounty. For example, he funded the annual comic book festival that now draws many participants. Early in their rise, he subsidized three rock bands, including the Gypsy Kings from Arles. And from the other side, the process of selective appropriation and adaptation of high culture forms for their own purposes by minorities and youth continues in France.[15]

Nor do I know if a concept of "popular culture" or at least a more participatory version of the national culture will ever achieve a modicum of legitimacy in France. However, the top-down approach has been tested for some time. Its most resolute champion, Malraux, could not extend cultured France beyond a small highly educated elite. In our democratic age the elitist democracy—an open elite, to be sure—of the past republics cannot function. Is there any choice for France, but to explore ideas for cultural democracy?

A fourth and final route out of the malaise, and the most important in terms of its long-term consequences, has to do with the proliferation of electronic media. New forms of communication and of creation carry new kinds of messages, which permit new ideas both of freedom and of connectedness. Fabrice Piault, Jacques Rigaud, and Régis Debray, among others in France, see the positive potential in the new communication technology. Piault, for example, who characterizes himself as a "child of the book," views the new electronic media with great hope: they open the way, as he puts it, for a "joyous democracy of knowledge."

Writing, is, if anything, more crucial than in the past in such a world. A useful distinction that Rigaud, once aide to cultural ministers, now head of Radio-Television Luxembourg, proposes is between the book as "an object, which is indeed menaced by the new media," and "writing [*l'écrit*] which today is seeing the opening of many new perspectives."[16] The craft of writing will continue; if anything, it will become more important and more widely practiced. The foundation of a film or a television program is the script. What is the Internet about if not new ways of writing and reading?

Not only are the images on TV and in films reaching many more of the

French population than the bookstore ever did; attendance at museums of fine arts is at an all-time high. The image media make another language available to the population. Today, the French (we also) live in a world in which increasingly information of its workings comes to us electronically, via the image. That is to say, the "experiences" most of us have of important things—war, calamities, celebrations, pleasures—are controlled by powerful businessmen who transmit their ideas of reality as the truth of the world. France, fortunately, has a strong governmental stake in the television industry. For all the caprices of state cultural officials we have seen, the workings of the marketplace allow the ascendancy of an even smaller number of decision makers, whom we did not elect to fashion programming at the lowest common, very common, denominator. With both public and private sectors in the media, as both France and Britain have, the checks and balances have made for better quality programming than we can see in the United States.

Of all the commentators of the Malraux Autumn whom I read, Régis Debray best understood Malraux's media projects, which were before their time or politically frustrated. Today, in the age of television, we are accustomed to seeing one unrelated image rapidly following another. Malraux's treatment of art, for example, as one obscurely connected image after another does not makes us dizzy as it did his contemporaries. Although he was a premature channel surfer, or *zappeur*, as they are called in France, in some ways today we are all Malrucians. Régis Debray credited Malraux with a better understanding than his contemporaries in government of the educational and cultural value of film, radio, and television. Malraux drafted a strategy—after he left office—whereby the media were to help the French schools, perhaps even take up some of their mission, to build, if not the global village, at least a national culture for our times (figure 35).[17]

The Many Deaths of André Malraux

During most of his life, André Malraux was fixated on death. Jean-François Lyotard thought that the death and funeral of his infant brother when he was still a boy marked him for life.[18] When he was older, his father committed suicide. His two half-brothers died in the Resistance. The mother of his two sons was killed in an accident at the end of the war. And both sons died in an auto crash early in his ministry. He often spoke of the special burden of death in his life. Death awaited, and often came to, the protagonists of his novels. Even in his philosophical meditations about culture, the limit of death determined what was of value. Art was the only hope of human immortality, the only life after death.

Malraux was the right person to confront the mortality of French culture

Figure 35. Malraux and the actor Jean Vilar discussing the filming of a made-for-television film they were doing, 15 May 1971. Keystone-Sygma.

in its historic form during his decade as France's first minister charged with overseeing cultural affairs. We saw in his fantasy of personally defending the Louvre how deeply he identified his life with the endangered culture.

After his withdrawal from politics Malraux returned to his writing. Most of what he published in his last years was, in various guises, his memoirs. We can understand why in 1971, at the age of seventy, he volunteered to go to the struggling new republic of Bangladesh to fight, perhaps to die, for its survival. Indira Gandhi, as head of the state that was Bangladesh's protector, thanked him warmly, but declined his help.

The different André Malrauxs died at different times (figure 36). Each was buried and honored according to the needs of the historical moment. Five years after he had sought a freedom fighter's death in Asia, on 23 November 1976, André Malraux died of an embolism. In a quiet and simple service held the next day, he was buried in the cemetery near his home in Verrières-le-Buissson.

In 1996 his last funeral, the one in the Panthéon, was staged as a great

Figure 36. Not a healthy man, Malraux makes a V-for-Victory sign to reporters at his home in Verrières-le-Buisson outside Paris a few months (23 February 1976) before his death. Keystone-Sygma.

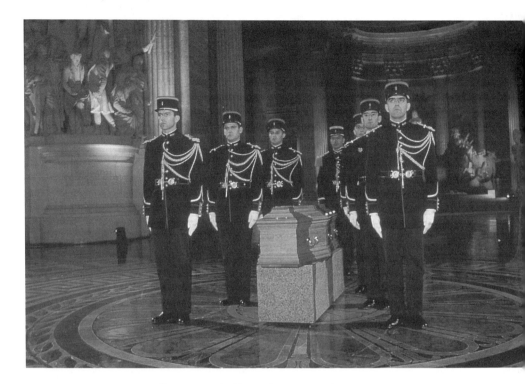

Figure 37. His coffin surrounded by an honor guard, Malraux's remains are entombed in the Panthéon, 23 November 1996. Berthe Judet–Sygma.

public ritual (figure 37).[19] In the eyes of the print-journalists there, and probably of the onlookers, the rite was not as splendid or as thronged as such ceremonies in the past. In 1885 more than two million spectators had watched Victor Hugo's funeral cortege move through the city's streets on its way to his burial in the Panthéon. In 1964 the solemn reburial in the Panthéon of the Resistance hero Jean Moulin inspired Malraux to give the most moving talk of his career. But the ceremony for Malraux did not arouse much passion in the small crowd standing well back from the iron fence surrounding the one-time church that cold November evening. In part that was because the rite was designed to show best on television. Yet watching the videotape in a comfortable chair at home, I felt no special magic coming from the screen, no aura.

A Chronology of the Places of Memory of the Malraux Ministry

1958

1 June Malraux made minister of information in first Gaullist government.

26 July Presidential decree charging Malraux with projects concerned with the spread of French culture.

1959

8 January Michel Debré made prime minister; Malraux named secretary of state for cultural affairs.

3 February Functions to be housed in the Ministry of Cultural Affairs determined.

15 May Malraux announces the nationalization of the Cinémathèque at the Cannes Festival

16 June Creation of the system of loans specifically for makers of quality films secured by future box office income.

24 July Decree stating the mission of the new ministry—"to make accessible . . . " —followed by a list of its component Directions.

2 October Inauguration of the First International Biennial of Young Artists.

21 October Inauguration of the Théâtre de France (the Odéon) under the leadership of Jean-Louis Barrault and Madeleine Renauld. Malraux and de Gaulle attend the opening of Paul Claudel's *Tête d'Or*.
Malraux orders cleaning of the facades of public buildings in Paris.

1960

14 March Emile-Jean Biasini named to ministry, to assume duties in Paris in early 1961.

4 April Opening of the "Treasures of India: 5000 Years of Indian Art in Paris" in the Petit Palais.

1961

23 May Death of Malraux's two sons by Josette Clotis, in an automobile accident.

11 December *Education populaire* taken from Cultural Affairs and restored to the Ministry of National Education.

11 December Biasini takes up his position as directeur du Théâtre, de la Musique et de l'Action Culturelle.

22 December	Actors, singers, and dancers in the performing arts made eligible for national health benefits.

1962

15 April	Georges Pompidou, a strong supporter of Malraux and his work, named prime minister. Malraux renamed to his office.
31 July	Law appropriating funds for the restoration of France's important historic buildings and monuments, beginning the braking of the destruction of the architectural heritage.
4 August	Law to permit declaring places or regions protected historic zones.

1963

9 January	Malraux speaks at the opening of the *Mona Lisa* Exhibition in Washington.
3 September	On behalf of the French government Malraux speaks at a ceremony held in front of the Louvre to honor the recently deceased Georges Braque.

1964

29 January	Creation of a full-fledged archaeological service in the ministry.
4 March	Julien Cain put at the head of a national commission to inventory the nation's treasures in buildings and art, the "Inventaire," the first complete and detailed central record of the state's artistic possessions.
April	*Venus de Milo* sent to Japan, admired, chipped.
18 April	Inauguration of the first Maison de la Culture at Bourges.
16, 26 December	Malraux speaks to the National Assembly in support of extending health benefits and protections, including medical insurance, to independent artists, sculptors, and engravers.
December	Marcel Landowski becomes chief of the music service.
	Malraux gives funeral oration at the reburial of Resistance hero Jean Moulin in the Panthéon.

1965

1 September	Malraux honors the recently dead Le Corbusier in the Cour Carré of the Louvre.
November	The ceiling of the Théâtre de France, painted by André Masson, is finished and unveiled.

1966

30 March	Malraux speaks at Dakar at the opening of the First World Festival of Negro Arts.
3 August	Malraux fires Gaëtan Picon from his post as directeur général des Arts et Lettres because of his support for Boulez against Landowski.
28 October	He fires Biasini for the same reason.
October	Demand by conservative parliamentarians to stop the production of Jean Genet's *Les paravents* at the Théâtre de France, and Malraux's defense of the autonomy of art before the legislators.

1967

23 October	Creation of the National Center of Contemporary Art (Centre national d'art contemporain), prelude to building the Pompidou Center.
28 December	Renewal and expansion of the law for the protection and restoration of historic monuments and structures.

1968

March	The Affaire Langlois.
May	The explosion in the Latin Quarter, which spreads.
12 July	Couve de Murville becomes prime minister. Malraux is reappointed to his post.
28 September	Malraux addresses the meeting of the Association Internationale des Parlementaires de Langue Française.

1969

17 February	Malraux addresses the conference of francophone countries meeting at Niamey, New Caledonia.
23 June	Malraux resigns his post soon after General de Gaulle leaves the presidency.

1970

Death of de Gaulle. Distraught or disoriented, Malraux comes late to funeral at Colombey.

1971

Malraux becomes president of the Institut Charles de Gaulle. Volunteers to fight to defend the newly created Bangladesh.

1972

President Nixon invites Malraux to the White House to get the writer's thoughts on China before Nixon's departure.

1973

Malraux honored in India by Indira Gandhi. Receives an honorary degree from Rajshahi University in Bangladesh. Opens an exhibition devoted to himself at the Fondation Maeght.

1974

Malraux publishes his book on Picasso, *La tête d'obsidienne*. During presidential elections, proposes reforming education by means of audio-visual technology. Visits Japan with the title of special ambassador for the *Mona Lisa* show. On the way back stops in India to receive the Nehru prize for promoting international understanding.

1975

Malraux lectures students and faculty at the Ecole Polytechnique on civilization. Speaks in honor of de Gaulle's memory. Once again condemns Franco Spain. Visits Haiti to see new Haitian art.

1976

Malraux devotes most of the year to finishing and publishing works started earlier in the decade, especially writings on art history.
Dies of an embolism on 23 November.

1996

On 23 November Malraux's body is reburied amid great ceremony in the Panthéon. Gaullist president Jacques Chirac gives the oration. The media of all political persuasions honor *their* Malraux.

Notes

Introduction: The Life Story of a Culture

1. Emmanuel Mounier, "André Malraux ou l'impossible déchéance," *Esprit*, October 1948. On the French exception see the book by a former aide to Jacques Duhamel, the culture minister after Malraux: Jacques Rigaud, *L'exception culturelle: Culture et pouvoir sous la Vᵉ République* (Paris, 1995).

2. Stanley Fish, "Biography and Intention," in *Contesting the Subject: Essays in the Postmodern Theory and Practice of Biography and Biographical Criticism*, ed. William H. Epstein (West Lafayette, Ind., 1991), 9–16. Fish writes, "if the originating author is dissolved into a series of functions [as Foucault argued], if the individual mind is merely the tablet on which the mind of Europe or the mind of the pastoral or the mind of the myth inscribes itself, then we have not done away with intention and biography but merely relocated them"(13).

3. Roland Barthes, "De l'oeuvre au texte," *Revue d'Esthétique*, 3 (1971), 225–32. I have used Stephen Heath's translated version, in *Art after Modernism: Rethinking Representation*, ed. Brian Wallis (Boston, 1989), 169–74; the quotation, 173.

4. See Joan W. Scott, "'Experience,'" in Judith Butler and Joan W. Scott, *Feminists Theorize the Political* (New York, 1992), 22–40.

5. Reported by Jorge Semprún, "L'Espagne sans retour, " *Magazine Littéraire*, 347 (October 1997), 41.

6. I found Cheryl Walker's arguments for the advantages of such a strategy compelling. "Choosing to concentrate on a composite persona removes the difficulty of having to decide who the writer 'really' was and what she 'really' meant, an irritating tendency of some psychological criticism. The persona is a mask, necessarily artificial and therefore unlike human subjectivity, which, with all its artificiality, also produces the genuine as one of its descriptive binaries." However, I will change her emphasis on *understanding* the "author" to *observing* Malraux, the "performer." Cheryl Walker, "Persona Criticism and the Death of the Author," in *Contesting the Subject*, 109–21; the quotations, 119.

The great sociologist of the construction of personae remains Erving Goffman. See, for example, *The Presentation of Self in Everyday Life* (Garden City, N.Y., 1959), 252–53, and *Asylums* (Garden City, N.Y., 1961), 168.

7. Gaëtan Picon, *Malraux* (Paris, 1953), 14, 39.

8. "Entretien accordé au journal allemand *Der Spiegel* par André Malraux, octobre 1968," French translation in the dossier "Discours d'André Malraux, 1959–1970," in the holdings of Ministry of Culture's research center, the Département des Etudes et de la Prospective.

9. Marc Bloch, *Etrange défaite* (Paris, 1946), written 1940.

10. On the symbolism of Coca-Cola in French public life see Richard Kuisel's "Coca-Cola and the Cold War: The French Face Americanization," *French Historical Studies*, 17 (1991), 96–116, and his *Seducing the French: The Dilemma of Americanization* (Berkeley, Calif., 1993).

11. Pierre Bourdieu, *Les régles de l'art: Genèse et structure du champ littéraire* (Paris, 1992), esp. 393–430; *The Field of Cultural Production* (New York, 1993), 29–141, and with Loïc Wacquant, *An Invitation to Reflective Sociology* (Chicago, 1992).

12. See the collection of essays on the contemporary crisis of French higher education edited by Martha Zuber, "La France: A la recherche de ses universités," *French Politics and Society*, 15 (Winter 1997), 1–56.

1. France's *Mona Lisa*

1. Alain Peyrefitte, *C'était de Gaulle*, vol. 1: "*La France redevient la France*" (Paris, 1994), 357.

2. Edward T. Folliard, "Escorting Mona Lisa to America," *National Geographic*, June 1963, 838.

3. John Walker, *Self-Portrait with Donors* (Boston, 1974), 62.

4. Ibid., 63.

5. Frank Getlein, "The Gioconda Affair," *New Republic*, 19 January 1963, 29–30.

6. *New York Post*, 11 May 1962; *New York Times*, 12 May 1962.

7. Peyrefitte, "*La France*," 357.

8. French text in the dossier "Discours d'André Malraux, 1959–1970," in the files of the Ministry of Culture's research office, the Département des Etudes et de la Prospective. The translation of Malraux's text: "Address by M. André Malraux, French Minister of Cultural Affairs on the Occasion of the Special Exhibition of the *Mona Lisa* at the National Gallery of Art in Washington, D.C., on January 8, 1963," Public Information Files RG14, Box 2A, Exhibitions: 8 January–3 February 1963, Mona Lisa, Gallery Archives, National Gallery of Art, Washington, D.C. These archives hereafter cited as NGA.

9. "Remarks of the President at Ceremony in Honor of the *Mona Lisa* at the National Gallery of Art, Washington, D.C., January 8, 1963," NGA. My italics.

10. "Protocole à soumettre à l'approbation du Gouvernement français et du Gouvernement des Etats-Unis," Dossier Correspondence, Mona Lisa Exhibition, item 13. Metropolitan Museum of Art, The Archives. Hereafter cited as Met. Archives.

11. Copy of the invitation in ibid.

12. See the gossip story "U.N. Officials Snub Mona Lisa," *Washington Post*, 8 February 1963; *New York Times*, Western Edition, 8 February 1963, 10.

13. In the Pléiade edition (3 vols. to date) of Malraux's *Oeuvres complètes*, vol. 1 (Paris, 1989), 1205.

14. Theodore Rousseau, "The Mona Lisa," *Metropolitan Museum of Art Bulletin*, February 1963, 224. Reprinted and included in visitors' pamphlet with same name, n.p., n.d.

15. Rousseau blames the artistic vandals of the twentieth century for trying to sully this icon of female beauty. But a closer look at the face, with the hair framing it covered over, suggests that Leonardo himself portrayed a rather manly woman.

16. Mona Lisa Exhibition, statistical summaries, Met. Archives.

17. "Statement by John Walker at the Closing of the Mona Lisa Exhibition at the Metropolitan Museum of Art, May 6, 1963," RG7 Central Files, C-25, Exhibitions, Mona Lisa and others, Box 43, file: Mona Lisa (from Director's Office), NGA. Over ten years later, in his memoirs, Walker reports his reflections at the time on the long lines of eager visitors who had come to see the great painting. "Wasn't the *Mona Lisa* also, I wondered, an icon of [a] novel religion, cultural sightseeing? . . . I decided I was the custodian of a precious relic belonging to a sect whose priests are professionals like myself, whose evangelists are writers on art, and whose pilgrimage sites are either architectural monuments or works of art assembled at museums." *Self-Portrait with Donors, 66–67*. Walker seems to have embraced Malraux's take on the place of art after the death of God, but with an elitist spin.

18. Walker, *Self-Portrait with Donors*, 66.

19. Peyrefitte, "*La France*," 357.

20. Frank Costigliola, *France and the United States: The Cold Alliance since World War II* (New York, 1992), 132–33. Anton DePorte, *Europe between the Superpowers: The Enduring Balance*, 2d ed. (New Haven, Conn., 1986), 229–43. Serge Berstein, *The Republic of de Gaulle, 1958–1969*, trans. Peter Morris (Cambridge, Mass., 1993), 162–63.

21. Charles Cogan, "Lost Opportunity or Mission Impossible: De Gaulle's Initiatives in China and Vietnam, 1963–1964," *French Politics and Society*, 13 (Winter 1995), 55–56. Michael Harrison, *The Reluctant Ally: France and Atlantic Security* (Baltimore, 1981), 101–63.

22. "Remarks of the President at Ceremony in Honor of the *Mona Lisa* at the National Gallery of Art, Washington, D.C. January 8, 1963," NGA.

23. Peyrefitte, "*La France*," 359.

24. Richard Kuisel asks, "Was de Gaulle anti-American?" and finds that, yes, he was anti-American in the sense that he didn't like the "American Way of Life" and values; but no, he always considered France America's ally in world politics. *La Revue Tocqueville/ The Tocqueville Review*, 8 (1992), 21–32.

25. That the United States had used, and in this period of the Cold War was using, its importation of artifacts of European high culture equally politically is certainly true and itself needs detailed exploration, which I cannot do here. I deal with this question in Chapter 8.

26. Archives Nationales (Paris), Ministry of Culture, 890127 Expositions.

2. Once and Future Trustees of Western Civilization

1. Anne-Marie Lecoq, *François I^er imaginaire: Symbolique et politique à l'aube de la Renaissance française* (Paris, 1987), 487–94. Although ceremonial entries like this were not new for French monarchs, the use of the symbolism of the Roman victory arch was a first for modern France.

2. Nor was François I^er 's going to Italy to accumulate glory, among other things, a first either. Charles VIII led an expedition to Italy in 1495–96. His heir, Louis XII, continued French military and political intervention there. So François I^er was the third French monarch in succession to become deeply involved in Italian affairs. The distinction I am draw-

ing here is that none of his predecessors advanced as frequent or as insistent claims that Italy's cultural heritage was passing to France. Cf. Robert W. Scheller, "Gallia cisalpa: Louis XII and Italy, 1499–1508," *Simiolus*, 15 (1985), 5–60, esp. 15, 28.

3. For example, as of 1539 François I^{er} ordered government documents to be printed in French, rather than in Latin which could still pass as an international language of law and learning. He envisioned a print statism which pulled together diverse regions and populations in France with a common printed language. See chapter 2, "Absolutism and Classicism," of Henri-Jean Martin, *The French Book: Religion, Absolutism, and Readership, 1598–1715*, trans. Paul Saenger and Nadine Saenger (Baltimore, 1996).

4. See Todorov's recycling of the "moderate humanism" of Montesquieu as the antidote for contemporary intolerance in a book that represents something of a leap backward for a man known earlier for his contributions to structuralist and semiotic writing: Tzetvan Todorov, *On Human Diversity: Nationalism, Racism, and Exoticism in French Thought* (Cambridge, Mass., 1993), trans. Catherine Porter of *Nous et les autres: La réflection française sur la diversité humaine* (Paris, 1989). See also Marc Fumaroli, *L'Etat culturel: Essai sur une religion moderne* (Paris, 1992).

5. Pierre Nora, "Nation," in *Dictionnaire critique de la Révolution française, 1780–1880*, ed. François Furet and Mona Ozouf (Paris, 1988).

6. Gérard Noiriel, *Le creuset français: Histoire de l'immigration, XIX^e–XX^e siècles* (Paris, 1988), 50–67. Eugen Weber, *Peasants into Frenchmen: The Modernization of Rural France (1870–1914)* (Stanford, 1976).

7. Roy McMullen, *Mona Lisa: The Picture and the Myth* (Boston, 1975), 147. The best informed current opinion on how François I^{er} came to own the painting, as well as two others by Leonardo, holds that we do not know. Cf. the view of the conservateur en chef of the Department of Paintings of the Louvre, Sylvie Béguin, *Leonard de Vinci au Louvre* (Paris, 1983), 20, 74–76.

8. McMullen, *Mona Lisa*, 147–50.

9. Ibid., 158–62.

10. Francis Haskell and Nicholas Penny, *Taste and the Antique: The Lure of Classical Sculpture, 1500–1900* (New Haven, Conn., 1981), 2–5, my italics. See also Giorgio Vasari, *Le vite de più eccellenti pittori, scultori ed architettori*, 9 vols. (Milan, 1962–66), 7:408.

11. "In fact the copies at Fontainebleau (which were for the most part placed in the gardens and which were themselves sometimes copied for other collections in France and elsewhere) provided the first example of that international recognition—later to be acknowledged everywhere in the Western world—of a canon of artistic values which was embodied not just in some vague concept of antiquity, but in certain specific works of antiquity, which were in, and to be seen together only in, France. As time passed, additions would be made to these works (Primaticcio's second journey to Rome was carried out partly in recognition of this fact) while others would decrease in esteem; but for centuries there remained in existence a limited number of sculptures which were used as a touchstone by artists, art lovers, collectors, and theorists alike for the gauging of taste and quality. It was the copies at Fontainebleau which demonstrated the possibility of that touchstone eventually becoming accessible to Europe as a whole": Haskell and Penny, *Taste and the Antique*, 6.

12. Ibid., 32.

13. Ibid., 37, 41–42; the quote from the *Mercure Galant* they cite from Pierre Nolhac, *La création de Versailles d'après les sources inédites* (Versailles, 1901), 238.

14. Haskell and Penny, *Taste and the Antique*, 79.

15. Ibid., 91, citing Stendhal, *Correspondance*, ed. Ad. Paupe and P.-A. Chéramy, 3 vols. (Paris, 1908), 2:123. My italics.

16. Andrew McClellan, *Inventing the Louvre: Art, Politics, and the Origins of the Modern Museum in Eighteenth-Century Paris* (Cambridge, Eng., 1994), 50–51.

17. Michael Levey, *Painting and Sculpture in France, 1700–1789* (New Haven, Conn., 1972), 236, 265–67, 286.

18. Edouard Pommier, "Idéologie et musée à l'époque révolutionnaire," in *Les images de la Révolution,* ed. Michel Vovelle (Paris, 1988), 57–78.

19. McClellan, *Inventing the Louvre,* 9, 10, fig. 6; 55, fig. 55.

20. *Le Moniteur,* vol. 14, 263, cited in ibid., 91–92.

21. *La Décade philosophique,* 10 Prairial, An VII, 434, cited in ibid., 11.

22. Patricia Mainardi, "Assuring the Empire of the Future: The 1798 Fête de la Liberté," *Art Journal,* 48 (1989), 155–63; Charles Saunier, *Les conquêtes artistiques de la Révolution et de l'Empire* (Paris, 1902); Cecil Gould, *Trophy of Conquest: The Musée Napoléon and the Creation of the Louvre* (London, 1965).

23. Mainardi, "Assuring the Empire," 157, 161.

24. Up to the 1980s, the offices of the minister of finance continued to share the building with the museum.

25. Mainardi, "Assuring the Empire," 158–60; Haskell and Penny, *Taste and the Antique,* 108–16; McClellan, *Inventing the Louvre,* 114–23.

26. Mainardi, "Assuring the Empire," 161.

27. Annalisa Zanni, *Ingres: Catalogo completo* (Florence, 1990), 80.

28. Other paintings on this theme are all French. The model for Ingres's was François-Guillaume Ménageot's 1781 work, *The Death of Leonardo*, which depicted the same scene but with François I^er at the painter's bedside showing more philosophical acceptance of death. Ménageot's king was greatly moved, but not distraught. Kings come and go. This was one of his regular commissions from the Court; in 1781 Ménageot had no reason not to expect others in the future. In his painting we see that, of course, kings respected great artists and were saddened by their death. And in Ingres's 1818 painting of the dying artist's expiring while held in the arms of a greatly suffering king of France we see a later version of the discourse: how self-evident the paintings' subtexts of France's mission to embrace great European art and artists had become by the early nineteenth century. Ménageot's model, in turn, had nothing to do with the Leonardo–François I story. For his inspiration, Ménageot drew on the formal composition—placement of the bed, dying man, mourners, etc.—of Nicolas-Guy Brenet's *Homage Rendered to Du Guesclin* painted in 1777. Levey, *Painting and Sculpture in France,* 229.

29. The painter manifests this marvelous compositional and iconographic doubling in his "Napoleon on the Throne" and his "Coronation of Charles X": Zanni, *Ingres,* 31 and 105.

30. Gaëton Picon, *Ingres: Etude biographique et critique* (Geneva, 1967). Picon, one of Malraux's chief lieutenants, as we will see, wrote this appreciation soon after he left his office as supervisor of the arts in the Malraux ministry. The first chapter, titled, "A Genius Out of Time," gives a good feel for the hagiographical approach. Robert Rosenblum, *Jean-Auguste-Dominique Ingres* (New York, 1967), 9, characterizes the artist's art-political role as the "conservative defender of Classical tradition for two-thirds of the nineteenth century."

31. Guizot, *Histoire générale de la civilisation en Europe* (Paris, 1828), 5.

32. Edgar Quinet, *De l'Allemagne et la Révolution* (Paris, 1832).

33. Victor Hugo, *La Pologne* (Paris, 1846).

34. For more on pride in art as the surrogate of lagging industrial accomplishments, see Patricia Mainardi, *Art and Politics of the Second Empire: The Universal Expositions of 1855 and 1867* (New Haven, Conn., 1987), 52, 97–107, 196.

35. See the brilliant article on the aesthetic politics of Manet by Michael Fried, "Manet's Sources: Aspects of His Art, 1859–1865," *Artforum*, 7 (March 1969), 28–82.

36. Most recently on the Commune, see Gay Gullickson, *Unruly Women of Paris: Images of the Commune* (Ithaca, 1997).

37. Albert Salon, *L'action culturelle de la France dans le monde* (Paris, 1983).

38. For a fine discussion of the *mission civilisatrice*, which—finally—combines the stories in France and in the colonies (West African in this case), see Alice Conklin, *A Mission to Civilize: The Republican Idea of Empire in France and West Africa, 1895–1930* (Stanford, 1997), esp. 11–37.

39. See my *Alliance of Iron and Wheat: Origins of the New Conservatism of the Third Republic, 1860–1914* (Baton Rouge, La., 1988), 156–59.

40. Martha Hanna, *The Mobilization of Intellect: French Scholars and Writers during the Great War* (Cambridge, Mass., 1996), 142–76. On the retreat of the avant-garde in art, see further Kenneth Silver's excellent *Esprit de Corps: The Art of the Parisian Avant-Garde and the First World War, 1914–1925* (Princeton, 1989).

41. Hanna, *Mobilization*, 156–57.

42. Philippe Bénéton, *Histoire de mots: Culture et civilisation* (Paris, 1975), 86–87.

43. Nicholas Murray Butler, president of Columbia University during the First World War and beyond, was so chagrined by the inability of some educated Americans to understand the stake of America in Western Civilization, and therefore the need to support the Entente powers, that after the war he fostered the first Western Civilization course in a U.S. university.

44. Bénéton, *Histoire de mots*, 106.

45. For more on this, see my *True France: The Wars over Cultural Identity, 1900–1945* (Ithaca, 1992), esp. chaps. 2 and 3.

46. Mirabeau's *L'ami des hommes ou traité de la population* (1757), cited from Bénéton, *Histoire de mots*, 23, 33–34.

47. Herman Lebovics, "Open the Gates . . . Break Down the Barriers: The French Revolution, The Popular Front, and Jean Renoir," *Persistence of Vision*, special number on Jean Renoir, 12/13 (1996), 9–28.

48. Quoted in Roger Shattuck's essay "Having Congress: The Shame of the Thirties," in his *Innocent Eye: On Modern Literature and the Arts* (New York, 1984), 3–31; the quotation, 4. The talks at the congress are reprinted as "Défense de la culture," in *Europe*, 15 July 1935.

49. Neither Brecht nor Walter Benjamin was officially invited; they sat in the audience. The ever-sardonic Brecht later told Benjamin that the conference had given him a grand opportunity to assemble material for the satirical novel on intellectuals he was planning (but never wrote): Momme Brodersen, *Walter Benjamin: A Biography*, trans. Malcolm R. Green and Igrida Ligers (London, 1996), 221. Bertolt Brecht to Karl Korsch, *Bertolt Brecht: Briefe* (Frankfurt-am-Main, 1981), 254.

50. Roger Shattuck's otherwise informative essay on the Paris congress doesn't give due credit to France's historic mission. He writes that "In the mid-thirties, France had assumed cultural leadership of Europe by default": *Innocent Eye*, 6.

51. Eugen Weber, *The Hollow Years* (New York, 1994).

52. Otto Abetz, *Histoire d'une politique franco-allemande, 1930–1950: Mémoire d'un ambassadeur* (Paris, 1953).

53. Jean-Pierre Rioux and a team of researchers he has gathered are beginning to produce studies of all aspects of Vichy culture. See also the new study by Emmanuelle Loyer on Jean Vilar and the rise of regional theater, *Le théâtre citoyen de Jean Vilar: Une utopie d'après guerre* (Paris, 1997), esp. 21–23.

54. See the end of chapter 1 of my *True France* on Vichy efforts to keep the empire from the Germans.

55. Only with the failure of big-city Marxism in the 1970s did the left seize upon local cultures as defenses against the power of centralizing capitalism.

56. Jean Lacouture, *De Gaulle: The Rebel, 1890–1944,* 2 vols. (New York, 1993), 1:271. After the war de Gaulle appointed Eboué governor of French Equatorial Africa.

57. The Third Republic's move of culturally and otherwise reaching out to the colonies when French power was checkmated in the West was again resorted to when de Gaulle tried to restore French grandeur in the first decade of the Fifth Republic. As a component of his overall foreign policy he oriented French policy to trying "to take the lead of, or at least to become an inspirational symbol for, those third world countries that were trying to dissociate themselves from what de Gaulle called 'the two hegemonies'": Anton DePorte, *Europe between the Superpowers: The Enduring Balance*, 2d ed. (New Haven, Conn., 1986), 239–40.

3. The Making of the Dandy-Übermensch

1. How can we do justice to the projects and activities of even the most extraordinary historical figures "without reducing them to obscure explanations of structural causation," asks Pierre Bourdieu, "and without sacrificing the mythology of the 'great man,' this 'refuge of ignorance,' as Spinoza would have put it?" Bourdieu's concept of the "field," the place of activity where conflicting players seek to control what happens within it, for Malraux the political and the cultural fields, perhaps even the military field, offers a scheme which permits us to speak of both agency (strategy) and structure without violating the specificities of behavior of each realm. Moreover, Bourdieu rightly criticizes as without value the approach that relates biography directly to broad social and economic conditions. He wishes rather to relate biography to the *specific* fields and groups in which the actor functioned, as I will do in what follows. The strategy allows us to articulate the many layers of mediation between life narrative, and the numerous contexts which interacted with that life. See Bourdieu's thoughts on biography, in "Sur les rapports entre la sociologie et l'histoire en Allemagne et en France: Entretien avec Lutz Raphael," *Actes de la recherche en sciences sociales*, 131 (1995), 108–22, esp. 121–22.

2. Jean Lacouture, *Malraux: Une vie dans le siècle* (Paris, 1973), 10–11.

3. Ibid., 12, 14, 20, 22–23.

4. Clara Malraux, *Le bruit de nos pas* (Paris, 1992), a republication of the first three volumes of her memoirs, with continuous pagination. I will give the name of the volume, and the page numbers of the 1992 edition. Vol. 1: *Apprendre à vivre*, 193–203.

5. Clara Malraux, Vol. 2: *Nos vingt ans*, 211–26, 270, 272.

6. For the story, Walter Langlois, *André Malraux: L'aventure indochinoise* (Paris, 1967) is still the first place to look.

7. The story of their two stays in Indochina may be found in Clara Malraux, *Nos vingt ans*, 207–382, and the whole of volume 3, *Les combats et les jeux*, and in Langlois, *André Malraux*.

8. Clara Malraux, *Nos vingt ans*, 302–24.

9. Her own family, however, not without insight into the character of her husband, did say, "We told you so." " 'This young man is a liar,' went the family chorus. 'He hasn't even got a high school diploma,' triumphed my younger brother, who didn't have one either. 'His father is director of nothing, he works as a clerk in a small factory.' 'When he came here to ask for your hand, he conned us with a rental car' ": ibid., 344.

10. Ibid., 349–52.

11. His friend Roger Stéphane in his last book, a return to studying Malraux, *André Malraux: Premier dans le siècle* (Paris, 1996), 23–57, still wants to see Malraux, archaeological collector, as a victim of bureaucratic caprice.

12. On resistance to the French in Vietnam, see chap. 3 of my *True France: The Wars over Cultural Identity, 1900–1945* (Ithaca, 1992).

13. Lacouture, *Malraux*, 81.

14. *Les combats et les jeux*, 497–505, contains Clara's description of the trip. Lacouture, *Malraux*, 94–101, effectively and thoroughly debunks Malraux's China myths.

15. Clara Malraux, *Les combats et les jeux*, 511.

16. Ibid., 515.

17. *La tentation de l'Occident* (Paris, 1926), 112.

18. Clara Malraux, *Les combats et les jeux*, 516.

19. Ibid., 468.

20. Lacouture, *Malraux*, 122–23.

21. Ibid., 105–9.

22. Clara Malraux, *Nos vingt ans*, 377.

23. Lacouture, *Malraux*, 119.

24. Janine Mossuz-Lavau, *André Malraux et le gaullisme* (1970; 2d ed., Paris, 1982), 13–19.

25. Lacouture, *Malraux*, 145.

26. So Ilya Ehrenburg, who was there, describes it in his *Memoirs, 1921–1941*, trans. Tatania Shebunina and Yvonne Kapp (Cleveland, 1964), 241.

27. The quotation is from "L'art est une conquête," his talk before the First Soviet Writers' Congress in Moscow, 17–31 August 1934, published in *Commune*, September–October 1934, and recently reprinted in Janine Mossuz-Lavau, ed., *André Malraux: La politique, la culture, discours, articles, entretiens (1925–1975)* (Paris, 1996), 104–8.

28. Lacouture, *Malraux*, 170–71.

29. Clara Malraux, *Nos vingt ans*, 264.

30. The speech, translated and revised, was published as "Forging Man's Fate in Spain," *Nation*, 20 March 1937, 315–16. Articulating a theme that remained central to his vision of the rapport of art and society for the rest of his life, he continued, "[there is a kind of suffering in the world] which it is a privilege to endure, the suffering of those who suffer because they want to make a world worthy of man—the suffering of those who know that defending the realm of the mind means imparting culture to an ever-growing number—of those who know that the realm of culture is not for the privileged, that possessing culture is not a question of privilege, and who know that the life of the culture throughout the centuries, if it depends first on those who create it, depends less on those who inherit it than on those who desire it."

31. The Frankfurt School, its members in exile, continued to publish the review in Paris with the publishing house Alcan. Benjamin asked Pierre Klossowski, a go-between for the French intellectuals and the German immigrés, to translate the essay into French. It was published in May 1936 as "L'oeuvre d'art à l'époque de sa reproduction mécanisée," in the *Zeitschrift für Sozialforschung*, 4 (1936), 40–68. Chryssoula Kambas, *Walter Benjamin*

im Exil: Zum Verhältnis von Literaturpolitik und Ästhetik (Tübingen, 1983), 177–78; Momme Brodersen, *Walter Benjamin: A Biography*, trans. Malcolm R. Green and Igrida Ligers (London, 1996), 221–24.

32. "'Sur l'héritage culturel,' Discours prononcé à Londres le 21 juin 1936, au secrétariat général élargi de l'Association des Ecrivains pour la Défense de la Culture," published with the same title in *Commune*, 1936, 1–2, 3–4 (italics mine), 8.

33. Ibid., 5–7. Malraux further contrasts liberalism and socialism with fascism as to the nature of their combat: fascists see other men as their enemies; life is a struggle of man against man. But nonfascists, in Malraux's view, see that "the adversary of man is not other men, but nature," and the struggle one for "the conquest of things" (9, 7–8). In exile, Max Horkheimer and Theodor Adorno were beginning to formulate their critique of Soviet instrumentalization of the Enlightenment Project.

4. Malraux and France as Works of Art

1. It is now available in videocassette in the French VCR format. I am preparing an article on the film, "André Malraux, Filmmaker."

2. Interview of Lacouture with Malraux, 29 January 1973, in Jean Lacouture, *Malraux: Une vie dans le siècle, 1901–1976* (Paris, 1973), 264.

3. *Antimémoires* (Paris, 1967); *Anti-Memoirs*, trans. Terence Kilmartin (New York, 1968), 95, note. References will be to the translated version.

4. Philippe Burrin, *La France à l'heure allemande: 1940–1944* (Paris: Seuil, 1993); *France under the Germans: Collaboration and Compromise*, trans. Janet Lloyd (New York, 1996), 336.

5. *Les noyers de l'Altenburg* first appeared in 1943 in Geneva in the magazine *La Semaine Littéraire* and in book form at the same time with a Lausanne publisher. It was published in the present form in France by Gallimard in 1948. On *The Walnut Trees of Altenburg* see Lucien Goldmann's close textual reading—curiously in a book meant to lay the basis for a sociology of the novel: *Pour une sociologie du roman* (Paris, 1964); *Towards a Sociology of the Novel*, trans. Alan Sheridan (London, 1975), 18–131.

6. Lacouture, *Malraux*, 280–83.

7. *Anti-Memoirs*, 385–86. I have modified the translation after comparing it to the original.

8. Of course, this is Malraux's account; the bravado might have been exhibited during the questioning, or it may have happened later, during the writing. *Anti-Memoirs*, 150.

9. Ibid., 171.

10. Lacouture tells the anecdote: *Malraux*, 293.

11. Interview of Lacouture with Jacquot, 19 November 1972, ibid., 294–95.

12. Interview of Lacouture with André Chamson, n.d., ibid., 295–96.

13. *Combat*, 28 January 1945.

14. "André Malraux s'explique," *Nouvel Observateur*, 14 October 1968, 7–8.

15. *Anti-Memoirs*, 83–95. Recently Janine Moussuz-Lavau has reaffirmed the Gaullist argument that Malraux found his way to the General in his search for *fraternité* because, as she writes, "Gaullism proclaimed its will to keep alive the idea of French *fraternité*, to bring together an entire people to 'remake France.'" Proposing that one mystical idea engendered another—fraternity producing national feeling—lacks explanatory power, I think. See her "Introduction" to the selection of Malraux texts put together for the Malraux Autumn of 1997, *André Malraux: La politique, la culture* (Paris, 1996), 30–39.

A. Chosy, "André Malraux: Méditation esthétique et action culturelle," mémoire de DEA [doctoral thesis proposal], Université des sciences sociales de Toulouse, 1977, 69.

16. Pierre Viansson-Ponté, "M. Malraux . . . ," *Le Monde*, 26 June 1958.

17. Interview of Lacouture with Arthur Koestler, 20 November 1972. *Malraux*, 353.

18. Cited in ibid., 341.

19. This question of the meaning of Malraux's move from fellow traveler to anti-Communist Gaullist was the theme of the special number of *Esprit* published in October 1948, titled "Interrogation à Malraux." The articles were written by both friends and foes, and with all their passion, lack perspective and, of course, the hindsight that often makes historians appear so clever after the event.

20. On this still-born real imaginary museum, see Janine Mossuz-Lavau, *André Malraux et le gaullisme* (1970; 2d ed., Paris, 1982), 58.

21. André Malraux, *The Voices of Silence: Man and His Art*, trans. Stuart Gilbert (Garden City, N.Y., 1953), 127.

22. André Dabezies discusses the Spenglerian Malraux in his "Malraux et les philosophies de l'histoire," in the special number on Malraux of *Europe: Revue Littéraire Mensuelle*, 67 (November–December 1989), 129–39.

23. Ernst Gombrich, the distinguished art historian and Malraux's most persistent critic from that field, dismisses this, and much of Malraux's other art writing, as either murkily expressed truism or empty rhetoric. See "André Malraux and the Crisis of Expressionism," in Gombrich's *Meditations on a Hobby Horse*, 4th ed. (Oxford, 1985), 78–85. His review of *The Voices of Silence*, "La philosophie de l'art de Malraux dans une perspective historique," first appeared in the *Burlington Magazine* in 1954 and was reprinted in *Malraux: Etre et dire*, ed. Martine de Courcel (Paris, 1976), 216–34.

24. André Malraux, *La métamorphose des dieux* (Paris, 1957); *Metamorphosis of the Gods*, trans. Stuart Gilbert (Garden City, N.Y., 1960), 34–35.

25. Ernst Gombrich, "Malraux on Art and Myth," in his *Reflections on the History of Art* (Berkeley, Calif., 1987), 218–20. The piece originally appeared as a review of *Metamorphosis of the Gods*, in the *Observer*, 9 October 1960, soon after Malraux has taken up his post in his new ministry.

26. *Metamorphosis of the Gods*, 21.

27. Gombrich, "La philosophie d'art de Malraux," 223. See the similar questions posed by Michel Foucault in his discussion of Velásquez's *Las Meninas* at the beginning of *The Order of Things* (New York: 1971).

28. Malraux, *La tête d'obsidienne* (Paris, 1974), 91.

29. For example, as "Adresse solennelle à Monsieur le Président de la République," *L'Express*, 17 April 1958.

30. *Anti-Memoirs*, 80.

31. Jean Lacouture, *De Gaulle: The Ruler, 1945–1970*, trans. Alan Sheridan (New York, 1992), 243–50, 487.

32. This interpretation is based on Richard Brace and Joan Brace, *Ordeal in Algeria* (Princeton, 1960), 270–73, a study reinforced by interviews with figures close to de Gaulle (Bernard Tricot); Phillip C. Naylor, "De Gaulle and Algeria: Historiography and the Decisions of Decolonization," *Proceedings of the Twentieth Meeting of the French Colonial Historical Society, Cleveland, May 1994*, ed. A. J. B. Johnston (Cleveland, 1996), 136–47.

33. See David Prochaska on the new settlers' culture which developed in Algeria, *Making Algeria French: Colonialism in Bône* (Cambridge, Eng., 1990). He continues to work on the development of a European settlers' culture in Algeria, the strength of which would not have made the transitions among the emigrés easier.

34. Pierre Cabanne, *Le pouvoir culturel sous le Vᵉ République* (Paris, 1981), 54.

5. Ministering to the Culture

1. Interview with Claude Mauriac, March 1972, in Jean Lacouture, *Malraux: Une vie dans le siècle, 1901–1976* (Paris, 1973), 369.

2. The letter was an important reason for his removal from Information according to Alain Peyrefitte, "Le ministre," *Revue des Deux Mondes*, November 1977.

3. The judgment of Jacques Rigaud, in his contribution to the conference *De Gaulle en son siècle: Actes des journées internationales tenues à Unesco Paris, 19–24 novembre 1990*, 7 vols. (Paris, 1992), vol. 7: *De Gaulle et la culture*, "Le général de Gaulle et la culture," 13–23, 20.

4. André Holleaux, "De Gaulle et Malraux," *De Gaulle et la culture*, 67.

5. Charles de Gaulle, *Discours et Messages*, vol. 1 (Paris, 1970–71), 331.

6. Michel Debré, *Mémoires*, vol. 3, *Gouverner* (Paris, 1987), 246. Geneviève Poujol, "The Creation of a Ministry of Culture in France," *French Cultural Studies*, 2 (1991), 251–60. Ministère de la Culture et de la Communication, "Journées d'étude sur la création du Ministère de la Culture, 30 novembre–1er décembre 1989" (Paris, 1989), photocopied talks by former coworkers of Malraux and researchers.

7. *Journal Officiel*, 26 July 1959, 7413.

8. Geneviève Poujol, *La création du ministère des affaires culturelles, 1959–1969: Eléments pour la recherche* (Paris: Département des Etudes et de la Prospective du Ministère de la Culture et de la Francophonie, 1993). The ministry hired Madame Poujol, making available to her its organized archives and research personnel, so that she might produce this excellent roadmap for future researchers. The text is an invitation to further work on the ministry's beginnings.

9. Décret of 26 July 1958.

10. Gérard Monnier, *L'art et ses institutions en France: De la Révolution à nous jours* (Paris, 1995), 19–67.

11. Patricia Mainardi, *End of the Salon: Art and the State in the Early Third Republic* (New York, 1993). Marie-Claude Gênet-Delacroix, *Arts et Etat sous la Troisième République: Le système des Beaux-Arts, 1870–1940* (Paris, 1992). On the state's funding of culture in the nineteenth century, see Paul Gerbod, "L'action culturelle de l'Etat au XIXe siècle (à travers les divers chapitres du budget général)," *Revue Historique*, 548 (Oct.–Dec. 1983), 389–401.

12. This is not to say that no works of importance were undertaken in those periods. There was some effort, too, to begin to consolidate a kind of office for cultural concerns. Some culture offices under the Popular Front government were grouped in the Sub-secretariat for Leisure under the Public Health Ministry, which Blum fused into the Sub-secretariat for Physical Education and gave over to the Ministry of National Education. Sylvie Raab, "Histoire de politique culturelles," in "L'histoire culturelle de la France: Bilans et perspectives de la recherche," ed. Jean-Pierre Rioux, 4 vols., photo-reproduced typescript survey of research done and underway for the Département des Etudes et de la Prospective (hereafter DEP), the research center of the Ministry of Culture, DEP archives (Paris, 1987), 2:87–127. For the Popular Front, see Pascal Ory, *La belle illusion* (Paris, 1994); on Vichy, Laurence Bertrand Dorléac, *L'art de la défaite* (Paris, 1993).

13. Debré, *Gouverner*, 188.

14. From the *Annuaire statistique de la France*. See also the talk by Jérôme Bourdon, on the panel "Actualités des ambitions gaulliennes pour la radio et la télévision," *De Gaulle et la culture*, 291.

15. "Discours d'André Malraux pour l'inauguration de la Maison de la Culture de Bourges, le 18 avril 1964." At the opening of Maison de la Culture of Amiens he described

the contemporary dream factories as especially terrible "because [they] are not there to help humankind to grow, they exist simply to make money": "Discours . . . le 19 mars 1966 . . . Amiens." "Discours prononcé par Monsieur André Malraux à l'occasion de l'inauguration de la Maison française d'Oxford, le 18 novembre 1967." All three in the dossier "Discours d'André Malraux, 1959–1970," DEP archives.

16. Emile-Jean Biasini, *Grands travaux: De l'Afrique au Louvre* (Paris, 1995), 120–26.

17. Ibid., 139.

18. "Entretien avec Francis Raison, le 30 mars 1989," Geneviève Poujol, *Eléments pour la recherche sur la création du Ministère des Affaires Culturelles, 1959–1966, Annexes* (Paris: DEP, Communication, Grands Travaux, 1991), 130–31.

19. Guy Brajot, "Les premières années des maisons de la culture," Ministère de la Culture et de la Francophonie: Comité d'Histoire, *Journées d'étude sur la création du Ministère de la Culture, 30 novembre–1er décembre 1989, Document provisoire* (Paris, 1993), 115.

20. At the request of the Comité d'Histoire du Ministère de la Culture, Marie-Ange Rauch-Lepage has begun drafting a study on these overseas *fonctionnaires* in the ministry. Geneviève Gentil, secretary general of the committee, has kindly sent me a prepublication draft. It is tentatively titled "Le bonheur d'entreprendre: Enquête sur le rôle des anciens administrateurs de la France d'Outremer dans la construction du ministère de la culture, document provisoire" (Paris: DEP, 1997).

21. Archives Nationales, Series F21, Beaux Arts, Fonds Jacques Jaujard, dossier Secrétariat Général de mai à novembre 1959, carton 11 (cote provisoire).

22. Assemblée Nationale, 2ème seance, 27 octobre 1966, *Journal Officiel*, 88, 3976. From the DEP cf. the overview "Le Budget du Ministère chargé des affaires culturelles de 1960 à 1985," *Développement Culturel*, 67 (Oct. 1986), 2–25.

23. On economic discourses as rhetoric, see these works by Deirdre [Donald] McCloskey: *The Rhetoric of Economics* (Madison, Wis., 1985); *If You're So Smart: The Narrative of Economic Expertise* (Chicago, 1992); and *Knowledge and Persuasion in Economics* (Cambridge, Eng., 1994).

24. Archives Nationales (Fontainebleau), 80368, carton 1, dossiers "Budget 1959," "Budget, 1960."

25. Charles-Louis Foulon, "L'Etat et la culture depuis 1959: Actes et messages du pouvoir gaulliste," *De Gaulle et la culture*, 26.

26. Jean-François Chougnet, "Un essai d'histoire budgétaire," in *Les affaires culturelles au temps d'André Malraux, 1959–1969*, ed. Augustin Girard and Geneviève Gentil (Paris, 1996), 231–39. This volume is the last version of the essays first drafted for the conference on the beginnings of the ministry organized by its current staff. It does not include the protocols of interviews and other materials of earlier drafts of a larger project on the ministry's first years which Geneviève Poujol has kindly made available to me.

27. André Malraux, Address before the Assemblée Nationale, 9 November 1967, 4761. Both the Fourth and Fifth Republics tried to address the growth in demand for education caused both by population increases and by demand at the university levels. From 1957 to 1967, measured in 1996 francs, the funds allocated to the Ministry of Education rose from 11 percent of the total budget to 20.3 percent. May 1968 exploded during a time of improvement, but, clearly, one that had not gone far enough.

28. By 1990, for example, the secular trends in the funding of cultural activities favored current aesthetic creation, with big relative increases in the share of the ministry's budget (compared to 1960) in subsidies to book publications, film, and, especially since the days of Jack Lang (1981—off and on), music.

29. Chozo Yoshii, *André Malraux: Dyables* (Tokyo, New York, Paris, 1995).

30. André Malraux, *Dyables* (New York, Tokyo, Paris: Gallery Yoshii, 1995). Malraux's last wife, Madeleine Malraux, published 380 of his doodles done between 1946 and 1966: Madeleine Malraux, ed., *André Malraux: Messages, Signes & Dyables* (Paris, 1986).

31. Pierre Cabanne, *Le pouvoir culturel sous la V^e République* (Paris, 1981), 66.

32. André Holleaux, for a time his directeur de cabinet, the chief administrative assistant, gives good evidence on this point. Geneviève Poujol, "Entretien avec André Holleaux, le 24 janvier 1989." This is one of the series of in-depth interviews that Madame Poujol conducted with key Malraux coworkers. She has kindly turned over copies of the transcripts to me.

33. With the free time his dismissal afforded him, Picon wrote a book—appropriately—on the artist Ingres: *Ingres: Biographical and Critical Study* (Geneva, 1967). In the great tradition of aesthetic solipsism, it has the right tone for a life of an artist so deeply involved in politics—for example, the chapter called "A Genius Out of Time."

34. Biasini, *Grands travaux*, 167–68.

35. In his memoirs, Alain Peyrefitte recounts a cabinet meeting in which the General intervened to protect Malraux on a budget issue that was going against him: *C'était de Gaulle* (Paris, 1994), 522–23.

6. Abolishing the Provinces

1. "Discours prononcé par M. André Malraux le 19 mars 1966 à l'occasion de l'inauguration de la Maison de la Culture d'Amiens," in the dossier "Discours d'André Malraux, 1959–1970," in the files of the Ministry of Culture's research center, the Département des Etudes et de la Prospective.

2. Philippe Urfalino, "Les Maisons de la culture et le théâtre, 1960–1966: Des affinités électives au mariage," in *La décentralisation théâtrale: Les années Malraux, 1959–68* (Arles, 1993), 18.

3. Geneviève Poujol, "Entretien avec Robert Brichet, le 1 mars 1989." Brichet was the directeur d'éducation populaire at the Haut-Commissariat à la Jeunesse et aux Sports in 1959 and from 1964 to 1979 head of research at what became the Ministry of Youth and Sports.

4. Philippe Urfalino, *L'invention de la politique culturelle* (Paris, 1996), 109–30.

5. Ibid., 13–89.

6. Jean-Jack Queyranne, "Les Maisons de la Culture." Thèse, Université de Lyon II, 1975, 535–48.

7. Emile Biasini, intervention in discussion, *De Gaulle en son siècle*, 7 vols. (Paris, 1992), Vol. 7: *De Gaulle et la culture*, "Le général de Gaulle et la culture," 49.

8. Queyranne, "Les Maisons," 618.

9. Urfalino, "Les Maisons," 6, 19–20.

10. Denis Bablet, "La remise en question du lieu théâtral," in Bablet, *Le lieu théâtral dans la société moderne*, 3d ed. (Paris, 1969), 15–20.

11. Compilations of Queyranne, "Les Maisons," 632–38.

12. On Vilar's vision of a populist theater, see Emmanuelle Loyer, *Le théâtre citoyen de Jean Vilar: Une utopie d'après-guerre* (Paris, 1997), esp. 222–30.

13. H. Gignoux, "Intervention aux rencontre d'Avignon, 30 juillet–4 août," in *Maison de la Culture*, publication of the Maison de la Culture of Rheims, 3 (January 1967), 20.

14. Queyranne, "Les Maisons," 8–12. The quotes are from "Topo pour les réunions des membres du Parti au sujet des Maisons de la Culture," mimeographed document, 1936, Archives of the Institute M. Thorez, Paris.

15. René Blech, "Les Maisons de la Culture et les cercles culturels," *Commune*, 47 (July 1937).

16. On the cultural values of the French Communists see my article on Jean Renoir's political films, "Open the Gates . . . Break Down the Barriers: The French Revolution, The Popular Front, and Jean Renoir," *Persistence of Vision*, special number on Jean Renoir, 12/13 (1996), 9–28.

17. Emile Biasini, *Action culturelle, An I* (Paris: Ministère d'Etat des Affaires Culturelles, October 1962), 2.

18. J. P. Gravier, *Paris et le désert français* (Paris, 1947).

19. Nor were physical education and organized sports included in the curriculum until the Popular Front governments introduced them. Many French intellectuals to whom I've spoken mistakenly associate this addition to the curriculum with the Vichy regime, and so keep alive a widespread prejudice among leftist intellectuals that collective physical training was a kind of preparation for fascism. Descartes, who burdened us with the mind-body problem, was of course French.

20. *Journal Officiel*, Débats parlementaires, 88 Archives Nationales (hereafter AN), 27 October 1966, 3976. See also *Journal Officiel*, Débats parlementaires, 94 AN 9 November 1967, 4761.

21. Philippe Cerny, *Une politique de grandeur* (Paris, 1986).

22. Of the vast literature on France's economic transformation, I will mention just a few important titles: Richard Kuisel, *Capitalism and the State in Modern France: Renovation and Economic Management in the Twentieth Century* (New York, 1981); William James Adams, *Restructuring the French Economy* (Washington, D.C., 1989); J.-J. Carré, P. Dubois, and E. Malinvaud, *French Economic Growth* (Stanford, 1975); and Henri Mendras with Alistair Cole, *Social Change in Modern France: Towards a Cultural Anthropology of the Fifth Republic* (Cambridge, Eng., 1991).

23. Serge Berstein, *The Republic of de Gaulle, 1958–1969* (Paris and Cambridge, Mass., 1991).

24. Queyranne, "Les Maisons," 510.

25. Mendras, *Social Change in Modern France,* 91–106.

26. Françoise Franton, "Participation sociale et équipement culturel," DES [doctoral thesis proposal], Philosophie, Aix-en-Provence, 101, mimeographed, cited by Queyranne, "Les Maisons," 718.

27. The quotation is in *Le Progrès,* 13 November 1968, 3. The larger story of Chalon and its contested House of Culture is in Queyranne, "Les Maisons," 1204–10. The May-assisted result was that the cultural conservatives in the region of the Gaullist party gained the upper hand. The well-known radical intellectual Francis Jeanson, slated to direct the Maison de la Culture of Chalon when it opened, was fired.

28. AN, F21 Beaux Arts, Fonds Pierre Moinot, carton 1 (cote provisoire), dossier, "Conference de Press de mai 1967."

29. *Le Figaro Littéraire,* 22 July 1965.

30. Biasini, *Action culturelle, An I,* 15. My italics.

31. Queyranne, "Les Maisons," 436.

32. Ibid., 87–88.

33. Queyranne gives the breakdown from a preliminary study of the 1968 census, ibid., 147.

34. Unfortunately most of us know the word in its degenerated form, the Club Med usage "gentile animateur," a social director.

35. Queyranne, "Les Maisons," 722.

36. Cited by Emmanuelle Loyer, "Jean Vilar, le pape d'Avignon," *L'Histoire,* 200 (June 1996), 70.

37. Queyranne has done the statistical break-downs, "Les Maisons," 677–700.

38. René Kaes, "Publics et participation ouvrière," *Esprit,* May 1965.

39. Queyranne, "Les Maisons," 697–98.

40. Pierre Bourdieu and Alain Darbel, with Dominique Schnapper, *L'amour de l'art: Les musées d'art européens et leur public,* 2d ed. (Paris, 1969).

41. René Kaes, "La culture, son image chez les ouvriers français," mimeographed text, 279–80, University of Paris (Nanterre, 1966), cited by Queyranne, "Les Maison," 698, 702.

42. Michel de Certeau, *The Practice of Everyday Life,* trans. Steven Rendall (Berkeley, Calif., 1984).

43. With the exception perhaps of Guy Debord and his Situationist friends. See Debord, *La société du spectacle,* for example. Since they were largely anarchists, their influence on state cultural policy was limited, however.

44. AN, Series F21 Beaux Arts, Fonds Pierre Moinot, carton 20 (cote provisoire), Pierre Moinot, "Les Maisons de la culture," in folder "Maisons de la culture, centres à créer, 1966–68."

45. Queyranne, "Les Maisons," 56.

46. Ibid., 477.

47. Geneviève Poujol, "Entretien avec Francis Raison, le 20 mars 1989," 1–19.

7. Public and Private

1. See the articles by Harvey Molotch and Marilyn Lester, on the utility of accidents and scandals for social science investigations of the ways socially explosive information is diffused, as exemplified by the press coverage of the great Santa Barbara, California, oil spill in January 1969: "Oil in Santa Barbara and Power in America," *Sociological Inquiry,* 40 (Winter 1970), 133–44; "Accidental News: The Great Oil Spill as Local Occurrence and National Event," *American Journal of Sociology,* 81, 2 (1975), 235–60; "News as Purposive Behavior: On the Strategic Use of Routine Events, Accidents, and Scandals," *American Sociological Review,* 39 (1974), 101–12.

2. The amazed exclamation "Wow, we're creating the music policy of France!" ("Mais . . . nous sommes en train de faire la politique musicale de la France. . . .") was made by Albert Beuret, Malraux's old war friend and personal secretary as he, together with Alain Trapenard, one of the first graduates of the National School of Administration to work in the ministry, and Marcel Landowski, completed weeks of working out the ministry's plan for the future of French music. Marcel Landowski, "La création d'une politique musicale," Ministère de la Culture et de la Communication, "Journées d'étude sur la création du ministère de la culture, 30 novembre–1er décembre 1989," published as *Les affaires culturelles au temps d'André Malraux, 1959–1969,* ed. Augustin Girard and Geneviève Gentil (Paris, 1996), 117.

3. Archives Nationales, series F21, Beaux Arts, Fonds Pierre Moinot, carton 1, "Rapport d'Activité 1967," chap. 3 (cote provisoire).

4. Marcel Landowski, *Batailles pour la musique* (Paris, 1979), 54. He adds that by 1978 there existed 115 local, regional, or state-recognized conservatories in France, subsidized on the average of 8–9 percent of their budgets. This was a jump of 1 million francs in state aid in 1966, 25 million by 1978.

5. Alain Trapenard, commenting on Marcel Landowski's recollections of the role of music in the ministry, recalled only three occasions in ten years when he remembered Malraux attending concerts *to hear the music.* Of course he went at other times for various official functions, but those were different. Trapenard, comments on Marcel Landowkci, "La création d'une politique musicale en France," in the conference volume *André Malraux: Ministre,* ed. Auguste Girard and Geneviève Gentil (Paris, 1996), 127.

6. Peter Heyworth, "Profiles: Taking Leave of Predecessors–II" [second part of a two-part article on Boulez], *New Yorker,* 31 March 1973, 65–66.

7. Georgina Born, *Rationalizing Culture: IRCAM, Boulez, and the Institutionalization of the Musical Avant-Garde* (Berkeley, Calif., 1995), 80–81.

8. Heyworth, "Profiles," 45–46; Born, *Rationalizing Culture,* 77–80.

9. See, e.g., Landowski's address before the Académie des Beaux Arts in which he criticizes aesthetic innovators as having gone too far, "Académie des Beaux Arts: Tradition et modernité," Publication of the *Institut de France, séance publique annuelle du mercredi 10 novembre 1991* (Paris, 1991).

10. Marcel Landowski, *La musique n'adoucit pas les moeurs* (Paris, 1990), 112–15.

11. Not as "directeur" of music, but only as "chef du service de la musique," as Pierre Cabanne points out: *Le pouvoir culturel sous la V^e République* (Paris, 1981), 180.

12. *Le Nouvel Observateur,* 25 May 1966.

13. Born, *Rationalizing Culture,* 83.

14. Cabanne, *Le pouvoir culturel,* 182–83.

15. Landowski, "Création d'une politique musicale," 116–20.

16. Geneviève Poujol, "Entretien avec Jacques Alluson, le 22 octobre 1989."

17. Landowski, "Création d'une politique musicale," 116–20.

18. Landowski, *Batailles pour la musique.* Landowski complained bitterly in a letter of 5 August 1968 to H. Gautier of the Education Ministry that in the curriculum then in effect, music history teaching did not begin with Gregorian chants and go to Debussy as he had been promised. Only the last three centuries were covered. Moreover, neither musical composition nor improvisation was being offered, as agreed. No non-Western music and no tonality, cadence, or modulation were offered, and last-year students got no exposure to contemporary music. Archives Nationales (Paris), series F21, Beaux Arts, Fonds Pierre Moinot, carton 1, Letter of Marcel Landowski to H. Gautier, 5 August 1968.

19. All quotations are from Bernard Frechtman's translation, *The Screens* (New York, 1962).

20. The debate can be read in the *Journal Officiel,* Débats parlementaires, Assemblée Nationale, 27 October 1966, pp. 3979–91.

21. Geneviève Poujol, "Entretien avec Maurice Fleuret, le 20 juin 1989."

22. Cabanne, *Le pouvoir culturel,* 109–10.

23. Archives Nationales, series F21, Beaux Arts, Fonds Pierre Moinot, carton 19, folder, "Réforme Opéra 1968," "Note sur une réforme de l'Opéra de M. Jean Vilar, 10 septembre 1968."

24. Donald N. McCloskey, "History, Differential Equations, and the Problem of Narration," *History and Theory,* 30 (1991), 36.

25. Claude Degand, *Le cinéma . . . cette industrie* (Paris, 1972), 28–29, 30, 33–61; 63; see table 16, p. 64. All money sums given in new francs.

26. Colin Crisp, *The Classic French Cinema, 1930–1960* (Bloomington, Ind., 1993), 78.

27. The law of 16 June 1959, decree 59–733. Gérard Valter, an administrator who transferred from Commerce to Culture when the CNC changed hands, gives Malraux a

great deal of the credit for organizing new financial support for quality films in France: Geneviève Poujol, "Entretien avec Gérard Valter, le 31 janvier 1989."

28. Crisp, *Classic French Cinema*, 78.

29. *Nouvel Observateur*, 14 February 1968, 6.

30. For Langlois's own history of the Cinémathèque, see the special number "L'Affaire Langlois," *Cahiers du Cinéma*, 200–201 (April–May 1968), 63–70.

31. Quoted by Jean de Baroncelli, in *Le Monde*, 11–12 February 1968, 18.

32. Photos reproduced in Georges P. Langlois and Glenn Myrent, *Henri Langlois: Premier citoyen du cinéma* (Paris, 1986), figures 11, 13, after p. 224.

33. Glenn Myrent and Georges P. Langlois, *Henri Langlois: First Citizen of Cinema* trans. Lisa Nesselson (New York, 1995), 128. I have compared the French and English editions and have altered the English translation here and there.

34. Myrent and Langlois, *Henri Langlois: First Citizen*, 176–77. On the Nouvelle Vague, and particularly Truffaut, see the fine biography by Antoine de Baecque and Serge Toubiana, *François Truffaut* (Paris, 1996).

35. 15 Mai 1959 Allocution de Malraux au festival de Cannes, in Geneviève Poujol, "Elements pour la recherche sur la création du Ministère des affaires culturelles, 1959–1969," working ms. (Paris: Ministère de la Culture, December 1990), 179.

36. "L'affaire Langlois," *Le Monde*, 25–26 February 1968, 19.

37. Myrent and Langlois, *Henri Langlois: First Citizen*, 233–35.

38. *Le Monde*, 11–12 February 1968, 18; 15 February 1968, 15.

39. On Truffaut's role see Baecque and Toubiana, *François Truffaut*, 345–53. In 1967 Malraux had offered Truffaut a Legion of Honor, which the filmmaker had refused (401–2).

40. Reprinted in *Le Monde*, 11–12 February 1968, 18.

41. *Le Monde*, 13 February 1968, 19.

42. "L'affaire de la cinémathèque," *Le Monde*, 2 March 1968, 15; 5 March, 15. The article was ostensibly a story about Pierre Mendès France's criticism of the Gaullists, but clearly Jerry Lewis's disapproval was of more weight. Officers and executive committee members of the Comité de Défense de la Cinémathèque, with a fund-raising, membership form, may be found in the *Cahiers du Cinéma* 200–201 (April–May 1968), 71.

43. *Le Monde*, 16 February, 12. Myrent and Langlois, *Henri Langlois: First Citizen*, 244–45.

44. For a survey of some of the Paris press on the affair, see *Le Monde*, 17 February, 24.

45. "L'affaire Langlois, *Le Monde*, 14 March, 15; Myrent and Langlois, *Henri Langlois: First Citizen*, 246, trans. corrected slightly by comparison with *Henri Langlois: Premier citoyen*, 332.

46. *Le Monde*, 20 March, 19; 21 March, 15; 23 March, 24.

47. *Le Monde*, 10 April, 15; 20 April, 15.

48. The outcome is summarized in the *Cahiers du Cinéma*, 202 (June–July 1968), 68.

49. *Le Monde*, 24 April, 1, 15. The reading of the Langlois Affair as a "prologue" to the May student uprising was already presented as common knowledge in July by the *Cahiers du Cinéma*: "Le retour de Langlois," 202 (June–July 1968), 68.

50. Jean Dubuffet, *Asphyxiante culture* (Paris, 1968).

51. Marc Fumaroli, *L'état culturel: Essai sur une religion moderne* (Paris, 1992), 170, 17, 23; "ce vaste travail de massification de la culture doit devenir le lien social et politique d'une société *organique*"(170).

52. Jacques Rigaud, *L'exception culturelle: Culture et pouvoirs sous la Vᵉ République* (Paris, 1995), 153–54.

53. Patricia Mainardi, *End of the Salon: Art and the State in the Early Third Republic* (New York, 1993), 23–30.

54. Pascal Ory distinguishes monarchical, liberal, and democratic art policies in France as ideal types, roughly chronological, but not precisely wedded to historical periods: Ory, "Politique culturelle avant la lettre: Trois lignes françaises, de la Révolution au Front populaire," in *Sociologie de l'art: Colloque international, Marseille 13–14 juin 1985*, ed. Raymonde Moulin (Paris, 1986), 23–30.

55. The story is told by de Gaulle's long-time aide Claude Guy, in his *En écoutant de Gaulle: Journal 1946–1949* (Paris, 1996), 81. Of course, de Gaulle had the same opinion of political parties, for they only "created a screen between the popular will and the executive" (295).

56. Archives Nationales, series F21, Beaux Arts, Fonds Moinot, carton 2, folder "Crise de Mai 1968" (cote provisoire).

57. A valuable conversation with my friend Bernard Crick in 1996 at the Woodrow Wilson Center in Washington made me see the countervailing forces of the private cultural sphere and of the culture state. Britons, including British scholars like Crick, have had long experience with state-private mixes in public policy. With some exceptions (F. A. Hayek and Margaret Thatcher), most do not fear totalitarianism as a consequence of state cultural activity, or state-private partnerships.

8. The Power of Art

1. Gilbert Pilleul, "La politique culturelle extérieure, 1958–1969," Institut Charles de Gaulle, *De Gaulle en son siècle: Actes des journées internationales tenues à Unesco Paris, 19–24 novembre 1990*, 7 vols. (Paris, 1992), Vol. 7: *De Gaulle et la culture*, 143.

2. By the same reasoning, Western economists have historically advised nations like China or India to make and export labor-intensive goods and borrow their capital from the industrialized lands. Thus some ideas for managing costs of development crossed the line into imperialist ideology.

3. My differentiation of different kinds of capital in international politics, of course, owes its inspiration to the work of Pierre Bourdieu, who speaks primarily of different capital holdings and flows in a domestic field.

4. Philip H. Coombs, *The Fourth Dimension of Foreign Policy: Educational and Cultural Affairs* (New York, 1964).

5. Irving Sandler's *Triumph of American Painting* (New York, 1970), remarkably, although proclaiming a power change, does not explore or explain it historically.

6. Guilbaut, *How New York Stole the Idea of Modern Art: Abstract Expressionism, Freedom, and the Cold War* (Chicago, 1983). All references will be to the 1985 (Chicago) paperback edition.

7. Henry Luce, "The American Century," *Life*, 17 February 1941, 61–65. See Guilbaut's discussion (60), in which he treats Luce's grandiose plans for America as policy blueprints.

8. Yves-Henri Nouailhat, "Aspects de la politique culturelle des Etats-Unis à l'égard de la France de 1945 à 1950," *Relations Internationales*, 25 (Spring 1981), 87–111.

9. Quoted by Pilleul, "La politique culturelle extérieure," 143, n. 2, from *Vers l'armée de métier*, 239.

10. Guilbaut, *How New York Stole . . .*, 2.

11. On rereading it, I find that Arno Mayer's discussion of the Cold War uses of the discourse of "totalitarianism" in post–World War II Europe is still the very best we have:

Dynamics of Counterrevolution in Europe, 1870–1956: An Analytical Framework (New York, 1971), 9–34.

12. Guilbaut, *How New York Stole . . .* , 3, 189–92.

13. Some of these photographs are reproduced in Timothy J. Clark's article, "Jackson Pollock's Abstraction," in *Reconstructing Modernism: Art in New York, Paris, and Montreal, 1945–1964*, ed. Serge Guilbaut (Cambridge, Mass., 1990), 172–238.

14. Guilbaut, *How New York Stole . . .* , 5, citing Pierre Cabanne, "Porquoi Paris n'est plus le fer de lance de l'art," *Arts et Loisirs*, 87 (1967), 9.

15. Contributions to the art-historical story in Paris may be found in Guilbaut's Introduction and the essay of John-Franklin Koenig ("*Abstraction chaude* in Paris in the 1950s") both in Guilbaut's *Reconstructing Modernism*. He will soon publish a fuller account of the Paris side of his story.

16. Ministère des Affaires Etrangères, Archives Diplomatiques, Relations Culturelles (1948–1959), René de Messières, "Activités culturelles, décembre 1949," carton 334, 1–2.

17. Ibid., "Note de Jacques Dupontin remise à la Direction des relations culturelles par M. J. Daridan, le 21 avril 1953," carton 334, 1–4.

18. The correspondence on the show may be found in the Archives Nationales (Paris), series F21, Beaux Arts, Fonds Pierre Moinot, carton 8, folder "Exposition peinture en France, 1967–1968." The painters in the show are worth noting. The artists in italics were singled out for mention in the English-language press release. The numbers after the names indicate how many pieces by the artist were shown.

"La Peinture en France: Section I" listed Arp, Bonnard, Braque, Chagall, Delaunay, Derain, Dufy, Dunoyer de Segonzac, Ernst, Gris, Herbin, Kandinsky, Kupka, La Fresnaye, Léger, Marquet, Matisse, Miró, Modigliani, Mondrian, Picabia, Picasso, Rouault, Rousseau, Soutine, Utrillo, Villon, Vlaminck, Vuillard (all the old warhorses . . . everyone pre–World War II).

Section II is postwar artists, works mostly of the 1960s: Agam, Aillaud, Alechinsky, Appel, Arman, Asse, Atlan, *Balthus* 3, Bazin 2, Beaudin, Bertholo, Bettencourt, Bischoff-hausen, Bissiere 2, Bores, Braune, Bury, Charbonnier, Charchoune, Dado, Damian, De-gottex, Demarco, Dewasne, Dubuffet 3, Esteve, 2, Fautriet, 3, Giacometti 2, Gillet, Gorin, Hantai, *Hartung* 2 prewar, 1 1966, Helion 2, Hosiasson, Hunderwasser, Jorn, Klasen, *Klein* 2, Lam Lanskoy, Lapicque, *Le Parc*, Magnelli 2, Manessier, Marfaing, Mathieu 2, Matta, *Messagier*, Michaux 3, Mortensen, Nallard, Pignon, Poliakoff 2, Rancillac, Ray-naud, Raysse, Rebeyrolle, Requichot, Riopelle, Saura, Schnider, Sima 2, Singier, Soto, *Soulages* 2, Stael 3, Sugat, Szenes, Tal Coat 2, Telemaque, Tomasello, Ubac 2, Vasarely 3, Van Velde Bram, Van Velde Geer, Viera da Silva.

19. Archives Nationales (Paris), series F21, Beaux Arts, Fonds Pierre Moinot, carton 1, dossier "Notes au Ministre," Memo Moinot to Malraux, 27 October 1967.

20. Pierre Cabanne, *Le pouvoir culturel sous la V^e République* (Paris, 1981), 90–91. Finally in 1975, some thirty years after his death the French state bought its first Mondriaan. Recently, Harry Bellet wondered in the pages of *Le Monde* (19 August 1997, 16) when the French public might see "the tiniest little retrospective."

21. Geneviève Poujol, "Entretien avec Claude Charpentier, le 10 novembre 1988," Whose side was he on? "He had been a necessary and helpful transitional-figure," his former chief assistant told Madame Poujol, "between the old and new order of things." With time Malraux could have brought him around more to his new way of dealing with culture. "But Jaujard was then already 71" See also Pierre Cabanne's characterization of Jaujard's conservative aesthetic tastes, in *Le pouvoir culturel*, 27.

22. On Bataille and "L'Informe," the 1996 Pompidou Center show of *anti-form* art, as

well as Bataille's criticism of Malraux's art criticism, see the group of articles by Rosalind Krauss and Yve-Alain Bois in *October*, 78 (Fall 1996), 21–105, esp. 72. On the second coming of anti-form, in the early 1960s — the one to which Malraux had referred in 1961 — see also Robert Morris, "Anti-Form," *Artforum*, 6 (1968), 33–35.

23. André Malraux, talk at the "Remise des Prix, Biennale de Paris, 1959," in the dossier "Discours d'André Malraux, 1959–1970," in the files of Ministry of Culture's research center, the Département des Etudes et de la Prospective (hereafter DEP).

24. The minutes of the meetings, Archives Nationales (Fontainebleau), Culture 890127, carton 17, dossier AFFA 1961. On the first biennial, see Cabanne, *Le pouvoir culturel*, 100–113.

25. Assemblée Nationale, 2ème séance du jeudi 27 octobre 1966, *Journal Officiel*, 88, 3981, 3988.

26. Archives Nationales, series F21, Fonds Moinot, carton 11, folder "Expositions étrangères, 1962–65."

27. See the largely positive judgment by Assane Seck, Senegal's first minister of culture, of Gaullist cultural relations with formerly French Black Africa, "L'Afrique noire," *De Gaulle et la culture*, 173–79.

28. The catalog, *Magiciens de la terre*, in the publication of the Centre Georges Pompidou, *Les Cahiers du Museé National d'Art Moderne*, 28 (Summer 1989).

29. "Discours et allocutions prononcés par Monsieur André Malraux à l'occasion de son voyage aux Antilles," septembre 1958, in the dossier "Discours d'André Malraux, 1959–1970," in the files of the DEP.

30. "Discours prononcé à Fort Lamy (Tchad) le 10 août 1960 par André Malraux," in ibid.

31. "Discours prononcé à Brasilia le 25 août 1959 par M. André Malraux," in ibid.

32. André Malraux, *Anti-Memoirs*, trans. Terence Kilmartin (New York, 1968), 129–31, 231–40. Michel Debré, *Mémoires*, vol. 3, *Gouverner* (Paris, 1987), 444. There are in fact three different versions of Malraux's interview with Nehru: the *Antimémoires*, Nehru's own in his *Discovery of India*, and yet another version carried in the pictorial history the French Embassy in India put out in English and French to mark the 23 November 1997 *panthéonization* of Malraux, *Malraux and India: A Passage to Wonderment* (Delhi[?], 1997). Since the issue here is not truth, but representation, I have retailed the Malraux account — which is almost surely the usual Malrucian fiction about events that happened.

33. See the article by K. Natwar Singh, "The Malraux Event: A Tribute to the Frenchman Who Was Greatly Influenced by India," *Outlook*, 26 March 1997, 91.

34. Emile Biasini, *Grands travaux: De l'Afrique au Louvre* (Paris, 1995), 167–68. *Anti-Memoirs*, 354–55.

35. Ministère des Affaires Etrangères, Archives Diplomatiques, Relations Culturelles (1948–1959) Japon, carton 216, [no author; most likely de Bourbon Busset, the then directeur des Relations Culturelles], "L'action culturelle de la France au Japon," [no date, most likely 1955], 7. Ambassador Daniel Lévy," "Activités culturelles de février à septembre 1955," 4–5. Ambassador Armand Berard, "Activités culturelles du poste de septembre à décembre 1958," dated 8 January 1959, 7–8.

36. Archives Nationales, Series F21, Beaux Arts, Fonds Jacques Jaujard, carton 18 (cote provisoire), Dossier, Ecole de Paris, art décor., Letter of Jaujard to Jean Herly, chargé des affaires culturelles in Tokyo, 4 July 1960.

37. Ibid., carton 17 (cote provisoire), Dossier, Exposition de peinture française 1850–1950 à Tokio et à Kioto. "Rapport Dorival, n.d. [March 1962?]." I can't imagine what this German or Italian art threat could have been in 1961.

38. "Il y a . . . eu quatre millions de Japonais pour aller voir le drapeau français placé derrière cette statue. Au Japon comme au Brésil, lorsque les gens viennent applaudir la France, ils viennent applaudir la générosité de l'esprit exprimé par le génie français." Assemblée Nationale, 7 November, 1964. See, further, Charles-Louis Foulon, "L'Etat et le gouvernement des Affaires culturelles de 1959 à 1974," *Culture et Société, Cahiers Français*, no. 260 (March–April 1993), 18–31.

9. The Language Holds Everything Together

1. As repeated or invented by André Malraux in his remembrance of de Gaulle, *Les chênes qu'on abat* (Paris, 1971); *Felled Oaks: Conversation with de Gaulle*, trans. Irene Clephane (London, 1971), 80.

2. Jean-Paul Aron, *Qu'est-ce que la culture française?* (Paris, 1975), 20.

3. Archives Nationales (Fontainbleau), C. 890127, carton 17, dossiers "conseil de l'AFAA" and "Jaujard." Archives Nationales (Paris) series F21, Beaux Arts, Fonds Pierre Moinot, carton 1, dossier "Rapport d'activité 1967" (draft).

4. Cited in François Roche and Bernard Pigniau, *Histoire de diplomatie culturelle des origines à 1995* (Paris, 1995), 32. See further Maurice Bruézière, *L'Alliance française: Histoire d'une institution, 1883–1993* (Paris, 1993).

5. Roche and Pigniau, *Histoire de diplomatie culturelle*, 32–36.

6. Ibid., 37.

7. Albert Salon, *L'action culturelle de la France dans le monde: Analyse critique*, Thesis, Université de Paris I, Panthéon, 1981 (Paris, 1983), 28.

8. Laurence Bertrand Dorléac, *L'art de la défaite, 1940–1944* (Paris, 1993), 74–106.

9. Ibid., 206–82.

10. Finally, we are beginning to get studies with a more nuanced understanding of the degrees of complicity in the Vichy years; see Philippe Burrin, *La France à l'heure allemande: 1940–1944* (Paris, 1993); *France under the Germans: Collaboration and Compromise*, trans. Janet Lloyd (New York, 1996), 306–57.

11. Roche and Pigniau, *Histoire de diplomatie culturelle*, 60.

12. Ibid. Ministère des Affaires Etrangères, Archives Diplomatiques, Relations Culturelles, 1948–1959, Series III, Enseignement, Etats-Unis, carton 329, Pierre Donzelot, à son excellence Monsieur Georges Bidault, Ministère des Affaires Etrangères, "Enseignement du français aux Etats-Unis."

13. Archives of the Ministère des Affaires Etrangères, "Rapports d'activité de l'année 1957, and 1958, de la Direction Générale des Affaires culturelles et techniques."

14. Ministère des affaires Etrangères, Archives Diplomatiques, Relations Culturelles, 1948–1959, Series III, Enseignement, Etats-Unis, carton 329, Denise Ravage, "Projet de création d'un centre du livre français aux Etats-Unis," 1–3.

15. All money values expressed in new francs. Based on Gilbert Pilleul, "La politique culturelle extérieure, 1958–1969," Annex I, II, IV, Institut Charles de Gaulle, *De Gaulle en son siècle: Actes des journées internationales tenues à Unesco Paris, 19–24 novembre 1990*, 7 vols. (Paris, 1992), Vol. 7: *De Gaulle et la culture*, 154–56. Archives of le Ministère des Affaires Etrangères, Report of Pierre Laurent, director general of the DGACT, "Relations culturelles, scientifiques et techniques, 1968–1969," 5–6.

16. "Discours prononcé par M. André Malraux . . . le samedi 28 septembre 1968 à l'occasion de l'Assemblée Générale de l'Association Internationale des Parlementaires de Langue française," and ". . . à l'occasion de la Conférence des Pays Francophones à Niamey le 17 février 1969," both in the dossier "Discours d'André Malraux, 1958–

1970" at the Ministry of Culture's research center, the Département des Etudes et de la Prospective.

17. Quoted in Roche and Pigniau, *Histoire de diplomatie culturelle*, 80.

18. Ibid., 100.

19. Cited in Daniel Coste, ed., *Aspects d'une politique de diffusion du français langue étrangère depuis 1945: Matériaux pour une histoire* (Paris, 1984).

20. I have drawn on Brian McKenzie's unpublished 1995 paper "Defending French: René Etiemble's *Parlez-vous franglais* and the Politicization of Linguistic Conservatism," for material in these two paragraphs.

21. Aron, *Qu'est-ce que la culture française?*, 25.

22. Pierre Grémion, "Les centres culturels français en Europe dans les années 70," in *Sociologie de l'art*, Actes du colloque international, Marseilles, 13–14 juin 1985, ed. Raymonde Moulin (Paris, 1986), 47–60, esp. 60.

23. Archives Nationales (Fontainbleau), C.890127, carton 17, dossier "Jaujard," "Conseil lundi 21 déc. 1964" and "Conseil vendredi 2 juillet 1965."

24. Archives Nationales (Paris), series F21, Fonds Moinot, carton 1, dossier, "Notes au ministre," memo, Moinot to Malraux, 24 Jan. 1967.

25. Assemblée Nationale, 2ème séance du jeudi 27 octobre 1966, *Journal Officiel*, 3989.

26. Salon, *L'action culturelle*, 28. Pilleul, "Politique culturelle extérieure," Annexes I-IV.

27. Salon, *L'action culturelle*, 14–26.

28. Roche and Pigniau, *Histoire de diplomatie culturelle*, 95.

29. See the number of *Esprit* of November 1962, entirely dedicated to the topic, with the hopeful title "Le français, langue vivante." The article by Léopold Sédar Senghor is credited by some as marking the beginnings of the non-French controlled movement of *francophonie*.

30. Archives Nationales (Paris), series F21, Beaux Arts, Fonds Pierre Moinot, carton 1, memo Moinot to Malraux, 27 Oct. 1967. I have presented the side of *francophonie* which was French manipulation. In fact, *francophonie* was a contested *champ*, in Bourdieu's sense, with former colonial nations seeing the power its unifying action would give them — against France if necessary. James Genova of SUNY Stony Brook is completing a dissertation on this aspect of *francophonie*.

31. Roche and Pigniau, *Histoire de diplomatie culturelle*, 95.

32. François Dosse, *History of Structuralism*, trans. Deborah Glassman, 2 vols. (Minneapolis, 1997).

33. Francis Jeanson, *L'action culturelle dans la cité* (Paris, 1973), 117–41.

34. Roland Barthes, "La mort de l'auteur," in *Le bruissement de la langue: Essais critiques* (Paris, 1984), 61–67. A valuable conversation with Jan Matlock in August 1997 alerted me to this essay and its importance. Priscilla Parkhurst Clark discusses the role of literati in French history. Although our approaches differ somewhat, I recommend her excellent book — the paperback edition with a new preface: *Literary France: The Making of a Culture* (Berkeley, Calif., 1991).

35. Roland Barthes, "De l'oeuvre au texte," *Revue d'Esthétique*, 3 (1971), 225–32. I have used and modified Stephen Heath's translated version, in *Art after Modernism: Rethinking Representation*, ed. Brian Wallis (Boston, 1989), 169–74. Italics Barthes's. Jack Donaldson shared with me (27 November 1997) an important conversation he had had with Roland Barthes, his teacher, in which Barthes glossed his essay on the death of the author as being about, finally, the triumph of the critic.

Conclusion: Deaths and Resurrections

1. Pierre Moinot, *Tous comptes faits* (Paris, 1993), 137–38.

2. Malraux, *Les chênes qu'on abat* (Paris, 1971); *Felled Oaks: Conversation with de Gaulle,* trans. Irene Clephane (London, 1971), 2, 98.

3. This point about market and autonomy is well put by Miriam Hansen, "Unstable Mixtures, Dilated Spheres: Negt and Kluge's *The Public Sphere and Experience* Twenty Years Later," *Public Culture,* 10 (1993), 179–212, esp. 191.

4. The 1960s was the time, recall, of many theories in which the state and civil society were seen as relatively independent one from another: European social democracy (which has always operated with that distinction to create socialist reforms in capitalist societies), French structural Marxists, like Nicos Poulantzas who specifically elaborated the idea, and Maoism in China and elsewhere with its ideology that a modern socialist party in command of the state could force a feudal society through the stages of socioeconomic development under the slogan "Politics in command!"

5. The most notable such model is Talcott Parsons and his school.

6. Chagall completed his brilliant paintings of the ceiling, walls, and curtain of the Jewish Theater in Moscow in forty days in the 1920s. What survived (the ceiling was lost) was found in 1973 again in Russia and exhibited in the United States in 1992–93 and in the Paris municipal modern art museum in 1995. Comparing the Opera ceiling with the work of the young artist suggests—to me at least—that France had not acted quickly enough.

7. "May '68 is the point at which an observer with retrospective binoculars cries: 'Nothing in intellectual society will ever be the same again'": Régis Debray, *Le pouvoir intellectuel en France* (Paris, 1979); *Teachers, Writers, Celebrities,* trans. David Macey (London, 1981), 89.

8. Ibid., 39–95.

9. Jean-Marie Domenach, *Le crépuscule de la culture française?* (Paris, 1995); Jacques Rigaud, *L'exception culturelle: Culture et pouvoir sous la V^e République* (Paris, 1995); Fabrice Piault, *Le livre: La fin d'un règne* (Paris, 1995).

10. Pierre Bourdieu, *Sur la télévision* (Paris, 1996).

11. Domenach, *Le crépuscule,* 152, 126, 100. The WORD, one could think, is finishing by being talked to death. We might see the activity as a mode of enjoying a fully ripe delicacy, a mannerism coming at the end of a style, or, perhaps, a love-death. It's marvelous and true to the classical heritage of late Roman endings, if a bit derivative of some—say, that of Petronius Arbitor. There's something right about the name of the expensive, punky new boutique I saw recently near Les Halles: "While Waiting for the Barbarians." Foreign and, I must say, especially American, specialists in French and comparative literature have seen the creative possibilities in the current situation. They are inventing varieties of French cultural studies which, by combining literature, film, art, sociology, and history— disciplines rigidly segregated from one another in contemporary France—are bringing new, rich, perspectives to the study of France.

12. *Granta,* 59 (Autumn 1997), 11.

13. Domenach, *Le crépuscule,* 93–94.

14. Pierre Moulinier, of the Département des Etudes et de la Prospective, the research center of the Ministry of Culture, made this point in my interview with him on 26 November 1990.

15. Michel de Certeau, who understood the power of *the culture,* wrote about the jujitsu-like strategies of the weak. See his *Heterologies: Discourse on the Other* (Minneapolis, 1986) and *The Practice of Everyday Life* (Berkeley, Calif., 1984).

16. Rigaud, *L'exception culturelle*, 293.

17. Régis Debray, "André Malraux: Perdant magnifique," *Le Monde*, 23 November 1996. With a group of coworkers from diverse disciplines and arts, including a librarian, Debray edits an interesting journal dedicated to the study of what he calls "médiologie," *Les Cahiers de Médiologie*.

18. Jean-François Lyotard, *Signé Malraux* (Paris, 1996), 10–11.

19. For a more detailed account and evaluation of the Malraux ceremony my two articles "André Malraux: A Hero for France's Unheroic Age," *French Politics and Society*, Center for European Studies (Harvard), 15 (Winter 1997), 58–69, and "Malraux's Mission," *Wilson Quarterly*, 21 (Winter 1997), 78–87.

Index